FILIPPINO LIPPI

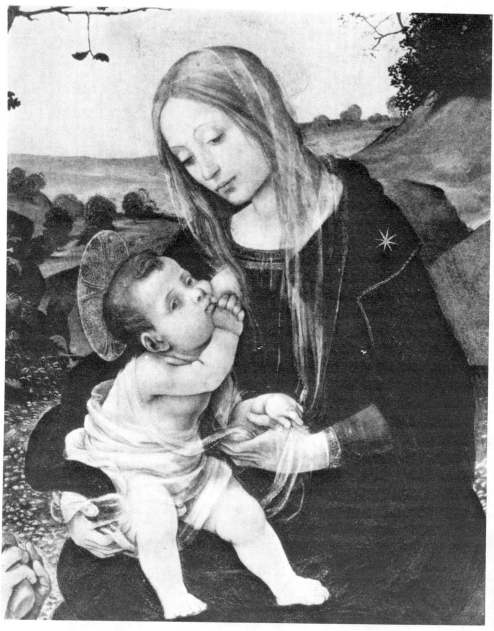

FILIPPINO LIPPI. MADONNA AND CHILD, DETAIL

NATIONAL GALLERY, LONDON

FILIPPINO LIPPI

A Critical Study

BY

KATHARINE B. NEILSON

GREENWOOD PRESS, PUBLISHERS
WESTPORT, CONNECTICUT

The Library of Congress has catalogued this publication as follows:

Library of Congress Cataloging in Publication Data

Neilson, Katharine Bishop.
 Filippino Lippi.

 Original ed. issued in series: Harvard-Radcliffe
 fine arts series.
 Bibliography: p.
 1. Lippi, Filippino, d. 1504. I. Title.
 II. Series: Harvard-Radcliffe fine arts series.
 ND623.L67N4 1972 759.5 77-138168
 ISBN 0-8371-5625-4

TO MY SISTER
JANE NEILSON TAFT

PREFACE

THE present study was originally undertaken with the intention of supplying an adequate monograph on the life and work of Filippino. Dr. Alfred Scharf's book, published in 1935, does much to fill the need for such a monograph; nevertheless I hope that a full length study in English may not be superfluous.

In the discussion of the work of Filippino himself, I have included all paintings which I accept as authentic. I have tried to make clear the influences which affected him, and those which he exerted on contemporaries and followers. In this connection the moot question of Amico di Sandro has been touched upon; and I have added brief comments on the work of Filippino's pupils and imitators. It has seemed impossible to speak of the best known of these, Raffaellino del Garbo, without entering at some length into the question of his puzzling identity; accordingly he has been made the subject of a separate chapter.

In view of Dr. Scharf's scholarly catalogue of Filippino's drawings, I have thought it permissible to omit a similar catalogue from this book. I have, however, spoken of drawings which can be directly related to existing paintings, since it is obviously impossible to understand or appreciate a painter without studying his sketches. In Filippino's case the drawings frequently surpass in quality the paintings derived from them.

With regard to the illustrations, I have felt justified in omitting some which are well known or accessibly reproduced, except in certain cases where convenient juxtaposition emphasizes a point of comparison or contrast. For additional illustrations the reader is referred to the fine plates in Dr. Scharf's book.

The bibliography is intended to be complete and up to date, although certain items, especially articles in periodicals, may have escaped my notice. One exception to this lies in the deliberate omission of references to some of the older histories of painting, which simply repeat one another and add nothing to such standard works as Crowe and Cavalcaselle and Venturi.

But not all sources are bibliographical in character; and I wish here to acknowledge my gratitude, both for helpful advice and for introductions to scholars abroad, to Professor Chandler R. Post, the late Professor A. Kingsley Porter, and Professor Clarence A. Kennedy. I owe a special debt to Professor Georgiana Goddard King, whose teaching first interested me in Filippino and at whose suggestion this study was undertaken. Without the hospitable assistance of the Kunsthistorisches Institut in Florence, the Biblioteca Hertziana in Rome, the library of the Uffizi, the Fogg Museum in Cambridge, and the photograph collections of Sir Robert Witt in London and Mr. Bernhard Berenson at Settignano, I should have been sadly handicapped. Private collectors have been most generous in permitting me to study pictures in their possession, and I am glad to express my appreciation of their courtesy. I wish also to thank those who have given me permission to reproduce paintings and photographs in their collections.

I am indebted to the Harvard-Radcliffe Fine Arts Series for the inclusion of my book in that series; and I wish to add a special word of thanks to its director, Professor Paul J. Sachs, for his interest and encouragement throughout the course of my work. Thanks are also due to my friend Roberta M. Fansler for a critical reading of the manuscript; to the Reverend Melville K. Bailey for helpful criticism and always stimulating comment; to the staff of the Fogg Museum for numberless good offices; and finally to my friend the late Ruth S. Murray and my sister Jane Neilson Taft, who in discussions during our travels together in Europe showed themselves to be discerning critics as well as sympathetic and enthusiastic companions.

K. B. N.

NORTON, MASSACHUSETTS
April 6, 1938

CONTENTS

ILLUSTRATIONS

FILIPPINO LIPPI

CHAPTER I

INTRODUCTION

On a certain day toward the end of the Quattrocento, an agent on the look-out for capable painters to work for Lodovico Sforza of Milan sent a report from Florence to his noble patron. Four masters, active in the city at that time, could be especially recommended, he wrote, and such were their merits that one could scarcely choose the best among them: Botticelli, Ghirlandaio, Perugino, and Filippino Lippi.

Later generations, past and present, have shared the enthusiasm of the Sforza agent and have given concrete expression to their approval in the form of books and articles, historical and critical, on the painters in question, with one exception: that of Filippino. He alone of the four has been allowed to fall into neglect, if not oblivion, and has had to wait for the year 1935 for the kind of scholarly and lavishly illustrated monograph [1] of which there have long been several for Botticelli, Perugino, and Ghirlandaio.

Today, thanks to Dr. Alfred Scharf's book, it is no longer necessary to present an apologia for Filippino, or to defend his reputation in terms that suggest that he still lacks a champion. Nevertheless, it may not be out of place to offer to the reader, in this introductory chapter, a brief summary of my aims in having undertaken the studies of which this book is the result, and to suggest some of the reasons why Filippino has been so recent a subject of scholarly investigation and critical analysis.

The absence of publications dealing exclusively with Filippino is especially surprising in view of the fact that general histories of art do not dismiss him as a poor or unimportant painter. To be sure, he is the subject of a slender and superficial, though appreciative, volume by Paul Konody; [2] and a pamphlet in the *Masters in Art* series [3] was devoted to him. He has twice shared honors with his father in separate books, both called *Les Deux*

[1] Alfred Scharf, *Filippino Lippi* (Vienna, 1935).
[2] *Filippino Lippi* (London, 1905).
[3] *Masters in Art*, vol. VIII, pt. 87 (Boston, 1907).

Lippi; the former, published by I. B. Supino in 1904,[4] is useful as far as it goes, but it is now out of date in many respects — for example, in the omission of the Spoleto documents which prove Filippino's presence in that city while his father was at work on the Duomo frescoes. The second volume, by M. Urbain Mengin of the French Institute in Florence, published in 1932, incorporates some of the material brought to light since Supino wrote, but it is a frankly popular publication, sentimental and effusive in style and of little service to the scholar.

At the same time, considerable documentary research has been quietly pursued on the subject of Filippino, with the result that if one pieces together these scattered fragments, for the most part buried more or less obscurely in magazine articles, one finds a fairly full documentation for the painter's life and work. It is otherwise with pure criticism. Little attempt has been made to evaluate and present Filippino in relation to his contemporaries or to indicate clearly his place in the general stream of Italian painting. Even Dr. Scharf touches only briefly on this question, his aim being to present all available facts as concisely as possible, with a minimum of critical discussion.

How does it happen that Filippino has been so consistently ignored or, at best, undervalued? For one thing, the combination of picturesque personality and outstanding genius in the elder Lippi has diverted interest from the son — to such an extent that literally for centuries pictures of his passed for those of Fra Filippo, a confusion for which the similarity of names is not satisfactory as the only reason. The publication of two books under the title *Les Deux Lippi* is symbolic; it would seem that Filippino cannot be discussed except as a relative of his more artistically distinguished father.

In the second place, Filippino received most of his artistic training from Botticelli, and Botticelli is a living exception to the usual rule that a master is surpassed by his gifted pupil. Filippino, being in many respects recognizably like Botticelli, can scarcely hope to be compared with him otherwise than to his own disadvantage. So he has been classified arbitrarily as a kind of *seguace* with little individuality or interest, and many artistic faults.

Berenson once remarked that "To a certain degree . . . it is undeniable that Filippino is the victim of ill-luck." [5] He cites as an example of this the Brancacci chapel, where, he says, "his frescoes . . . are crushed by the too

[4] Translated by J. De Crozals.

[5] Bernhard Berenson, *The Study and Criticism of Italian Art*, Series II (London, 1902), p. 91.

close proximity of Masaccio." I do not agree that Filippino's work is "crushed" in the Brancacci; far from it; but the ill-luck comes out in the fact that many critics, starting from the point of view of Masaccio's supreme greatness, have proceeded to a kind of aesthetic *non sequitur* and dismissed Filippino's work not only as less fine, but as definitely weak.

Filippino met with a good deal of attention in the nineteenth century apropos of the question: how much of the Brancacci decoration is Masaccio's and how much Filippino's? The point was contested so hotly that Milanesi made it the subject of his *Commentaria sulla vita di Filippo Lippi* [6] (i.e., Filippino). That such a controversy could arise at all is certainly a point in Filippino's favor; this was not, however, recognized at the time, and the painter's period in the public — or rather academic — eye only served to lower his reputation, because the scholars concerned started with a prejudiced point of view as well as with eyes less experienced than those of later generations of critics.

Again, Filippino had the misfortune to be rivaled and ultimately eclipsed by the three giants of the Cinquecento, Leonardo, Michelangelo, and Raphael, although this rivalry occurred during his lifetime only in the case of Leonardo. Certain incidents in his career are prophetic of his future status in comparison with these men. At least once he accepted a commission which Leonardo had discarded for something more interesting; only a few weeks before his death he helped indirectly to further the young Michelangelo's reputation by voting on the placing of that sculptor's David as a public monument. His contact with Raphael is less direct; but we have evidence of one debt at least which the Umbrian painter owed to Filippino. [7]

Now I have no intention of trying to place Filippino on a par with the trio just named. But how has he been judged in comparison with the lesser men of the Transition? Once again, he fares worse than Piero di Cosimo, the contemporary with whom at one period of his development he exchanged artistic ideas. In power of invention and in progressive tendencies I do not believe Piero had any tremendous advantage over Filippino, but he did have

[6] Gaetano Milanesi, edition of Giorgio Vasari's *Le Vite de' più eccellenti pittori, scultori, ed architettori*, III (Florence, 1878), 479–490.

[7] I refer to the figure in Raphael's cartoon of Saint Paul preaching to the Athenians, for the Arazzi in the Vatican, which is very close in pose and type to that of the Saint Paul visiting the imprisoned Saint Peter, in the Brancacci chapel. It may be argued that this is Masaccio's design, but we have no proof of this, and it was certainly painted by Filippino. The similarity has occasionally been pointed out.

certain qualities which help to insure a posthumous reputation: not only considerable artistic gifts in which there is a fascinating eclecticism and marked originality, but also personal eccentricities that make him a highly picturesque if not attractive individual. In contrast to this apparently morbid misanthrope Filippino had a history and character disappointingly normal for a man born under such unconventional circumstances as he was. It is that fact, I think, rather than prudish disapproval that has been in part responsible for the neglect of a painter whose one personal fault seems to have been the too accommodating nature which caused him to accept more commissions than he could carry out.

Finally, I believe that Filippino has been overlooked by scholars and laymen alike because he simply has not appealed to the taste of recent generations. A very few of his pictures have enjoyed considerable popularity, notably the "Vision of Saint Bernard" of the Badia and the "Madonna Adoring the Child" in the Uffizi [8] (the latter not even universally accepted as his). The obvious charm of these, and their sentiment, which few trouble to analyze, have brought them a well-deserved reputation among scholars also; but because they seem to present no problems, they have not been found interesting.

Unfortunately, there is current a misconception to the effect that pure aesthetic enjoyment is not the business of the scholar. If I subscribed to that idea I should not have the temerity to present this study, for I am perfectly aware that it contains little in the way of factual material that was not known before, though perhaps not widely known. But I do believe that there is absolute beauty in the "popular" Madonnas of Filippino, just as there is in those of Raphael (and Filippino's are far less hackneyed), which we should do well to contemplate. If this were not so, indeed, I should scarcely have cared to devote to this work the years of which these pages are the result.

It is only fair to say that the charm of Filippino's altarpieces has been generally admitted, even by those who, like Berenson, have a tendency to be patronizing about the painter. One must remember with gratitude that critic's estimate of the Badia Saint Bernard and the Santo Spirito Madonna, which, he says "live, or should live, in the memory of everyone who cares for beauty." But it is also fair to recall that in Berenson's opinion these two, plus the Warren *tondo* of the Madonna and Saint Margaret, are the only

[8] Number 3249.

examples, save the Brancacci frescoes, worthy of immortality. What of the exquisite Madonna and Saints of the National Gallery, the Uffizi Madonna and Saints of 1486, or even the damaged but still monumental "Triumph of Saint Thomas" in Santa Maria Sopra Minerva? It is from just this sort of limited appreciation that Filippino has chiefly suffered.

In art there seems to be something about enjoying favor among one's contemporaries which is fatal to posthumous reputation. Even of painters in the Quattrocento, when standards of taste and criticism were at a level unsurpassed in other periods, this tends to be true. But the law of compensation is pretty universally operative; for it is also a fact that most painters pass through alternating periods of popularity and disfavor if not of oblivion. A man may be "revived" as a novelty, or to increase his sponsor's reputation for unusual discernment or erudition, or for the excellent reason that he actually turns out to have virtues which had been overlooked. For Filippino, a return to favor may be just beginning. Intensely admired during his lifetime, signally honored and widely mourned at his death, he soon entered upon a period of eclipse which even today has not wholly ended. It is easy to account for the beginning of this eclipse, since he died while Leonardo was still at the height of his powers, with Raphael and Michelangelo beginning to be famous. Vasari praises Filippino, and we know that Benvenuto Cellini admired his sketches. But who in the sixteenth or seventeenth centuries was aware of his existence, apart from historians such as Félibien [9] and Richa? And did not even they make blunders in attribution?

In the nineteenth century, when it began to be legitimate to prefer Quattrocento altarpieces to those of Raphael and the Bolognese, visitors to Florence did occasionally take note of the Saint Bernard along with Fra Angelico and Fra Filippo. And although the point has seldom been made, I think a false dawn came for Filippino through the Pre-Raphaelites, whose works, especially those of Burne-Jones, closely approach his particular kind of feeling and even physical type.[10] Those earnest and charming Englishmen must have found in him a thoroughly kindred spirit. Yet as research pro-

[9] The only thing that Félibien found worth mentioning was the fact that Filippino had painted for Matthias Corvinus, King of Hungary, whom he makes the real subject of paragraphs ostensibly concerned with Filippino. See *Entretiens sur les vies et sur les ouvrages des plus excellents peintres anciens et modernes*, I (Paris, 1666), 197–198.

[10] I do not know whether the Brotherhood ever admitted the influence of Filippino. Their debt to Botticelli is well known, and their likeness to Filippino may have its origin in this common ancestor.

gressed and painter after painter was graduated from Crowe and Caval-
caselle to a monograph, Filippino remained bound and limited by the
general histories of art.

The son of Fra Filippo has two claims on that universal attention which
has long been accorded his contemporaries: one, the quality of his work
itself, combining as it does much pure visual beauty with an unusual psycho-
logical sensitiveness which should be of particular interest to the twentieth
century; the other, distinct importance as a link between the Quattrocento
and both Cinquecento and Seicento.

Of the first, little can be *said* with profit; the most one can hope to do is to
point out such things as the writer has found beautiful, and leave the reader
to make up his own mind on the basis of his own visual and emotional re-
sponse to the paintings. On the other hand, progress and change are historic
rather than aesthetic facts, and a painter's importance may happen to de-
pend purely on them as elements in his work, to the total exclusion of beauty
as such. It is therefore necessary, in considering the place of a given painter
in the history of art, to keep distinct what might be called the aesthetic and
the historical aspects of his work. Too often people confuse the two, and
evaluate one by means of standards only applicable to the other. Filippino
is a case in point. On the one hand his early Madonnas, obviously attrac-
tive, are found less admirable than those of Fra Filippo and Botticelli from
which in part they derive, the implication being that they are reactionary
and old-fashioned, or at best mild and unexciting; per contra, the purely
progressive qualities in his later work are dismissed or condemned because
they offend the aesthetic sense. The more indulgent critics, such as Konody
and even Berenson, make excuses for this late work on the grounds that it
shows "the faults of the epoch." But is it not more accurate to say that an
epoch (i.e., in art) shows the faults and virtues of its leading spirits? A minor
man is certainly at the mercy of the tendencies of his age, but these tenden-
cies must exist in certain individuals before they can characterize a whole
period, and I believe that Filippino was decidedly one who, directly or in-
directly, did as much as any of his immediate contemporaries to formulate
the character of the Cinquecento and at the same time of the Seicento. Let
us not deprive him of this distinction by calling him the product of an age of
which, in the last analysis, he had so large a share in determining the course.
Not until after his death do we find many painters of equally progressive

tendencies; and the Minerva frescoes (his own most road-breaking achieve-
ment) were painted some fifteen years earlier. The work of developing
and disseminating the new ideas fell to Michelangelo and Raphael; many
of these ideas, as I hope to show, had already been given expression by
Filippino.

In speaking of Botticelli as a fresco painter, Professor Yashiro offers a
statement concerning the requirements of wall decoration which, if applied
to the Strozzi frescoes of Filippino, would condemn them instantly as failures.
"The art of the Cinquecento," he says, "had its guiding principle in two
motives ill-suited for wall-painting: the dramatic and the realistic." [11] I shall
not go into the question whether the Baroque tends to contradict this state-
ment (i.e., as regards the requirements of wall painting); but by this defini-
tion Filippino's Strozzi frescoes are altogether of the Cinquecento. I hope
to show in a later chapter that they contain, in addition to the dramatic and
realistic, some of the elements fundamentally suitable to mural decoration,
such as color and design; here I would point out simply that Filippino does
more than any other Florentine of his day (i.e., before 1500) to further the
development of wall painting, along Cinquecento lines.[12] Those who dislike
the Cinquecento will doubtless describe these frescoes as decadent; what I
wish to emphasize is the essentially progressive character of the work. In
addition, I would urge the presence in it of real beauty discernible by every
unprejudiced eye.

[11] Yukio Yashiro, *Sandro Botticelli* (London, 1929), p. 139.

[12] Mantegna and Melozzo da Forlì, of course, represent different schools and traditions, al-
though, like Filippino, they foreshadow the Cinquecento solutions to various problems, especially
those of ceiling decoration. The great frescoes of Raphael and Andrea del Sarto are, of course, later.

CHAPTER II

THE EARLY YEARS

In striking contrast to that of the elder Lippi, Filippino's life, so far as it is known, was comparatively uneventful, and his character the reverse of his father's. Various writers have given the date of his death as 1505 (it actually occurred in 1504), following the statement of Vasari, who says he died, universally beloved and honored, at the age of forty-five.[1] This, if true, would date his birth in 1459–60, and indeed the inscription on Fra Filippo's house in Prato states that his son was born there in 1459.[2] The correct date is now generally believed to be 1457, following the famous elopement of Fra Filippo and Lucrezia Buti on the Feast of the Girdle of Our Lady, in May 1456. As yet no good reason has been found for rejecting this romantic scandal, the story of which is too well known to need repeating. We may assume that for once Vasari was not obliged to draw on his imagination, or on earlier *novelle*, for this picturesque page of Fra Filippo's biography.

In view of a document relating to the stay of the Frate and his son in Spoleto, to be discussed later, Gronau has felt it desirable to push Filippino's birth date back a few years. While I agree that this would make the Spoleto document more plausible, I question whether it can be done convincingly on the basis of the evidence we have. Lucrezia and Spinetta Buti [3] had been clapped into the convent of Santa Margherita in Prato before Fra Filippo came to that town to begin the Duomo frescoes. They must have been carefully cloistered during their novitiate, and we may perhaps assume that they

[1] Milanesi-Vasari, *Le Vite de' più eccellente pittori*, III, 475, 476.

[2] The inscription runs as follows:

FILIPPO LIPPI / COMPRÒ E ABITÒ QUESTA CASA / QUANDO COLORIVA GLI STUPENDI AFFRESCHI DEL DUOMO / E QUI NAQUÈ DEL MCCCCLIX FILIPPINO / PRECURSORE DI RAFAELLO / IL COMUNE / PONEVA NELL' OTTOBRE DEL MDCCCLXIX.

The line, "Precursore di Rafaello" is more than mere local pride on the part of the Pratesi! The house is in the Via Magnolfi.

[3] They are known to have been professed nuns in 1454, having voted in that capacity in that year; see Milanesi-Vasari, II, 634.

regarded their final vows (even though they seem to have lacked anything like a "vocation") seriously enough to abide by them for the first year or so. Fra Filippo was not appointed chaplain to the convent until 1456; consequently, it is unlikely that he had an opportunity of meeting either sister before that year. Hence, unless we choose to guess that Filippino was the son of neither of the Buti but of a third woman — an improbable hypothesis — I think the date 1457 must be accepted as that of the boy's birth, in Prato, and Vasari's statement of his age at death rejected.

Another piece of evidence which throws some — if not very clear — light on the question of Filippino's childhood is the *tamburazione* dated May 8, 1461.[4] This anonymous statement, accusing Fra Filippo of having in his house a son by Spinetta Buti, brings up the question as to which of the sisters was Filippino's mother. In both of his wills he names Lucrezia, however; this evidence should have more weight than that of an anonymous accusation written at least three years after the elopement, by one whose information may well have been inaccurate, based as it probably was on gossip and hearsay. But even if we ignore the reference to Spinetta, there is still the mention of Filippino to consider, since he is described as "grande" and living in the Frate's house. We have no way of knowing exactly what "grande" implies here; some have thought that it must mean a child older than three or four, which would, if true, account for the apparent precocity of the boy in Spoleto eight years later. Horne simply translates the word "is growing up." [5] But the word "grande" seems to me to be as likely to mean three or four, as, say, ten years of age. The accuser was writing primarily about another illegitimate child about two months old, son of Ser Piero d'Antonio di Ser Vannozzo,[6] procurator of the convent of Santa Margherita; and he adds the reference to Fra Filippo as though reminded, naturally enough, of an old but juicy bit of scandal. To contrast this older child with the younger, he called the former "grande," I think, as one might speak of a child who can walk and talk, as "a big boy," simply meaning that he is no longer a real baby. The fact that Filippino's name is distinctly

<hr/>

[4] Archivio di Stato, Florence, Deliberazioni degli Ufficiali di Notte e Monasterii del 1459–1462; the entire text is printed in Edward Strutt's *Fra Filippo Lippi* (London, 1901), p. 181.

[5] Herbert P. Horne, *Alessandro Filipepi* (London, 1908), p. 9, hereafter referred to as *Botticelli*.

[6] "Già fa mesi due o circa ebbe detto ser Piero un fanciullo maschio in detto Ministerio (i.e., Santa Margherita). E'l detto fanciullo mandò di nocte tempo fuori della porta per una certa buca, e fu portato allo Petriccio, e la mattina poi fu arechato in Prate a battezzare" (Strutt, *Fra Filippo Lippi*, p. 181).

given[7] leaves no room for doubt as to the identity of the child in the Frate's house. Finally, the farther back we push Filippino's birth year, the less reasonable becomes his inclusion in the *tamburazione*; there would have been little relish in the revival of a scandal ten or twelve years old, especially as all Prato would have known the story, and, indeed, probably did in 1461.

For several years following this, Filippino is lost sight of. His parents were released from their vows by Pius II,[8] though whether they took advantage of the resulting opportunity to marry is not known. In any case there seems to have been a daughter, Alessandra, born in 1465,[9] and it is safe to assume that the family remained in Prato for the first decade of Filippino's life. Then in 1466 [10] came the summons to Spoleto, where Fra Filippo undertook his last monumental work.

Although it is natural to suppose that during these early years Filippino must have been learning the rudiments of painting from his father, it has been objected, reasonably enough, that if Fra Filippo left Prato forever in 1466–67, his son could hardly have had time to learn much, having been left, as was assumed, at home with his mother. He must have been too young to have been interested in the frescoes of the Prato Duomo, finished in 1464; but that he watched the progress of those in Spoleto is now known, thanks to the discovery by Dr. Fausti of an account book [11] in the Duomo there, sections of which he published in 1915. This article is almost embarrassingly complete in its picture of the situation, for not only is Filippino proved to have been with his father throughout the latter's stay in Spoleto, but he seems to have been thought sufficiently responsible to pay fees and receive payments in his father's name, in spite of the presence of the collaborating painter, Fra Diamante. Indeed, the accounts read as though Filippino were already of age or nearly so, a circumstance which has led Dr. Gronau to the belief that he must have been older at the time of the Frate's death than is generally supposed.

Since Fausti's article is neither well known nor readily accessible, it may be useful to summarize its contents in so far as they affect our knowledge of

[7] "E detto fanciullo è in casa: è grande, e a nome Filippino" (Strutt, p. 181).

[8] Vasari says the pope was Eugenius (IV); see Milanesi-Vasari, II, 629; but Milanesi points out (p. 638) that it would have to have been Pius II. [9] Milanesi-Vasari, II, 638.

[10] The actual invitation may well have come in the winter of 1465, since expenditures in February 1466 were already being made for colors; see below.

[11] Luigi Fausti, "Le Pitture di Fra Filippo nel Duomo di Spoleto," *Archivio per la storia ecclesiastica dell' Umbria*, II (1915), 1 ff.

Filippino. The Spoleto record consists of a volume of receipts and expenditures of the cathedral canons. On February 8, 1466, this Libro dell'Opera records 10.5 florins, 40 soldi, spent for gold and blue.[12] On May 1 of the same year a payment is made to Tommaso di Giacomo of Spoleto for Fra Filippo's traveling expenses. The family headquarters of the Lippi appear to have been in Florence at the time; Fra Filippo went back there in June 1466 and does not seem to have returned to Spoleto until April of the following year, in spite of a summons from the Opera in November 1466. This time Fra Diamante and Filippino went with him. The presence of both Lippi in Spoleto is indicated by an entry of April 26, 1467; but it was not until September of that year that the actual painting was begun, judging from a payment recorded in that month for plastering and vases for color.

Meanwhile, however, Fra Filippo was proving something of an expense to the Opera. He was in Spoleto steadily between 1467 and 1469, when he died. He had a house and garden leased for him by the canons, who seem to have paid the living expenses of the ménage as well. There are almost monthly entries in the account book — expenditures for beds and bed linen, supplies of food, and occasional presents such as pigeons, capons, and salt meat. Even clothing was provided out of the Opera's coffers: on May 13, 1467, the Libro records the payment to Fra Filippo of 1 florin, 30 soldi, for "uno paro di calze per filippino suo." More stockings were bought the following July; some "panno rosso" in January 1468. Later come items doubtless connected with Filippino's going into mourning for his father, who died October 9, 1469 [13]: October 12, 1469, two days after the funeral, "Pagose . . . soldi 47, den. 6 sonno che se pagaro ad don diamante et filippino et per loro ad antonio da monte lione per una berretta negra se comparò da lui"; October 19, 1469, "Pagose . . . fior. 3, sonno che se pagaro ad filippino . . . per pagare la fattura del mantello et sui altri bisogni"; October 23, 1469: "soldi 12. den. 6 ad giacoangilo sartore per facetura de uno paro di calze de perpignano biancho." Under November 29, 1469, we read: "Pagose . . . fior. 2, soldi 52, den. 6 . . . ad filippino et per lui ad lucha de colantonio, cioè bolognini 54 per vino tolse da lui et bol. 47 per panno tolze da lui per calze." On Christmas eve, two months after his father's death,

[12] This and the ensuing quotations from the Libro dell'Opera are taken from Dr. Fausti's article; see note 11. Dates are given in modern style unless otherwise stated.

[13] Possibly October 10; see below, note 14.

and just before his departure from Spoleto, Filippino received a pair of capons from the Opera: "Pagose . . . soldi 27, den. 6 . . . si pagaro per comparare uno paro di capponi per donare ad filippino." No Christmas present to Fra Diamante is recorded!

Interspersed with these homely items are expenditures for medical care of Fra Filippo. The first of these is recorded on July 2, 1469: "Pagose . . . fior. 1, soldi 50, sonno che se pagaro ad frate filippo, *porto filippino* [italics mine] quando stava infirmo." Four days later one florin, 50 soldi, are issued "ad frate filippo et per lui ad mastro nicholò per haverlo medicato." Finally on October 10 appears the entry, "Pagose . . . fior. 2, soldi 15; sonno che se pagaro ad don diamante et filippino et per loro ad preti et frati et vicini per lo exequio di frate filippo." The Necrologium of the Carmelites in Florence gives the date of his death as October 9.[14] Some of the expenses of the Frate's illness were not paid until later; payments toward fees of the doctor, "Maestro Giovanni di Girgorio" (Gregorio) were made — to Filippino — on October 21, November 29, and December 31, the last one on the eve of the boy's departure for Florence; and also on November 29, 3 florins 11 soldi were issued "ad filippino et per lui ad perurbano de battista per cura se tolse da lui per fare lo exequio di frate filippo."

Just at the end of December 1469 a mysterious figure enters the records under the name of "frate giovanni." On the twenty-ninth of that month, we read, 2 florins 4 soldi were paid to Filippino, "volse per dare ad frate giovanni quando venne a spoleti lultima volta," and on December 31, "Pagose . . . fiorini 3, soldi 8, . . . se pagaro a filippino in fiorini 2 in oro. Volsero per dare ad frate giovanni." Was this perhaps an envoy from the Carmine in Florence?[15] And did Filippino return to Florence in Fra Giovanni's care?

Another entry in the Libro dell'Opera under December 31 runs as

[14] "VIIII Octobre, F. Philippus Thomae Lippi de Lippis Flor. pictor famosissimus obiit Spoleti pingens cappellam majorem in ecclesia Cathedrali." Quoted by Dr. Fausti, p. 15. He also cites the records of the notary Giovanni di Luca da Spoleto (pp. 15–16), which contain a calendar with marginal notes set down when striking happenings occurred. These notes include a statement to the effect that Fra Filippo died on October 10. The entries in the Libro dell'Opera sound as though the funeral rather than the death had taken place on that date, and I am inclined to believe that the date given in the Carmelite Necrologium (October 9) is correct. Giovanni di Luca may not have entered the date on his calendar for some days after the event, and it would then have been easy to confuse the date of the funeral with that of the death.

[15] This is Dr. Fausti's suggestion (p. 30). He thinks that Fra Giovanni may have come to Spoleto to get details about Fra Filippo's death, "e per le ragione che l'ordine potesse avere su di lui." One wonders whether this has any bearing on the choice of Filippino to complete the Brancacci frescoes some fifteen years later.

follows: "Pagose ... fior. 9, soldi 24, sonno che se pagaro ad filippino in ducati 6. dixe voluere per dare ad simone quando tornò ad firenze." Who "Simone" was is not clear; but it is evident that the boy left Spoleto early in the new year (1470) — perhaps actually on December 31, 1469 — while Fra Diamante stayed two months longer in order to collect the remainder of the seven hundred ducats originally agreed upon for the frescoes. The last instalment was paid on February 23, 1470, shortly after which Fra Diamante presumably left Spoleto. The frescoes themselves had been finished before Christmas, 1469.[16]

One further item of interest occurs in the Libro dell'Opera — the mention of a visit, in the year of Fra Filippo's death, of Antonio Pollaiuolo. The entry reads, under the date December 29, 1469, "Pagose ... fior. 1, sold. 2 e mezzo: sono che se pagaro ad permarcho spitiale per una scatola de coliandii se compraro da lui per donare ad frate filippo quando vinniro in casa sua antonio del pulagiolo et per ingnoverata." [17] The specific reference to Fra Filippo indicates that the visit must have taken place before his death, but apart from that there is no suggestion of the exact time. One supposes that Pollaiuolo must have brought news of Botticelli, in whom Fra Filippo would of course have been interested, and who was to collaborate with the Pollaiuoli in the following year in the series of Virtues for the Mercanzia in Florence. A favorable report of the rising young painter may have inspired Fra Diamante, a few months later, to put Filippino in Botticelli's workshop. It is natural also to suppose that Filippino's own interest in his future master dates from this visit.

What we thus learn of Filippino's years in Spoleto certainly encourages Gronau's theory of a date prior to 1457 for the boy's birth; but until further evidence be forthcoming, I believe we must regard any such earlier date as pure conjecture.

If, then, Filippino was a boy of ten when his father was called to Spoleto,

[16] The same Giovanni di Luca inserts the following note: "Dies Sabbati, 23 (dicembris) fuit completum opus picturae tribunae ecclesiae sanctae Mariae" (Fausti, pp. 15–16). The progress of the frescoes can be followed with some definiteness in the Libro dell'Opera; for example, on November 12, 1368, Piermatteo d'Amelia, Fra Filippo's *garzone*, was paid 3 florins "per tramotare le ponte della Tribuna," and "acquistava l'Opera degli altri legnami per la nuova sistemazione del palco stesso." This suggests that the upper part of the choir was finished and the scaffolding moved to a different spot.
[17] The curious Italian at the end of this sentence is explained by Fausti as perhaps meaning that both the Pollaiuoli came to Spoleto; the form of the verb "vinnero" implies more than one visitor, and the "et per" might mean "e Piero."

he was not too young to have begun learning something about painting. However dilatory the Frate's habits, his son must have grown up in an atmosphere of fresco and tempera; he must, while still in Prato, have watched the designing of cartoons, the grinding of colors, and the preparation of panels. As one who reached his artistic maturity early, he may well have shown signs of his talent before he reached his teens, and Fra Filippo must have made the boy useful in minor tasks, if not in Prato then certainly by the time they got to Spoleto. It requires little stretch of the imagination to picture Fra Diamante doing the same; he may have been secretly jealous of the child from the first, and have begun to exploit him long before matters came to law between them. Filippino's character as a grown man gives every indication that his was the reverse of a spoiled childhood.

That he had any hand in the actual painting of the Spoleto frescoes I greatly doubt. The work, although probably designed throughout by Fra Filippo, is largely Fra Diamante's in execution; [18] he seems to have worked with Fra Filippo as well as alone after the latter's death, and there was at least one partially trained assistant, the Piermatteo d'Amelia mentioned above. The fresco has suffered somewhat from restoration, particularly in the upper part of the semidome, and doubtless the whole effect is today less impressive than it must have been on Christmas day, 1469, when it first appeared to the Spoletans in its completed glory. It is discouraging to try to identify any portion as Filippino's; if he did paint any parts they must have been extremely minor ones, and his budding style must have been enough like that of his two guardians to be virtually indistinguishable from the work, if not of his father, at least that of the comparatively uninspired Fra Diamante. At most he might have filled in outlines drawn for him, and such work as that would be practically impossible to detect in a series of frescoes in which the execution throughout is undistinguished.[19] I suspect, too, that Fra Diamante may have had too much professional pride to allow Filippino to put brush to plaster in the Duomo; it seems to me much more likely that the boy was kept busy at more prosaic jobs, such as grinding and mixing

[18] As Dr. Fausti points out, the Spoleto records make it appear that Fra Filippo had practically finished the work at the time of his death. The poor quality seen in much of it he thinks is due less to Fra Diamante than to Fra Filippo, working below standard on account of recurrent ill-health. It is worth noting that the series of references to illness and medical care should explode once and for all the foolish but picturesque story that the Frate was poisoned by the family of one of his *innamorate*.

[19] A careful study of the frescoes themselves has failed to reveal anything that I can accept as showing Filippino's hand.

colors, or running errands — such work as any apprentice would be qualified and expected to do. He could by this means have learned a good deal about the technical side of painting, and what is equally significant he could watch the production of a famous fresco and study the finished product, as his father, not many years older himself at the time, must have watched the creation of Masaccio's frescoes in the Brancacci chapel in Florence.

Since careful scrutiny of the Spoleto frescoes has convinced me that no details show the hand of Filippino, they demand no further notice in this book. But before passing to another topic a word may be said as to the possibility of portraits, since these were regularly introduced into frescoes of the Renaissance, and are therefore to be suspected at Spoleto.

The features of Fra Filippo himself are believed by many to be recognizable in those of the middle-aged Carmelite facing directly forward, to the right of the Virgin's bier in the Dormition. The identification gains color from the near-by bust of the Frate on his memorial tablet, designed, says Vasari, by Filippino,[20] and probably the most authentic likeness we have of the painter (Fig. 1). I am convinced that the celebrated portrait in Fra Filippo's "Coronation of the Virgin," [21] inscribed " Is perfecit opus," cannot represent the rascally Carmelite, but shows, rather, the aged donor of the picture, Canon Francesco Maringhi.[22] Certainly the grizzled old man who is always accused of eying the pretty Saint Theophista (how easy it is to see what one is looking for!) bears no resemblance to the rather handsome and agreeable, if self-satisfied, individual of the memorial tablet. There is, of course, no accounting for feminine taste; but certainly the latter head looks more like a Don Juan than does Canon Maringhi, and more like the sort who could turn the heads of romantic young nuns.[23]

[20] Milanesi-Vasari, II, 629–630.

[21] Ordered in 1441 for Sant'Ambrogio, Florence; now in the Uffizi, number 8352.

[22] The arguments against this man's being Fra Filippo were set forth by Montgomery Carmichael in the Burlington Magazine, XXI (1912), 194 ff. They are based on the following facts: (1) the man does not wear the Carmelite habit; (2) he is far too old, Fra Filippo having been at most in the late thirties when he painted the picture, and probably about thirty-five; (3) he is in the traditional pose for a donor or founder, such as would hardly be occupied by a self-portrait; and (4) the form of the inscription is unprecedented in a signature, which uses the imperfect or perfect tense of the verb fare or pingere. Here perfecit might be translated as "brought to pass," thus logically referring to Canon Maringhi.

[23] If Fra Filippo's face occurs anywhere in the "Coronation of the Virgin," I believe with Mengin that it is to be recognized in the rather disdainful young Carmelite leaning his chin on one hand, in the left foreground of the picture. The self-appraising concentration of the gaze toward the spectator is in agreement with autoritratto tradition, and certainly suggests the use of a mirror in the painting thereof. Cf. Urbain Mengin, Les Deux Lippi, pp. 13–14.

Such portraits as those of Fra Diamante and Piermatteo d'Amelia, if present at all, need not detain us. But attempts are also made — by the verger or priest who shows you the cathedral, for example — to identify the features of Filippino. Some recognize him in the young angel standing at the foot of Our Lady's bier, next to the supposed Fra Filippo; others, in the boy shepherd of the Nativity, who stands directly behind the Virgin with his left hand on his breast. Either of these is about the height of a boy of eleven or twelve, compared to the adult figures; the shepherd looks more like a portrait than does the angel, but even he is not clearly individualized, although we should not insist that he resemble closely the self-portrait of Filippino in the Brancacci, painted some fifteen years later. I think it very doubtful that the Spoleto frescoes contain a real likeness of the boy, although he may in a general sense have been model for the more youthful figures represented.

A modern psychologist might find it interesting to speculate on Filippino's early character as the product of heredity and environment. A layman may go so far as to see in the boy a precocity born of inherited talents and of hard experience.[24] Like many children of erratic parents he seems early to have developed a power of shouldering responsibility, and it is hard to imagine him as anything but a solemn little boy, although Fausti draws a cheerful picture of play in Spoleto with companions of his own age, perhaps under the very scaffolding on which his father was working: "Who knows how often the lively company sneaked in under the scaffolding in the cathedral to watch Lippi and Diamante absorbed in the precious work! From the apse vault the angels must have smiled on this childish joy, while on Filippino's brow there fell the warm kiss of art (mentre sulla fronte di Filippino sarà disceso il caldo bacio dell'arte)!"[25] The final phrase, for all its florid sentimentality, is significant.

The Spoleto records speak of Filippino's having gone to Florence after his father's death.[26] Whether he subsequently went to Prato, where his mother and sister were perhaps living at the time, or whether he stayed in

[24] He was temporarily motherless while scarcely more than a baby, owing to Lucrezia's repentance (whether actual or enforced it is hard to say) and renewal of her vows in the cathedral on December 23, 1459 (see Milanesi-Vasari, Le Vite, II, 636–637). It is not known exactly when she returned to Fra Filippo; Milanesi thinks it may have been within a year, and that she probably was in the Frate's house in 1461 at the time the tamburazione was written (Milanesi-Vasari, p. 637).

[25] Fausti, p. 26.

[26] See p. 15.

Florence and joined Botticelli, we do not know. If he did visit his birthplace between 1470 and 1472 he could again have studied his father's work in the Duomo there. This must have become familiar to him even before the trip to Spoleto, especially if, as is conceivable, he had served as choir boy or acolyte in the cathedral. The solemn beauty of the "Funeral of Saint Stephen" perhaps contributed to the formation of his monumental style and helped to prepare him for the Brancacci frescoes; the grace and melancholy of the dancing Salome may have influenced his taste in feminine types and drapery as they did Botticelli's. The step from these to the style of his new master must have been a logical and easy one.

Whether Fra Diamante found the custody and training of Filippino irksome, or whether he was carrying out a wish of Fra Filippo's which has not been officially recorded, he seems to have handed the boy over to Botticelli soon after the return from Spoleto, probably in 1470. This may be taken as the date which marks the beginning of Filippino's systematic training as a painter. Fra Diamante went his way alone, though later he let himself be heard from, in no pleasant fashion; [27] Filippino became established in Botticelli's *bottega* in Florence.

[27] In 1478 a lawsuit resulted from his attempt to swindle Filippino out of possession of a house in the parish of San Pier Maggiore in Florence; cf. Gronau in Thieme-Becker, XXIII, 268, and Horne, *Botticelli*, p. 31.

CHAPTER III

THE STUDENT PERIOD

IN JUNE 1472 the "Libro Rosso" of the Guild of Saint Luke in Florence records, on the debit side, an item of six lire against the name of "Filippio [*sic*] di filippo dapat° [i.e., da Prato] dipintore chon sandro [detto] botticello." [1] Several similar entries follow, and then, in 1473, appears the first item on the credit side of Filippino's account. Horne very plausibly takes these to mean that by 1473 the young man had finished his apprenticeship under Botticelli, begun two or three years earlier, and had become a "'garzone' or journeyman painter." [2]

Botticelli himself was still a young man; to the early teaching of Fra Filippo [3] he had lately added a strong influence of Antonio Pollaiuolo, with whom he collaborated in 1470, painting the "Fortezza" of the Uffizi. At the same time he seems to have been affected by the style of Verrocchio. [4] His Judith panels and several of the Madonnas (e.g., the Chigi Madonna of Fenway Court, Boston, and the Madonna della Melagrana) were probably finished, but the most famous works — "Primavera," the "Birth of Venus," and "Pallas Taming the Centaur" — were as yet unthought of. Thus the young Filippino was the pupil of a painter whose own style was still in process of formation and in whose work the borrowed elements were still clearly recognizable. This fact helps to account for certain elements in Filippino's own early manner, and a youthful tendency to experiment before he finally fulfilled himself in his first masterpiece, the Badia "Vision of Saint Bernard."

The elements of Botticelli's style — love of movement, sensitive line,

[1] Archivio di Stato in Firenze, Accademia del Disegno, No. 2: Debitori e Creditori, Libro Rosso 1472–1520, segnato A. c. 57.

[2] Horne, *Botticelli*, pp. 31–32.

[3] We have no documentary proof of this, but Botticelli's early work clearly bears out Vasari's assertion that he worked with Fra Filippo.

[4] Professor Yashiro seems to me to be right when he insists that the influence of both Pollaiuolo and Verrocchio is discernible in Botticelli's work of the early seventies; a good many critics have maintained the influence of one to the exclusion of the other. See his *Sandro Botticelli*, p. 12.

gradually increasing melancholy — were transmitted in generous measure to Filippino, as will be discussed later. At this point it is necessary to speak of the problem of "Amico di Sandro," because of the influence he is believed by some critics to have exerted on the young painter while both were associated with Botticelli. His is a ghost which refuses to be laid, in spite of Berenson's recent resolution of this "artistic personality" into the separate parts that originally he brought together as one of Botticelli's most attractive disciples.[5] These parts included pictures attributed to Botticelli himself, to anonymous followers and assistants, and to Filippino. Venturi observed of Amico that many pictures had been wrongly ascribed to him; [6] van Marle goes to the other extreme and adds new ones.[7] My own feeling is that Berenson's original Amico group [8] requires subdivision, as Venturi suggests; I see in it paintings which it is safer to call simply "school of Botticelli," and, as will be seen presently, one or two early Filippinos.

The core of the Amico *œuvre* I take to be the *cassone* panels illustrating the story of Esther, at present divided among the Liechtenstein collection in Vienna, the Musée Condé at Chantilly (Fig. 2), and the collection of Comtesse Charles de Vogüé, in Paris. These have been reassigned to Filippino, as early works, in Berenson's most recent lists.[9] Much as I should like to give Filippino the credit for having painted these delightful panels, I am unable, after careful study, to accept them as his. That they are closely dependent on Botticelli is obvious, but, as Berenson himself pointed out in his original essay, they have a daintiness, a quality of lively, exquisite imagination, a miniaturist touch and lightness of feeling, that is at once slighter and more charming than that of Botticelli. There is, of course, no question of their being Botticelli's; but are the qualities just named those of the young Filippino? I think not, unless we can postulate a period, necessarily between 1472 and 1480, during which he painted as never again later. Not only is the lightness of touch, the exquisiteness of calligraphic line, and above all the gaiety of feeling, never present in his undisputed work, but

[5] Dr. Scharf follows Berenson in reattributing the Amico group to Filippino or to other Botticelli followers.

[6] Adolfo Venturi, *Storia dell' arte italiana*, vol. VII, pt. 1 (Milan, 1911), p. 679, n. 1.

[7] Raimond van Marle, *The Development of the Italian Schools of Painting*, XII (The Hague, 1931), 244 ff.

[8] Bernhard Berenson, *The Study and Criticism of Italian Art*, Series I (London, 1901), pp. 46–69.

[9] Bernhard Berenson, *Italian Pictures of the Renaissance* (Oxford, 1932), pp. 285–287. Dr. Scharf also restores this series to Filippino.

the color, which certainly would not have changed entirely at a given date, is so utterly different from that of the authentic Filippinos that it alone goes far to preclude the possibility of the Esther panels' being his. Not very closely related to Botticelli's work in this respect, their color is gay, bright, charmingly decorative: light blue, yellow, and rose, with touches of vermilion for emphasis, greyish white, a judicious use of gold, and, for all the choice of warm hues, the kind of silvery tonality which is foreign to Botticelli, and calls up unexpected visions of an eighteenth-century palette. Finally, even if it be objected that Filippino could easily have made radical changes in his coloring between the seventies and the eighties, I believe that the Esther panels give every evidence of being the work of a painter whose style, though youthful, was definitely formed and strongly characteristic when he executed the *cassone* in question. He already has a set of mannerisms and formulae perfectly adapted to his purpose; there is no fumbling or indecision such as one expects of a youth still finding himself. Botticelli seems indeed to have recognized that "Amico" was equipped to decorate *cassoni* as he himself was not — or at all events in the same way — and had the discriminating good taste to assign to his assistant this type of work, in which he appears to have specialized as an independent master. We do not know, of course, how long he stayed in Botticelli's *bottega*, or even, for that matter, whether he actually did assist the greater master, but his style certainly points to such a relationship.

This style of his, in addition to the qualities just mentioned, is marked by excessively small, pointed hands and feet, and mincing, posturing gait and gestures. Filippino's authentic early works, and those pictures most closely related to them, show absolutely different characteristics. Hands, particularly, are abnormally large, probably as a result of over-careful study of their structure; and although there is an ever-increasing interest in movement it never, particularly in the eighties, has the tiptoeing, fluttering affectation so pronounced in the Esther panels.

In short, these pictures seem to me impossible to fit into Filippino's *œuvre*. It is not enough to assume that something must have come from his brush before 1480, and therefore to fill the gap with a set of otherwise unattached panels which show Botticelli's influence. Such panels must indicate a convincing relationship to the later work of the painter in want of *œuvres de jeunesse*, and that is precisely what is lacking in the "Amicos" under discussion.

I cannot here undertake an exhaustive analysis of the Amico question, but will mention briefly the most important paintings which I believe to be his. It is worth noting that he seems to have worked exclusively on panel; at any rate I know of no fresco from his hand, and what we know of his manner indicates that there was no hint of the monumental in his artistic makeup.

I would leave to Amico the charming "Adoration of the Magi" in the National Gallery (number 1124) (Fig. 3), which is an excellent example of the color described above; the "Tobias and the Angel" formerly in the Benson collection in London,[10] which van Marle astoundingly calls a Filippino of about 1486; [11] the panel with five allegorical figures in the Corsini Palace in Florence (its juxtaposition to the Filippino *tondo* in that gallery makes all the more convincing the theory that the two are not by the same hand); the little "Esther" of the Horne Foundation in Florence; the Hermitage *tondo* with the Madonna and six angels; the *cassone* panels illustrating the story of Virginia (Louvre, 1662 A) and of Lucretia (Pitti, 388); the flying angels in the Stroganoff collection in Rome; [12] and finally the "Tobias with Three Archangels" in the Turin gallery.[13] Such portraits as the "Esmeralda Bandinelli" of the Victoria and Albert Museum, and the Bergamo "Giuliano de' Medici" or the ex-Liechtenstein "Man in a Cap," [14] I believe are safer classed simply as school of Botticelli. My own feeling is that Amico was a kind of Pesellino, specializing in small panels and *cassoni*, and only occasionally, as at Turin, producing anything on a large scale. Indeed, the exception proves the rule, since the whole feeling of the Turin panel is of the same small dainty scale as the tiny ex-Benson "Tobias and Raphael." No one would guess from a photograph the actual size of the Turin picture.

If there were any purpose to be served thereby, I should call this painter the "master of the Esther panels"; but since the name "Amico di Sandro"

[10] This, I believe, is still in the possession of the Duveen gallery in New York. It was exhibited as an anonymous loan at the Hartford Athenaeum in the spring of 1931, when that museum acquired the ex-Benson "Hylas and the Nymphs" by Piero di Cosimo.

[11] Van Marle, *The Development of the Italian Schools of Painting*, p. 318.

[12] These are illustrated in Berenson's *Study and Criticism*, Series I, p. 60.

[13] Berenson, *Study and Criticism*, Series I, p. 50, gives a reproduction, and one also of a drawing for the picture, in the Louvre. Amico's drawings, as Berenson himself once recognized, are not to be confused with Filippino's.

[14] All three are illustrated in the Amico di Sandro article, *Study and Criticism*, Series I, pp. 60–64. The "Man in a Cap" is now in the Andrew Mellon collection.

has found such general acceptance and become so familiar, it may as well be retained. The painter may actually have been Berto Linaiuolo, who worked for Matthias Corvinus, King of Hungary; this, as Horne first pointed out,[15] would be one way of accounting for that ruler's commission to Filippino after Berto's death; but this ingenious guess is so far unsupported by documentary evidence.

Filippino's debt to Amico I shall try to indicate as we find it manifested in his work. It is most apparent, I think, in the treatment of architectural backgrounds, in landscape, and in a tendency to paint a snub-nosed type of face which also recalls Verrocchio, who doubtless is partly responsible for this feature in the work of Amico.

If Filippino did not paint the Esther panels and such others as I have listed (all of which have been attributed to him or to Botticelli, if not to Amico) what can be cited as having come from his brush during the seventies? Before venturing on attribution, we may consider what to expect in such work, which should certainly show the hand of a master still in process of development. When Filippino entered Botticelli's *bottega* his head must have been full of his father's style. Botticelli in the early seventies had graduated from the Filippesque phase and was under the combined influences of Verrocchio and Pollaiuolo, as I have said. His own individual style was, however, strong, as we see it in the Judith panels, the personal elements including a special calligraphic quality of line and a hint of poetic melancholy. Filippino might therefore have chosen a Botticellian, a Pollaiuolesque, or a Verrocchiesque emphasis for his own manner. To these possible elements must be added, I think, the influence of Amico, although that, reflecting as it does the somewhat more mature Botticelli, is hardly to be looked for until the latter seventies, perhaps about the time of the "Primavera."

In the Museum of Fine Arts, Budapest, is a panel representing the Madonna seated in a landscape (Fig. 4). Before her kneels a monk in the Franciscan habit, presented by Saint Anthony of Padua, who stands beside him, his right hand, holding a lily, on the worshipper's shoulder. One is immediately struck by the elongated proportions of the Madonna, who is larger in scale than the two monks. Such a type is clearly Pollaiuolesque,

[15] Berenson cites the suggestion, made verbally to him by Horne, in *Study and Criticism*, Series I, pp. 67 ff.

although the head is less round than Antonio's and in the faintly sad expression suggests Botticelli. The flowers in the foreground also point to Botticelli's influence, although they seem studied primarily from nature. This is in short just such a picture as we should expect from a painter imitating Botticelli in the early seventies — a period which would scarcely have entered into the formation of a "Botticelli school," i.e., made up of imitators rather than pupils. Filippino is almost certain to have been in Botticelli's *bottega* by the end of 1470, and he would seem the likeliest candidate for the authorship of the Budapest picture, provided we can point to any elements in it which seem related to his subsequent work. In the original "Amico di Sandro" article Berenson classified the panel as an Amico;[16] his 1932 list calls it early Filippino.[17] With the latter attribution I am in agreement, first because I see no reason to defer the appearance, as it were, of Filippino, by filling the seventies with early Amicos, and second, because comparison of the Budapest panel with known works of Filippino indicates in the former a clear foretaste of his future manner. This is true of the head of Mary, with its more restrained melancholy than Botticelli's Madonnas show; the bunchy veil over the hair, based on Botticelli and going back through him (or perhaps directly) to Fra Filippo, nevertheless points to the type we see later in Filippino's Santo Spirito and Cleveland panels; the unduly large hands of the Virgin, the left one with an elongated middle finger held straight out, continue to be characteristic as late as the mid-eighties; the deprecatory manner of the monks, again doubtless a reflection of Botticelli, points to an early instance of Filippino's peculiar psychology, which seems to me entirely foreign to the temperament of Amico; and finally the feeling for distant landscape, in the mature Filippino always more poetic and at the same time closer to nature than Botticelli's, is here illustrated in the charming play of sun and shadow on green slopes and rippling water. Spacious landscapes were never Botticelli's forte. Filippino is here almost Umbrian in feeling; later, as will be seen, he develops a landscape sense akin to that of the Flemish painters.

Yet with all its promising features the Budapest panel is unmistakably youthful and immature in quality and style. The Madonna is seated, pre-

[16] *Study and Criticism*, Series I, pp. 58–59. Berenson observes (p. 59) that "the folds (i.e., of the Madonna's robe) are large and of a severely Filippo-Botticellesque character."
[17] *Italian Pictures of the Renaissance*, p. 285. Dr. Scharf calls the picture an early Filippino.

sumably, but she does not seem to sit on anything definite, being hardly more convincing in this respect than a Cimabue figure. The proportions of the body are imperfectly understood; and there is a certain naïveté in the age-old convention of a discrepancy in scale between the mortals and the divine personages.[18] Throughout the work one has the sense of a painter feeling his way; of working slowly and with care, but not yet able to give unity to the details so painstakingly studied. I venture to call this Filippino's earliest extant work; [19] as to its date, I do not think 1473 is any too early.

Closely related to the foregoing picture is the Madonna and Child in the Kaiser Friedrich Museum, Berlin, number 82 [20] (Fig. 5). The Child again stands on his mother's knee, turning the leaves of a book she holds. The Virgin, shown in three-quarters length, is seated in a room; a window at the left affords a view of a quiet river and a romantic tower that suggests a piece of nineteenth-century Gothic Revival architecture. A metal bowl of scarlet and white flowers stands on the window sill.

The picture is in bad condition, most of the drapery of the Madonna being blurred by a bluish haze, and there has perhaps been repainting. Originally grouped by Berenson as an Amico, this has been restored to Filippino in the new list, the latter being the name over which it hangs in the gallery. Certainly it appears to be the work of whoever painted the Budapest panel; the hands of the Madonna are the same, though reversed in position; the tall, high-waisted, Pollaiuolesque figures are similar, and the drapery, allowing for the bad state of the Berlin picture, is virtually identical. Only in the heads of the two Marys does one feel a difference: the one in Berlin is rounder and more snub-nosed than its counterpart in Budapest, and is indeed the most Verrocchiesque head in Filippino's *œuvre*. Moreover, she looks at the spectator, which is unusual in his work. The snub-nosed type is related to that of Botticelli in the early seventies, such as the "Fortezza" and the "Judith," and I am inclined to explain its exaggeration in the Berlin panel simply as an experiment. Perhaps too the influence may have been that of Amico, who consistently affects a pert, snub-nosed type.

The Bambino amounts to a signature of Filippino: the rather tall,

[18] Saint Anthony seems to have been thought of in his human aspect in this case, as friend and companion to the uncanonized brother whom he presents to Our Lady.
[19] Dr. Scharf shares this opinion.
[20] This is given by Dr. Scharf to Filippino.

slender baby form, with characteristically thin arms and high skull with abundant brown curls. He is essentially the child of the Strozzi (Bache) and Santo Spirito Madonnas (Figs. 26, 28) and like no other painter's Bambino type that I know of. Hence I would follow Berenson's 1932 list and restore Berlin 82 to Filippino, dating it not long after the Budapest Madonna, and probably not later than 1475.

A third panel closely related to the group under discussion, and originally called Amico by Berenson, is the Madonna and Child with San Giovannino in the National Gallery, London (number 1412), labeled "school of Botticelli" (Fig. 6). The Virgin stands behind a parapet on which are an open book and a bowl of flowers; she holds her Son, who clutches a split pomegranate and bends down to meet the rather vacantly adoring gaze of his small cousin. I understand that this picture was at one time retired as a forgery,[21] and it certainly has been, if not completely painted by a modern hand, at least freshened up by a restorer and given a highly lustrous coat of new varnish. The Child is especially typical of Filippino; the hands of the Virgin are better drawn than those in the Budapest and Berlin panels, but still have the rigidity that comes of painstaking effort in drawing them. The Madonna is again snub-nosed, and, as in Berlin 82, the halos are dotted with gold.

One of the loveliest of the Amicos — the "Epiphany," number 1124 [22] — hangs just across the corner from the "Madonna and Saint John," the two thus being placed at right angles to one another. This juxtaposition imposes, for me at least, the conviction that the two are not by the same hand. Color has a great deal to do with this conclusion; the strong, unimaginatively used blues, reds, and dark olives of the Madonna and San Giovannino are in vivid contrast to Amico's delightful harmonies of soft blue, rose, and oyster white. Moreover the dainty miniaturist draughtsmanship of the Amico (which the National Gallery calls Filippino) is utterly foreign to that of its neighbor. The real ancestor of Amico in Botticelli's *œuvre* is, I think, the Judith panel.

One more of Berenson's original Amicos deserves to be restored to Filippino: [23] the beautiful "Madonna Adoring the Child in a Landscape,"

[21] The picture is given by Dr. Scharf to Filippino.

[22] Catalogued as school of Botticelli. Dr. Scharf restores it to Filippino.

[23] The curious little "Adoration of the Child with San Giovannino," in the Museo Ferroni, Florence, which Berenson has successively called Amico and early Filippino, seems to me an eclectic work based largely on Filippino, especially the Madonna, but the robust Verrocchiesque baby

number 3249 in the Uffizi. This has undergone a thorough but careful restoration.[24] Iconographically the panel derives, of course, from Fra Filippo, with whose altarpiece in the Medici (now Riccardi) chapel Filippino may possibly have been familiar.[25] But in style by far the most formative influence is that of Botticelli. The Bambino whom Fra Filippo represented as a perfectly human baby sucking his finger is here the sadly knowing Child who looks at his mother, as does Botticelli's in the Poldi-Pezzoli Madonna, with comprehension of his future life. Mary is again a distinctly Botticellian type; yet here for the first time I think we begin to see the difference between Botticelli's and Filippino's conception of her. Lacking Botticelli's strength of line, Filippino models the face with a subtler softness recalling Leonardo's manner of representing transparent shadow on solid form. The emotional content is less immediately apparent than in Botticelli, but already we recognize the accurate psychology, here interpreted in terms of that highly characteristic gentle sadness and humble sweetness destined in modern times to expose the painter to the charge of sentimentality. He did in this panel produce a "popular" picture; it occurs even oftener than the Badia Saint Bernard in colored reproductions in frames or on calendars at Alinari's today. But, as in the case of Raphael's finest Madonnas, the fact that the Uffizi Adoration appeals to the untutored populace does not prove that it is a poor picture. It stands rather as a lovely example of that type of Neoplatonic painting of which Filippino, following Botticelli, became a superlative exponent, and which, if for a dozen different reasons, is universally enjoyed.

It is just this quality of Neoplatonism — the yearning after the divine as revealed in earthly beauty — that seems to me to mark the Uffizi panel as Filippino's rather than Amico's. One cannot say categorically that Amico never expressed such ideas, though they are wholly lacking in what I regard as his characteristic work; but since we know that Filippino did,

cannot be paralleled elsewhere in his work, and the extraordinarily out-of-proportion head of the little Baptist, added to a slim body reflecting Filippino's developed style, seems to me unthinkable save from the hand of a man who was awkwardly imitating the manner of another (Fig. 7).

I tentatively accept as an early Filippino the Marquis of Lothian's "Coronation of the Virgin" in a lunette with two angels (illustrated in Berenson's Amico article, p. 52) with its strong reminiscences of Fra Filippo in the figure of God the Father. It looks to me closer to Filippino than to Amico, as Berenson decided in the list of 1932.

[24] It was published and illustrated before restoration in L'Arte, VI (1903), 302 ff., by Arduino Colasanti.

[25] The original is now, of course, in Berlin, Kaiser Friedrich Museum, number 69.

and since the most typical pictures of Amico show absolutely opposite tendencies, the weight of evidence points to Filippino as the painter. Especially in the landscape (allowing, of course, for restoration) we are carried a step farther along the path indicated in the Budapest Madonna.

The panel is sufficiently accomplished to be dated toward the end of the seventies, perhaps about 1477–1478, but there is not enough evidence to make greater definiteness safe. At most it may be said that the picture falls between the Berlin Madonna (82) and the Badia Saint Bernard.

Before we pass to the firmer ground of practically undisputed work, a not uninteresting attribution remains to be rejected. Some scholars have proposed, to eke out Filippino's scanty youthful work, the fresco series depicting the Seven Acts of Mercy, and two scenes from the life of Saint Martin, in the little oratory of the Buonuomini di San Martino in Florence.[26] These, cleaned within the last decade, may be more satisfactorily judged today than when they were first noticed by scholars. They seem to have been painted about 1479 in connection with the lease by the Buonuomini, in 1478, of property belonging to the monks of the Badia near-by, although the records supply no precise information as to date or authorship. In general the frescoes have been recognized as showing the style of Ghirlandaio, Botticelli, Filippino, or even Raffaellino del Garbo, although the hands of pupils or assistants of these masters have been suspected.[27] Ulmann and Berenson disagree, however, with Rumohr, Milanesi, and Cavalcaselle in the matter of Filippino's style in the chapel, advancing the theory that Ghirlandaio was responsible for the design, David rather than Dominico, however, having been the actual painter.

The last-named attribution seems to me the most plausible. But the lunette to the right of the altar, showing the "Dream of Saint Martin" differs in style from the other frescoes, which are strongly Ghirlandaiesque in manner. It is the one which led to the mention of Filippino and Botticelli by Cavalcaselle, and with good reason. The types are distinctly reminiscent of both these painters, of whose style there is not a trace in the other frescoes; specifically, the group of Our Lord attended by angels vividly recalls the similar group in Filippino's "Vision of Saint Bernard,"[28] which cannot be

[26] For illustrations and a full discussion see *Dedalo*, March 1928, pp. 610 ff.
[27] *Dedalo*, March 1928, 610 ff.
[28] Botticelli's style is most clearly reflected in the head of the sleeping Saint Martin.

earlier than 1480. Although a painting of Filippino's datable before 1480 is something to wish for, this fresco is certainly not his work. Its stylistic contrast to all the other lunettes can scarcely be accounted for except by the supposition that it was painted by a different hand, and since such a hand occurs, it is natural to assume that this particular fresco was painted at a different time, presumably after the rest were finished. There are several possible reasons why this may have happened. The painter in charge might have been called to more important work before the chapel was completed; a shortage of funds might have caused delay; or (though this is less likely) the fresco of the "Dream," actually finished by the original painter, might have been badly enough damaged, some time later, to have needed entire repainting, on fresh plaster. Certainly it is curious that a composition so out of key with the rest of the frescoes should have been placed deliberately in so conspicuous a place as to the right of the altar. It is conceivable that if the work extended over a period of two or three years Ghirlandaio's departure for Rome and the Sistine Chapel may have been the cause of the interruption. In my opinion the most plausible hypothesis is that the "Dream" was painted at least two years later than the other lunettes, possibly in 1481–1482, by an early assistant of Filippino's whose not very able services could be had cheap; and that this *garzone* used his knowledge of the Badia altarpiece in carrying out a piece of work which may indeed have previously been requested of Filippino himself.[29]

Although nothing in the oratory of San Martino can be accepted as Filippino's own, a group of panels, generally regarded as his, appear to belong to the end of the seventies and the beginning of the eighties, although documentary evidence for dating has so far not come to light. Stylistically they mark a gradual evolution of which the Badia Saint Bernard is in my opinion the climax, belonging as it does to a relatively definite date (1480–1481) founded on documents. This panel, which announces Filippino as an independent and developed master, I take as a *terminus ad quem* for the group

[29] Rosselli and del Turco (*Dedalo*, March 1928) believe that the sleeping squire in the "Dream" "ricorda molto il ritratto di Filippino della Cappella Brancacci" (p. 619). The pose of this figure suggests that of the sleeping guard in Filippino's "Liberation of Saint Peter" in the same chapel. I am not convinced that there is enough similarity to prove influence, but it is conceivable that the Brancacci antedates the "Dream of Saint Martin," which would then belong to about 1484–1485. Del Turco is wrong in calling Filippino "barely nineteen years old" — "di appena dicianove anni" (p. 620); even if he had painted the fresco in 1478–1479, he would have been twenty-one or twenty-two at the time. The writer must have been reckoning from the year 1460, formerly accepted as that of Filippino's birth.

under discussion and, similarly, as the point which marks the beginning of the painter's second period, to be discussed in Chapter IV.

The earliest of this group, probably not much later than the Uffizi Adoration discussed above, is the Naples panel of the Annunciation with Saints John the Baptist and Andrew (Fig. 8). Although not universally accepted as Filippino's,[30] it seems to me to give clear indications of being an early work of his. In effect it is rather eclectic, with strong reminiscences both of Fra Filippo and of Botticelli. It is, in fact, a battleground on which the issue at stake is the whole future manner of the painter. The most obviously Filippesque part is, of course, the Gabriel, who wears the rose wreath so often seen on the Frate's angels. The drapery is also reminiscent of Fra Filippo; it has the effect, frequently observed in the work of the older painter, of a great many layers of some thin material, the costume as a whole being soft and bunchy instead of heavy or clinging. The drapery of the Baptist recalls that of the London Madonna (1412) and early examples in Botticelli's work; it is treated in broad, swinging folds without the restlessness that was soon to become habitual with Filippino and of which there are already indications in the robes of the Madonna and of Saint Andrew. The edges of the latter's tunic are crumpled around the ankle in characteristic fashion; they are prophetic of a similar arrangement in the garment of the discomfited priest of Mars in the Strozzi chapel (Fig. 80). The drapery of the two kneeling figures is crumpled in the same way; the parts lying on the ground take the long narrow rectangular forms observable in so many of Fra Filippo's kneeling Madonnas,[31] which in turn become a trade mark of Filippino's. The heads show the latter's types still in the formative stage; they give indications of future developments, but have the uncertainty of line and modeling that betrays an incompletely formed style. Only in the case of the Virgin do we feel real mastery; she is the frail, gently melancholy young woman who, like the Uffizi "Madonna Adoring the Child," becomes Filippino's personal expression of the Neoplatonism of the time. Based on Botticelli's feminine type, Filippino's is more naturalistic and less mournful, showing rather a faint sadness and quiet resignation. It is partly this gravity, habitual with the painter, that saves his frankly sentimental types from sentimentality. He does not resort like Botticelli to drooping mouths and exaggerated inclinations of the head, nor does he, in this early period, ex-

[30] Dr. Scharf considers it Filippino's.　　　[31] The two in the Uffizi, for example.

press intense emotion through agitated gestures and wind-blown draperies. Even when, in his later work, he becomes more dramatic, there is usually this underlying seriousness. As Venturi puts it, "L'arte sua non ride mai; s'adorna a festa, ma è triste; s'inghirlanda, ma geme pianamente." [32] Not only does this gravity save Filippino's work from sentimentality, but this element in his personality largely accounts for the fact that he is among the few painters who could undergo Leonardo's influence and emerge without a smirk or a simper.

In the Saint Andrew of the Naples Annunciation we have a type more reminiscent of Botticelli's than of Fra Filippo's greybeards, but as yet not specifically Filippinesque. He is a dignified, even monumental figure, framing the picture, with the Baptist to balance him, in a manner looking forward to Cinquecento practice, especially in Venice. The hands are studied with an almost Flemish accuracy of detail. The Baptist is far weaker, and stiffly posed, though in the squarish head and shaggy hair we have the beginning of another familiar Filippino type. The saint raises his left hand, palm forward, as though exhibiting it as a model to the painter; its rigidity betrays the student not yet master of anatomy and movement. The hand does, however, show the Filippinesque fingers, widely separated at the roots. The same feature is noticeable in the Madonna's hands, which, as usual in this period, are rather too large, probably as the result of particular concern for their structure. [33] The very long middle finger and the pointer, extended separately (i.e., in the left hand of the Virgin) and the broad, fleshy palm, are all characteristic, as is the straight middle finger, with the others slightly relaxed, in the right hand of Saint Andrew.

The scene of the Annunciation takes place on a terrace before a loggia seen in perspective and somewhat perfunctorily treated. This scientific exercise, uninteresting enough in itself, seems to be an instance of Amico di Sandro's influence. The latter has a distinct predilection for such rather austere architectural settings, which he draws with a tidy precision productive of a certain charm. Good examples occur in the *cassone* panels of Paris, Chantilly, and the Pitti. Unlike Amico, Filippino misses the compositional

[32] Adolfo Venturi, *Storia dell' arte italiana*, vol. VII, pt. 1, p. 652.

[33] One is reminded of the Anonimo's remark to the effect that Filippino always made one hand larger than the other, in spite of all his efforts to correct the fault. See Carl Frey, *Il Codice Magliabecchiano* (Berlin, 1892), p. 117. There seems to be no circumstantial evidence to support this tale, but it is certainly true that the hands of the early panels are too large, as I have already remarked in connection with the Amico problem.

possibilities of his loggia, but later on the example of Amico bears admirable fruit. It is interesting that in the Naples panel he chooses, probably under Amico's influence, square piers with simple mouldings in place of capitals of a classic order, a simplicity in architectural forms which, reappearing later in the Minerva frescoes, produces an unexpectedly Cinquecentesque effect of breadth and monumentality.

Infinitely charming is the carpet of flowers on which Our Lady kneels — flowers such as Botticelli paints, exquisite in color and delicacy of structure. A rose hedge behind the figures has burst into the same large, flat blooms in pink and white that one remembers in the "Primavera," which was probably painted about the same time, circa 1478. Perhaps most attractive of all is the view of Florence in the distance. We look out between tall, slender trees to the valley of the Arno, where rise Brunelleschi's dome, Giotto's Campanile, the towers of the Badia, Bargello, and Palazzo Vecchio, the dome of the Baptistery, and the spire of Santa Maria Novella. That the scene was not taken from an actual spot overlooking the city is shown by the mistakes in the relative positions of the buildings;[34] for instance, the tower of the Palazzo Vecchio is placed between the Baptistery and the Campanile. But the picturesque group rises among the hills with a nostalgic loveliness, and the hills themselves fade into a hazy distance in which real light and air can be felt.

While there is no documentary evidence for a date, the panel surely cannot be later than the end of the seventies, combining as it does elements clearly derived from Filippino's teachers and exemplars. At the same time the suggestions of Fra Filippo should not be taken as a reason for dating the picture too early. I believe that these suggestions are the result of Filippino's familiarity with his father's work in Florence and Prato as well as in Spoleto; the latter's Sant' Ambrogio altarpiece, for example, with its rose-crowned angels and exquisite lilies, or the Madonna of Santo Spirito,[35] must have been well known to him. I should place it, as suggested above, about 1478.

In my opinion the next picture chronologically is the *tondo* of the Corsini gallery in Florence.[36] In this lovely panel the Madonna, holding her son,

[34] The view approximates most closely the one obtained from some high point in the vicinity of Poggio Imperiale.

[35] These pictures are now in the Uffizi (number 8352, "Coronation of the Virgin") and the Louvre (number 1344, "Madonna and Two Saints").

[36] Thanks to the courtesy of the Principessa Corsini, I was able to see this collection, which has for some years been closed to the public.

stands in a loggia before a richly ornamental Renaissance niche; two angels
bring dishes of flowers to the Child, while three others kneel on the inlaid
pavement and sing from a long scroll of music. The young Saint John the
Baptist can be seen at the far end of a corridor opening on an enchanting
landscape (Fig. 9). One of Filippino's most attractive altarpieces, this
tondo presents more than one problem for discussion.

The attribution to Filippino has not, I think, been seriously challenged,
although Berenson was once tempted to ascribe it to Amico di Sandro.[37]
In a sense the question is complicated by a small panel in the gallery of the
New York Historical Society [38] (Fig. 10), which corresponds closely to the
Corsini *tondo* in general composition. The chief differences are: (1) the New
York panel is a high rectangle instead of a *tondo*; (2) there are four angels, as
contrasted with five in the Corsini; (3) the San Giovannino is lacking, and
(4) there are some differences in setting and color. The pose of the Madonna
and Child, and those of the angels, correspond closely. Berenson, who did
not know the panel, apparently, at the time when he wrote his Amico di
Sandro essay, told me in 1930 that as soon as he saw it, he realized that it
was unmistakably an Amico, but also unmistakably by the hand responsible
for the Corsini *tondo*, which he is convinced is Filippino's. Therefore the
New York picture must be his likewise, and hence Amico and Filippino are
one and the same. Thus the apparently unexciting little panel which hangs
obscurely among ancestral portraits and Egyptian antiquities in an unfre-
quented gallery was a direct means of destroying an "artistic personality"
originally constructed on the basis of Berenson's favorite principles of
connoisseurship.

All this is disconcerting at first glance. Nevertheless, continued study of
the New York Madonna has convinced me that for those of us who still see
Amico as a separate individual, a different conclusion is possible. To begin
with, I agree with Berenson that the little panel is the study on which the
Corsini *tondo* was based, and that the two, in spite of differences, were painted
by the same hand. It is also true that the New York picture shows various
elements comparable to those in the paintings I accept as his. Of these the
most striking is the architecture, simply designed with round arches and

[37] Cf. the article on Amico, *The Study and Criticism of Italian Art*, Series I, p. 66. Dr. Scharf re-
tains the traditional attribution to Filippino.
[38] Number B–330. Dr. Scharf calls this a copy of the Corsini panel.

plain mouldings. Amico liked to decorate spandrels with round medallions; they occur, for example, in the Chantilly Esther panel, and in the Louvre "Story of Virginia" we see piers with square-headed passageways cut through them — a device repeated in the New York picture. Amico generally made careful preparations for his architecture by scoring sharp outlines of straight line and semicircle in the plaster surface of his panel; these lines sometimes show through the figures, as for instance at the extreme left of the Chantilly panel. Amico is, of course, not alone in following this procedure, but it is worth noting that the same thing occurs in the Historical Society Madonna. Again, the color of the latter is not unlike Amico's. As regards the figures, they have suffered so much, particularly the heads, that it is dangerous to be too dogmatic about them; but for all the rubbing, scraping, and patching up that the picture has undergone, I cannot help feeling that the "general quality" is Filippino's. There is something about a typical Amico that one cannot take quite seriously; his characters are perpetually enacting plays, which sometimes, as in the case of the Louvre Virginia, take the form of a dramatic ballet. This is, of course, highly appropriate for furniture decoration such as *cassone* panels; but if we turn to the little Benson "Tobias and the Archangel" we again have a decorative, fairy-book illustration for what is incidentally one of the most engaging of all stories. The "Adoration of the Magi" in the National Gallery (number 1124) is as serious as Amico ever gets; and even in this, for all the gravity of the faces, there is a kind of nonchalance and informality, summed up in the romantically elegant young squires who mark the two limits of the composition — the one standing jauntily, the other seated, with a greyhound at his feet. In this picture Amico shows himself the lineal descendant, in spirit, of Gentile da Fabriano and the International Style.

Turning back to the New York Madonna, I myself feel a difference, subtle perhaps, but distinct. Amico and Filippino share a certain lyricism of mood, native to both and probably stimulated by such things as Botticelli's "Judith"; but Filippino's lyricism is colored by a kind of mysticism — a religious fervor which the lighter-hearted Amico does not put into his work. This seriousness of feeling, of which I have already spoken in connection with the Naples Annunciation, persuades me that what we have in the New York picture is one of the few existing sketches or *bozzetti*, on panel, from Filippino's brush. More concrete evidence for this lies in the crisply crumpled

folds around the knees of the singing angels; the body of the Child (his head is too blurred and smudgy to afford proof one way or the other); and above all the angel at the left, who looks like a brother of the angel similarly placed in the "Vision of Saint Bernard." We have seen evidence of Amico's influence in the Naples panel; why should it not have been even more profound in this instance? I should guess that Filippino, in dealing with a small-scale picture, deliberately based his work as far as he could on that of a painter especially gifted in this type of painting.

Whether the New York Madonna was designed definitely as a preparatory study for the large *tondo* is a difficult question. There is, for one thing, the difference in shape. Nothing in the composition suggests a circle; the design was clearly planned for a rectangular frame. Comparison with the Corsini shows that the group is ill-suited to a *tondo*. Was the latter picture originally ordered to be rectangular, and the specifications altered after Filippino had made the preparatory study? Such changes were sometimes made; the town fathers of Prato, for instance, changed their minds about the shape of the altarpiece ultimately provided by Filippino in 1503.[39]

In the case of the Corsini *tondo* we have a hint as to its first owner in the fact that it came into the Corsini collection from the Villa Careggi.[40] By 1482 Lorenzo il Magnifico was interested in Filippino, whom he had a hand in appointing to take over a commission, originally given to Perugino, in the Palazzo della Signoria.[41] We know further that Lorenzo recommended him enthusiastically to Cardinal Caraffa some five years later.[42] Very possibly Filippino's first contact with Lorenzo dates from this time. It is tempting also to see in the architecture an indication that he was lured from the simple forms of Amico to richer effects of garland, arabesque, and candelabra by the study of antique fragments in the Medici collection, but the change could just as easily have come about through the influence of such painters as Verrocchio and Ghirlandaio.

As I have said, it is not necessarily true that the New York panel was painted definitely in preparation for the Corsini. It may have been nothing more than an experimental study made with Amico's style in mind, and Filippino may have used it in painting the *tondo* some time later — perhaps as much

[39] See below, Chapter VIII.
[40] J. A. Crowe and G. B. Cavalcaselle, *A History of Painting in Italy*, IV (London, 1911), 289, n. 3.
[41] *Ibid.*, vol. IV, Chap. IV, p. 30.
[42] *Ibid.*, vol. IV, Chap. V, p. 152, n. 3.

as a year or two. Any number of guesses are possible; Lorenzo might have seen and liked it, ordered an enlargement, and then decided on a round shape such as was still rather novel in the seventies, becoming very popular at the end of the Quattrocento; or he may have specified a *tondo* from the first, leaving the precise design to Filippino, who, as yet inexperienced in that type of composition, made use of an earlier idea originally adapted to a rectangle.[43]

It should scarcely be necessary to go into the reasons why the Corsini Madonna is not by Amico. A comparison of it with the group I accept as Amico's does everything to confirm the attribution to Filippino, granted signs of the former's influence; and most of these have been lost in the transferring of the sketch to the *tondo*. The snub-nosed Madonna is an example, though here again the influence may have come directly from Verrocchio. The bowls of flowers, once thought by Berenson to show borrowing from Amico, will not be taken as such by those who agree with me in accepting as Filippino's the Berlin 82 Madonna and the one in the National Gallery, number 1412.

The matter of its date has by no means been agreed upon by critics; it has been placed almost anywhere from 1480 to 1486, depending usually on whether a particular scholar chose to date the Badia panel early or late. But wherever one decides to put the Saint Bernard, 1486 is, I think, too late for the Corsini.[44] Filippino's "Madonna and Four Saints" in the Uffizi, with its incontrovertible date 1486 (the year 1485, on the panel, would mean 1486, since the picture was finished in February, which according to the old style of Florentine dating would belong to the same year as the previous December), is of a more developed, mature style than the *tondo*, and in particular the Madonna type is that subsequently favored by Filippino and only changed for one quite different again from the Corsini Virgin. Also I take it to be earlier than the Badia Saint Bernard, though not much earlier. Now, certain critics to the contrary notwithstanding (e.g., Venturi and Scharf), I believe the Saint Bernard must have been painted in 1480–1481, which would make 1479–1480 a possible date for the Corsini. Fritz Knapp has made a good deal of the panel's dependence on Hugo van der Goes' Portinari

[43] A final guess before I leave the realm of speculation: has the Corsini panel been cut down from an original rectangle, to fit a circular frame?

[44] Van Marle, *The Development of the Italian Schools of Painting*, XII, 316, suggests *c.* 1486.

altarpiece,[45] which, if it was set up in Santa Maria Nuova in Florence in 1480, might tend to support that date for the Corsini, as Knapp believes it does for the Badia as well. Personally I am not much impressed by the argument for van der Goes' influence on the *tondo*; I should like to propose instead that of a painter destined later to exert a powerful influence on Filippino, namely Leonardo. In the presence of the Corsini panel I am haunted by the memory of Verrocchio's "Baptism of Christ," not by the work ascribed to that master himself but to just those portions which criticism tends with ever-increasing conviction to attribute to the young Leonardo. The view at the end of the loggia in the Corsini suggests nothing so much as the lovely background in the Baptism which contrasts so sharply with Verrocchio's stiff palm tree and pines on either side of the river. A sensitive, poetic treatment of landscape was to become one of Filippino's chief contributions to Quattrocento painting; here already he passes beyond anything of the kind by Botticelli, whose treatment of nature shows a minimum of feeling for aerial perspective.

Had Filippino seen other landscapes by Leonardo? The Baptism was about ten years old by 1480. Leonardo seems to have gone to Milan in 1483, leaving behind him the unfinished "Adoration of the Magi," the commission for which was carried out by Filippino himself in 1495–1496. It is doubtful whether the latter saw Leonardo's underpainting for this until he began work on the altarpiece substituted for it. Possibly he knew the Annunciation now in the Uffizi (number 1618), though this, however much Leonardo may have painted, is still under the direction of Verrocchio and hence early. Yet I know of no one apart from Leonardo who could have set such an example to Filippino, unless we are satisfied to say that he was learning to look at nature somewhat as Leonardo did; and this I think was not the case, since with this one exception he avoids the weird and fantastic so fascinating to Leonardo, and follows a naturalistic trend akin rather to the Flemish.

It is tempting to see in the pointer finger of the dark-haired angel, lifted as he marks his musical rhythm, another connection with Leonardo. But the tendency to isolate and elongate fingers is observable in earlier work of Filippino's, and Leonardo need not be called upon to account for the mannerism.

[45] *Mitteilungen des Kunsthistorischen Instituts in Florenz,* II (1917), 194 ff.

I have spoken of the elaborate niche behind the Madonna. Such a set-
ting with its cockleshell and rich arabesques was common property in the
Verrocchio and Ghirlandaio schools, but Filippino provides a new note by
carrying out the stonework in a deep blue-green, with candelabra colored
to represent bronze — a scheme curiously eighteenth-century in effect.
Otherwise the color of the *tondo* is characteristic: the strong deep red, green-
blue, and orange-yellow which form the basis of his palette in the eighties.

A comparison with the Naples Annunciation shows the Corsini to be a
distinct step forward. The style here comes into its own, still partially
affected in types and drapery by Botticelli, but with virtually nothing of
Fra Filippo left. The hands are still over-studied and too large; compare
especially the left hand of the Corsini Virgin with that of the Naples Ma-
donna, and the heads of the two, although that of the Corsini is Verrocchi-
esque where the Naples Madonna is not. Halos are still dotted with gold;
drapery is better understood and more plastic. Above all, the Corsini panel
has unity; the stylistic elements, still somewhat at odds in the Annunciation,
have been fused into a formed and personal style. It should be noted in
passing that the Child, while reminiscent of those of Berlin (82) and Buda-
pest, emerges for the first time as a distinct type, peculiarly Filippino's in
the high skull, thick brown curls, and slender arms. It is unfortunate that
we have no other Bambino to compare with this one until we come to the
dated altarpiece of 1486.

At this point must be mentioned another picture, the date of which has
not been settled to universal satisfaction: namely, the Four Saints in San
Michele, Lucca [46] (Fig. 11). Clearly this is a fairly early work, and looks
transitional between 1480 and 1486; it has affinities, particularly in drapery
treatment, with the Madonna of 1486 and the Brancacci frescoes, but shows
at the same time the elaborately studied hands (in Saint Helena's case
awkwardly large) of the Naples and Corsini panels. In general, it seems
safer to date it early in the eighties — the slightly Verrocchiesque facial
types of Saints Helena and Sebastian particularly bear this out — and to
explain the drapery as looking forward to the work of 1484–1486. If, as is
conceivable, the picture is later than the Badia Saint Bernard, it shows a
definite reaction toward the pre-Badia manner; but this is less surprising

[46] Saints Roch, Sebastian, Jerome, and Helena. The picture hangs on the west wall of the
south transept.

when one reflects that in the nineties Filippino could sink to the level of the Copenhagen "Meeting of Joachim and Anna" (1497) and the following year give us a masterpiece like the Prato tabernacle. In both cases the lapse may be accounted for by the fact that the painter was too busy to give his best to every commission.

In Filippino's Portata al Catasto of 1497, he mentions the fact that he was unable to make a declaration in 1480 because he was "fuori di Firenze." [47] We have no clue as to his whereabouts in that year. However, I am tempted to guess that he may have been in Lucca, a city with which he seems to have had various associations.[48] The only painting from his hand now in Lucca is the aforementioned panel in San Michele. While Filippino need not necessarily have gone there to paint it, the mention of an absence from Florence in 1480 makes the idea of a sojourn in Lucca quite plausible, since the painting belongs stylistically to about that year. I do not insist on the point, but I do repeat that if the Lucca panel be later than the Badia it shows either a weakening of the artist's powers or else undue haste.

One piece of evidence exists for placing the Lucca panel somewhat later than 1480, although it proves nothing conclusively. In the Pinacoteca in Lucca is a panel of the Madonna and four saints (Fig. 12) with an inscription giving the donor's name and the date 1487, but not, unfortunately, the name of the painter. Not only is this clearly the work of a follower of Filippino, but it shows so many analogies to the Uffizi "Madonna and Saints" of 1486 that it cannot have been painted without a pretty thorough knowledge of the latter picture. I suspect that Filippino, in an early journey to Lucca (possibly in 1480), attracted there a pupil or regular apprentice, whom he brought back with him to Florence, and who was in his studio when the 1486 Madonna was being painted. This assistant may then have gone back to Lucca and painted the Pinacoteca panel on the

[47] Carlo Pini and Gaetano Milanesi, *La Scrittura di artisti italiani* (1876), p. 78.

[48] Milanesi-Vasari, III, 466: "In Lucca lavorò parimente alcune cose: e particolarmente nella chiesa di San Ponziano, de' frati di Monte Oliveto, una tavola in una cappella, nel mezzo della quale in una nicchia è un Sant Antonio bellissimo, di rilievo, di mano d'Andrea Sansovino, scultore eccellentissimo." Of this work no trace is left; but as Sansovino was only twenty in 1480, it seems probable that the work referred to would have been executed some years later.

A drawing of Filippino's in the Uffizi (no. 227, cornice 88) seems to represent the "Volto Santo" of Lucca, and looks therefore like a study for some other altarpiece intended for that city. Stylistically this drawing is of the nineties rather than of the eighties; see Berenson's *Drawings of the Florentine Painters* (1903).

basis of sketches from the Uffizi picture, eked out by suggestions from the saints in San Michele.

Or, of course, the painter of the 1487 panel may have been an assistant of Filippino's (he seems to have had more than one in the mid-eighties; see Chapter IV) who migrated to Lucca after having been in the master's *bottega* while the Uffizi Madonna was being painted. Such a man might quite naturally have taken suggestions also from the San Michele panel as required.[49]

The earliest date which can at present be connected on documentary grounds with Filippino's work is 1480, to which year have been assigned two altarpieces. One of these is the Saint Jerome now in the Academy, Florence (number 8652; see Fig. 13). Vasari mentions that he made "per la chiesa della Badia di Firenze un San Girolamo bellissimo." [50] Puccinelli later mentioned this as having been painted for the Ferranti family.[51] He is also responsible for the date 1480, which he simply quotes, offering no source for his information. Until fairly recently this picture was thought to have been lost; finally the Academy panel, which had gone for years under the name of Andrea del Castagno, was recognized as Filippino's. Furthermore the coats of arms in the upper corners have been identified as those of Ferranti (or Ferrantini) and of Conte Ugo respectively, the latter name, of course, providing a clear connection with the Badia.[52] The only real difficulty in regard to the picture is the date, which seems to me, as to Venturi and others, at least ten years too early for the style. Although cer-

[49] Analyzing the Lucca panel of 1487, we may list the following borrowings from Filippino: from the Uffizi Madonna of 1486 the painter took the type and attitude of the Virgin, slightly modifying the pose of the Child; details of drapery; the left hand of San Peregrino (based on that of the Uffizi Madonna); the pose of the Baptist (somewhat altered); the four saints of San Michele provided models for the feet of San Peregrino (virtually copied, though in reversed position, from the Saint Roch of Filippino); the right hand of Saint Matthew (cf. the San Michele Saint Sebastian); the feet of the Baptist (again cf. the Saint Sebastian). Here too suggestions have been taken from Filippino's drapery.

That Raffaellino del Garbo could have painted the picture I question, although no less a scholar than Adolfo Venturi makes the suggestion (*Storia dell' arte italiana*, vol. VII, pt. 1, p. 678), and the attribution is accepted by Alfred Scharf in *Jahrbuch du Preussischen Kunstsammlungen*, LII (1931), 201 ff. That painter was at the time still in his teens, which is rather young to have done the work. This attribution is however more plausible than that of van Marle, who proposes, though with hesitation, Amico di Sandro's name. I see nothing whatever in the style to indicate Amico's authorship. (See van Marle, *The Development of the Italian Schools of Painting*, XII, 256.)

[50] Milanesi-Vasari, III, 475.

[51] Placido Puccinelli, *Istoria dell' eroiche attioni di Ugo il Grande* (Milan, 1664), p. 11. "L'arme pure de' Feranti si vede nel quadro di san Girolamo, il quale si conserva in sacrestia . . . dipinto l'anno 1480. da Filippo Lippi." The date is printed in arabic numerals.

[52] Supino, *Les Deux Lippi*, p. 145.

tain authors, such as Supino and Scharf, accept it, and even draw parallels
between it and Botticelli's Saint Augustine painted in the Ognissanti in
1480, the Saint Jerome has always struck me as belonging to Filippino's
post-Roman period, although probably painted not long after his return to
Florence from Rome. In 1933 I found it had undergone thorough restora-
tion which has so altered it that what with retouching (?) and new varnish it
has taken on the look of a modern copy, and is more difficult than ever to
judge. I postpone further consideration of the picture, for the present say-
ing only that I believe it to be later than 1480, and that Puccinelli was mis-
taken, either through the misreading of a document or reliance on a faulty
memory.

The second picture associated with 1480 is the one generally accepted as
Filippino's masterpiece: the "Vision of Saint Bernard" now in the Badia in
Florence. Originally painted for a chapel outside the city, it was brought
to the Badia for safekeeping at the time of the siege of Florence in 1529, and
was consequently there when Puccinelli wrote his Chronicle. He gives it
the date 1480. Does this not perhaps explain the slip in regard to the Saint
Jerome? The writer may through carelessness have transferred the date of
the Saint Bernard to what I regard as the later panel.

With 1480 we arrive at the end of the student period of Filippino, since,
even if that date be incorrect for the Saint Jerome, it is certainly associated
with the Badia "Vision," and thus shows the painter the recipient of inde-
pendent commissions. At the beginning of the new decade we see him as
definitely formed, having assimilated elements from Fra Filippo, Amico di
Sandro, and Botticelli particularly, and through him (directly as well, per-
haps) Pollaiuolo and Verrocchio. The relationship between him and Botti-
celli is to continue, but in general the paths of the two painters now diverge
with some sharpness. The most striking difference is Filippino's lack of
apparent interest in classical subject matter. Working outside the circle of
Lorenzo de' Medici and his humanist associates, he gives us no illustrations
for Lucian, no reconstructions of Apelles. He seems to have remained al-
most untouched by the antique, except for architectural details which were
common property in Florence, until the Minerva frescoes were undertaken
in 1488. Herein lies a fundamental difference between him and Botticelli.
Filippino's classicism, even when it becomes strong, is of the eye and hand,
stimulated by actual objects which he tries to copy, without thorough

understanding; Botticelli sees the antique world through his poetic imagination, stimulated by the writings of men like Politian, and arrives at expressions of it which are truer to the spirit of classical antiquity than to its form. This may be accounted for in part by the scholarly environment which Botticelli enjoyed, and with which Filippino, so far as we know, had less contact, or to which he may have been indifferent. Filippino seems to have approached ancient Greece and Rome from the point of view of an eager but untrained student of history, collecting antiques like facts, and reserving the keenly poetic side of his mind for heavenly visions, which he understood and interpreted far better than he did the age of Augustus or of Nero. Always less intellectual than Botticelli, he does not seem to have been troubled by the conflict of paganism and Christianity as was the older painter; in this he is perhaps closer to the Cinquecento point of view than is the purely Quattrocentrist Botticelli, yet spiritually he expresses through his painting a Neoplatonism even subtler and more sensitive than that of his master. It is to the development of the latter quality that he bends his energies while Botticelli is at work on the "Primavera" and the "Birth of Venus."

I dwell on this point here because I believe it gives added force to the theory that Filippino, an independent master by 1480, did not go to Rome with Botticelli in the following year to work in the Sistine Chapel.[53] I shall have more to say on this subject in the following chapter.

[53] Neither do I find evidence to prove that Filippino was in Rome during the seventies, as some have maintained, working in the Vatican with Fra Diamante.

CHAPTER IV

THE PRE-ROMAN PERIOD

THERE would be little to say of the "Vision of Saint Bernard," beyond repeating such praise as has always been given it, if there were not, in spite of Puccinelli, some room for argument as to its date. Accepted as Filippino's masterpiece in panel painting, it has also been generally taken as his earliest dated picture. The documentary evidence is full and satisfactory except in one particular: it is not clearly stated whether the picture was finished in 1480–81, or some time during the next five years. In 1903 Supino published [1] the texts of the documents relating to this commission, which are too well known to require repeating. The difficulty lies in the fact that the existing record [2] of the Campora monks, dated 1488, is a copy of an earlier manuscript listing expenditures prior to that year. It fails to specify in what year Filippino received his hundred and fifty ducats, although he is named as having painted the altarpiece for Pugliese's chapel. The entry runs as follows: "Item per la dipintura dello altare c(i)oè della tavola la quale dipinse m° Filippino di m Filippo et per oro e per la cortina in tucto dixe decto ma°. Filippino montava duch. centocinquanta ut sopra." [3] Immediately after this item comes a note recording the gift to the chapel of a chalice, from Pugliese, with the date 1486. This on the face of it would suggest that payment for the altarpiece was made shortly before, possibly in the same year. As the style of the painting tallies nicely with that of Filippino's dated Madonna of February 1486, there should be no trouble about accepting the same date for the Badia panel. Unfortunately for this hypothesis a second account,[4] bound with the list of Pugliese's gifts, records the building

[1] *Miscellanea d'arte* (later called *Rivista d'arte*), I (1903), 1 ff., "La Cappella del Pugliese alla Campora e il quadro di Filippino."

[2] Archivio di Stato in Firenze, Arch. Badia no. 333, Camporearum, vol. III, c. 63.

[3] Supino, "La Cappella," n. 1.

[4] This document was neither published nor cited by Scharf, who dates the Badia panel 1487. He seems to have misread the Badia account book of 1486 and following, since he says (*Filippino Lippi*, p. 29) that it lists payment for a gilded frame, bearing the arms of Pugliese and of the Corsini, for Filippino's panel: "Dieses Rechnungsbuch gibt unter dem Jahr 1486 an, dass er für einen gold-

costs of the chapel in such a way as to leave little doubt that it was finished and ready for use as early as 1481; for in May of that year it was plastered, and payments were made for the "gabella de la predella de lo haltare," while on May 30 the monks paid "soldi cinque a uno scarpellino per fare i buchi pei torchi a lo haltare." [5] This certainly sounds as though in 1481 there was nothing further to do except consecrate the chapel and begin saying mass there.

To be sure, the chapel might have been ready for its altarpiece several years before the painter supplied it; this was only too often the case in the Quattrocento. But one cannot assume such a state of affairs without some grounds. If a painter is known to have been busy with other commissions, or if he had, like Fra Filippo or Leonardo, a reputation for being hard to pin down to the completion of a picture, or again if there was trouble about payments, we are justified in assuming a delayed altarpiece. But there is no way, short of documentary proof that Filippino finished the Saint Bernard later than 1481, of proving that the commission was not carried out on schedule. Funds were available, specifically donated by Pugliese; Filippino is said by Vasari to have been honest, conscientious, and obliging; and at present we know of no reason for delay, such as another commission on which he could have been working. [6] Even if one believes that he went to Rome with Botticelli, that would not have prevented the completion of the picture by the summer of 1481, since there is documentary evidence that Botticelli did not leave Florence until October of that year. [7] The tantalizing "fuori di Firenze" referred to in the previous chapter can hardly be taken as proving an alibi here. If Filippino had not been on hand Pugliese and the monks would have found someone else.

Just why Filippino was chosen is not certain; perhaps it was thought

nen Rahmen, den das Bild erhalten sollte und der sein Wappen und das der Corsini trug, acht Dukaten und zehn Soldi bezahlt habe." But the item in question, which Scharf does publish (p. 87) reads: "Item dello anno 1486 diede a decta capella uno calice di rame dorato con la patena de ariento dorato con la arme sua et de Corsini la quale vi fece ponere per buono respecto, costò duch. 8½ cioè duch. 8 soldi 10." This certainly records the gift of a chalice and paten, not payment for a gilded picture frame. Had we a record of payment for a frame in this year, it would of course strengthen the argument for the panel's having been finished in 1486–87. But under the circumstances I must insist upon the greater probability of the earlier date, although admitting that payment may have been delayed until 1486 or 1487.

[5] Supino, "La Cappella," pp. 3–4, footnote.

[6] Even if the Corsini tondo and the Lucca saints were painted in 1480, there would still have been time before the summer of 1481 to complete the Saint Bernard, I think.

[7] Horne, Botticelli, document XXII.

that a young and not yet famous painter could be engaged at a lower figure [8]
than, say, Botticelli or Ghirlandaio, who as it happened were both occupied
in that year with the frescoes of Saints Jerome and Augustine in the Ognis-
santi. By 1481 Leonardo was keeping the monks of San Donato in suspense
over their "Adoration of the Magi"; even if he had been free in 1480 he
might already have established a reputation for dilatoriness which would
not have recommended him to the evidently businesslike Pugliese. Filippino
rose to the occasion and produced a masterpiece.

The Saint Bernard has been eulogized too often for me to add any praise
of my own. Like so many of Fra Angelico's paintings it has enjoyed continu-
ous popularity, usually for the wrong reasons. It strikes the characteristic
note in Filippino's work: that note directly derived from Botticelli and the
Neoplatonism of the latter Quattrocento, already sounded, more faintly,
in the Naples Annunciation. The types show just the right blend of healthy
naturalism and genuine spirituality to give sentiment without sentimentality.
The Madonna is again more human and more spiritually subtle than those
of Botticelli; the delicate profile with its high forehead and refined features
calls up memories of Fra Filippo's Virgins, but it is as if one of those very
human girls had been transformed by the true "vocation" denied to
Lucrezia Buti. She is still pure Quattrocento in her daintiness of gesture
and slightness of physique. For all his later "Seicentismo" Filippino never
painted a Cinquecento Madonna; he never relinquished the slender type
conforming to Neoplatonic standards of beauty.

In the figures of Saint Bernard and the angels, the painter shows himself
a sensitive psychologist and a careful student of nature. The head of the
monk will bear comparison with Spanish seventeenth-century sculpture, than
which there is perhaps no higher expression of spirituality rendered in terms
of complete naturalism. [9] The angels are children at mass, subtly differentiated
in their reactions to a holy mystery, the youngest frankly curious, the older
ones more fully comprehending, but all taking the occasion with immense
seriousness. Pugliese himself, the subject in the past of more encomiums than
any other figure in the picture, is certainly a vivid portrait, but his abrupt
introduction in a lower corner of the picture is not altogether happy.

All the detail and still life which so took the eye of Vasari are treated

[8] Although it seems to have been Pugliese's wish that no expense be spared.
[9] The work of Pedro de Mena is perhaps the closest parallel.

with an almost Flemish accuracy and realism; we note careful differentiation of textures, continued feeling for landscape, and a new geological interest which manifests itself in rock forms suggestive of Leonardo's, but without their fantastic quality. The strange stratifications also imply a memory of Fra Filippo's panels, such, for instance, as the Madonna painted for the Medici-Riccardi chapel. Here Knapp may well be right in seeing an influence from the Portinari altarpiece, although it takes the form of a new scientific accuracy and expression rather than an actual borrowing of types or forms.[10] It is not every painter who could successfully blend influences from Botticelli and Hugo van der Goes!

I have said that stylistically the Saint Bernard is close to the Madonna of 1486 — so close that five years seem an unlikely interval between them. But it must be remembered that during those years Filippino was busy with his first important commissions in fresco, in which medium, so far as we know, he had had little previous experience, although his regular training in Botticelli's shop must have included the study of its technique, a technique which he also knew from his days in Spoleto. These commissions included decorations for Lorenzo il Magnifico's villa near Volterra, the "Spedaletto," probably secular or mythological in subject; a fresco in the Palazzo Vecchio, ordered by the Signoria; and the Brancacci chapel, in which he completed the unfinished work of Masaccio. Under such circumstances it is not altogether surprising if his style in tempera altarpieces shows little change during this period. Indeed, he could hardly have improved upon his manner in the Saint Bernard. But of this, more presently.

In the fall of 1481 Botticelli went to Rome, whence he had returned by October 5, 1482. Whether or not Filippino went with him is a question as yet unsettled to universal satisfaction. As contemporary documentary evidence we have (1) the contract of October 27, 1481, recording the agreement of Botticelli and others to provide "10 stories" before March 15, 1482;[11] (2) the letter of Lodovico Sforza's agent in Florence,[12] undated, in which the

[10] I cannot agree with Knapp that the profile of the Madonna has anything directly to do with the kneeling angel in van der Goes' panel. Filippino must have recognized a kindred spirit in the landscape of the Portinari altarpiece and in the sensitive portraits. He did not, however, allow the thrilling blues to modify his palette, although in the Badia he comes closer than ever before to a Flemish rendering of the total visual effect. The drawing corresponding to the Virgin's head, preserved in the Uffizi (no. 139, cor. 68) appears to me to be a study made from the painting, by a hand other than Filippino's. Dr. Scharf shares this view.

[11] Horne, *Botticelli*, document XXVII.

[12] R. Archivio di Stato, Milan, Studi-Pittori, pp. 113–114.

statement is made that Botticelli, Filippino, Perugino, and Ghirlandaio "hano [*sic*] facto prova di loro ne la capella di papa syxto excepto che philippino. Ma tutti poi allospedaletto del Mco Laur$^{o.}$ et la palma e quasi ambigua"; (3) the statement of Albertini,[13] published 1510 and based probably on the document of 1481, to the effect that Filippino worked in Rome.

Thus we have two directly opposed statements as to Filippino's presence in the Sistine Chapel in 1481–82, and scholars have not been slow in taking sides either with Albertini or with the Sforza agent, neither of whom has any particular intrinsic advantage over the other as a reliable source. Gnoli, writing in 1893,[14] expressed the opinion that Albertini misread his document, remarking that Cosimo's real name was Filippo. This might clear up the difficulty were it not for the curious form, "Cosimo Laurentii Philippi Rosselli," which Venturi says is an impossible one for Cosimo Rosselli's name.[15]

In the face of these difficulties one must look for confirmatory evidence in the frescoes themselves. Venturi suspects Filippino's hand in the "Punishment of Korah," though he does not regard his participation as certain.[16] Ulmann[17] goes further and attributes to Filippino the landscape and architecture in the "Cleansing of the Leper," and suspects his hand in the three figures to the left, seated on a bench, in the same fresco. Personally I am unable to feel that any of this is in Filippino's style. Certainly Botticelli must have had assistants, and their work may be detected in the weaker details of the frescoes; but nowhere do I distinguish Filippino's own manner, even admitting that he was an adaptable person in adjusting his style to that of another painter, as he proved some two years later in the Brancacci chapel. As for the documents, the papal contract must contain an error in the form of Cosimo Rosselli's name. Even if the "Philippo" did refer to Filippino, it

[13] *Memoriale di molte statue e pitture della città di Firenze*, edited by Luigi Mussini and Luisa Piaggio (Florence, 1863).

[14] *Archivio storico dell' arte*, VI (1893), 128–129. The contract of October 27, 1481, lists the painters thus: "Cosmo Laurentii Phylippi Rosselli, Alexandro Mariani, et Dominico Thomasii Corradi de Florencia, et Petro christofori Castri Plebis perusine"; Arch. Secr. Vatic. Notae Camerales, etc. sub Sixto IV et Innocent VIII ab an. 1480 ad 1496. Tom. 586, fol. 15 vo. Albertini, says Gnoli, assumed a comma after the "Laurentii," writing "Cosmae atque Philippi": the names as Albertini lists them are "Petri de Castro Plebis et Alexandri et Dominici et Cosmae atque Philippi Floren" (Schmarzow, *Francisci Albertini*, Heilbronn, 1886, p. 13).

[15] Adolfo Venturi, *Storia dell' arte italiana*, vol. VII, pt. 1, p. 588, footnote, continued from previous page.

[16] A. Venturi, *Storia*, vol. VII, pt. 1, p. 647, n. 1.

[17] Hermann Ulmann, *Sandro Botticelli* (Munich, 1893), pp. 97 ff.

is most unlikely that his name would head the list, or become confused with that of Piero. And whoever headed the list, surely Botticelli would have taken precedence over a collaborator still enough of a subordinate to be entrusted only with minor fragments of his master's work. If the Badia panel really was painted in 1480–81, that alone would show that Filippino was a full-fledged and independent master; and even if, as is probable, his Saint Jerome should turn out to postdate the Sistine Chapel, I consider the Corsini *tondo* enough to prove Filippino's powers at the time. I also feel that a good deal of credence should be given to the letter of the Sforza agent; Lodovico was not a man to send inefficient envoys, and the agent was in a position to know whereof he spoke. Quite possibly he was personally acquainted with the four painters whom he recommended, and had discussed with them their qualifications and careers. I admit that the form of the statement "hano facto prova di loro ne la capella di papa syxto excepto che philippino" might be taken to mean, not that Filippino had not worked there, but that he had had no chance to show his real powers as had the other three; such an interpretation, however, seems merely quibbling, and I take the agent's choice of language to be nothing more nor less than an example of official elegance and rhetoric.

I assume then that Filippino stayed in Florence or its environs for the opening years of the eighties, gradually making his talents known, so that on December 31, 1482, he was deemed worthy to complete the decoration in the Palazzo della Signoria which Perugino, doubtless in going to Rome, had left unfinished. The subject is not recorded. Gaye published the contract,[18] in which the Operarii agree that Filippino shall be paid and employed under the conditions of Perugino's contract, which they revoke. Filippino is referred to as "absens," which, whatever it may mean, certainly does *not* indicate that he was in Rome, inasmuch as he would, had he gone at all, have been back in the previous October, as Botticelli was. The word probably means that he was not present at the time the contract was being drawn up.

Today nothing remains of this work in fresco, but it is not unreasonable to believe it was carried out. Why it should have been effaced is not hard to

[18] Giovanni Gaye, *Carteggio inedito d'artisti dei secoli XIV, XV, XVI, publicato ed illustrato con documenti pure inediti*, I (Florence, 1840), 579: "Item concesserunt Filippo fratris Filippi, absenti, ad pingendum eam partem, quam aliis locaverunt Perugino, pictori, et pro illo pretio et cum illis conditionibus et qualitatibus, prout dicto perugino locaverant; locationem antem dicto Perugino factam revocaverunt."

imagine. So much of the decoration of the Palazzo Vecchio bears witness to post-quattrocentist taste, that we may simply assume that the city fathers got tired of the old-fashioned work and removed it to make way for something more up-to-date. It must have been satisfactory to Filippino's contemporaries, for not more than three years later, it is generally believed, the painter had completed the Brancacci frescoes and was finishing the altarpiece of the Madonna and Saints (February 1486) for the Sala del Gran Consiglio of the Palazzo Vecchio. The commission for the latter panel may well have been a direct result of his having given satisfaction with the frescoes of the Signoria, and very likely the authorities at the Carmine were partially influenced in their choice of Filippino by the reputation he thus acquired.

I suspect that about this time — i.e., 1483–1484 — Filippino was at work on the frescoes at the Spedaletto. The record of this, in Lodovico Sforza's agent's letter, has already been cited; the high quality of Filippino's share may be assumed from the phrase "la palma e quasi ambiqua." It was no small thing to vie in excellence with the Botticelli, Perugino, and Ghirlandaio of the eighties. If the work was done before 1485 it would provide yet another reason for Filippino's commission for the Signoria Madonna, since Lorenzo was among those who made the arrangements for the picture.

The exact date of the Spedaletto frescoes is not known, and as a fire in the early nineteenth century destroyed the work, we have lost the evidence that the paintings themselves would otherwise afford. The letter of the Sforza agent, being undated, is of no help in establishing a *terminus ad quem*, but the fact that the writer follows up a reference to the Sistine frescoes with one to the Spedaletto makes it appear probable that one followed fairly closely after the other. The villa itself must, of course, date before Lorenzo's death in 1492, and since the building of Poggio a Caiano occupied the latter years of the eighties, the Spedaletto may well (though not necessarily) have been constructed during the first half of that decade. Then, too, the painters concerned were freer at that time than later when we know them to have been engaged on important commissions. Ghirlandaio was working in Santa Trinità in the mid-eighties, having completed his Saint Zenobius in the Palazzo Vecchio in 1484, and he finished out the decade with his frescoes in the choir of Santa Maria Novella; Perugino stayed in Rome longer than the others, and may not have done his share of the Spedaletto decoration

until 1484, by which year Filippino had probably finished his and was at work in the Brancacci chapel. Botticelli's activities are harder to check up because of the lack of known dates, but at least there is no major work in fresco to prevent his having painted at the Spedaletto soon after getting back from Rome in 1482.

Virtually nothing of this series of frescoes survived the fire which robbed the world of important links in the chain of Quattrocento painting. The loss of Filippino's share is particularly to be deplored, since in all probability the subjects were chosen from classical mythology or ancient history,[19] in accordance with the taste of Lorenzo and his circle. Thus we might have been able to study Filippino in a new field, the one so dear to Botticelli, and as we have seen, hitherto untouched by the younger painter, so far as is known. We shall never know whether Filippino allowed himself in this work to be influenced by his master, or whether his admittedly fertile imagination produced something wholly individual in style. One would indeed be willing to give up one of his Madonnas, beautiful as they are, could its loss restore the burned frescoes. To have almost no examples of classical subjects from the brush of a man later one of Florence's most enthusiastic antiquarians is particularly unfortunate.[20]

It is again unfortunate that we are without documentary evidence for the date of what seems to have been Filippino's next commission; but scholars are in general agreed that about 1483–84 he was chosen for what was in some respects the highest honor a Florentine painter could receive: the completion of Masaccio's frescoes in the Brancacci chapel. There are several possible reasons for his selection. To begin with, he had personal claims on the interest of the Carmelite monks, although, to be sure, his father had been no moral credit to the Order. In the second place he was by this time unquestionably a painter of first rank; he had worked, or was working, on the frescoes of the Spedaletto, and Lorenzo de' Medici's patronage was enough recommendation for any painter; besides which he had pro-

[19] Vasari records that Ghirlandaio painted "allo Spedaletto, per Lorenzo vecchio de' Medici, la Storia di Vulcano; dove lavorano molti ignudi, fabbricando con le martella saette a Giove" (Milanesi-Vasari, III, 258).

[20] The sketch of the Dying Meleager, recently published by Berenson ("Filippino's Design for a Death of Meleager," in Old Master Drawings, vol. VIII, no. 31, December 1933, pp. 32 ff., and plate, p. 35) is, if it be authentic — which I gravely doubt — too late in style to have served as a study for the Spedaletto, certainly reflecting the manner of the late nineties, after Lorenzo's death. Of this I shall speak more fully in a later chapter.

vided frescoes for the Palazzo della Signoria. And perhaps there may be some significance in the fact that he had worked satisfactorily for Piero del Pugliese, whose family had a chapel in the Carmine.

At this time the older and more experienced painters were otherwise employed, Ghirlandaio in Santa Trinità, Botticelli probably painting panels for the Medici, and Leonardo pursuing his brilliant and erratic career in Milan. Given the choice of all the competent fresco-painters of the latter Quattrocento, one would almost inevitably select Ghirlandaio as most likely to have succeeded alongside of Masaccio; his "Calling of Peter and Andrew" in the Sistine Chapel shows how admirably he had mastered the precepts of the earlier painter. Pollaiuolo, Botticelli, and Leonardo are unthinkable in the Carmine; they would almost certainly have failed to accommodate their styles to that of Masaccio. The same might well have been expected of Filippino, for such work of his as we know before the Brancacci frescoes is about as far removed from that of the earlier master as anything could be. If, however, there had been any such fears among the Carmelite brothers (and Florence was far too well aware of the importance of the old frescoes to have wanted them improved upon or modernized) they were destined to be set at rest. As things turned out, it is doubtful whether even Ghirlandaio could have done better.

Indeed, such was the success of the new work that as recently as the last century critics were in fierce dispute, with careful searchings of the early writers, as to just where Masaccio left off and Filippino began. Nowadays no one at all familiar with Quattrocento painting would have trouble in drawing at least an approximate line between the two. At the same time, those who come to the chapel with no previous knowledge of the frescoes are never, I venture to guess, struck by any differences of style. Just as Filippino was to withdraw gracefully from a commission when Leonardo showed signs of wanting it,[21] so here he set aside, as completely as might be, his personal manner in order to let Masaccio have his full effect. His work is at once a civil gesture and an intelligent comprehension of the requirements of his task.

Just what he found awaiting him when he arrived with his paints and plaster at the Brancacci, we do not know. Some think there was nothing on

[21] This, at least, is the story told by Vasari in connection with the "Deposition" begun by Filippino in 1503. Whether true or not, it is the sort of thing that fits Filippino's character as we know it.

the walls save Masaccio's (and, if you accept them as such, Masolino's) frescoes, with a blank wall below the "Raising of Tabitha" and a glaring empty space in the middle of the scene in which Saint Peter revives the emperor's nephew. Many critics have felt that Filippino must have had sketches or designs of Masaccio's to work with, and it has been suggested that the outlines of the compositions may still have been on the wall, ready to be plastered over and painted. An interesting suggestion was made not many years ago by Heinrich Brockhaus,[22] who pointed out the fact that the Brancacci family, together with the Pugliesi, Soderini, and others who had chapels in the Carmine, were among those active in expelling the Medici from Florence in 1433. After the restoration in 1434 these enemies were banished in their turn. Mr. Brockhaus believes that Masaccio had finished the fresco of the Resurrection of the Youth, in which he had introduced portraits of the Brancacci and their anti-Medici contemporaries; that these portraits were destroyed at the time of the Medici restoration, and perhaps repaired after a fashion when in 1474 the exiles were allowed to return. In view of the particular parts of the fresco executed by Filippino, this is a tempting hypothesis.[23] Still, one hesitates to believe that the Medici would have countenanced such vandalism where a work of art was concerned, however ready they were to destroy their living enemies!

Whatever the state of the chapel in 1483–84, Filippino fitted in his own figures with consummate skill. The group of six men at the extreme left (Fig. 14), including the portrait of the poet Pulci,[24] are placed against Masaccio's early Renaissance architecture. The drapery folds are kept broad, simple and quiet, the gait and gestures stately, in accordance with the tempo set by Masaccio. We then pass to the Saint Peter, by Masaccio,[25]

[22] "Die Brancacci-Kapelle in Florenz," *Mitteilungen des Kunsthistorischen Instituts in Florenz*, vol. III, no. 4, pp. 179 ff.

[23] Such a hypothesis would also account for what has puzzled critics such as Mather, who remarks, "Evidently Masaccio was called rather abruptly to his last sojourn in Rome. For the fresco of the Raising of the Boy could have been finished in a fortnight" (Frank Jewett Mather, *A History of Italian Painting*, New York, 1923, p. 141). According to Brockhaus, there was no such sudden breaking off in the middle of the work.

[24] Vasari says there were portraits of Tommaso Soderini, Piero Guicciardini, father of the historian, Piero del Pugliese, and Antonio Pollaiuolo, in addition to Luigi Pulci (Milanesi-Vasari, III, 462–463). Pollaiuolo has been identified as one of the spectators in the scene of Peter and Paul before the proconsul; otherwise only that of Pulci can be recognized with certainty, except for the well-known portraits of Botticelli and Filippino himself, both on the same wall as the likeness of Pollaiuolo.

[25] Masaccio's work has suffered here; the lower half of the body of the figure seated just behind Saint Peter is not as he left it, nor is Filippino responsible for its present appearance. The same is true of the rather washed-out head above and behind the seated man. Considering the trouble the

and can follow the groove in the plaster which marks Filippino's work be-
ginning again. It runs along the right edge of Saint Peter's robe, cuts across
his right arm above the elbow (so that Filippino had to complete the arm
and paint the hand extended toward the resurrected boy), passes just under
the bearded chin of the kneeling Saint Paul, and up again to outline the
green robe of the turbaned man the long end of whose cap, painted by Filip-
pino, is flung across his chest and back over his left shoulder. The head is
Masaccio's, and a contrast to the one next to it, in which Filippino's hand re-
curs. From this point on the division follows the line of the tops of the heads
until eight have been counted, when it descends abruptly to outline the
eighth figure, in profile, dividing him from the Carmelite on whom he turns
his back (Fig. 15). Everything within the boundary just indicated is Filip-
pino's; what appears further to the right is unmistakably Masaccio's, as is
the entire background, with its trees, flowerpots, and paneled garden wall.

However admirably Filippino has adapted his palette, drawing, and
arrangement to that of his predecessor, the individual heads contrast strik-
ingly with Masaccio's. Those of the earlier painter, broadly and simply
painted in three main values, stand out vividly as rounded forms; in "tactile
values" they surpass Filippino's, which in turn excel Masaccio's in subtlety
of detail and faithfulness to the model. Where Masaccio's are types, these
are individuals. They are not, however, suitably cognizant of the drama
taking place before them. Masaccio's figures are gravely absorbed in the
miracle; Filippino's gentlemen take no more real interest than a group of
committee members casually conversing while waiting for the chairman to
begin proceedings. They seem very literally innocent bystanders, or, at
most, witnesses of a commonplace affair.

One figure proclaims Filippino unmistakably — the kneeling boy, who
might be a kind of human brother to the angels of the Badia panel. This, of
course, is the figure for which Vasari erroneously says that the painter
Francesco Granacci was the model.[26] He shows (as well he may under the
circumstances) all the timidity and awe which Filippino so sympathetically
expresses throughout his work, and which toward the end of his life becomes,

church has been through, the wonder is that so much of the Brancacci chapel has survived so well.
Yet it is hard to describe one's outraged feelings on seeing the layers of dust and swinging cobwebs
which today veil the frescoes.

[26] Milanesi-Vasari, III, 462. The age of the youth precludes the possibility of his representing
Granacci, who was born in 1469.

for some tastes, oversentimental and almost neurotic. The nude is adequately handled, and the skulls suggesting death from which Saint Peter's miracle has called the boy are carefully studied and sensitively modeled.

Another personal touch occurs in the fair-haired little boy standing demurely among his elders. Children were to become stock figures in Filippino's frescoes; this one is among his best. The plump hands, with their stubby little fingers, are particularly well observed.

It is tantalizing to think what Masaccio would have done with the scene. Certainly the sentiment in the resurrected youth would have been lacking; the drama would have been more solemn and deeply felt. We have, of course, certain of the spectators to give us a hint of what the general *Stimmung* would have been. They are calm and impassive, the old man behind Saint Paul raising both hands in grave surprise. Like good actors, each one contributes his share to the creation of a single emotional effect. Filippino could set his stage with approximations of Masaccio's characters, but he could not make them perform the play with equal success. He has failed to fuse the groups into the emotionally unified whole which is so striking a feature in Masaccio's work. Granted this limitation, he has accomplished an extraordinary adaptation of new to old, and deserves the reward of his self-effacement as it appears in the fine result.

It is not known whether he first finished this fresco or whether he began with one of the sections left entirely to his hand. These include the lower half of the right-hand wall, showing Saints Peter and Paul before the proconsul (Fig. 16) and the crucifixion of Saint Peter; also the narrow strips of wall at either side of the chapel entrance, representing respectively Saint Paul visiting Saint Peter in prison (Fig. 17) and the delivery of the latter by an angel (Fig. 18). All of these have been too fully discussed by other writers for me to add anything here; in general they show less modification toward Masaccio's style than does the Resurrection, the angel releasing Peter being a type clearly derived from Botticelli. The debt of Raphael to the figure of Saint Paul at the prison has been mentioned more than once; it may well have been the basis for the figure of Saint Paul preaching at Athens, seen in the series of tapestries now in the Vatican. The head of the proconsul in the scene with Saints Peter and Paul seems derived from some coin of Nero, or Diocletian, the emperor under whom the martyrdom took place. Just to the proconsul's (not the spectator's) right comes the portrait of Antonio

Pollaiuolo. It is interesting to recall that sculptor's visit to Fra Filippo and his son in Spoleto, when special preparations were made for his reception. It is a pity we cannot identify the portly and complacent individual next to him, or the vividly characterized figure, who looks like a cleric, seated beside the throne.[27]

The head in the corner, turned toward the spectator, is, of course, Filippino's *autoritratto*, the one used by Vasari for his second edition of the *Vite*, and of which he remarks that Filippino never painted himself at a more advanced age, so this one had to be used for the engraving in the book. It brings up the question of a second portrait, better known perhaps on account of its prominent place in the Uffizi collection of artists' self-portraits (Fig. 19). This vivid sketch in water color,[28] apparently done on a tile of some sort, is generally regarded as a self-portrait of Filippino. It shows a younger person than the Brancacci head, hardly more than a boy. He resembles the Brancacci portrait, but more as a son might look like his father, or a younger like his elder brother. Stylistically it is similar to the fresco, so that I personally doubt that it can be a self-portrait painted some years earlier. Yet the differences in feature — the rounder face, shorter nose, wider set eyes, and weaker mouth — make it appear to me doubtful that it can be the same person as the Brancacci portrait. I should rather regard it simply as a sketch, made for practice or amusement, of one of the painter's *garzoni*.[29] It is well known (Botticelli is a case in point) that painters often adopt for general use a type somewhat resembling themselves, perhaps because they are their own most readily available models. In any case we should, I think, base our visual idea of Filippino on the portrait reproduced by Vasari. It is an interesting and haunting face, with its high cheek bones, rather sensuous mouth, and great dark eyes which fix you with a sad penetrating gaze reminiscent of those of encaustic portraits from Fayûm (Fig. 20).

Botticelli's portrait occurs, of course, at the extreme right of the group surrounding the crucified Saint Peter. He appears as rather pleasanter than the haughty person he represented himself as being in the Epiphany of the Uffizi (Fig. 16). The youth next to him again has the look of a self-

[27] The arrangement of his drapery is somewhat like that of the Saint Bernard of the Badia.

[28] "Sopra una tegola comune," according to a description filed with the photograph in Sir Robert Witt's collection in London. I do not know from what publication this clipping was taken. Dr. Scharf (*Filippino Lippi*, p. 63, n. 132) mentions Manet's copy of this, now in the A. M. Faure collection in Paris; it is reproduced in Jamot and Wildenstein's *Manet*, vol. II, pl. I, fig. 2.

[29] Dr. Scharf also rejects this as a self-portrait.

portrait, but can scarcely be such; he differs slightly in type, and is also several years younger. Filippino would have been twenty-six or twenty-seven when he painted the fresco — surely too old for the figure beside Botticelli.[30] Filippino may, however, have used his own face as a basis for the portrait, modifying it as he saw fit.

In this connection I shall digress sufficiently to mention the portrait of an old man (Uffizi) which used to be ascribed to Masaccio, but now bears the name of Filippino. This attribution is sponsored by Berenson and has been accepted by others; I myself do not feel convinced.[31] Painted in fresco, this must, if by Filippino, belong to about the time of the Brancacci work, but it seems to me rather earlier, and stylistically not Filippino's own, being more suggestive of Ghirlandaio's school.

To return to the Brancacci. The scene before the proconsul is set off from that of Saint Peter's martyrdom by a simple round archway through which appears a pleasant piece of landscape with horsemen riding beside a river. Filippino here shows that he could transfer from panel to plaster something of his feeling for landscape. Confronted as he was by the problem of composition after the continuous method of narration, essentially medieval in character, he has managed the situation satisfactorily. Indeed, the separate incidents in the story are more clearly differentiated than in, for example, Botticelli's Sistine frescoes. The credit for clarity may here be due to Masaccio, who must certainly have planned some such arrangement; compare, for example, his predella in Berlin. The Crucifixion particularly suggests that Filippino had had access to some cartoon or sketch from his predecessor's hand.

This scene (Fig. 16) is of special interest for the contrast it affords with Filippino's handling of a similar subject, the Crucifixion of Saint Philip, in the Strozzi chapel in Santa Maria Novella, completed more than fifteen years later. Here there is no more stress on mechanics than a drawing of Masaccio's might have suggested. There is no emotion; the workman to the left, holding an arm of the cross, looks even distrait. Here for the first time we meet the type of torturer, or sometimes simply peasant, which becomes so familiar in Filippino's subsequent work. He has a characteristically short, broad face, squeezed together, so to speak, from forehead to chin, and un-

[30] If the birth date of Filippino be pushed back to some years prior to 1457, the possibility that this and the Uffizi portrait can represent him becomes even more remote.

[31] Dr. Scharf also rejects the attribution to Filippino.

kempt dark hair and short rough beard. A Roman officer in full fifteenth-century (!) armor directs the proceedings, not without boredom. The Crucifixion of Saint Philip, in the Strozzi chapel, in sharp contrast to this, shows an absorbed interest in the mechanics involved in the raising of the cross; there is an intellectual and dramatic unity, a definite concern with what is being done, as will be discussed in a later chapter.

The left side of the Brancacci Crucifixion is considerably damaged, and I suspect the hand of a restorer, but the original fresco is so dark and dirty that it is difficult to form an opinion. The scene takes place before a low, battlemented wall, beyond which buildings are silhouetted, but all detail has disappeared. What can be made out is medieval rather than Renaissance. The general simplicity may be the result of Amico di Sandro's influence or it may have been suggested by what architecture already existed on the wall of the chapel before Filippino's day.

At last, then, more than half a century after its beginning, the completed chapel could be admired by the Florentines. Of no painting in the latter Quattrocento, probably, would criticism have been more exacting than of this, the greatest of models for artists; yet there is every reason to assume that the verdict was favorable. Filippino continued to the end of his life to enjoy noble and enlightened patronage; in this instance we may hope he got the high praise he deserved. No one who passes beyond a prejudice which blinds him to all merits but Masaccio's can fail to admit the strength, dignity, reticence, and good taste shown by the later painter in a task which for him was doubly difficult. He had not only to approach as nearly as possible one of the highest standards set in the Quattrocento, but he had almost wholly to abjure his own manner. That he succeeded so well does honor to his modesty and generosity of spirit as well as to his technical powers. His tour de force is the more surprising inasmuch as this close association with Masaccio left no significant mark on his subsequent work. Yet the experience, with his memories of Fra Filippo's Prato and Spoleto frescoes, was destined to keep alive in him a sense for the monumental even when he had most wholeheartedly plunged into archaeology combined with Baroque movement.

Before leaving the subject of the Brancacci frescoes I should like to emphasize a point that is sometimes lost sight of. Although the younger painter followed Masaccio closely in composition and in broad, simple handling of

drapery (as well as in color), a sense for the actual, always strong in Filippino, comes out clearly in the fine realistic portrait heads. It is not necessary to embark on a discussion of the subtle distinction between realism and naturalism in order to point out the difference between Masaccio's and Filippino's heads. Masaccio conveys truth to type, and through form conveys an overwhelming sense of life; but it is the life of super-human beings, as it is with Michelangelo. With Filippino there is no less life, but it is the individual, breathing life of a particular Soderini or Pulci whom you might have encountered in the streets of Florence in 1484. No heads by Ghirlandaio are more vivid human documents. This eye for fact Filippino does not owe to Masaccio; it was his when he recorded the features of Piero del Pugliese, and continued with him throughout his life.

It is probable that during the months occupied in the Brancacci Filippino had acquired a prosperous *bottega* and assistants to help in carrying out commissions of a less monumental character. A considerable series of drawings (those described as "early" in Berenson's *Drawings of the Florentine Painters*) exists to prove this. Chiefly studies of the human figure done in silverpoint with heightenings of white on grey or tinted paper, these can only occasionally be associated with finished panels, but they suggest that Filippino, absorbed in the Brancacci, furnished designs to assistants and had them execute the required pictures.[32] Two such altarpieces hang in the Kaiser Friedrich Museum in Berlin under the name of Raffaellino del Garbo. This chief pupil and, according to Vasari, closest imitator of Filippino was probably born some time during the sixties; the exact year is unknown, but 1466 is the one usually given. The two panels,[33] both Madonnas and Saints (Figs. 21 and 22), are unmistakably imitations of Filippino's style during the early eighties. They do not seem to be by the hand that painted the Lucca panel of 1487 described above, nor are they, in my opinion, certainly by a single master. I defer the discussion of Raffaellino to a later chapter; suffice it to say here that he is a possible candidate for the somewhat doubtful honor of having painted the Berlin panels, but whoever painted them, they show that Filippino was employing assistance in the early eighties. I think it probable that these altarpieces issued directly from his workshop, in fulfill-

[32] One may guess that he deliberately avoided painting on panel himself, in order to keep his hand adapted to the manner of Masaccio.
[33] Number 87: Madonna with Saints Nicholas, Dominic, Vincent and Peter Martyr. Number 98: Madonna with Saints Sebastian, Andrew, Giovannino, and two angels.

ment of commissions; it was rather too early in his career for them to have been painted by outside imitators.

If not actually finished, the Brancacci frescoes must have been well on toward completion by the fall of 1485, for on September 27 of that year we read of the first payment (428 libri, 8 soldi) for the Madonna and Saints for the Palazzo della Signoria,[34] number 1268 in the Uffizi (Fig. 23). The history of this panel has been somewhat confused. Vasari says that it was begun by Leonardo and finished by Filippino from the former's design.[35] The same statement occurs in the Anonimo Magliabecchiano, expressed as follows: "He painted in the small council chamber of the palace the panel in which is represented Our Lady with other figures, which Leonardo da Vinci had begun, and the said Filippino finished it after Leonardo's design." Cavalcaselle tried to show a relationship between Leonardo's style and that of Filippino's Madonna. More recently, Dr. Valentiner, in an article published in the Art Bulletin,[36] dealt at some length with the same matter. Accepting the statement of Vasari and of the Anonimo, he concludes, in view of similarities between drawings of Filippino's and Leonardo's, that the altarpiece was indeed based on designs of the latter's, who had perhaps got as far as the underpainting. He stresses likenesses between Filippino's panel and the Madonna and Saints in Pistoia, generally attributed to Lorenzo di Credi under the direction of Verrocchio, which he believes is largely Leonardo's in execution. In pose and gesture there is certainly a resemblance between the two Madonnas and Bambini, both babies being akin to drawings by Leonardo, although Verrocchiesque in type. Dr. Valentiner admits the introduction of elements taken from Botticelli, mentioning particularly the Saint Barnaba panel, which he dates 1483. He proceeds to carry the matter of Leonardesque influence still further by ascribing to that master practically all that is admirable and progressive in Filippino's picture, which he quite rightly says makes the Saint Barnaba picture seem "flat and quattrocentesque" in contrast.

Before commenting further on all this, I wish to state that in my opinion Dr. Valentiner, together with Vasari and the Anonimo — be he never so

[34] Giovanni Gaye, Carteggio inedito, I, 581–582.

[35] For the references which follow, and for a discussion of the whole question, see Giovanni Poggi in Rivista d'arte, September–December 1909, pp. 305 ff. The statement of Vasari occurs in the first edition of the Vite.

[36] "Leonardo as Verrocchio's Co-Worker," Art Bulletin, XII (1930), 43 ff.

trustworthy — is very probably making one picture of two. Milanesi cites the commission to Leonardo, January 1, 1478,[37] "to paint an altarpiece in the chapel of Saint Bernard in the palace of the Florentine people" (i.e., the city hall). For this he was paid twenty-five florins on March 15, but had done no work; by May 30, 1483, the authorities had got tired of waiting (and Leonardo was off to Milan), so they transferred the commission to Domnico Ghirlandaio.[38] Subsequently, says Vasari, the commission was turned over to Filippino, who finished it. But Filippino's picture was ordered expressly for the Sala del Consiglio, now the Sala del Dugento. We have no record of the original commission; the first mention of it is in an entry dated September 27, 1485 (Gaye prints the date 1484), when "the officials decided that the price of the altarpiece in the *council hall* [aula consilii; italics mine] of the said palace should be that which should be named by Lorenzo de' Medici." Further on, under the same date, we find the following record of payment: "The painter Filippo, son of the other Filippo, 428 lire, 8 soldi for the panel . . . in the council hall." An additional sum of one hundred lire is also mentioned as payable to him.[39]

It would seem from this that Filippino was to provide an altarpiece to be hung in the council chamber, whereas Leonardo's picture was ordered for the chapel of Saint Bernard; and unless we can assume the presence of an altar of Saint Bernard in the Sala del Consiglio, I do not see how the references can be interpreted except as meaning two different rooms. It follows that two separate pictures were involved.

The confusion might well have arisen in the mind of the Anonimo in view of the well-known fact that Filippino actually did complete, a decade later, another picture begun by Leonardo — the famous Epiphany of the Uffizi, commissioned in 1481. As for the documents, why should the one of 1485, mentioning a payment to Filippino, have spoken so explicitly of the Sala del Consiglio, whereas the contract with Leonardo had specified the "cappella sancti Bernardi"? Poggi points out the fact that the chapel is a

[37] Poggi, in *Rivista d'arte*, September–December 1909, pp. 305 ff.: "ad pingendum tabulam altaris cappella sancti Bernardi site in palatio populi Florentini."

[38] See Poggi for this and for what follows.

[39] The original text as printed by Gaye (*Carteggio inedito*, I, 581–582) reads as follows: "Operarii deliberaverunt quod pretium tabule altaris in aula consilii dicti palatii sit illud quod declarabitur per Laurentium de Medicis," and further: "Filippo alterius Filippi, pictori, libras quadringentas viginti octa s. octo sunt pro parte picture tabuli area [sic] sive altera [sic] in sala consilii. Filippo suprascripto lib. centum etiam pro parte dicte pitture dicte tabule."

perfectly distinct room, the decoration of which was finished by Ridolfo
Ghirlandaio. Supposing Filippino's picture to have been painted for an
altar of Saint Bernard, why was not greater prominence given to that saint?
Both the Child and his mother turn away from him and toward Saint Victor.
We might indeed have expected the subject to be the appearance of the Vir-
gin to Saint Bernard, although the introduction of other special patron saints
of Florence is equally to be looked for in an altarpiece for the Palazzo della
Signoria. Nevertheless there is nothing in the picture which forbids it a
position over an altar of Saint Bernard; my doubts are based on the distinct
statement that it was ordered for the Sala del Consiglio.

Supposing the Saint Bernard altarpiece ordered of Leonardo and Filip-
pino's panel of 1486 to have been two entirely different commissions, is
Dr. Valentiner right in feeling so strong an influence of the former painter
on the latter? Starting with the assumption that Filippino was using cartoons
and even the underpainting of Leonardo, he is naturally predisposed to
recognize the older painter's hand in every possible detail. One of these is
the bunch of fluttering ribbons encircling the cruciform emblem of Florence,
which occurs at the top of the picture, above the flying angels. Granted that
such lively calligraphy was one of Leonardo's enthusiasms, was not Filippino
also fond of it? And had he not studied with Botticelli, one of the greatest
masters of animated line? Dr. Valentiner says the work "surpasses in bold-
ness of invention and drawing the power of a twenty-five-year-old painter of
the type of Filippino." [40] This I would challenge. To begin with, Filippino
was twenty-eight or twenty-nine at the time, rather than twenty-five, and in
the second place I cannot see that there is anything startlingly brilliant in
the ribbon arabesque. Why must Filippino be dismissed patronizingly as the
"type" implied by Dr. Valentiner? Must all originality be taken from him,
along with the honor of the original commission? I should be the last to set
him up as a genius of Leonardo's caliber (though in some respects he is
successful where Leonardo fails, notably in the expression of purely spiritual
qualities), but I do maintain that a man trained under Botticelli and highly
sensitive to agitated line should have been perfectly capable of the design
here, without benefit of Leonardo's drawings.

Furthermore, the qualities which Filippino's panel shares with the Pis-
toia altarpiece, such as the attitude of the Child, Our Lady's left hand, and

[40] *Art Bulletin*, 1930, XII, p. 64.

in general the fairly obvious gesture of Saint Zenobius, are all fundamentally Verrocchiesque qualities. It is possible to ascribe their conception to the young Leonardo; but might they not also have come to Filippino directly from the Pistoia altarpiece? It was finished no later than Filippino's Uffizi panel, and Pistoia is only some twenty miles from Florence, lying a short journey beyond Prato.[41]

One other point made by Dr. Valentiner deserves comment. I have already quoted in part his remark to the effect that "we . . . are astonished to see how flat and quattrocentesque even Botticelli's work (i.e., the Saint Barnaba Madonna) looks beside the altarpiece of Saint Bernard." This is perfectly true, but must Leonardo be called upon to account for the difference? The effect of depth, in Filippino's picture, is obtained in two ways: first, through insistence on the third dimension in the architecture, as indicated by the converging lines of the side walls, whereas a painter such as Ghirlandaio, in similar settings, keeps the architecture in one plane (this is true also of the Pistoia picture); and in the second place through a use of chiaroscuro and cast shadows which suggests masses in space rather than Botticelli's usual "mode of relief." Nevertheless I see nothing in these methods of suggesting three-dimensionality that is exceptional for Florentine work of the 1480's, or that postulates such an underpainting as Leonardo would have executed at that period — for example, the unfinished "Adoration of the Magi." Ghirlandaio was equally capable of rendering effects of depth — for instance, in the frescoes of Santa Trinità; Botticelli, on the other hand, was always more concerned with linear than with spatial design, so that merely because his work looks flatter than Filippino's it does not seem to me to follow that Filippino's panel is exceptionally three-dimensional for its period. In short, I do not feel that the circumstantial evidence of the painting itself at all supports the theory that Filippino proceeded on the basis of Leonardo's abandoned beginnings, though he may have taken suggestions from sketches or from products of the school of Verrocchio. And if the commission given to Filippino really was a different one from that assigned to Leonardo, the fact that its inception dates from 1485, when Leonardo had been in Milan for two years at least, makes a reversion to his ideas on the part of Filippino the more unlikely.

The tendency to render the "total visual effect" and the careful observa-

41 Also, incidentally, on the road to Lucca, which again brings up the possibility of a journey thither.

tion of realistic detail noticeable in the altarpiece of 1486 would point, as does
the Saint Bernard of the Badia, to some acquaintance with Northern Euro-
pean painting. Particularly is this true of the hands of Saint Zenobius. One
is also inclined to wonder whether the color of the Madonna's gown — blue
instead of the traditional deep red — was suggested by the costume of the Vir-
gin in the Portinari altarpiece, with which, as a member of the parish of Santa
Maria Nuova,[42] Filippino may easily have been particularly familiar, albeit
no Florentine painter in the eighties can be supposed to have ignored the Flem-
ish masterpiece. The color effect in Filippino's panel is unusually happy, far
more so than that of his Epiphany of 1496, which hangs beside it in the Uffizi.

To return to the Signoria altarpiece in further detail. It must have been
begun by September 27, 1485.[43] In December of the same year payments
were made to Clemente del Tasso, "legnaiulo," "pro parte intagli fecit pro
altare sale consilii," and to "Ieronimo battiloro" for gold. Finally on
February 25, 1486, "Matteo Mei, scarpellatore," is paid for breaking the
wall in the Sala del Consiglio for the reception of the panel, as are ten boys
for carrying the altarpiece. Everyone is partially paid off at that date;
Filippino gets 159 lire, 4 soldi toward his total, Clemente del Tasso 31 lire,
"Ieronimo battiloro" 16 lire, 2 soldi. Filippino himself painted on the
panel the date February 20, 1485 (1486, new style), which fits in as neatly
as possible with the date of the wall preparation and transportation. He did
not, however, receive the last instalment due him until June. On April 7,
1486, the Operaii, "absente tamen Laurentio de Medicio eorum collega,"
declared the total sum to be twelve hundred libri, whereas Clemente del
Tasso was to have a total of five hundred for the frame. "Antonio Christo-
fani banderaio" and "Antonio Dini Simonis linaiuolo" were paid on the
same day for a curtain and fringes for the panel. An instalment of 217 lire
was paid to Filippino, and finally on June 3 he got the remainder, Clemente
del Tasso also being paid in full on this date. The final details seem to have
been attended to still later, for on November 17, 1486, payment was made to
Giovanni Clementi "pro pictura aurei et omnibus aliis expensis pro pingendo
altarem in sala consilii." [44]

[42] He so described himself in his will of 1488; see below, in connection with the journey to Rome
in that year.

[43] A.S.F., Delib. degli Operai di Palazzo, 1484–1494, num. 4, carta 3, published by Poggi,
Rivista d'arte, VI (1909), 305 ff.

[44] Can this refer to a painted antependium of the sort one sees today in Santo Spirito, where so
many, belonging to the eighties, are still in place?

The altarpiece itself shows clearly how little Filippino was affected by Masaccio. It reverts in style to the Badia Saint Bernard, and indicates the influence of Botticelli throughout. One specific instance of this is to be seen in the figure of the Baptist, whose pose and gesture are almost identical with those of the same saint in Botticelli's Madonna with the two Saint Johns,[45] painted in 1485 for the Bardi chapel in Santo Spirito. It is not, of course, absolutely certain which way the influence went, since the panels are so nearly contemporaneous; the probability is, however, that the younger man drew upon the older.

Possibly the introduction of an accent in the foreground (in Filippino's panel a book, covered by a cloth) was suggested by the covered jar and small framed picture of the Crucifixion occurring in the Bardi altarpiece.

Somewhat less certain is the matter of priority in the case of Filippino's Madonna and the Saint Barnaba altarpiece of Botticelli, already mentioned. The two hang side by side in the Uffizi, and at first glance one is inevitably led to suspect a relationship between them. Unfortunately the latter has not, so far as I know, been definitely dated; the most that can be said is that it probably belongs to the eighties, though Gamba puts it about 1490, the date generally accepted for Botticelli's "Coronation of the Virgin with Four Saints," also in the Uffizi; if this be correct, then the influence would have gone from pupil to master. Most critics, however, agree with Berenson in putting the Saint Barnaba panel about 1483, on stylistic grounds, and my own opinion coincides with this one. The general arrangement of the panel, with its rendering of the *sacra conversazione*, may perhaps have determined the composition of Filippino's, although his is a rather free translation. He almost certainly drew on the Bardi altarpiece, and might have taken suggestions from the two simultaneously.

Each of the Uffizi altarpieces is strongly characteristic of its author, and shows clearly their likenesses and dissimilarities. Both, as I have said, are of the *sacra conversazione* type, a handling of the Madonna and saints theme which achieved marked popularity in the second half of the Quattrocento. Filippino's has greater intimacy, his Madonna showing more concern with her Child than does Botticelli's; though enthroned as queen, she has the gentle, modest aspect characteristic of his early Madonnas — their faint sadness, gravity, and utter unselfconsciousness. The same spirit is observable

45 Now in the Kaiser Friedrich, Berlin, number 106.

in the flying angels, who might be the same ones who escorted the Virgin on
her visit to Saint Bernard. Here Filippino has characterized the Cistercian
saint less vigorously than in the Badia panel; he is even a trifle weak of
countenance. A finer figure is Saint Zenobius, splendid in full episcopal
vestments, and contrasting effectively with the Baptist opposite, who has a
deep wine-red cloak over his camel's-hair shirt, and a slender reed cross in
lieu of the bishop's jeweled crozier. Saint Victor, also richly vested, is receiv-
ing the full attention of the wistful Child, who looks thoughtfully at the saint
as he ruffles the leaves of a book. His attitude, whether borrowed from
Verrocchio or from Leonardo, leaning to one side with one leg drawn up
under the other, is used by Filippino again in more than one picture.

The throne has the form of a semicircular niche, with a cockleshell and
rich adornment of arabesques in relief. Its platform shows a pattern of dol-
phins and cockleshells, framed above and below with a kind of braided rope
design. On the floor below is the book just mentioned, the dark red cloth in
which it is wrapped overhanging and separating the digits of the date:
ANNO. SALVTIS. M. CCCCL — XXXV. DE. XX. FEBRVAR. Here, as in the Corsini
tondo, the painter shows his taste for antique detail, but it is the modified
classicism of the early Renaissance, not yet archaeology.[46]

A similar throne occurs in Botticelli's Saint Barnaba Madonna, but that
one interposes a curved entablature between the throne and the shell above;
a rich curtain, ermine lined and bordered with pearls, is drawn aside by two
angels, while two others hold instruments of the Passion; the whole is set
under a barrel-vaulted arch. The arrangement recalls that of Antonio Ros-
sellino's tomb of the Cardinal of Portugal in San Miniato. The arabesques
of the throne are flatter and more linear in treatment than Filippino's.
The Madonna is characteristically dolorous; she looks ahead of her, past the
spectator, on whom the Child, standing on her knee, bestows an abstracted
blessing. The solemn hieratic group is wholly without the more human
feeling of Filippino's figures. The same is true of the attendant saints (six
here instead of four); they have come into the presence of the Madonna, but
they do not expect her attention. The two bishops lower their eyes, the one
to the book in which he writes,[47] the other simply in meditation. It is inter-

[46] Compare, for instance, the carefully drawn colonnettes and sarcophagus of Ghirlandaio's
Santa Trinità "Epiphany," painted in the same year.

[47] This figure is almost exactly reproduced in Botticelli's "Coronation of the Virgin," which
hangs on the adjacent wall.

esting to observe that Botticelli here follows medieval tradition in giving Saint Michael a full suit of "Gothic" armor; [48] he could have equipped the archangel in a more classic panoply, but possibly thought it too pagan for this particular saint.

I have already spoken of the color and its beauty of effect, although, as is so often the case in Filippino's work, one feels that fewer hues might have been used. Nevertheless, this panel seems to me to be more satisfactory in color than the Saint Barnaba panel.

As Dr. Valentiner suggests, the comparison between these two pictures serves to show how purely quattrocentist Botticelli remained in the eighties, whereas Filippino, starting with similar tendencies, was already by 1486 showing a different feeling. That this is in part due to Leonardo I am willing to allow, but in general I think it must be set down to the credit of Filippino's own genius. I am not alone in believing further that he was influenced by the sculptors of his day and slightly earlier: men like Antonio Rossellino and Benedetto da Maiano particularly, the mild sweetness of whose Madonnas finds a close reflection in paintings of Filippino's. The chief difference lies in the essentially happy mood of the sculptors mentioned, a mood which is never quite expressed by Filippino. At the same time Filippino never gives us the intense tragedy of Donatello. By the last quarter of the Quattrocento the day of the universal genius (of course, with certain notable exceptions) was passing; otherwise we should have had perhaps, in Filippino, one more sculptor to rank with Antonio Rossellino. But Filippino probably had no training in this field of art and, so far as we know, very little in architecture, although what remains of his ideas in that form of artistic expression gives evidence of interesting talents.

Such, then, is the panel set up in the Palazzo Vecchio in February 1486, in its way as worthy to preside over a council chamber as Simone Martini's great "Maestà" in the Palazzo Pubblico in Siena. For us it is a touchstone of much importance, as the one incontrovertibly dated example of the painter's pre-Roman period. It epitomizes the style of his early maturity — a style which he equaled once or twice in his later years but never surpassed. Almost exactly ten years later he finished the "Adoration of the Magi"

[48] A very similar suit, of about 1450, is preserved in the Dean Memorial Collection of armor in the Metropolitan Museum, New York; see fig. 48, p. 91, in the museum's *Handbook of Arms and Armor*, by Bashford Dean, 4th edition, edited by Stephen V. Grancsay (New York, 1930).

which today hangs beside it in the Uffizi, balancing the Saint Barnaba altar-piece. Midway between these two, chronologically, lies the fresco cycle of Santa Maria sopra Minerva; after 1496 we have dated pictures for nearly every year up to the time of Filippino's death. It now becomes necessary to fit into the decade 1486–1496 a series of undated works, the Roman period creating a break between them. Those which I believe to have been painted after the Minerva frescoes I shall discuss in a later chapter.

A group of altarpieces all more or less closely related in style affords the first step in the problem of dating. These include the "Madonna" of Santo Spirito, painted for Tanai de' Nerli; the "Madonna and Child" in the Bache collection, New York City; the "Madonna with Saints Jerome and Dominic" in the National Gallery, London; and the tondo formerly in the Warren collection and now in the Cleveland museum. I confess at the outset that I am not entirely satisfied as to their exact chronology. Broadly speaking, Filippino's stylistic development is a pretty clear and recognizable progression, yet, as the juxtaposed panels of 1486 and 1496 show, certain elements persist to a degree just sufficient to give rise to knotty problems. And the four panels just named combine elements which tend to pull them in both directions.

Least problematical of the group is the panel in the collection of Mr. Jules S. Bache [49] in New York City. This is usually referred to as the Strozzi Madonna, since it bears the arms of that family and was probably made for the illustrious Filippo Strozzi himself. The escutcheon with its three crescents appears on one of the capitals (which is modified Ionic, such as one finds in early Renaissance architecture, not the correct classic order) and the crescents are again introduced in the spandrel above.

Filippo Strozzi's contract with Filippino, to paint his chapel in Santa Maria Novella, is dated April 21, 1487.[50] Whether the Bache Madonna was a kind of morceau de réception in connection with this commission, or a sample piece (cf. the "Hercules" required of Annibale Carracci before he was entrusted with the frescoes in the Farnese Palace) it is impossible to say; but I think it must have been painted about this time. Filippo, having given the commission, might have been impatient to own a "Filippino," and knew that the decoration of his chapel (which, alas, he was destined never to see) would be

[49] This was formerly in the collection of Professor Martius in Kiel.
[50] See Vita di Filippo Strozzi il vecchio, scritta da Lorenzo suo figlio, edited by Giuseppe Bini and Pietro Bigazzi (Florence, 1851).

a matter of months if not of years.[51] It is also possible that the picture may have been ordered for the oratory he built at his villa at Santuccio.[52]

The panel itself is one of great charm (Fig. 26). It may derive from Botticelli's Madonna of the Poldi-Pezzoli, which, though undated, appears to belong to the eighties. The general arrangement is similar, but Filippino has reversed the position of the window and substitutes for Botticelli's clear sky and group of trees a view seen through the above-mentioned colonnade. This view is, I think, a free rendering of the Ponte Vecchio, with the Ponte Santa Trinità in the foreground — a neighborhood not far from the site of the then nonexistent Palazzo Strozzi. In effect this is so Flemish as to constitute proof that Filippino had continued to be interested in northern painting; here he temporarily becomes a kind of Florentine Rogier van der Weyden. On the other hand, Botticelli's motive of the Child reading a book has been taken over, together with the cushion and parapet on which the volume lies. But where Botticelli asserts his particular type of melancholy symbolism in the nails and crown of thorns held by the Child, who looks up at his mother as though he had grasped the meaning of the printed words, in Filippino's picture he idly rumples the pages with exactly the clumsy gesture of a baby too young to handle books, and it is only by the faint sadness of Mary's expression that we are reminded of how she "kept all these things and pondered them in her heart." One symbolic detail has been admitted: the half pomegranate lying on the parapet beside the Child. His attitude is not that of Botticelli's, but is a repetition of that in Filippino's altarpiece of 1486. The Madonnas of these two are very similar. Filippino still seems to be experimenting with color; here he reverts to the red dress but emphasizes the green lining of the cloak. This green is the color which Piero di Cosimo seized upon and made prominent when he painted his Madonna (now in Stockholm) so unmistakably based on the Bache picture (Fig. 27). The knotted girdle of the latter is similar to that of the "Virgin of Tanai de' Nerli" in Santo Spirito, if not quite identical in arrangement; here too

[51] The contract allows two years for the completion of the frescoes; see *Vita di Filippo Strozzi*.

[52] *Vita di Filippo Strozzi*, pp. 43-44, n. 29. The Strozzi palace was not begun until 1489, which is too late for the Bache picture, though it is permissible to guess that Filippo had the palace in mind some years earlier, and ordered the Madonna with a view to hanging it in the new dwelling. The picture, while of fair size, is small enough to be appropriate for a private chapel or oratory.

I do not quite see what Dr. Scharf means when he says (*Art in America and Elsewhere*, February 1931, XIX, 59 ff.) that if the Bache panel were painted in 1487, as he thinks it was, this would relate it to Filippo's marriage with Selvaggia de'Gianfigliazzi, which took place in 1477 — unless he implies a connection between it and the tenth wedding anniversary!

we find the veil looped over the breast and arranged in like fashion on the head.

I turn now to a further consideration of the Nerli Madonna (Fig. 28), which still hangs over the disused altar in that family's chapel, in the right transept of Santo Spirito. The Anonimo Magliabecchiano mentions it as follows: "In the church of Santo Spirito he made an altarpiece for Tanai de' Nerli, in which he represented him as in life (*al naturale*) with lady Pippa his wife. He also made the design of the glass for the window of Saint Martin."[53] Vasari also lists the painting, and indeed it has long been among Filippino's best known works. The rectangular panel, of a shape which seems to have been *de rigueur* for Santo Spirito altarpieces, still preserves its original blue and gold frame, richly adorned with arabesques, Corinthian capitals, and a frieze of palmettes surmounted by a cornice with dentils and egg-and-dart moulding. The Virgin is seated on a kind of antique altar; she holds the Child, who plays with the reed cross held up by the kneeling San Giovannino. Further to the left Saint Martin [54] presents Tanai de' Nerli, who is on his knees in adoration; Saint Catherine of Alexandria sponsors "Madonna Pippa." Behind the Virgin is an open loggia formed of four segmental arches carried on square piers carved with arabesques; in the spandrels above are three winged *putti*, two of them clutching shields with the Nerli *stemma*, the central one holding a dove. In the distance we see a view toward Monteoliveto, and a delightfully characteristic Florentine street showing the Porta San Frediano and the Nerli palace, at the doorway of which Tanai himself embraces a small child,[55] while the Signora looks on. This again is very Flemish in effect.

Scholars are not agreed as to whether this picture was painted before or

[53] Frey, *Il Codice Magliabecchiano*, p. 116. The window has since been blocked up, but we have Filippino's drawing for the glass (Uffizi print room, no. 1169 esp.). It is a fresh, delightful pen sketch, of a long lancet shape such as would suit a window in Santo Spirito. The design represents Saint Martin on horseback, with the Nerli arms below, between two centaurs, and two *putti* above.

[54] Miss Helen Sacher, in her dissertation, *Die Ausdruckskraft des Farbe bei Filippino Lippi* (Strassburg, 1929), wrongly identifies him as Saint Nicholas. His name, "S. Martinv/Episcopvs," is clearly embroidered on his crossed stole.

[55] This is always said to be a daughter of Tanai's. But I think she is more likely a grandchild, of whom he had a number by the time the picture was painted, notably Filippo di Benedetto di Tanai de'Nerli, born March 9, 1485 and destined to become a Senator; cf. *Raccolta d'elogi d'uomini illustri toscani, compilati da vari litterati fiorentini* (2nd ed., Lucca, 1770), II, cccxvi. This Filippo's father Benedetto is listed in Tanai's Portata al Catasto of 1457, as "Benedetto mio figliuolo, d'anni 8"; the document is published in Supino, *Les Deux Lippi*, p. 166, n. 1. In spite of the almost annual arrival of children in the Nerli family, I hardly think that the last of them can have been as young, in the late eighties (the earliest possible date for the picture) as the child whom Tanai is embracing.

after the Roman journey. Berenson and Venturi feel that the classical detail in the architecture and accessories points to a post-Roman date. Others, such as Langton Douglas in his edition of Crowe and Cavalcaselle, put it about 1488. Dr. Scharf, in an article in *Art in America*,[56] makes the flat statement that it was ordered in 1487 and painted before Filippino left Florence, but he does not cite any document as proof. Van Marle begs the question, indicating what is only too evident — that there is something to be said on both sides.

Certainly the picture is later in style than the Badia Saint Bernard, but the latter Venturi takes to belong to 1486, which if correct might push the Nerli panel ahead of the Roman period and into the nineties. The most convincing argument for the later date lies, as Berenson and Venturi have asserted, in the classical details. The Madonna's throne undeniably sug-gests an antique altar, although I do not know of any exact prototype for the centaurs represented upon it; they recall rather the architectural sculp-ture in Botticelli's "Calumny of Apelles." The ram's head is a thoroughly Roman touch. On the other hand, the architecture seems hardly more archaeological than that in the Uffizi altarpiece of 1486. Indeed, the small masks and dolphin forms of the pilasters are noticeably similar to those on, respectively, the moulding and base of the Uffizi throne. The frame of the Nerli panel, though rich, has none of the extravagance or the archaeological quality we might expect of Filippino after his return from Rome. As for draperies, those of Saint Catherine are admittedly more restless than those we have seen up to this point; but are they really much more so than those of the angel in the left foreground of the Badia panel? Saint Catherine (Fig. 29) even harks back to the slightly snub-nosed Verrocchiesque type of the Corsini *tondo*. The Madonna differs only slightly from her counterpart in the Signoria altarpiece. The Child's hair is longer, but his position is very similar; he also resembles the Bambino in the Bache picture. Saint Martin is of a fine vigorously masculine type worthy to succeed the Saint Bernard of the Badia.

In the donors I feel a strong argument for a pre-Roman date. We know from Tanai's Portata al Catasto [57] of 1457 that he was then thirty-one; his wife, whom he calls Monna Nanna, was twenty-eight, and had already pre-sented her husband with eight children. She was, said Tanai, expecting a

[56] February 1931, XIX, 59 ff. [57] Supino, *Les Deux Lippi*, p. 166, n. 1.

ninth. Now if we date Filippino's painting in 1493–1494, as Berenson suggests, Tanai would have been sixty-seven or sixty-eight, his wife about sixty-five. But Tanai seems not to have a grey hair in his head, though Piero del Pugliese, who was not yet out of his fifties even if one dates the Badia panel as late as 1486, is thoroughly grizzled.[58] Even if we allow that Tanai was a well-preserved individual, I cannot see how his face in the altarpiece can be that of a man of nearly seventy. If Monna Nanna, not yet quite sixty (as she would have been had the picture been painted not later than 1488), looks older than her husband, no one should be surprised, in view of her strenuous career and of the fact that Italian women tend to age fairly rapidly.

In favor of the later date it has been suggested that the scene in the background, where Tanai embraces the child, refers to a successful mission in France, from which he returned in 1494. The horse tethered beside him, and the embrace, might indicate either a departure or a return. This is logical enough, yet I would set against it the likelihood of Tanai's wishing to adorn his chapel in the eighties, at the time when various great families, such as the Bardi in 1485, were dedicating new altarpieces.

Finally, the color of the Nerli altarpiece has so many analogies with those of the Badia and the Uffizi panels that I am tempted to the conclusion that they all belong within a few years of each other. In particular the soft grey-blue, growing whiter in the high lights, which is worn by the angel in the Badia, is repeated in the dress of Saint Catherine; and in general the tonality and choice of color is the same, although the thick varnish of the Nerli panel gives it an unnatural golden effect. If it were cleaned I feel sure it would show closer correspondence with the other altarpieces just named. There is no hint of the cold quality characteristic of so much of Filippino's color in the nineties, in which one constantly feels undertones of black or grey.

If this picture was actually ordered in 1487, as Dr. Scharf says, that date would agree comfortably with the style of the painting as I see it. A year may well have elapsed between it and the Madonna of the Uffizi. I have already indicated that I regard the Bache Madonna as of about 1487. Be-

[58] His Portata al Catasto for 1480 gives his age as fifty-two, his wife's, thirty-four; see Supino, *Les Deux Lippi*, p. 152, n. 3. In this, by the way, Signora del Pugliese is designated as "Mona Pipa [sic] sua donna" — precisely the name given to Tanai's wife, who, however, appears in the cadastral list as Monna Nanna. One would imagine that the Anonimo had consulted these records and confused the two ladies or, rather, transferred the name of one to the other.

tween 1486 and 1488 Filippino also painted the two pictures for Matthias Corvinus, King of Hungary; of these I shall have more to say later.

There remain the other two in the group I listed: the Warren or Cleveland *tondo* and the National Gallery "Madonna with Saints Jerome and Dominic." When he published the former in *The Study and Criticism of Italian Art*,[59] Berenson pointed out as its closest parallel the Santo Spirito altarpiece, and close it is. He might however have cited the London panel, which to my way of thinking is even closer in some respects: e.g., the Saint Joseph seems to have been taken from the same model as the Saint Jerome, and the Saint Margaret is almost identical in feature with the London Virgin. If — and this is my own opinion — they can both be separated in time from the Santo Spirito Madonna, I should place them after the return of Filippino from Rome. This cannot have taken place later than 1493,[60] though it may have been a year or so earlier. Hence I defer the discussion of the panels until after the Roman period has been dealt with; suffice it to say here that, if the style of the Badia Saint Bernard could recur so clearly five years later in the Uffizi Madonna, after the Brancacci frescoes, it does not seem to me impossible that the same might have happened with the Santo Spirito and the Cleveland and London pictures, the Minerva frescoes coming between. I have, however, shifted their positions repeatedly, in my chronological list, and even now am not wholly satisfied with my conclusions.

Three fragments of larger paintings may as well be mentioned here; the earliest is a panel showing the head and shoulders of a youthful angel seen in three-quarters view. This picture (Fig. 24), number 220 in the museum of Strasbourg, certainly belongs to the early eighties, not later than the Badia Saint Bernard and perhaps as early as the Corsini *tondo*. The costume, with its turn-down collar, is very like the one worn by the fair-haired angel to the right in the *tondo*, the nose has the faintly Verrocchiesque "snub," and the lips are slightly parted as in some of the Badia and Corsini angels, this and the upcast eyes giving the characteristic expression of wistful reverence. The high oblong shape of the head, with its dark tangled curls, is again an unmistakable mark of Filippino. The panel must

[59] Series II, p. 95.
[60] We know this from the inscription on a tablet in the chapel, recording a visit of Alexander VI in that year, this visit indicating that the chapel was finished.

originally have formed part of a Madonna composition, of high quality, judging from that of the angel.[61]

It would be satisfactory to be able to propose as a pendant for the Strasbourg angel the fragment of similar character in the National Gallery in London (number 927, Fig. 45), particularly as this one faces in the opposite direction. But although in certain details this figure is close to the praying angel in the foreground of the Saint Bernard (Fig. 30) (the London panel shows the angel in half length, with hands together as in the Badia example) the former seems to me to show a thin sharpness of outline and a lack of fullness in form that would put it into the nineties rather than in the earlier decade. The very likenesses serve to reveal the differences, which are chiefly apparent in the drawing of the face, with its long pointed nose in contrast to the softly rounded ones of the Badia, Corsini, and Strasbourg angels. Moreover, the drapery is more mannered, and less indicative of the underlying form. This picture was probably part of a Madonna and Child with the infant Baptist; a portion of a halo to the right doubtless indicates the position of the Child, and the top of a blond curly head, presumably that of San Giovannino, can just be made out at the lower edge of the frame. There may have been a second angel to the right; such a composition, met with more than once in Botticelli's work, can be paralleled in that of Filippino and his school — for example, the *tondo* in Berlin (Simon collection), although this omits Saint John.

The third fragment, belonging to Mr. William Harrison Woodward of London, shows San Giovannino kneeling in a landscape. Again we have a panel which cannot be associated with the fragments just cited. Mr. Woodward believes, as he told me when he showed me the picture, that it is a complete whole, but I am disposed to agree with Berenson and Constable (who wrote the catalogue of the collection) that it originally formed part of a larger composition, no doubt the Madonna or the Holy Family. The downward gaze of San Giovannino suggests that the Christ Child was lying

[61] The lost altarpiece might conceivably have been similar to that of the Maître de Moulins, in the cathedral of Moulins, in which Italian influence is generally recognized. The angels in the French panel wear dark turn-down collars like that of the Strasbourg angel, and have much the same kind of wistfully reverent expression. It is also noteworthy that the topmost pair in the Moulins altarpiece hover in mid-air, holding a crown above the head of the Virgin — the same motif used by Filippino in his Signoria panel of 1486 and elsewhere. I do not mean to argue the direct influence of the latter painter on the Maître de Moulins; but one would like to know more about the peregrinations of the Strasbourg angel before he found sanctuary in his present home.

on the ground, as in Filippino's Uffizi panel. In type he is analogous to his counterpart in the altarpiece of Tanai de' Nerli, and the panels are probably contemporary, in my opinion painted about 1487.

On April 21, 1487, Filippino signed the contract for Filippo Strozzi's chapel in Santa Maria Novella. According to its terms he was to complete the work by March 1, 1489. Filippo, who had in 1466 returned from exile in Naples,[62] thanks to the magnanimity of the young Lorenzo il Magnifico, was by 1487 established as one of the most powerful citizens of Florence, and about to embark on an artistic program intended to glorify the house of Strozzi. The most ambitious part of this program, the Palazzo Strozzi, was to be begun two years later to the accompaniment of highly characteristic Renaissance ceremonial — the singing of mass at dawn and the taking of auspices according to pagan prescription, when the cornerstone was laid. Second in importance was no doubt the chapel, in which Benedetto da Maiano was appointed to carve the tomb, with Filippino to supply the frescoes.

Complete arrangements were made for Filippino's payment, and we may suppose that he began tentative sketches for the chapel, although such studies as have been preserved all belong stylistically to the post-Roman period. It is possible that the work was actually begun, only to be interrupted in 1488 by Filippino's summons to Rome. If so, it is natural that he should have destroyed the incomplete beginnings when he returned with his head and sketchbook full of Roman antiquities. These would have made the earlier work seem out of date and incompatible with his newly formed style. It would also account perhaps for the disappearance of the earliest preliminary studies, of which there certainly must have been some. Then, too, such a hypothesis would do something toward vindicating Filippino in the otherwise inexcusable delay on the frescoes. Other extenuating circumstances are possibly to be found in the fact that at the time he signed the Strozzi contract he was busy probably with the Santo Spirito and certainly with the Matthias Corvinus panels to be discussed shortly. This may be doubted by some in view of the fact that the contract gave permission to the painter to hire assistants if the work failed to progress according to schedule.

Now as to Matthias Corvinus: Vasari says [63] that that sovereign tried to

[62] He had gone there as a child at the time of his father's banishment for his share in the expulsion of the Medici in 1433. Interesting details of his life are contained in the biography written by his son Lorenzo; for the full reference to this, see *Vita di Filippo Strozzi*.

[63] Milanesi-Vasari, III, 467.

persuade Filippino to come to Hungary, but was only able to obtain from him two pictures which were sent from Florence. What has become of these paintings we do not know, but it is certain that they were painted, since in his will dated September 21, 1488,[64] Filippino requests that Francesco di Filippo del Pugliese collect payment due him, "pro pretiis et mercede duarum tabularum immaginum virginis Mariae et aliorum sanctorum per eum pictarum ad instantiam mandatarii illum domini regis Ungarie." This sounds as though there were either two Madonnas, or one Madonna and a panel containing only saints, such perhaps as the one in Lucca.[65] Vasari goes on to say that one of the pictures contained a portrait of the king, "as he is represented on medals" ("secondo che gli mostrarono le medaglie"); [66] had this been a separate portrait it would probably have been so described in the will. It would most likely have been introduced in the position of a donor; the king would scarcely have appeared as one of the saints, although it was allowable for contemporary dignitaries to be painted as the Kings in scenes of the Epiphany.

If the Madonnas, or even one of them, were of any considerable size, the work on them might well have occupied the months of 1487 not devoted to the Santo Spirito or Bache Madonnas, and also the summer of 1488, since Filippino does not claim payment until September of that year. At the same time it is to be hoped he was working on sketches for the Strozzi chapel. He received regular payments from the Strozzi, whether or not he had anything to show for it. We do not, of course, know all the circumstances, but it is something of a blot on Filippino's otherwise exemplary reputation that he allowed the frescoes to be delayed so long, accepting new commissions before the old one was finished, or even seriously begun.[67]

In 1488 the painter received an invitation from Oliviero Caraffa, cardinal of Naples, to decorate his chapel in Santa Maria sopra Minerva in Rome. We know from a letter of the cardinal's written on September 2 [68]

[64] Strutt, *Fra Filippo Lippi*, p. 183. See also Poggi in *Rivista d'arte*, IV (1906), 106.

[65] The genitive plural form of "imaginum" would, however, indicate that two pictures of the Virgin were meant.

[66] Milanesi-Vasari, III, 467.

[67] Payments were even made, as will be seen, while he was, presumably, in Rome working on the Caraffa chapel.

[68] Printed in Zanobi Bicchierai, *Alcuni Documenti artistici non mai stampati* (Florence, 1855), pp. 15–16, and by Muntz in *Archivio storico dell'arte*, II (1889), 483 ff. The original letter is preserved in the Biblioteca Marucelliana, Florence, codex no. 65, among "Lettere originali di uomini illustri de'secoli XV, XVI; opuscoli greci e latini di vari."

of that year that Lorenzo de' Medici had recommended him. This fact may have had much to do with Filippino's acceptance of the commission, although under contract to Filippo Strozzi; he may have felt that Il Magnifico and a cardinal were to be accommodated before a somewhat less exalted, albeit influential and powerful, Florentine citizen. The situation shows us for the first time the chief weakness in the painter's character: a tendency to undertake more than he could reasonably expect to carry out. This may have been because he could not resist the flattery, or the promise of funds, inherent in a commission; or — a pleasanter and I think more characteristic reason — he was anxious to be obliging and disliked turning away a patron even when it meant delay on contracts already undertaken. Had he suffered from professional vanity he would scarcely have yielded contracts to others, as he is said to have done, or have been willing to take the leavings of another. He certainly does not seem to have had the erratic temperament of Leonardo, but he must have lacked an efficient business sense. Filippo Strozzi here shines in contrast to the painter, he, and after his death his widow and firm, having shown the strictest integrity in carrying out the Strozzi side of the contract and making payments whether the frescoes progressed or not.

The summer of 1488 marks a clear turning-point in Filippino's career, terminating what many regard as the greatest period of his work. In his single figure he parallels the situation which was about to obtain in Northern European art, through contact with the antique, with, as some feel, irreparable harm to native genius. Up to 1488 Filippino's style had been but lightly touched by the classicism of the Renaissance. Except on the work in the Brancacci his painting shows qualities curiously akin to those of the north in the fifteenth century: sympathetic observation of visual fact, a flair for characterization rather than idealization in portraiture, a relish, sometimes undiscriminating, for bright color, and above all a love of landscape, which like the Flemish painters he makes poetic not by rendering it imaginatively but by recording sympathetically its actual appearance. In contrast to northern work are his innate melancholy and nervousness, enhanced through contact with Botticelli but undoubtedly in large measure the product of heredity and of early environment. In the eighties he shows himself above all a painter of satisfactory altarpieces, feminine, if you will, but unquestionably sincere in their tenderness of feeling. As expressions of

genuine piety embodied in beautiful and essentially natural forms they rank, I feel, with those of Raphael and of Giovanni Bellini. Moreover, I believe there was no more sensitive psychologist in the Quattrocento, although Leonardo's researches in abnormal psychology made his scope broader than Filippino's. The restraint to which I so often refer in the latter's work keeps it fundamentally healthy. If this is not the robust healthiness of the pleasantly solid and prosaic Ghirlandaio, neither is it the neuroticism occasionally seen in Botticelli.

This fresh, charming, capable style was not destined to change the course of Florentine painting. It lacked the force and novelty necessary to affect other painters, and it contained too little that was new. One might describe it as an appreciative synthesis of elements already present in Florentine painting, strongly colored by an individual temperament. That the painter had made an enviable reputation by 1488 is clearly apparent, and that reputation was well deserved. The years immediately following were in the opinion of most critics the beginning of his decline. That this is emphatically not the case I hope to show in the following chapters.

CHAPTER V

THE ROMAN PERIOD

SINCE we know of no work except the Minerva frescoes done by Filippino in Rome, it is perhaps arbitrary to speak of a Roman period. Moreover, I feel that the Roman sojourn has received a wrong sort of emphasis in discussions of Filippino's stylistic development. It is generally implied, if not actually stated, that the study of antiques wholly altered the style of all his subsequent work, as Vasari suggests when he says, "He never executed a work in which he did not make use of Roman antiquities, carefully studied, such as vases, buskins, trophies, banners, crests, temple ornaments, headdresses, strange costumes, armor, scimitars, swords, togas, mantles, and other such things, various and beautiful, so that a great and perpetual debt is due him for having in this way added such beautiful ornaments to art." [1] Although this is partly true, it cannot be maintained in the face of, say, the "Adoration of the Magi" of 1496. Too many critics, unsympathetic to begin with, would seem to have let themselves be misled by Vasari's rapturous appreciation of the antiques in the Strozzi frescoes, dismissing the whole body of the late work as decadent because it embodies some of the less attractive phases of the Cinquecento — those which would have appealed to what these critics regard as the debased taste of the period.

I believe that the Roman sojourn had a considerably less radical influence on Filippino than is generally assumed, the painter having been profoundly affected also by quite different tendencies during the last fifteen years or so, in Florence. Nevertheless, Roman influence is not to be denied, and the years in the Eternal City constituted a turning-point, whether the road subsequently led uphill or down. It is therefore convenient to dis-

[1] Milanesi-Vasari, III, 462. The Italian, from which I have translated, runs as follows: "Non lavorò mai opera alcuna, nella quale delle cose antiche di Roma con gran studio non si servisse in vasi, calzari, trofei, bandiere, cimieri, ornamenti di tempj, abbigliamenti di portature da capo, strane fogge da dosso, armature, scimitarre, spade, toghe, manti, ed altre tante cose diverse e belle, che grandissimo e sempiterno obbligo se gli debbe, per aver egli in questa parte accresciuta bellezza e ornamenti all'arte."

cuss the Roman phase apart from the work immediately preceding and following it. The mere fact of Filippino's having been absent from home for a period of three years or more is striking; it was probably his first long absence since the years in Spoleto.

He arrived in Rome on August 27, 1488,[2] and was at once presented by the Florentine ambassador Giovanni Antonio Lanfredini to Cardinal Caraffa, who wrote enthusiastically about the contract in a letter to Don Gabriello, abbot of Montescalari,[3] dated September 2 of the same year. Filippino himself realized at once that his stay in Rome was likely to be a long one, and accordingly went back to Florence within the month, to set his affairs in order. His will, already cited in the connection with the panels for Matthias Corvinus, is preserved in the Archivio di Stato in Florence,[4] and bears the date September 21, 1488. Filippino describes himself as "Filippus alterius Filippi Thomasii de Lippis civis et pictor Florentinus, sanus mente, sensu, corpore, visu, et intellectu," of the parishes of San Michele Bisdomini (the church in which he was to be buried some sixteen years later) and Santa Maria Nuova. Having named his executors, commented on the uncertainty of this mortal life, and commended his soul to God and to the Blessed Virgin, he disposes of his quite considerable property to his sister Alessandra, wife of Ciardo di Giovanni Ciardi, living near Prato, and to the hospital of Santa Maria Nuova, through which "Lucretia his beloved mother, daughter of the late Francesco Buti of Florence," is to receive, throughout the rest of her life, regular supplies of oil, wood, and salt meat. The will seems to indicate three houses owned by Filippino at this time, two in Prato, which he leaves to his sister and mother respectively, and one in Florence, of which Lucrezia is to have the use. This is apparently the one cited by Dr. Gronau as purchased on January 4, 1488,[5] in the Via degli Angioli (now the Via Alfani). The will describes it as "domum emptarum per dictum Filippum a monasterio de Angelis de Florentia." This street bounds on the northwest the block containing Santa Maria

[2] Milanesi-Vasari, pp. 468–469, n. 2.

[3] This oft-quoted letter is printed in its entirety by Eugène Muntz in *Archivio storico dell'arte*, II (1889), 483 ff., and by Alfred Scharf in his *Filippino Lippi*, p. 89. It refers to Lorenzo's recommendation of the painter, and contains the famous phrases, "lo haveriamo preposto ad uno Apelle" and "non lo haveriamo cambiato, per quanti altri pictori furono mai in Grecia antiqua."

[4] A.S.F. Firenze, Sezione dell'Archivio Notarile, Rogiti di Ser Giovanni di Ser Marco da Roma, Protocollo del 1846 al 1504. The text is printed in Strutt's *Fra Filippo Lippi*, p. 183.

[5] Thieme-Becker, *Allgemeines Lexicon*, XIII, 268–270.

Nuova and Santa Maria degli Angioli, and crosses at right angles the Via de'Servi, along which, according to Vasari's famous account,[6] Filippino's funeral procession passed on its way to San Michele.

Filippino presumably returned to Rome as soon as his affairs in Florence were settled, and must have been ready to begin on the Caraffa chapel by October. According to Vasari, Lorenzo the Magnificent commissioned him to travel via Spoleto in order to design the memorial to Fra Filippo [7] which was to be his substitute for the noble sepulture he had hoped to give the Frate in the cathedral of Florence. Filippino may have complied with this request far enough to stop at Spoleto — one's imagination is stirred at the thought of the emotions aroused in the painter by such a visit — but the existing tablet to Fra Filippo gives every indication of having been designed during or after the Roman period, and hence was more probably executed in connection with Filippino's return journey.

Just when this return journey took place we do not know, but it can hardly have been later than the spring of 1493; I have already mentioned the tablet in the Caraffa chapel, bearing the date May 19 of that year and recording the visit of Alexander VI, the Borgia pope who had assumed the tiara in the summer of 1492 and now offered indulgences to all who should pray in the chapel.

Another possible date for the return of Filippino to Florence is before January 5, 1491, when he entered a design in competition for the façade of the Duomo. If this design were submitted in person, he must have left Rome before New Year's day of that year, perhaps in December 1490. On the other hand, there is no reason why such a design could not have been sent by messenger from Rome. But of this, as of the date 1493, I shall say more presently.

On May 2, 1489, Filippino wrote his famous letter to Filippo Strozzi asking his indulgence on account of the delay of the Santa Maria Novella commission.[8] He comments enthusiastically on the general decoration of the chapel, mentioning particularly the rich marbles and porphyry of the pavement, altar, and parapet; he does not speak of the frescoes, remarking simply that the cardinal is satisfied with his work ("l'opera mia gli sodisfa").

[6] Milanesi-Vasari, III, 476. [7] Milanesi-Vasari, III, 467.
[8] Printed in Bicchierai, *Alcuni Documenti*, and by Muntz in *Archivio storico dell'arte*, II (1889), 483 ff.

Either Filippo Strozzi was a man of much forebearance, or else his business ethics would not allow him to hold back the payments he had promised; for the Strozzi archives contain records of instalments issued to Filippino on August 8 (65 florins) and September 26, 1489 (25 florins).[9] The next instalments were paid after the painter's return to Florence.

So far as is known, Filippino painted nothing in Rome except the Caraffa frescoes, and presumably the design for the Duomo façade (scarcely to be classified as painting). Such time as was not spent in Santa Maria sopra Minerva was doubtless occupied in studying antique buildings and fragments of sculpture wherever he could see them. Probably it was at this time that he had his first view of the Sistine Chapel, and made the sketch after Botticelli's "Punishment of Korah."[10] He must have had access to the Lateran collections, transferred by Sixtus IV to the Palazzo dei Conservatori in 1471. The Strozzi chapel bears witness to these excursions into archaeology. No doubt the sketchbook seen by Benvenuto Cellini[11] while his crony Francesco di Filippo, Filippino's son, owned it, contained studies made in Rome with a view to their adaptation to the walls of Santa Maria Novella. Vasari's celebrated book of drawings must also have included such work.

The Caraffa chapel was presumably the most extensive work Filippino had so far undertaken. Occupying the right transept of the church, it offered to his brush three walls and a quadripartite vault, all of generous dimensions. The east wall was destroyed in the sixteenth century to make room for a sculptured monument to Paul IV, the Caraffa pope who died in 1559. Vasari luckily was able to see it before its ruthless destruction, and reported the subject as follows: "Various very beautiful fancies, all by his hand. . . . Here we see Heresy taken prisoner by Faith, with all the faith-

[9] See n. 8, above. Dr. Scharf thinks that these payments indicate Filippino's presence in Florence during the summer and autumn of 1489 (*Filippino Lippi*, p. 60). He cites the painter's letter to Filippo Strozzi dated May 29, 1489, in which he promises to undertake the Sta. Maria Novella frescoes by "S⁰. Giovanni" (i.e., June 24, St. John the Baptist's day) of that year. Dr. Scharf believes that he made good his word, in part, by painting the Strozzi chapel vault, returning to Rome to finish the Caraffa frescoes after Filippo Strozzi's death in 1491. In that case the design for the Duomo façade, of January 1491, would no doubt have been prepared in Florence. The hypothesis strikes me as quite plausible.

[10] Berenson, *Drawings of the Florentine Painters*, II, 70, number 1289. Berenson rightly rejects the theory that this is a study made by Filippino for Botticelli's fresco, and hence a piece of evidence that he collaborated in the Sistine. The style of the sketch is decidedly too late to have served as a preliminary to the fresco.

[11] *Memoirs*, bk. I, chap. III.

less and the unbelievers. Likewise, below, Hope overcomes Despair, and many other Virtues have subjugated their corresponding Vices." [12]

The dominating theme of the chapel is one eminently suited to a Dominican church: the Triumph of Saint Thomas Aquinas. The altar wall is, however, decorated in honor of the Blessed Virgin, while the vault above contains four Sibyls.

It cannot be sufficiently deplored that this, one of Filippino's most important and significant works, should have suffered so much at the hands of restorers as to be virtually useless as a point of departure for criticism and dating of other works. Chronologically midway between two other dated paintings (the Uffizi Madonna of 1486 and the Epiphany of 1496) it once provided a touchstone by means of which such problematical pictures as the Santo Spirito and London Madonnas might safely have been dated, on stylistic grounds (allowing, of course, for differences between fresco and tempera; but these are not pronounced in the case of Filippino's work, always excepting the Brancacci). As it is, we can make few absolutely safe deductions from style except to note the interest in the antique. Equally regrettable is the fact that the repainting of the ceiling has deprived us of what might otherwise have been a useful piece of evidence as to the style of Raffaellino del Garbo, who according to Vasari [13] was responsible for the four Sibyls. Today it is quite impossible to be sure whether Vasari was right; except for the composition, the vault frescoes show little of what may have been their original appearance.

But the remains of that general composition are of great importance and interest in the development of ceiling design. In spite of damage, the original arrangement is probably virtually unchanged. Of the four Sibyls the "Delphica" appears to have suffered least, the "Hellespontica" perhaps most (Figs. 50–52). The latter's ample physique is too clearly influenced by Cinquecento or later taste to be entirely Filippino's; the other three are more slender and characteristic. But there is no lack of suggestion of the sixteenth century, particularly in the marked *contrapposto* of all four figures, especially that of the Tiburtine Sibyl. This variety of pose cannot but strike one as a foretaste of the Sistine ceiling. The very presence of Sibyls in vault

[12] Cf. Milanesi-Vasari, III, 468, for the Italian version.
[13] Milanesi-Vasari, IV, 235. According to Vasari, "Filippo suo maestro lo reputava in alcune cose molto migliore maestro di sè."

decoration is unusual; the common subjects are the Evangelists or Church Fathers. Cardinal Caraffa may in this instance have been responsible for the choice of subject.

In each compartment attendant angels, smaller in scale than the Sibyls, occupy themselves with books, scrolls, and tablets; they are of the youthful, slightly languishing type seen below in the boys present at Saint Thomas' Triumph. *Putti* crowd in among the clouds to fill out the lower corners of each triangular vaulting compartment; counterparts of these are to be met with regularly in Filippino's subsequent work.

The damaged state of this ceiling has been one reason for the very cursory notice usually accorded it. The figures are of great interest and significance in their complete break with Quattrocento tradition. Compare them with earlier Florentine examples of the same compositional problem: Fra Angelico's Evangelists in the Vatican chapel of Nicholas V, Benozzo's similar iconography in the chapel of San Francesco, Montefalco, or those directed by Ghirlandaio in the choir of Santa Maria Novella, painted 1486–1490. In all these purely Quattrocento vaults there is only the most rudimentary attempt to relate the figures to the space they occupy. The venerable personages sit facing forward, naïvely drawn masses of cloud beneath their feet (the apparent curve of these is partly the result of the concave wall surface). At most there is a slight twist of head or knee; otherwise frontality is observed.

Filippino's figures look fifty years later by contrast. They sprawl, lean sidewise, gesticulate, glance over their shoulders — all with a view to emphasizing the shape of the space and achieving liveliness and variety. The influence of Melozzo da Forlì, whose work Filippino now encountered for the first time, has been adduced to account for certain features, but this I think has to do only with the foreshortened effect especially noticeable, in the Minerva, in the fresco of the Assumption. Melozzo's work does not show the Baroque torsion of the Sibyls. To be sure, this Baroque quality is the result of bunchy draperies, straining for effect, and nervous movement. Originally the frescoes must have been distinctly pleasanter to look at than they are today. Yet in these agitated ghosts of originals there remains enough to entitle Filippino to much credit for his study of novel poses adapted to awkwardly shaped spaces, and for his attempt to introduce life and emotion into the figures through movement. For are not these qualities

— too often regarded merely as faults in Filippino — the very fundamentals of Baroque art? Veronese, more than half a century later, was to solve brilliantly the problems which Filippino, far less richly endowed as a decorator, here attacked with boldness and inventiveness. If to a great extent he was unsuccessful, he still remains a progressive in ceiling design, and as such takes at least a modest place in the long line of decorators which, for Italy, ends gloriously with Tiepolo.

How far is Filippino to be regarded, in this case, as a wholly independent designer? As we have seen, a general survey of late fifteenth-century ceiling painting for quadripartite vaults encourages the conclusion that in the Minerva the painter appears as an innovator of a striking sort. But I believe that his originality lies in his *adaptation* of a design to the space at his disposal, not in the creation of that design itself. The inspiration may well have come from his older contemporary and personal friend, Antonio Pollaiuolo, and the specific object which served, I suspect, as his model was the bronze tomb of Sixtus IV.[14]

A comparison of the allegorical figures adorning the base of the tomb shows many analogies, which to me seem striking, with the Minerva Sibyls. To begin with, the panels are roughly similar in shape, having flaring sides, although, of course, in the bronze panels the form is that of a trapezoid rather than the triangular outline of a section of Gothic vaulting. Each panel contains a female figure with various accessories and small attendant figures, together with plaques bearing the names of the Virtues or Sibyls represented. These details are not in themselves enough to justify the belief that Filippino based his Sibyls on the Sixtus IV tomb; but if the individual figures be compared, one can hardly fail to be struck by a number of resemblances. The Tiburtine Sibyl is almost exactly like Pollaiuolo's Philosophy (Fig. 32), in *contrapposto* attitude, leaning her head on one hand; the Hellespontic resembles the Theology of the tomb except for the position of the legs, and Filippino has borrowed the motif of the small "angel" holding up a book, except that he substitutes a scroll for the book. The Cumaean Sibyl is like Pollaiuolo's Grammar (Fig. 34) except for the right arm; there are also suggestions of motifs taken from the Theology, though reversed. The Delphic Sibyl seems to have been designed independently of Pollaiuolo. Of the Hellespontica

[14] Dr. Scharf (*Filippino Lippi*, p. 39) compares the physical type of the Minerva Sibyls to that of the Pollaiuolo Virtues of *c.* 1470, but he does not pursue the analogy further.

one may say further that the front facing pose and the vertical rather than
horizontal proportions of the "panel" might be a free adaptation of one of the
Virtues on the flat top of the Sixtus tomb. Finally, the small "angel" figures
present some parallels, notably one of the Cumaean Sibyl's attendants, who
is approximately a reversed version of one accompanying the bronze Dialectic.

My theory receives some support, and no clear contradiction, from his-
torical evidence. Although we do not know exactly what years were spent
in working on the tomb, we do know that they must have been among those
between 1484, when the pope died, and 1493, when the work was finished.
Venturi says that the sculptor went to Rome to begin the commission in
1490; [15] van Marle gives 1484,[16] assuming apparently that work on the tomb
was begun shortly after Sixtus' death. There seems to be no certainty as to
the year in which Pollaiuolo did make a start, but it may have been before
1490. We know that Filippino was in Rome from 1488 until the early
nineties.[17] We know further that he had known Pollaiuolo from his boyhood
(witness the Spoleto records, with their mention of a visit to the Lippi in
that town); that the only authentic painted portrait of the sculptor occurs in
Filippino's Brancacci fresco, painted just at the end of Sixtus IV's reign. It
is entirely to be expected that the two Florentine artists would have seen
something of each other in Rome, and that the younger man would have
taken a keen interest in the design of the tomb, the more so perhaps because
his master Botticelli had also had close associations with the sculptor. And
from whom else, in Rome about 1490, could Filippino have drawn inspira-
tion for his strikingly novel figures? I should like to give him full credit for
the innovation, but Pollaiuolo seems to me a possible and even a probable
source for his ideas.

There is, of course, the possibility of a "common ancestor" in ancient
Roman work which might have served both Pollaiuolo and Filippino. Or it
could be argued that Filippino had seen sketches of Pollaiuolo's in Florence
which he adapted to the Minerva ceiling when he got to Rome. Again, it
might be said that Filippino would naturally have begun the chapel with
the vault, which (if Pollaiuolo came to Rome in 1490) would surely have
been finished before the tomb was made. Vasari says that Filippino painted
the vault and then went back to Florence for a time. If he and Dr. Scharf [18]

[15] *Storia dell'arte italiana*, VI, 738. [17] Gaye, *Carteggio*, I, 341.
[16] *Italian Schools of Painting*, XI (1929), 320. [18] Scharf, *Filippino Lippi*, p. 60.

are right about this, the repainting of the vault may have been the direct result of the painter's interest in Pollaiuolo's tomb, whether or not the actual execution is his or Raffaellino del Garbo's.

Incidentally it is interesting that Pollaiuolo should have been given, by Lorenzo de' Medici, a recommendation to Cardinal Lanfredini — the same auspices under which Filippino also went to Rome. Gaye [19] prints the letter, of November 12, 1489, which would seem to suggest Pollaiuolo's arrival in Rome soon after that date.

To return to the discussion of the Minerva frescoes themselves.

The Annunciation over the altar (Fig. 54), although in fresco, is treated like a panel, with a rich enframement showing arabesques and profile masks on its carved cornice. Similar architectural ideas are carried out in the setting of the Virgin's room: a square pier with arabesque paneling and a frieze showing Roman bucrania and garlands, the simply moulded cornice supporting the barrel vault of a loggia or vestibule. I would point out that the arabesque here, based on a candelabra form, and including bucrania, medallions, and small hanging bundles like fasces without the axe (flutes, perhaps?), is more archaeological in detail than anything previously noted in Filippino's work; I believe that the Nerli panel would have shown such elements in its decoration and frame had it been painted after the Roman period. Otherwise the picture is in no way novel. Our Lady rests one knee on a cane-bottomed chair such as one uses in the church today, interchangeably, as a seat or as a *prie-dieu* at mass; she is, however, accorded the luxury of a tasseled cushion. Books lie open on a desk beside her; a shelf above reveals more books, a vase, and an inkwell. In type she was probably once similar to the Madonna of Santo Spirito; her face is of about the same shape, although the features have suffered from retouching. Raising her right hand, she looks vaguely into space, as though not wishing to give the preference either to Gabriel or to Cardinal Caraffa, who kneels in profile to the right, presented by Saint Thomas Aquinas. Undoubtedly repaint has deprived us of two fine portraits; Saint Thomas was of a type well known, never requiring to be shown in the generalized ideal fashion of, for example, the Apostles, and Filippino would certainly have given the cardinal the sort of likeness with which he immortalized the features of Piero del Pugliese, Tanai de' Nerli, and the Florentines of the Brancacci.

[19] Gaye, *Carteggio*, I, 341.

In the angel Gabriel we again have an assertion of that quality in Filippino's later work justly regarded by some as proto-Baroque. The type (allowing for repaint) is virtually that of the principal Badia angel, but the movement is entirely new. This Gabriel is less timid than obsequious, even apologetic — wholly different from the Badia angel, whose youthful shyness never makes him lose his reverent self-possession. The Minerva Gabriel is not sure of his reception, for all his adoration. He comes in with a kind of lunge, his draperies billowing around him and adding to the agitated effect. In him we detect the intense religious fervor which constantly increases after the nineties, and which takes Filippino's work close to the borderline between sentiment and sentimentality.

Flanking this "altarpiece" we have two sections of wall showing the Apostles present at the Assumption of the Virgin, which takes place in the lunette above.[20] This is thoroughly and badly repainted, and the halos have been scratched over and lettered with the names of the Apostles.[21] Saint Philip's pose as he turns to call his companion's attention to the miracle is quite seventeenth-century in feeling; heavily swathed in draperies, this figure again points forward to Raphael, as did the Saint Paul in the Brancacci. Saint Peter kneels beside the Virgin's coffin, which is badly out of drawing (this must be blamed on the restorer). One of his keys dangles over the edge, in rather unfortunate prominence. In the distance Saint Thomas, with the same cringing lunge noticed in the Gabriel, holds up his hands to receive Our Lady's girdle. Was this incident introduced because as a native of Prato Filippino could scarcely think of the Assumption without it? Iconographically it is not essential to the scene of the Assumption, but it must have seemed so in the minds of all good Pratesi.

On the other side, rather better preserved, the standing Apostle in the foreground looks upward in rapt yearning; his raised right hand, with the fingers spread, is from now on a trade mark in Filippino's work. Saint Thomas appears again at the right, talking to Saint Bartholomew. He is Filippino's dark, short-bearded and moustached type. The landscape background must once have had considerable amplitude and beauty; the archi-

[20] The Uffizi print room has a drawing reproducing the right-hand composition; it is clearly a copy rather than a preliminary study, drawn by a painstaking and uninspired hand.

[21] One, to the left, says "Paulus," obviously an error in spite of that saint's close association with the Twelve. In this instance he would not even have been introduced to make up the dozen, since only eleven figures are present.

tecture looks more medieval than Roman. As in the Brancacci, the middle distance shows horsemen, and among them a curious and apparently refractory camel.[22]

In the lunette of the Assumption the clearest note of "Seicentismo" is struck. The Virgin stands on a mass of cloud; from beneath her swirling draperies peep *putti* swinging censers or holding lighted candles (Fig. 39). Three angels with torches in the form of cornucopias fly below the cloud like animated caryatids. This casual taking for granted a support where none exists is an idea sympathetic to the seventeenth-century mind; it recalls, for instance, the four Church Fathers who appear to hold up the throne of Saint Peter in Bernini's great bronze shrine. Six more angels playing musical instruments (one has the bagpipe known to the heavenly choirs since the days of Giotto and earlier) disport themselves in mid-air with more enthusiasm than grace. Their draperies, where not repainted to a kind of stringy bunchiness, indicate that Filippino was losing his sense, never very strong, of form under fabric. The folds are calligraphic and nervous, but flattened as though crushed under a heavy weight (e.g., the lowest angel to the right).

Yet on the whole, damaged and faulty in detail as this fresco is, the general effect is one of fine bravura and monumentality. The Madonna, encircled with rays of light and "crowned with twelve stars,"[23] is singularly like a Baroque Immaculata, and the whole lunette is treated like an apse, the concavity of shape suggested by the way in which the angels sweep through the air in a semicircle. This is essentially the device employed by Raphael in the Disputà of the Vatican. Van Marle suggests that the angels show the influence of Melozzo's in Santi Apostoli,[24] which were painted in 1480 — a plausible theory, although the foreshortening, to suggest actual figures seen from below, is less emphatic in Filippino's work. Much of the architectural setting is painted: *putti* sitting on cornices, and a coffered soffit framing the Assumption.

[22] An interesting preliminary study for the Apostles is preserved in the Pinacoteca in Siena. This sketch, in pen and bistre heightened with white, treats the composition as a whole, with no space allowed for the Annunciation which, in the chapel, divides the Apostles into two groups. The drawing was published by Cesare Brandi in the *Burlington Magazine* (vol. LXVII, July 1935, pp. 30–35, "The First Version of Filippino's Assumption").
[23] Iconographically this crowning with stars shows a confusion between the Assumption of the Virgin and the Immaculate Conception such as is not uncommon in Spanish art.
[24] Van Marle, XII, 321.

Undoubtedly the most successful part of the chapel is the "Triumph of Saint Thomas" (Fig. 40), who sits enthroned between the Liberal Arts, holding a scroll inscribed SAPIENTIA VINCIT MALITIAM and crushing under his feet a bearded man representing a kind of sum total of evil, like the symbolic figures beneath the feet of medieval sculptured saints. In the foreground are scattered the heretical books of Averroës, Arius, and Sabellius, each clearly marked ERROR, while the heretics themselves, monumental figures of dignified if subdued bearing, look on, attended by a group of men and boys. The grizzled, bareheaded man leading the right-hand group, apparently Sabellius, has a splendidly realistic head perhaps studied from life, but the close-cropped hair and the cloak fastened on the left shoulder with a great brooch suggest that Filippino was thinking also of Roman sculpture.[25] The portly Dominican to the extreme right illustrates at its best Filippino's power of vivid portraiture. The elegant long-haired boys are good examples of his delicate, rather feminine type of youth, like the resurrected boy in the Brancacci. On the other side stands a typical greybeard (Arius?) who looks like a Hebrew prophet — a mighty and venerable figure. Indeed, these two heretics are nobler and more impressive than Saint Thomas, who owes what presence he has largely to the fine throne which gives him prominence. The growing interest in exotic costume is illustrated in the turbaned figures, who take their motivation from the idea of the eastern heresies.

The setting is in some respects the most interesting part of this fresco. It introduces the statue of Marcus Aurelius in its old place outside the Lateran, the Campidoglio of Michelangelo having been a matter of many years later. The nearer buildings have the massive simplicity of the late Quattrocento, and indeed suggest that of the Cinquecento. Bramante's Roman work comes at once to mind; yet he probably did not arrive in Rome until a decade later (1499). The building to the left in the ".Triumph" looks like a close relative of the cloisters of Santa Maria della Pace, which were not built until 1504, the year of Filippino's death. The heavy, plain Roman arch order of the ground floor is perhaps derived from the Coliseum. This kind of architecture is too often forgotten when Filippino's debt to Rome is under discussion. Clearly his enthusiasm as a collector of antique odds and

[25] The head is very like Roman busts of the Republican period, but the cloak would have been derived from portrait busts of the Empire, when chest and shoulders came to be included, Republican taste showing only the head and neck.

ends did not blind him to the monumental character of fine Roman buildings, however ruinous.

Another striking feature of Filippino's architectural background here is the introduction of figures leaning over parapets and balconies, some of them silhouetted against the sky. This again is a startling anticipation of Veronese, and is to be met with some time later in the porch frescoed by Filippino in the Medici villa at Poggia a Caiano. The throne of Saint Thomas is more conservative, showing a shell niche behind the saint, framed by wide pilaster forms with fasces in relief,[26] and supporting a moulded entablature with a lunette above, in which sit two *putti* holding a medallion with Saint Thomas' attributes, the book, blazing sun, and lilies. Portions of the entablature are carried forward on either side on rectangular supports having fasces in relief and modified Corinthian capitals. These in turn support a kind of domed groin vault. *Putti* with inscriptions stand on the cornice at either side. The decoration makes use of simulated mosaic and of such antique elements as bead-and-reel and egg-and-dart mouldings; the effect of the whole is restrained and elegant.

The derivation of this throne is not far to seek. Clearly it shows dependence on the Quattrocento wall tombs of Florence for which Bernardo Rossellino set the type, although Desiderio's tomb of Carlo Marsuppini offers a closer parallel.[27] In this case contact with Rome did not very strongly modify Filippino's memory of Florentine work.

Whatever may be thought of the rest of the chapel, this one fresco surely deserves the adjective monumental. It shows that the painter's knowledge of the work of Fra Filippo and Masaccio was strong enough to restrain him even in the midst of a nascent Baroque style and an essentially uncritical passion for the antique. In spite of the repainting (there is less here than elsewhere in the chapel) the color contributes to the effect, having a suitable sobriety and considerable harmony of cool tones. Here the medium stood Filippino in good stead, since in fresco he could not get such brilliance as occasionally becomes harshness in his tempera work. If the design has lost

[26] According to Peter Halm, these were derived from the monument of M. Antonius Lupus on the road to Ostia, which remained *in situ* until the seventeenth century. Drawings of the monument by Giuliano da Sangallo, Baldassare Peruzzi, and Antonio da Sangallo have come down to us. See "Das unvollendete Fresko des Filippino Lippi in Poggio a Caiano," *Mitteilungen des Kunsthistorischen Instituts in Florenz*, Heft VII, Band III, July 1931.

[27] The entrance to the chapel shows similar architecture, ascribed by Venturi to Giuliano da Maiano.

something in the transferring to plaster (a splendid drawing is preserved in the British Museum; Fig. 41) it is nevertheless a dignified, well arranged, and impressive composition.

The same cannot quite be said for the lunette above, in which Saint Thomas hears the words of the Crucified — "Bene scripsisti de me, Thoma." Starting with a really fine architectural setting — a series of arches on square piers richly decorated with arabesques and mosaic — Filippino fails to handle either the grouping of figures or the story with success. The setting, indeed, hints at the arrangement in Raphael's "School of Athens"; but where Raphael has disposed his characters so as to give prominence to the most important, Filippino represents the miracle over in one corner, and leaves the center of the stage to a charming baby and a woolly white dog — a group suggestive of Murillo. To the right, a young man,[28] heavily swathed in draperies, excitedly points out the miracle to a turbaned patriarch and two women; further to the left a startled Dominican hurries from the loggia in which kneels Saint Thomas, attended by two angels. The miraculous Crucifix is half hidden behind the pier from which it hangs. Under the central arch, which in the "School of Athens" is made so effective a frame for the two philosophers, we see only a Florentine youth who looks back dreamily over his shoulder.[29] Behind him rise crowded buildings, no doubt representing a section of medieval Rome.

Examining details of the fresco, one perceives that the arms and hands of the kneeling Saint Thomas are similar to those of the Saint Martin in the Santo Spirito altarpiece; so are the folds of the sleeves, regularly crinkled. Except for the fleeing monk and the young man addressing the spectators, the drapery is not unduly agitated. Nor is there overloading with ornament. The two women are fine serious figures; the child and barking puppy are so delightful that one forgives them their unbecoming prominence. Such genre touches become more exaggerated in the Strozzi frescoes; they offer parallels with many in Ghirlandaio's work. But Filippino is never so comfortably mundane as Ghirlandaio; always in his figures the restlessness of the body implies a similar unquietness of the spirit.

[28] Mengin identifies this scene as Saint Thomas taking leave of his parents (*Les Deux Lippi*, pp. 164–165). I do not find this altogether convincing.

[29] Mengin (p. 165) takes this to be Saint Thomas at the time when, having been taken from the Dominican convent in Naples by his parents, he was held prisoner in their castle of Rocca Secca. This again seems to me a little farfetched.

Filippino's fondness for the antique, far from spoiling the frescoes, manifests itself where it is least inappropriate, that is, very largely in the painted architectural enframements of the compositions. These as I have said include arabesques in which Roman bucrania are made use of; masks, garlands, griffins, and so on — such things as Vasari enumerates with the relish of a collector — are lavishly combined, occasionally with the introduction of a Christian motif such as a cross or a haloed cherub. In the article to which I have already referred,[30] Peter Halm thoroughly discusses the antique elements in the chapel. He draws an interesting parallel between a frieze from the Temple of Vespasian (now in the Capitoline) and the painted frieze above the "Triumph of Saint Thomas," in which Filippino has used Christian ceremonial accessories as the Roman sculptor employed the paraphernalia of pagan sacrifice.

The painted pilasters framing the altar wall are the most exuberant in archaeological detail. About halfway up occur horned and bearded male figures seated on the candelabra and supporting, back to back, simulated medallions sculptured in relief (Fig. 42). The attitudes of these figures are startlingly like those of some of Michelangelo's youthful masculine figures on the Sistine ceiling. The total effect of these decorations is overcrowded and none too pleasant; they are interesting chiefly as leaves from Filippino's antique scrapbook, and as work that the Carracci, a century later, might have understood and approved.

Of the lost east wall, with the battle of Virtues and Vices, we can form no clear picture, though it is not difficult to imagine what the individual figures may have been like. I have already remarked on the rarity of such subjects in the extant work of the painter; it is the irony of Fate that we should have lost both this important example and the presumed one of the Spedaletto. But of draped feminine forms there is no lack in the paintings which have been preserved, though the closest parallel in subject, the "Allegory of Music" in the Kaiser Friedrich, Berlin, is to be dated at least a decade later. The windblown draperies and fantastic coiffures of the women seen in the Strozzi chapel also afford a clue, although again these are some ten years later. Unluckily there seems to be no engraving based on the lost work,

[30] See Halm, "Das unvollendete Fresko."

Robetta's association with Filippino [31] apparently having been limited to Florence. Probably the general effect of the wall approached that of the Assumption in animation of movement and calligraphic line. This Baroque character may have shown Filippino's progressive qualities better than the frescoes of the opposite wall; we must however be grateful for the perhaps more conservative but finely monumental "Triumph" which the presence of Alexander's commemorative tablet may have been the means of preserving.

Such, then, is the work about which Filippino wrote so enthusiastically to his patron in Florence. Those who come to it with eyes unprejudiced by the usual generalization that the painter's stylistic decline began in Rome can scarcely fail to find in it (discounting, of course, the restoration) a work of power, originality, and real beauty. There is genuine monumentality in the "Triumph," the more effective for its sober color and the spaciousness afforded by Filippino's treatment of background and architectural setting. There is again power and movement, and a genuinely decorative sense, in the Assumption which anyone who appreciates the Baroque will find stimulating. To contrast it with the Brancacci frescoes and thereby to demonstrate its inferiority is to ignore all the elements of vigor and originality which were Filippino's own, deliberately renounced, for good reasons, in the Carmine. Why should not Raphael and Michelangelo have studied it with profit and admiration?

I have already cited Vasari's statement that Lorenzo de' Medici, disappointed in his efforts to obtain the body of Fra Filippo from the Spoletans, contented himself with commissioning Filippino to design a memorial to be placed in the Duomo of Spoleto. This, says Vasari, was done en route to Rome. The tablet, now in the right transept of the cathedral, bears no date; however, I think it probable that Filippino deferred this task until the return journey, perhaps making drawings for it while the Caraffa frescoes were under way. While we have no authority for the authorship of the memorial beyond the word of Vasari, the story is in itself plausible, and the style is acceptable as Filippino's.

The bones of the Frate had not, it would seem, enjoyed unbroken rest. The Carmelite Necrologium speaks of an impressive funeral — "Maximo honore in tumba marmorea ante portam mediam dictae ecclesiae sepul-

[31] For a further discussion of this, see below, Chapter X.

tus";[32] but a humbler burial seems to be referred to in the lines of the epitaph composed by Politian:

> Marmoreo tumulo medices Laurentius hic me
> Condidit ante humili pulvere tectus eram.

The way in which this is phrased might possibly mean that Lorenzo, by way of revenge aimed at the Spoletans for having refused to grant his request for the body, had Politian refer to the earlier burial as "a covering of lowly dust." But there are records to indicate that the Frate's burial place was shifted more than once [33] and that finally the actual bones were lost; so that Filippo really appears to have been in need of a suitable memorial.[34]

The marble tablet (Fig. 1) is placed near the frescoes which Fra Filippo did not live to finish. The epitaph composed by Politian is set in a frame suggesting a sarcophagus, embellished with panels and delicate arabesques in low relief, the details picked out in gold. Below is a section bordered by scroll-like curves framing a lovely vine pattern with birds. Bolder scrolls are to be seen at the top, with skulls and masks fitted into their curves. The whole is surmounted by a bust of Fra Filippo, in high relief, set in a circular frame with shell flutings. We do not know the sculptor; it was probably not Filippino, though I have little doubt that he furnished the design of the tablet as a whole.

A careful comparison of the details of the memorial with those in the Caraffa chapel does much to confirm this hypothesis. Note particularly the motif of a cross above a winged cherub's head (seen in the Caraffa chapel on the pilasters flanking the Annunciation, at Spoleto in the panels on either side of the epitaph). The masks in profile, set within the curves of the crowning member of each composition (i.e., above the Madonna Annunciate, Fig. 54, and above the epitaph), also echo one another. And although candelabra and arabesques tend to show a general family resemblance wherever found, the ones in these two cases could perfectly well have come from the same hand. In short, the Spoleto tablet is just the sort of thing we should expect Filippino to have designed while in Rome. He need not have delivered the design personally, any more than he would have to have taken his competition plan for the Duomo to Florence in 1491, but one assumes

[32] Fausti, "Le Pitture di Fra Filippo," p. 15.
[33] Fausti discusses these in his article.
[34] It would not have been in accordance with Lorenzo's notions of suitability to write "Si monumentum requiris, circumspice" in the Duomo!

that he stopped in Spoleto, partly perhaps to refresh his memory of his father's appearance as recorded in the fresco, partly to pay his respects at the Frate's grave, and, no doubt, to revisit old friends.

On May 14, 1491, Filippo Strozzi died, thus living to see neither his palace nor his chapel in the finished state. Apparently not even his tomb, the work of Benedetto da Maiano, was ready for him.[35] If Filippino was still in Rome at the time the news reached him, he must have felt serious qualms of conscience, and made, let us hope, all haste to finish the Caraffa frescoes in order to get back to Florence. Just when this may have taken place I shall discuss in the following chapter.

[35] It was still incomplete in that year, since Filippo's will (which seems to bear the same date as that of his death) reads, "Voglio e lascio che il mio corpo, quando io sarò passato di questa misera vita, si riponga nella chiesa di Santa Maria Novella di Firenze, e nella mia Cappella che è in detta Chiesa, e nella mia sepoltura che ha essere in detta cappella, se finita sarà detta sepoltura" (*Vita di Filippo Strozzi*, document C, pp. 63 ff.).

CHAPTER VI

FLORENCE: A PERIOD OF NEW EXPERIMENTS

THE decade which saw Filippino's return to Florence was one of important and tragic consequences for the city. Its opening found Savonarola established at San Marco, of which he had been elected prior in 1491. Lorenzo de' Medici died in the following year, as did Innocent VIII, whose successor, Alexander Borgia, proved to be no lover of Florence. In 1494 Piero, Lorenzo's heir, fled the city, and Charles VIII of France entered it on his triumphant progress southward; his brief visit was followed by the political confusion of the Interregnum, which lasted until the restoration of the Medici in 1512, eight years after Filippino's death. From 1494 to 1498 Savonarola pursued his dramatic career unhampered by Medici opposition, his fierce conflict with the pope leading to his excommunication, and his unabated efforts at reform culminating in the "Burning of the Vanities" in 1497 and 1498. After the execution of the fanatic Dominican the popular reaction seems to have led to conditions considerably worse than those against which he had inveighed so powerfully.

It is difficult to conceive of any artist's accomplishing work under such conditions. Only when we recall the chronic disturbances in the Italian communes — civil skirmishes and bitter family quarrels, if not warfare with neighboring towns — can we realize that *bottegas* continued to function, although public projects or undertakings on a large scale might be curtailed. Conditions were, however, worse in the nineties, in Florence, than they had been within the memory of any living citizen, and seem in themselves sufficient explanation for delayed or unfinished commissions, if not, indeed, for periods of complete inaction on the part of some painters. Small wonder, after all, if work in the Strozzi chapel was suspended while stones were flying in the streets, French soldiery quartered on Florentine citizens, and Savonarola thundering fire and brimstone from the pulpit of San Marco!

It is well known that the nearest we can come to a documented date for Filippino's return to Florence is the tablet in the Caraffa chapel commemo-

rating Alexander VI's visit in June 1493, and this is certainly a safe *terminus ad quem* for the frescoes. Alexander had been elevated to the papacy in August of the previous year. Now there is no particular reason why he should have set off posthaste to view the chapel on its completion; supposing it to have been finished some months earlier, he need not necessarily have gone at once to see it, or at any rate to make an official tour of inspection such as the inscription indicates.[1] Even though there seem to have been cordial relations between Cardinal Caraffa and Alexander,[2] it does not follow that a pontiff busy with newly assumed duties (and Heaven knows what more congenial occupations) would have been in haste to see a work of art so patently intended to glorify someone other than himself.

I have said that from the fall of 1488 till the spring of 1493 seems a generous allowance of time for the chapel; even that of the Strozzi, about equivalent in size, seems to most writers to have consumed no more than three years in the actual painting, and that while at least two good-sized altarpieces were under way.[3] On the other hand, if we accept Filippino's design in the competition for the Duomo façade (January 5, 1491) as indication that he was at home again, it leaves a scant two years, which, though possible, is not overgenerous, even with the assistance we know him to have employed.

Vasari says [4] that Lorenzo de' Medici commissioned Filippino to paint, at his villa at Poggio a Caiano, a fresco of "a sacrifice," which was never finished. This latest country seat of Lorenzo's, of which Giuliano da Sangallo was the architect,[5] was begun during the eighties, and occupied by 1491. It was one of Il Magnifico's dominating interests toward the end of his life.

[1] The winter months are, as every traveler knows, anything but satisfactory for the viewing of frescoes in Italian churches. The pope, of course, not being a modern scholar concerned with exact effects of color, might not have minded looking at the chapel by torch or candlelight.

[2] Witness the story of Caraffa's having taken the ring from the Holy (!) Father's finger and sealed with it the brief separating the Tuscan Dominicans from those of the north — an act favored by Savonarola. According to one of the old tales of Alexander's death by poison, it was Caraffa who was sent back to fetch the pyx with the Host which Alexander always carried and which he had omitted to bring to the banquet where — so the story goes — he drank by mistake the wine he had himself poisoned for his enemies.

[3] I.e., "The Marriage of Saint Catherine" in Bologna, 1501, and the "Madonna with Saints Stephen and John the Baptist," for Prato. The latter was not finished until 1503.

[4] Milanesi-Vasari, III, 474. He speaks of Lorenzo as "Lorenzo de'Medici," without the more specific title of "il Magnifico" or "il Vecchio," so he might conceivably have been thinking of another member of the family, such as Lorenzo di Pierfrancesco, Botticelli's patron.

[5] Christiano Huelson, *Il Libro di Giuliano da Sangallo, Codice Vaticano Barberiniano Latino, 4424* (Leipzig, 1910), and Stegmann and Geymüller, *Die Architektur der Renaissance in Toscana, dargestellt in den hervorragendsten Kirchen, Palästen, Villen, und Monumenten*, V (Munich, 1885-1908), 5 ff.

Politian celebrated it in his *Ambra,* and we read of Lorenzo's ambitions for a great vaulted ceiling, which was successfully carried out after Giuliano had experimented on a house of his own.[6] Nothing would be more natural than for him to have commissioned Filippino, that "alter Apelles" whom he had so warmly recommended to Cardinal Caraffa, to contribute part of the decoration of the new villa. We know of no documentary evidence beyond the statement of Vasari [7] to show that there was such a commission; but the fresco is still in place, at one end of a porch, unfinished, as Vasari describes it, and unmistakably by the hand of Filippino (Fig. 43). The Minerva frescoes had been a signal success, so that Lorenzo, who had admired Filippino's work even before the Roman period, would have had all the more reason to want something from his hand after his return, especially, perhaps, if he had heard rumors as to the painter's studies of the antique.

The fresco as it exists today shows a background of blue sky, cloud-streaked, with elaborate architecture and three figures sketchily indicated. The scene of sacrifice which was to fill the lower portion of the wall has not even been begun, beyond one unfinished figure at the extreme left. What has been done can hardly have taken much time, since a great deal of it is sky, which would have gone rapidly. Is it possible that Filippino was at work on this fresco in the spring of 1492? The winter climate of Florence and its environs is not such as to encourage out-of-door fresco painting, so that the artist would scarcely have met with suitable weather conditions earlier than February (although the cold mist which in winter settles over the Arno does not usually rise high above the actual river valley, and therefore would tend to spare Poggio a Caiano). If we suppose he began no later than March 1492 we may reasonably imagine the work to have progressed well toward its present state by the ninth of April, when Lorenzo died at Careggi. This would allow his return from Rome to have taken place as late as the winter of 1491, about a year after the Duomo competition, and would thus afford a full three years for the Caraffa chapel. Personally I think it quite likely

[6] Milanesi-Vasari, IV, 270–271. Vasari declares that Lorenzo preferred Giuliano's designs to those submitted by other architects.

[7] It seems likely that the biographer, writing less than half a century after Filippino's death, would have been correctly informed about a work of his done for Lorenzo, in whom Vasari naturally took a deep interest. What would have prevented his getting information from friends of Lorenzo's sons? Or possibly from one of the sons of Filippino? Or, again, from Pontormo, who worked at Poggio a Caiano in the Cinquecento for the Grand Duke Cosimo? Poggio a Caiano was one of the most important of the Medici residences in that century, and as such should have been well known to Vasari.

that Filippino did leave Rome in the fall or winter of 1491, and that on his return Lorenzo ordered the Poggio a Caiano decoration,[8] which probably was intended to include the whole wall surface of the porch.

It seems improbable that anyone other than Lorenzo should have commissioned a fresco for Poggio a Caiano during Filippino's lifetime. Clarice Orsini, Lorenzo's wife, died before him; Piero, his heir, was far more interested in games and wild company than in the arts, and Giuliano would have been too young, whereas Giovanni, the middle son, was presumably occupied by his office of cardinal. Furthermore, the banishment of the family in 1494 makes it most unlikely that decorative work would have been carried out at the villa after that date. It is conceivable that, since Poggio a Caiano is some distance from Florence, it may have been occupied during the exile by some members of the family, but these would have to have been outside the number of immediate relatives, and as to their whereabouts between 1494 and 1512 I am not informed. Lorenzo di Pierfrancesco, a member of the bar sinister branch of the family, and Botticelli's patron, seems to have taken over the villa of Castello. I venture to believe, in spite of the tendency of critics to date the Poggio a Caiano work after 1500,[9] that it was begun soon after Filippino's return from Rome, and then, not later than 1494, the year of the flight of Piero de' Medici and the invasion of the French, it was abruptly discontinued, never to be resumed.

Such a hypothesis must, for acceptance, be supported by the stylistic evidence of the painting itself, and here I know that I am running counter to learned opinion in proposing so early a date. Every critic who has gone into the question [10] has emphasized its likeness to the Strozzi chapel, which, whenever it was begun, bears the date 1502 as that of its completion. Only

[8] Dr. Scharf believes the commission was given in 1488, before Filippino went to Rome; see *Mitteilungen des Kunsthistorischen Instituts in Florenz*, Heft VIII, Band III, January 1932, p. 532. If so, it is surprising that Lorenzo should almost immediately have recommended the painter to Cardinal Caraffa. Of course, if Filippino stayed in Rome until 1493, Lorenzo must almost inevitably have ordered the "Sacrifice" not later than 1488, and this is possible even if the painter returned to Florence before Lorenzo's death. The latter may have accepted the delay necessitated by the Minerva frescoes, out of characteristic willingness to further the fortunes and reputation of a distinguished artist.

[9] My one supporter in this theory (so far as I know) is Bernhard Patzak, who says, "Der Tod Lorenzos im Jahre 1492 hat offenbar der baldigen weiteren Ausmalung der Villa Poggio a Caiano ein plötzliches Zeil gesetzt" (*Die Renaissance- und Barock-villa in Italien*, Band II, Leipzig, 1913, p. 118). However, this author is interested primarily in the architecture; he even sounds as though he were not quite clear as to whether he is dealing with Filippo *père* or *fils*.

[10] This includes the most recent writers, Drs. Halm and Scharf, *Mitteilungen des Kunsthistorischen Instituts in Florenz*, July 1931, and January 1932.

within the last few years has the fresco been given thorough study, although at the end of the last century it was reproduced, without comment, in an architectural publication.[11] I admit the similarities between the Strozzi and Poggio a Caiano frescoes, but I hope to show that the latter has equally strong affinities with the work in Santa Maria sopra Minerva.

The content of the fresco may be seen in the illustration (Fig. 43). As I have said, this consists chiefly of architectural background, which offers a rich and elaborately detailed combination of classical and pseudo-classical elements, yet does not lack monumentality of effect. In color it is mainly monochrome; a rather warm grey predominates, contrasting agreeably with the blue of the sky.

Two drawings for this fresco,[12] preserved respectively in the Uffizi and in the Koenigs collection, Haarlem (Fig. 44), show how the general design was planned, and prove that the "sacrifice" mentioned by Vasari was to have been that of Laocoön. As Berenson pointed out years ago, this is of special interest because the famous sculptured Laocoön group of antiquity had not yet come to light.[13] Of the two sketches the Haarlem version is closer to the unfinished fresco than is the Uffizi drawing, although neither corresponds exactly to the mural as far as it was carried out.

The architecture of the Haarlem sketch is more impressive than that of the finished fresco. To the right is a temple like a great *baldacchino*, showing an entablature raised on Ionic columns and surmounted by a low dome and lantern. The structure to the left, on the roof of which stand figures comparable to those in the fresco, is a palace-like building with a great pilaster order supporting an entablature and having between each pair of pilasters a

[11] Stegmann and Geymüller, Plate 7b. The illustration is too dark and dim to be very useful.

[12] For a study of the Haarlem drawing, see Peter Halm, in *Mitteilungen des Kunsthistorischen Instituts in Florenz*, July 1931; the Uffizi sketch (Cat. II, no. 169; Berenson no. 1294) was discussed by Dr. Scharf in the *Mitteilungen* of January 1932.

[13] It was discovered after Filippino's death, in 1506. Dr. Scharf (*Mitteilungen*, January 1932) suggests that the incident of the death of Laocoön's sons, omitted in the Haarlem sketch, but present in the Uffizi version, might have been intended as the subject of a fresco on the opposite side of the porch. Such a pendant to the Laocoön scene would certainly be desirable in the interests of symmetrical design.

The sketch of the "Dying Meleager," published by Berenson as a Filippino (*Old Master Drawings*, December 1933) and suggested by him as a rejected subject for the porch, I cannot, as I have already remarked, unquestioningly accept as Filippino's. At best it seems to me to be the work of a none too gifted assistant. Miss Agnes Mongan suggests that the reversed figure borrowed from Filippino's drawing of witches in the Uffizi (no. 203, cornice 54; Berenson no. 1300) may mean that his Meleager sketch was intended for the use of an engraver. It may be based on some lost original of Filippino's, but it seems altogether too weak and slipshod to be the master's own.

round-headed window crowned by a pediment. This almost anticipates Michelangelo's design for the twin palaces of the Campidoglio, and it certainly has much of the massive severity of Bramante's Roman work, which Filippino probably never saw. The Uffizi sketch shows an open temple hall, with ruins to the left, less effectively related to the figures than in the Haarlem study, which makes good use of the *tempietto* to frame the tortured Laocoön at his altar. Doubtless a similar arrangement was planned for the fresco; but as in the case of the Minerva "Triumph of Saint Thomas," some of the power and unity of the sketch has been lost in transferring the design to the wall. Apparently Filippino, once embarked upon the final work, became fascinated by details, and lost sight of the broader effect of the whole, which he had so well envisaged in a rapid sketch.

There is little in the Poggio a Caiano fresco to compare with the work in Santa Maria Novella except the architecture, which offers various analogies. Especially is one struck by the columns to the left in the former work, fluted halfway up and then embellished with delicate vine patterns. These are in general much like those flanking the window in the Strozzi chapel (Fig. 45); in both cases the columns stand out *en ressaut*, as suggested no doubt by Roman prototypes such as those of the Arch of Constantine. A comparison of the Laocoön drawings with Filippino's brilliant sketch for the "Raising of Drusiana" in Santa Maria Novella shows equally striking similarities. Allowing, for example, for the restorations in the Haarlem drawing, its style seems certainly close to that of the Drusiana study; note particularly the small human figures rendered with a quick oval line for the head and half a dozen rapid touches to indicate bending and turning bodies — admirable "gesture drawing." In the Drusiana sketch two of these figures lean out of an upper loggia or balcony, as they do from the roof of a building in the Haarlem drawing; but this Venetian-looking motif was abandoned in the finished Strozzi fresco. It is, on the other hand, a striking feature in the Minerva "Triumph of Saint Thomas." Compare, further, the British Museum sketch for this fresco. Again, discounting the softened effect of the retouched Haarlem sheet (this is limited to the figures and does not involve the architecture), is there any real objection to placing them within a few years of each other? The lightly indicated columns, for example, are almost identical, although the Minerva drawing shows supporting arches instead of entablatures. I see no reason why the Laocoön studies should not have

been made, if not actually in Rome, at least not long after Filippino got back to Florence.

Another point in favor of this earlier date lies in the crowning motif of fruit basket and sea horses (?), combined with slender chains and profile masks, in the finished portion of the Poggio fresco. This is enough like the enframement of the Minerva Annunciation to persuade me of a close relationship in time, and this conclusion receives support from the design of Fra Filippo's memorial tablet in Spoleto, which is a variation of the same theme, substituting the bust of the monk for the fruit basket. If it be objected that the tablet is not definitely by Filippino, I would reply that the closest analogies lie between the Minerva and Poggio frescoes, which, on the other hand, tend to confirm the attribution of the memorial to Filippino. One may note in passing that the shell occurs both at Spoleto and at Poggio — in the former case behind the bust, in the latter as a background for sea deities. Would that we had one of those Virtues and Vices of the Caraffa chapel to compare with the ghostly Praxitelean maiden painted as a bas-relief between the fluted columns at Poggio!

Perhaps one may go one step further in the analysis of the problem and suggest that the sketch for the "Raising of Drusiana" may, since it is so similar to the Laocoön drawings, have been drawn some years earlier than is generally believed. For it is also close, in quality, to the Saint Thomas drawing of the British Museum, though more rapid in execution. Observe, too, that the Drusiana fresco was, according to the sketch, first planned with a strong central accent of architecture — a kind of loggia seen in perspective, with a coffered barrel vault indicated.[14] What is this but a reworking of the setting in the "Bene Scripsisti" fresco? I have mentioned the figures leaning out from an upper story, exactly as they do in the Minerva and Haarlem drawings. The architecture to the right in the Saint Thomas sketch is reflected in that of the Drusiana study. Now this architectural setting is entirely modified in the finished fresco of Drusiana's resurrection, in which Filippino repeats only the central and right-hand groups, with minor variations from the drawing. As in the "Triumph," the consequence is loss of emphasis and monumentality. Indeed, the impression of diffusion and

[14] This is so like the architectural arrangement of the "School of Athens" as to startle one into the suspicion that Raphael knew it. Even a statue in a niche is similarly placed in both, beside the loggia in each case.

confusion we get from the Drusiana fresco is, I think, largely due to this very fact; the *tempietto* to the left and the ornate gateway to the right constantly tend to draw the eye away from the central group of figures, which are well emphasized by the architectural centralization in the sketch. Filippino may have made this change because he wished to avoid the monotony of repeating on the left-hand wall of the chapel [15] the strong central accent of architecture he had already introduced in the "Miracle of Saint Philip" opposite. Whatever his reason for rejecting the ideas in the sketch, the results show him to have made an error in aesthetic judgment.

It seems to me clear that the Drusiana study must have been made with the Caraffa chapel still vividly in the mind of the painter; and, while I do not suggest that he drew it while still in Rome, I do believe that it dates some time, perhaps several years, before the fresco itself was begun. There can surely be no question that Filippino was at work on such designs in the nineties, although most of these, including no doubt the earliest ones, have disappeared.

It may be objected that the architecture indicated in the porch fresco and its preparatory drawings is frankly too late in style to have been designed in 1492–1494. A comparison of all three with architectural drawings and actual buildings of the late Quattrocento gives satisfactory evidence, I think, that such a date is admissible. The studies of Giuliano da Sangallo, for example (he went to Naples in 1488–89, after finishing his direction of Poggio a Caiano, and had been in Rome even earlier, about 1465),[16] are no less advanced; and, moreover, the motifs seen in Filippino's work, as in Giuliano's, may be accounted for by Roman remains plus a lively power of invention. One of Piranesi's engravings [17] is enough like Filippino's Poggio fresco and the related Uffizi drawing for the latter to have based his design on a sketch taken from the same spot. One Renaissance building which comes to mind in this connection is the Palazzo Cancelleria, now generally believed, I think, to have been begun in the eighties. However, the detail which it shares with the Laocoön architecture is the arrangement of roundels or medallions in the spandrels; in the latter case on the arch to the left, in the former, spanning each window on the exterior. This is a simple decorative

[15] The last one painted, since it is this one he signs and dates 1502.

[16] Christiano Huelson, *Il Libro di Giuliano da Sangallo*, and Stegmann and Geymüller, V, 5 ff.

[17] Arthur M. Hind, *Giovanni Battista Piranesi* (London, 1922), Plate LI, forum of Nerva. See also Plate XXVI, frieze of the temple of Vespasian, which sculpture Filippino must have known.

form such as Filippino may have thought of as easily as anyone else; in fact, he used it in the New York sketch for the Corsini *tondo*. It is not uncommon in north Italian architecture of about this time, especially in Venice. It is also conceivable that, if the Cancelleria had not progressed far enough, when Filippino left Rome, for him to have observed its details, he might still have seen drawings by the architect, who appears to have been a pupil of Alberti's. Since Giuliano da Sangallo was in Rome before 1490, it may have been through him that such an opportunity for the study of designs was brought about.

I have already mentioned the interesting way in which the building to the left in the "Triumph of Saint Thomas" (i.e., in the fresco) anticipates Bramante's cloisters of Santa Maria della Pace, built in 1504 and therefore impossible for Filippino ever to have seen, since he died in that year. Here again the dignified simplicity of the painter's work may be ascribed to the same cause underlying Bramante's austere Roman style: the study of ancient buildings such as the Coliseum. This largeness of conception characterizes the architecture in both the preparatory studies for the Laocoön. Such terms will not, however, apply to the Poggio a Caiano fresco itself. Here the painter is carried away by his enthusiasm for detail, which is almost Rococo in character, a blend of lively fancy and antique motifs executed *scherzando*. The resulting effect suggests the admixture of yet another element — the influence of Lombard Renaissance architecture. So far as we know, Filippino never saw Milan himself, but in 1492–93 Giuliano da Sangallo made a trip thither,[18] and in the following year began a systematic collection of his drawings. He is of all Florentine architects the most likely to have exchanged ideas with Filippino, concerned as he was with Poggio a Caiano, and later as one of the architects of the Strozzi palace. The Lombard Renaissance flavor is strongest in Filippino's Strozzi frescoes, but there are reminiscences of it at Poggio; not, be it noted, in either of the Laocoön drawings. Might this mean that Giuliano's Lombard sketches stimulated Filippino's imagination as he was engaged on what there is of the fresco, in the months immediately following Lorenzo de' Medici's death? However this may be, I think it highly likely that for the Strozzi chapel Filippino took suggestions from such designs for Giuliano's.

Between 1493 and 1495 the documents are silent as regards paintings by

[18] This and further information about Giuliano da Sangallo I have taken from Huelson.

Filippino. Vasari, to be sure, says [19] that he painted the ceiling of the
Strozzi chapel immediately on his return from Rome, but was then sent for
a second time by Cardinal Caraffa in order to design that dignitary's tomb,
and a "cappellino" elsewhere in the church, in which undertaking he again
had the assistance of Raffaellino del Garbo. No one seems to believe this
story, for which there is no other evidence either documentary or circum-
stantial. Such activity would fill an otherwise chiefly blank period in the
painter's career, but I share the prevailing opinion that Vasari's notes, or
memory, were playing him false. That he was confused about the Minerva
frescoes is made more apparent when he goes on to name the committee who
valued the work ("maestro Lanzilago padoano, e . . . Antonio detto
Antoniasso romano") and the amount of their estimate, "duemila ducati
d'oro, senza le spese degli azzurri e de'garzoni." This must refer to the
original Caraffa chapel rather than to a probably mythical tomb and
stucco-work, which Vasari gives us to understand was what Antoniazzo
and Lanzilago were called upon to value.

I have said that the political condition of Florence in the nineties is
enough to account for periods of artistic inactivity, and it is quite possible
that Filippino's work was temporarily suspended, although I personally
suspect that before 1494 he was busy at Poggio a Caiano. The deficiency in
documents can, however, be supplied in one interesting detail. In spite of
the disturbances following Lorenzo's death and the rise of Savonarola, the
firm of Strozzi and Company, only three months before the flight of Piero
the Unfortunate, indicated "business as usual" by paying Filippino a fresh
instalment on the chapel frescoes, for in August 1494 he acknowledges the
receipt of 29 florins, 8 soldi, and 2 denarii "a oro di sugello, in fiorini trenta
d'oro in oro, da mona Selvaggia vedova, e donna fu di Filippo Strozzi,
tutrice de' pupilli; e per lei da Carlo Strozzi e Compagni, e per detta cap-
pella finire." [20] It seems from this that the painter must surely have given
some evidence of progress at this date; the use of the word "finire" implies
as much, as well as the mere fact of payment. Incidentally, it would be in-
teresting to know just what the phrase "tutrice de' pupilli" indicates as to
the activities of Signora Strozzi.

In the following spring (March 5, 1495) the monks of the Certosa di
Pavia ordered an altarpiece from Filippino, whose fame was evidently

[19] Milanesi-Vasari, III, 469–471. [20] *Vita di Filippo Strozzi*, Document B, pp. 60 ff.

spreading far afield, partly, no doubt, in this case as a result of the letter of Lodovico Sforza's agent, which must have been written some time before this year. This altarpiece was to contain a Pietà with Saints Paul (the Hermit) and Anthony Abbot. That the picture was never finished is indicated by the fact that on June 25, 1511, the monks made a fresh contract, this time with Mariotto Albertinelli, for an altarpiece of the same subject. At the time of the commission to Filippino, a second altarpiece was ordered, from Perugino; this, a polyptych,[21] was completed after a long delay.[22]

A letter dated October 10, 1496,[23] and written by "Jacopo d' Antonio legnaiuolo" from Santa Maria in Campo, Florence, to Frate Girolamo at the Certosa, is a reply to complaints from Pavia about the delayed panels, which, the writer indicates, would have been finished if the promised funds had been sent. Payment evidently did no good, for on May 1, 1499, a second letter was dispatched, this time from Milan, complaining that the painters had been given their money but that no pictures had resulted, and declaring that if the work were not duly finished by the end of the period previously specified (but not stated in the letter) the painters would be expected to return the money.

Perugino ultimately, as we know, fulfilled his contract with the "Madonna with Archangels," for the chapel of Saint Michael. As for Filippino's, there exist three drawings for Pietàs, one in the Louvre, the others now in the Fogg Museum, which obtained them as part of the bequest of the late Charles A. Loeser (Figs. 46 and 47). All three, as Dr. Scharf has pointed out,[24] seem to be studies for the Certosa altarpiece. Of the three the Louvre sketch is probably the earliest, the Loeser drawings being more elaborately worked out. It contains only the bare essentials — Christ on the knees of his mother, and Saints Paul and Anthony. Next in point of elaboration and perhaps chronology is the Loeser drawing in which two delightfully animated angels are introduced above and another pair kneel beside the Virgin to help support her burden (Fig. 46). Both this and the second Loeser

[21] Three panels of this — the Madonna and two archangels — are now in the National Gallery in London.

[22] See L. Fumi, "Pietro Perugino e il quadro nella cappella di San Michele della Certosa di Pavia," *Bollettino della regia deputazione di storia patria per l'Umbria*, XIV (1908), 97.

[23] Fumi, in *Bollettino*, XIV (1908), 97.

[24] *Jahrbuch der Preussischen Kunstsammlungen*, 1931, LII, 201 ff., "Studien zu einigen Spätwerken des Filippino Lippi." Berenson made the same suggestion years ago; cf. his *Drawings of the Florentine Painters*, II, 74, no. 1360.

sketch (on the reverse of the same sheet) show a composition higher than its width, whereas in the Paris drawing the paper stops just above the line of the heads, producing a design in a wide rectangle. It is interesting to see Filippino reviving the familiar motif of the flying angels used some ten years earlier in the Signoria altarpiece.

The second Loeser drawing (Fig. 47) differs from the first most strikingly in its introduction of architecture. The flying angels are omitted, and in their place is introduced a stairway with figures, framed under round arches. Saints Paul the Hermit and Anthony Abbot now kneel; two different poses for the Madonna's head have been tried. The assistant angels are retained. In both these drawings the group of the Madonna and the Saviour are prophetic of Michelangelo's early Pietà in Saint Peter's.

Once again I would point out the effectiveness of the architectural setting, a characteristic in Filippino's work seen during and after the Roman period. Dr. Bodmer has indicated, in a study of the painter's later style,[25] his increasing tendency to conceive figures in relation to surrounding space and architectural background, which characterizes the post-Roman period and is so clearly Cinquecento in its nature. Here as in the Minerva frescoes, the drawing for the Strozzi Drusiana, and, I think, the Bologna "Marriage of Saint Catherine," we have to do with figures in a three-dimensional enclosed space, with emphasis on the architectural perspective by means of which this space is insisted upon and made credible. There is an interplay of planes, rather than a series of parallel planes superimposed as in characteristic design in the Quattrocento. Such an attempt to convey a sense of the third dimension was hinted at in Filippino's work as far back as the Uffizi "Madonna and Saints" of 1486; but if one compares the later works just listed with, say, the Santo Spirito altarpiece which I have dated c. 1487, one sees that the architecture in the latter is merely a screen, parallel to the plane of the picture, and providing openings through which, after the Flemish fashion, bits of landscape can be seen. There is, as it were, no middle distance, only "near" and "far," and no space exists between the figures and the loggia behind them. This circumstance encourages me in the belief that the Santo Spirito altarpiece belongs to the pre-Roman period.

It is possible that the staircase over an arch in the second Loeser drawing may have been suggested by Leonardo's unfinished Epiphany of 1483

[25] *Pantheon*, April 1932, pp. 126 ff., "Der Spätstil des Filippino Lippi."

(Fig. 51), with which Filippino was directly concerned in 1495 (the probable year of the Pietà studies), having been asked to fulfill the former's abandoned contract for that panel.

It is much to be regretted that the Pietà was never carried out, not only because of the beauty of which the sketches give promise — the subject is one which we should expect Filippino to have handled in his most sympathetic manner — but because we have thereby missed another datable picture to place between the Minerva frescoes and the Epiphany of 1496, where a dated work is badly needed. Since, however, the latter panel was finished in March 1496, it may have been the chief reason why the Certosa altarpiece was put off, inasmuch as execution of the Epiphany would have taken place chiefly in 1495.

Unfortunately there is no certainty about the date of the panel (number 1074, formerly number 1008) in the Alte Pinakothek in Munich (Fig. 48). This has been taken to be the painting ordered from Domenico Ghirlandaio on June 25, 1491, by the monks of Zoccolo del Palco near Prato. Stylistically it seems to belong to about the year 1495.[26] It is believed to have come from Prato, and perhaps from the Palco monastery, which was suppressed in 1785.[27] Some time between 1814 and 1816 it was bought in Florence for the collection of King Ludwig I of Bavaria, whence it passed, in 1850, into the State collection.

The question is complicated by the record of a commission dated August 20, 1490,[28] in which Francesco del Vernaccia orders from Domenico and David Ghirlandaio a panel for the Palco monks, to contain Our Lady with Saints Francis, Bonaventura, Anthony of Padua, and Bernardino of Siena, with seven half-figures in the predella, the price to be thirty-five florins "in oro larghi." On December 17, 1492, David Ghirlandaio recèived the final payment for this in his brother's name. Milanesi says that unless the picture in question is Berlin 84 it has been lost; at any rate, two panels seem to have been ordered for the monks.

If the payment of December 1492 was really a final one, it seems reasonably certain that the picture was finished at that date. It has been argued that, as the description of this panel fails to correspond with the Munich

[26] Bodmer dates this c. 1498, and calls it "Christ appearing to the Magdalen." The subject is usually identified as Christ appearing to his mother.

[27] Milanesi-Vasari, III, 465, n. 3. [28] Milanesi-Vasari, III, 465–466, n. 3.

Filippino, the latter cannot be the one ordered of Ghirlandaio in 1491, which is obvious enough. There are, to be sure, seven half-length figures in the predella, not counting the angel supporting the dead body of Christ in the tomb, but otherwise there is no connection whatever. But if, as Milanesi believed, the "Madonna and Four Saints" was actually the one ordered in 1490, then the Munich panel might still be the one commissioned in 1491, although it is not easy to see why poor monks should have expected to get two good-sized altarpieces within some five years.

On the other hand, the Munich picture may have had nothing whatever to do with the Palco monks. The fact that it passed for some years as a Ghirlandaio may have led directly to the confusion as to the documents. I prefer to treat it apart from any question of Ghirlandaio's commissions of 1490 and 1491 and base my judgment on the picture itself, since the documents cannot be proved to refer to it.

The panel has been variously attributed: to Ghirlandaio, as I have said, and later to Filippino, which is its present designation in the gallery. Morelli [29] ascribed it to Raffaellino del Garbo; Berenson, after omitting it from his earlier list, now calls it Filippino in part. To me it seems clear that, while the design is Filippino's, much of the execution is due to the hand of an assistant. The pose and expression of Christ are such as one finds in other works of the nineties (the yearning upturned eyes are particularly characteristic of the period, though the tendency goes back to the Badia Saint Bernard); [30] the nervous, tumbled drapery, falling on the ground in rectangular folds, is his also, and so in general is the landscape, with small figures in the middle distance. There is a hint of Umbria in the low horizon and general feeling of spaciousness. The color is also fairly typical. In the drawing and general texture, however, one feels a hardness and heaviness quite unlike Filippino. The hands and feet are coarse; the type of the Madonna heavy and dull, lacking the psychological sensitiveness so characteristic of Filippino throughout his life. The Virgin's drapery falls in folds clumsy and exaggerated even for Filippino's restless later style; the vivid orange-yellow lining of the mantle is garish and out of key.

[29] *Italian Painters: Critical Studies of Their Works*, II (London, 1893), 97.

[30] Wernher Meinhof, in *Repertorium für Kunstwissenschaft* (vol. LIII, no. 3, 1931, pp. 118 ff.), discusses the possible influence on this painting of Leonardo's Saint Jerome now in the Vatican. He thinks Filippino may have seen the Saint Jerome about 1495, when he was painting his Adoration of the Magi to replace Leonardo's unfinished panel.

Now all these non-Filippinesque qualities are precisely those which characterize a panel hanging on the same wall in the Munich gallery: the "Pietà" (number HC. 801, formerly 1009) labeled Raffaellino del Garbo (Fig. 49). Once called a Filippino, this is now almost universally accepted as a highly characteristic work of Raffaellino's. After prolonged study and comparison of the two I cannot escape the conclusion that he was the assistant in the "Appearance of Christ," and that he took over certain details of that panel for subsequent use in the Pietà. Chief among these are the attitude of Our Lord, which is repeated, though reversed, in the Magdalen of the Pietà; the rather coarse type of the Virgin (coarse, that is, in contrast to Filippino's frail Madonna faces); and perhaps to some extent the land-scape.[31] If Garbo was the assistant, the Munich "Appearance" is the only example of an altarpiece now extant (to the best of my knowledge) in which we can, on the basis of style, recognize the two painters working together.

The predella of the "Appearance" is now accepted by Berenson as Filippino's. I cannot agree with this opinion; while the design is probably his, I question whether he did any of the actual painting. The assistant here does not seem to have been Garbo, but someone more old-fashioned in manner, with something of the dull, perfunctory character of Cosimo Rosselli.

As we approach the study of the first dated panel of the nineties, it will be well to make a few general remarks as to the state of Filippino's artistic ideas about the middle of the decade. I also wish to explain why I have taken the year 1497 as the apparent terminus of a period of the painter's career.

A generalization commonly made is that which asserts that Filippino came back from Rome with his head so full of antiques that he could paint nothing else. The Epiphany of 1496 shows how far this is from being true. As a matter of fact, the full flowering of his archaeological studies was post-poned until the end of the century — not earlier than 1497 — when he did most of the work in the Strozzi chapel. In the years just before this time he underwent various influences of other sorts, not all of them encountered for the first time, but now having a fuller effect on his mature style. The re-sults, I think, show him to have been less an eclectic and a follower of con-

[31] Other elements, such as the evident influence of Perugino, enter into the Pietà; these I shall speak of in Chapter IX.

temporary fashion than a genuinely open-minded painter, interested in and able to profit by significant achievements of his fellow-artists which they had been developing during his absence in Rome. This tendency to experiment goes far to account for the difficulty in dating exactly pictures which belong to the late period but which sometimes show such opposite characteristics that they refuse to form a logical sequence.

The influences which temporarily diverted Filippino's interest from ancient Rome were, in the first place, that of Leonardo; [32] in the second, that of Flemish painting; and in the third, that of the painter's fascinating contemporary, Piero di Cosimo, whose own interest in northern painting largely accounts, I believe, for Filippino's revived enthusiasm for it.

Apparently these new currents of influence affected Filippino simultaneously, though we find him giving preference now to one, now to another. The most striking example of this coexistence is the Epiphany of 1496 (Fig. 50), which I take as the core of what I have called the period of experiment. With the Copenhagen panel of 1497 (Fig. 65) the painter settles down to the manner characteristic of the Strozzi frescoes, as there are further dated works to prove; hence I choose that year as the dividing line between two phases of his career.

The "Adoration of the Magi" (Uffizi, number 1257) is not only signed and dated but heavily documented, [33] so that one's studies in regard to it

[32] Leonardo's influence has been noted in the pre-Roman work as well, but I believe it exerted its fullest force in the mid-nineties. Cf. Meinhof, in *Repertorium*, vol. LIII, no. 3, 1931, pp. 118 ff.

[33] See especially Mesnil, *Rivista d'arte*, May–June 1906, pp. 100–102, and Poggi, *Rivista d'arte*, VII (1910), 98 ff. The facts relating to the San Donato commission are briefly as follows:

On August 25, 1479, a certain Simone di Antonio Pieri, father of one of the monks of San Donato, gave to that monastery a piece of land in Val d'Elsa on condition that after his death a third of the property be sold to pay for a picture to be hung over the high altar in the church of San Donato. When Simone died, soon after this, the monks commissioned Leonardo, in 1481, to paint an "Adoration of the Magi." As this was left unfinished when Leonardo went to Milan a year or two later, the commission was transferred to Filippino, presumably in 1495. The archives of the monastery show that on March 29, 1496 (the exact date written on the panel itself), "Baccino intagliatore de lengiame [*legname*]" received two gold florins ("d'oro innoro larghi"), and he was again paid on April 1 of the same year, "per fattura e fornitura delle cholonne sono alla tavola da altare grande co chapitagli e base" (Mesnil). On April 8 of the same year the monks agreed to sell a third of the property given them by Simone "per soddisfare Filippino Lippi dei 300 fiorini, prezzo della tavola dipinta per l'altare maggiore della loro chiesa"; and on May 2, 1496, Filippino signed the receipt for payment in full.

Antonio Billi mentions the picture, which he probably saw in San Donato, his book having been written some years before the destruction of that church in 1529; cf. Carl Frey, *Il Libro di Antonio Billi esistente in due copie nella Biblioteca Nazionale di Firenze*, printed in 1510; see the republication edited by Mussini and Piaggio (Florence, 1863). Vasari mentions it in the first edition of the *Vite*, printed twenty-one years after the demolition of the church, but does not give the whereabouts of the panel at that time. Later it is listed in the inventory of Cardinal Carlo de'Medici, son of the

are to be concentrated solely on an analysis of the style. An inscription on the back of the panel reads, "Filippus me pinxit de Lipis florentinus addì 29 di marzo 1496." It was ordered for the high altar of the church of San Donato a Scopeto, outside of Florence, to take the place of the painting of the same subject ordered in 1481 from Leonardo, who never got beyond the underpainting.

Critics are not agreed as to whether the unfinished Adoration by Leonardo (Fig. 51) is the one he began for San Donato; Poggi,[34] for example, is inclined to think that Filippino painted directly over Leonardo's panel, and that the monochrome in the Uffizi is a different one. Personally, I think it more likely that the latter picture is actually the one abandoned by Leonardo, and that Filippino made a fresh start.

In either case what cannot be denied is Filippino's knowledge of the Uffizi Leonardo.[35] The panels are very nearly of the same dimensions. In general Filippino has taken over Leonardo's [36] composition, with the triangular group formed by the Madonna and two kneeling kings; the figures to left and right correspond roughly, particularly those standing at the right. Details such as the youth raising his right hand, further back and to the right, are taken directly from Leonardo. At the same time Filippino has shown independence — for example, by reversing the position of Saint Joseph, who, with the two figures behind him and higher up, leads to the apex of a larger triangle in which the central one, with the Madonna as its apex, is included.

Leonardo's influence is here limited to composition and such details of

Grand Duke Ferdinand I, who died June 17, 1666; the painter is given as "Fra Filippo Lippi carmelitano," a natural enough mistake in view of the signature. After the cardinal's death the panel passed into the Uffizi.

[34] *Rivista d'arte*, VII (1910).

[35] If Filippino did carry out his picture on the actual underpainting of Leonardo, that unfinished original must have been much like the monochrome preserved in the Uffizi; but I find it impossible to accept the theory that he painted directly on a panel of Leonardo's.

[36] Is it fantastic to see in this masterpiece of Leonardo's evidence that he took suggestions for it from the Portinari altarpiece? I know that that magnificent Flemish picture has been made to play a perhaps exaggerated rôle in the formation of late Quattrocento painting, but in this case, especially as one studies the earlier, more traditional designs for the Epiphany as Leonardo planned his altarpiece, there is a haunting suspicion that it may have been just the van der Goes which awoke in Leonardo his final inspiration. There is the same deep triangle in both, emphasized by the minor triangles at each corner (angels in the Portinari, kings in the Leonardo), and the tall figure of Saint Joseph in the former is vaguely echoed in the brooding old man to the extreme left in Epiphany. Beyond these suggestions, which have to do strictly with composition, comparison of the two panels simply serves to show how fundamentally different were the two painters' points of view.

gesture as I have mentioned. Filippino's own characteristics are recognizable, first, in the Madonna type, which is little changed from that of Santo Spirito or even the Virgin for the Sala del Consiglio, except that the features tend to be smaller and more pointed. The "lunging" attitude of the Child is a variation on that of the Strozzi-Bache or Consiglio (i.e., Uffizi) panels. It is interesting to see Filippino clinging to his own Madonna type in spite of the fascinating novelty and beauty of Leonardo's. The young king kneeling in the foreground [37] is typical in attitude and sentiment; he is spiritually akin to the Christ of the Munich panel. The figure with the astrolabe, kneeling at the extreme left, is said to be a portrait of Pierfrancesco de' Medici [38] — long since dead — a member of the bar sinister branch of the family and one, incidentally, whom it would not, presumably, have been undiplomatic to introduce in a picture painted during the exile of Il Magnifico's heirs. The finely painted head shows that Filippino had lost none of his powers as a portraitist. The position, kneeling on one knee, the other turned toward the spectator, recalls that of the Munich Christ. Hardly less vivid is the head of the man standing to the right, his hand raised in a typical Filippinesque gesture.[39] The boy kneeling on a ledge of masonry, with his head turned away, seems to have been introduced primarily as a study in *contrapposto*.

One of the striking features of the picture is the almost total lack of classical elements. Fragments of an entablature with rather simple mouldings lie on the ground; one of these shows a frieze with figures, sketchily drawn. But the "stable" of Bethlehem is a rough lean-to roof covered with scanty thatch and supported partly by the trunk of a dead tree, partly on a ruinous piece of masonry wall having only the barest suggestion of a moulded cornice below the springing of an unornamented arch. Nearly a decade earlier Ghirlandaio, while frankly borrowing from the Portinari altarpiece (in which the architecture is Gothic), had managed to make classical accessories

[37] A drawing for the head of this figure is in the Uffizi; a study of a kneeling figure (no. 1670 in the same collection) may also be related to it, although Berenson is inclined to date it earlier.

[38] "Vi ritrasse, in figura d'uno astrologo che ha in mano un quadrante, Pier Francesco vecchio de'Medici, figliuolo di Lorenzo di Bicci, e similmente Giovanni, padre del signor Giovanni de'Medici, e un altro Pier Francesco di esso signor Giovanni fratello, ed altri segnalati personaggi" (Milanesi-Vasari, III, 473).

[39] A wash drawing for this is preserved in the Ambrosiana library, Milan. Dr. Scharf has published a sketch, in the Berlin Kupferstichkabinett, of a beardless head, undoubtedly a study for the left-hand king in the altarpiece; in the painting he has been given a beard. See *Berliner Museen*, Jahrgang LI, Heft 6, 1930, pp. 145–147, "Eine Pinselzeichnung Filippino Lippis im Berliner Kupferstichkabinett"; illustration, p. 146, Fig. 2.

dominant features of his Santa Trinità "Adoration of the Shepherds." Filippino, supposed to have had little except antique motifs in his head, turned out an altarpiece far more closely akin to Hugo van der Goes in feeling and detail, even allowing for the famous shepherds in Ghirlandaio's picture.

This Flemish flavor is apparent very specifically in the turbaned head in the background at the extreme left, behind the fair-haired attendant who hands the youngest king a jeweled chalice. The turban wrapped tight above the high forehead looks like an adaptation of Saint Margaret's headdress in the Portinari altarpiece (Fig. 52). Such a head taken out of its context would scarcely be identified as the work of Filippino. The difference from his usual type is made clearer by reason of a very characteristic head alongside, with the bushy eyebrows and knotted forehead so familiar even as far back as the torturers who crucify Saint Peter in the Brancacci. The head with the light turban near-by again suggests Flanders in its vividly realized ugliness.[40] To a lesser extent this is true of the unconventionally beardless Saint Joseph.[41]

There are occasional hints that Filippino had studied the chiaroscuro of van der Goes: the way in which the light strikes the left hand of the servant removing his master's crown, the shadow cast by Saint Joseph's staff on his shoulder, and the treatment of the same saint's head. Finally, I suspect the northern painter's influence in the landscape,[42] both in the amount of lively genre introduced and in the general atmospheric effect. A person so sensitive to landscape as Filippino could hardly have failed to appreciate that of van der Goes, than which there is nothing else, before Peter Breughel the Elder, more charged with the subtle poetry of weather and season. Filippino has in general employed his own admirably sympathetic manner; yet, particularly in the way in which the light strikes the upper edges of the

[40] It brings to mind the extraordinarily realistic sculpture in polychrome by Guido Mazzoni in north Italy — for example, the group in the crypt of Modena cathedral.

[41] Generally speaking, the Italian conception of an old man seems to have included a beard, at least where the saints were concerned. The beardless chin, or one with a short stubble, associated with saints, is more a northern idea, and some such figure I suspect is behind Filippino's Saint Joseph, although I cannot point to a specific example which might have inspired him. By 1495–96 there must have been plenty of other Flemish pictures in Florence in addition to the Portinari. If, as Mr. Meinhof thinks, Filippino knew Leonardo's Saint Jerome, this also might have influenced his Saint Joseph.

[42] Cf. Johannes Guthmann, *Die Landschaftsmalerei der toskanischen und umbrischen Kunst von Giotto bis Rafael* (Leipzig, 1902), pp. 332 ff.

clouds, and the delicacy of bare or almost leafless trees, a study of the Flemish master is suggested.

On the other hand the Florentine painter contrived to remain completely untouched by the magnificent color of the Portinari altarpiece, a study of which he could have pursued with profit. His palette in the San Donato picture shows him as still fond of plenty of variety. This lavish spotting of hues over the panel tends to increase its confused and nervous effect. No doubt the emotional force is heightened thereby, but strictly from the point of view of color it compares unfavorably on the one hand with the deep singing harmonies of blue in the van der Goes, and on the other with the beautifully somber unity of tone in the monochrome of the unfinished Leonardo.

I turn now to the two panels mentioned in the previous chapter in connection with the Strozzi-Bache and Santo Spirito (Nerli) Madonnas — those in the National Gallery, London, and in Cleveland. The first (Fig. 53) is a large, almost square altarpiece in which the Madonna, nursing the Child, is seated in a landscape between Saints Jerome and Dominic. There is a predella divided into five compartments, which contain respectively Saint Francis, Joseph of Arimathea supporting the body of the dead Saviour in the tomb, and Mary Magdalen, the end compartments bearing the arms of the Rucellai. This is the altarpiece which hung in the Rucellai chapel in San Pancrazio, in Florence, until the suppression of the church, when it was transferred to the family's palace. There it remained until bought for the National Gallery in 1857. One of the masterpieces not only of Filippino but of the entire late Quattrocento, it has received far less notice than it deserves.

There can be no question as to the attribution, although, as so often happened, early writers attached to it the name of Fra Filippo.[43] Its connection with the Rucellai is well authenticated; the chief uncertainty concerns the date, about which there has been a good deal of disagreement, though some writers avoid the question altogether. Mengin suggests[44] that the panel was painted in connection with the redecorating of the church in 1485. This renovation is recorded in Stefano Rosselli's *Sepoltuario*, which is quoted by Richa[45] as follows (I translate): "Of the present church large

[43] E. G. Richa, in *Chiese fiorentine*, III, 320: "la tavola di Fra Filippo Lippi, che vi effigiò la Virgine Santissima, che dà il latte a Gesù Bambino con appiè S. Girolamo, c. S. Domenico." This was of course written while the picture was still in San Pancrazio.

[44] *Les Deux Lippi*, p. 120, and pp. 123 ff.

[45] Richa, III, 310: "Nella chiesa presente hanno gran parte, e più cappelle, e Sepolture i Rucel-

portions and many chapels are owned by the Rucellai and the Federighi, who still have their houses near-by, where there is the loggia of the Rucellai, and the so-called Via de' Federighi; this church was consecrated in 1485, on the twenty-eighth of August, as appears on a tablet."

Now that the main body of the church has been replaced, alas, by a tobacco factory, there is not much in the way of extant remains by which one may check the records. The chief survivor is the Rucellai chapel fronting on the Via della Spada. This chapel, of which Alberti is said to have been the architect, contains the famous "Holy Sepulchre" set up in 1467 and based on measurements obtained from Jerusalem by Giovanni di Paolo Rucellai.[46] The only inscription in the chapel, apart from those on the sepulchre, which bears the date 1467, occurs on a slab below the altar, on the floor, and reads: "Filiorum Philippi Vannis de Oricellaris et eorum descendentium, MCCCCLXXXV." [47] The slab quoted by Rosselli and Richa was no doubt in the church proper, as is implied by the word "chiesa" rather than "cappella."

Granted that some sort of decoration or addition was made in the chapel in 1485,[48] there is still no proof that it contained the London altarpiece, as Mengin seems to assume. In fact, the previously quoted sentence of Richa's tends to prove that it did not; he says,[49] "Avvi *altra cappella de' Rucellai* detta di S. Girolamo, nella quale degna di osservazione è la Tavola di Fra Filippo Lippi . . ." (italics mine). This statement follows a full account of the chapel of the Holy Sepulchre, in which account there is no mention of Saint Jerome, Filippo, or even an altarpiece. Hence Richa can scarcely be interpreted except as meaning that the Rucellai had two chapels in San Pancrazio. Nothing would be less surprising; families very often maintained

lai, e Federighi, che vi hanno ancora le Case loro vicine, ove e la loggia de' Rucellai, e la Via detta de' Federighi; fu consecrata questa chiesa l'anno 1485. a di 28 di Agosto, come apparisce da una cartella, che dice, 'An. Dom. 1485. die XXVIII Augusti, Ecclesia hec consecrata fuit a Reverendissimo D. Alexandro Episcopo Cimbaliensi Innocentio Abbate existente.'"

[46] Inside the "sepulchre" is a damaged fresco of Christ between two angels, which the custodian assures visitors is the work of Filippino. Although badly blackened by candle smoke, enough is visible to show that Filippino did not paint this fragment; Berenson has attributed it to Baldovinetti. See his *Italian Pictures of the Renaissance*, p. 37.

[47] Mengin, in citing this inscription, misprints the date MCCCLX. He says this is the one quoted in the *Sepoltuario*, but there seems to be some confusion here; the inscription Richa quotes is certainly not the one in Mengin's footnote (p. 120, n. 1.)

[48] The presence of the Holy Sepulchre, dated 1467, would indicate that the date 1485 cannot refer to the original dedication of the chapel.

[49] Richa, III, 320.

two or even more chapels in the same church, as for example the Strozzi in Santa Maria Novella, or the Capponi and Corbinelli in Santo Spirito. The same is implicit in Richa's quotation from the *Sepoltuario*: "Nella chiesa presente hanno gran parte, e più capelle, e Sepolture i Rucellai, e Federighi," [50] although inasmuch as two families are named there is no definite indication that the Rucellai had more than one. And if the London panel was *not* in the chapel of the Sepulchre, which underwent some sort of treatment in 1485, we are under no obligation to relate that date to the picture, and may proceed with perfect freedom to attempt a dating on stylistic grounds.

Those who would place the picture in the eighties point out certain affinities with the Badia panel, particularly the rock forms at the left in the London picture. It is even closer to the Madonna of 1486 in the types of the Virgin and Child. The same is true of the Santo Spirito panel, in which, moreover, the Saint Martin is just enough like the London Saint Dominic to make one wonder whether the same model could have been used. On the other hand, there are striking points of contact with the Adoration of 1496. Allowing for the difference of coiffure, the Virgin is very similar, and the Child is of precisely the same type. But the strongest argument for a date in the nineties seems to me to lie in the evidence of Leonardo's influence. The composition here is another adaptation of the central group in Leonardo's Epiphany of 1481; the motif of two trees, in the latter picture, is taken over by Filippino, who shifts their position to the left and substitutes for Leonardo's straight palm a crooked trunk growing up into the foliage of the larger tree. [51] Finally, the color of the panel — like nothing else from Filippino's brush — is a soft brownish-green in tone, quite different from his characteristic brightness and variety. Was there something in the harmony of Leonardo's brown underpainting which impressed Filippino where the more brilliant tonality of Hugo van der Goes failed to make itself felt? Sir Charles Holmes, in a charming passage, [52] compares the subdued blend of brown, green, and gold to Oriental painting. He points to the influence of Leonardo's Epiphany and of the "Madonna of the Rocks," "which," he says, "must have been carried far, if not completed, before Leonardo left Florence

[50] Page 310.

[51] It is pleasant to see that this is an oak — the very species, so they tell you in Londonderry, that harbored the angels who so often held friendly converse with Saint Columba.

[52] *Old Masters and Modern Art; the National Gallery, Italian Schools* (London, 1923), I, 67.

for Milan." But the "Madonna of the Rocks" was painted for a Milanese church, and so far as I know it was never in Florence.[53] Filippino never went to Milan, and if he had he might very well have had only the Ambrogio da Predis (?) copy to study there (i.e., the problematical version in the National Gallery, London).

It might, of course, be argued that Filippino saw Leonardo's Adoration at the time when it was being painted; but he certainly saw it in 1495 while his own panel was in progress, and this seems to me to be the more likely date for the London picture. It might be another case like that of the Brancacci frescoes, of a sensitive nature suddenly grasping the essence of his preceptor's style and using it, not as a copyist would, but to develop and enrich his own individual artistic character.

As a devotional picture Filippino's Madonna is infinitely more satisfactory than the "Virgin of the Rocks," or Leonardo's Epiphany. If it lacks the latter painter's magic of atmosphere and brilliance of draughtsmanship, it has a purity and sincerity of religious feeling unsurpassed in the latter Quattrocento. For parallels one should again turn to Renaissance sculpture. How readily the London Virgin might be transformed into a relief by Antonio Rossellino! As an altarpiece for a family chapel, nothing could be more satisfactory. As for the landscape, if it has not quite the airy spaciousness of a Perugino or a Raphael, it still shows the exquisite feeling for nature which is one of Filippino's chief contributions to the development of Italian painting.

One element in the London picture remains to be mentioned. The introduction of the bear at which Saint Jerome's lion is growling, the carefully studied bird in the oak tree, and the peculiar knobby, rounded forms of the trees in the distance, point to a contact with Piero di Cosimo. A realist himself, deeply interested in Flemish painting, given to the study of nature, Piero was producing in the mid-nineties pictures which for the time being seem to have stimulated Filippino's taste for such things. He had already borrowed an entire composition from Filippino (Fig. 27), the "Madonna and Child" now in the Royal Palace in Stockholm, which is a very individual but unmistakable reworking of Filippino's Strozzi-Bache panel.

[53] Unless, as a result of the mystery which surrounds this painting and its replica in the National Gallery, it could have made its way south, while the Milanese church got an Ambrogio da Predis. However, if it went anywhere from Milan, the probabilities are, as Venturi suspects, that it was carried off to Paris by Louis XII.

How he happened to know it I have no idea; the indisputable fact that he did know it may indicate that the Strozzi picture hung in some public place, no doubt a chapel.[54] Gronau believes that Piero's version was painted about 1490,[55] during Filippino's absence from Florence. The whole question of the relationship between the two painters is somewhat difficult to settle, because the chronology of Piero's work is so much a matter for speculation. It seems to me most likely that the closest connection occurred in the nineties, before the return of Leonardo, who seems to have succeeded Filippino as a formative influence on Piero.

All things considered, I should date the London Madonna not later than 1496, though conceivably it was begun in the previous year. I am willing to believe it may have been ordered as early as 1485, since Filippino was so well supplied with work in that year that a delay over the Rucellai commission is quite understandable. There is of course the possible objection that, for all their similarities, the London and Uffizi altarpieces are on the whole too different to belong to the same year. This, I grant, is a difficulty; but the group of pictures which are universally assigned to the nineties shows that Filippino was constantly experimenting and varying his manner under the influences either of his contemporaries or of his own ideas. Moreover, the tendency of his color is increasingly toward darkened, subdued effects as contrasted with the palette of the eighties — this in itself a mark of the oncoming Cinquecento. The rather garish effect of the Adoration may conceivably have been a conscious attempt to cater to the less cultivated taste of poor monks, as contrasted with the presumably greater sophistication of Bernardo Rucellai.

Be that as it may, we have in the London picture an example of the painter's power to absorb and transform the influence of another master and make of it a pure expression of his own genius. We have seen something of the process in the Brancacci chapel, and again in connection with Botticelli, whose influence is still faintly traceable in the head of the London Virgin. Far from being the merely imitative type of eclectic, he here amply proves himself a finely creative and independent master. Yet I know of no

[54] Who knows but that it was for a time in the chapel of Santa Maria Novella? It might conceivably have been placed on the altar there.

[55] *Pantheon*, November 1930, "Über zwei Florentiner Madonnen des Quattrocento." I have already referred, in Chapter IV, to Alfred Scharf's comparison of these two pictures, in *Art in America*, February 1931, XIX, 59 ff. He would date Piero's picture soon after 1487, which year he accepts for the Bache panel.

one save Sir Charles Holmes who has given this masterpiece the praise it deserves.

The predella,[56] with its figures isolated against a plain dark background, suggests already the influence of Savonarola toward simplification in religious pictures. The figures belong to the style of the nineties, with their bunchy, wind-blown draperies, and the thin, sharp-featured Saint Francis. His hands show the projecting point at the base of the thumb where it meets the back of the hand, a mannerism which becomes very marked toward the turn of the century, though it does not appear in the eighties. Joseph's turbaned head is related to similar ones in the Minerva frescoes and the later work in the Strozzi chapel. The motive of the dead Christ supported by Joseph of Arimathea is repeated in a lovely little panel, probably part of a predella, formerly in the Benson collection and now the property of Mr. Frederick Housman in New York. Two angels are added to the composition, flanking the tomb in which Joseph supports the body of the Saviour.[57] Filippino's characteristic flat stratified rocks loom out of the dark background. The free brushwork, agitated drapery, carelessly drawn hands, and curving wings all point forward to the Strozzi chapel. The gently sorrowful, rather feminine head of Christ is to be compared with the "Crucified Saviour" in Berlin (Kaiser Friedrich, number 96), unquestionably a late work, of 1497–98. Hence the Housman Pietà tends to confirm the dating of the London Madonna in the nineties rather than in the previous decade. And if this be correct, I believe it follows that the *tondo* in Cleveland must be of the same period.

This *tondo* (Fig. 54) showing the Holy Family with Saint Margaret and the infant Baptist, acquired by the Cleveland Institute of Art in 1932, is by far the most important work of Filippino's in the United States. During the early nineteenth century it was in the Palazzo Sant' Angelo in Naples,[58] where its label bore the name of Ghirlandaio; it then passed into the collection of Samuel D. Warren of Boston, and later went to England as the

[56] Dr. Scharf calls this predella the work of a pupil.

[57] The picture was bought by the Bensons at the railway station in Bologna, which may indicate that Filippino painted for that city another panel in addition to the "Marriage of Saint Catherine" now in San Domenico, dated 1501. A drawing for the Pietà was for many years in the Earl of Pembroke's collection. At the disposal of that collection in 1917 it passed to the Oppenheimer collection in London. See *Burlington Magazine*, 1917, vol. XXX, in which it is illustrated in connection with the sale through Messrs. Sotheby, Wilkinson, and Hodge.

[58] Crowe and Cavalcaselle, IV, 290.

property of Mr. Warren's son. There, at Lewes House in Sussex, it was known and published by Berenson.[59] It remained at Lewes House until its purchase for Cleveland.[60]

The panel is a masterpiece not unworthy of comparison with Botticelli's various *tondi*, although I cannot go quite as far as Berenson did in 1902, when he regarded it as threatening the supremacy of the Badia Saint Bernard in Filippino's output. If less subtle in design than the "Madonna of the Magnificat," it is nevertheless composed with a fine sense of the requirements of a *tondo*, showing in this respect tremendous advance over the Corsini panel. Essentially pyramidal, the group of figures beautifully recognizes and emphasizes the shape of the frame, especially in the interplay of curved lines along the arms of the Virgin, Saint Margaret, and the holy Children, and in the slightly curved, diagonally inclined bodies of all the figures. This closely-knit, serenely dignified group set against a luminous sky, prophesies the Madonnas of Raphael. In color I confess I find the picture disappointing; there are rich jewel-like tones of red, blue-violet, and the favorite orange-yellow, but the effect on the whole is inclined to be cold and just a little harsh. Especially in the flesh tones of the women one recognizes the greyish pallor so characteristic of the late panels, such as those of Bologna and Genoa. Most pleasantly typical of Filippino is the gentle, faintly sorrowful sentiment expressed, as though the children's embrace were one of farewell. A comparison of this with Fra Filippo's Uffizi Madonna with the grinning angel will show strikingly how far apart psychologically were father and son.

The date of the Warren *tondo* [61] has been variously fixed. Berenson [62] placed it soon after the painter's return from Rome, in the early nineties, basing his conclusion on the obvious likeness between the *tondo* and the Nerli altarpiece in Santo Spirito, which he regarded as post-Roman work. His argument was affected by his dating of the Badia Saint Bernard after the Signoria Madonna of 1486,[63] there being, as he rightly recognized, more

[59] "Un chef-d'œuvre inédit de Filippino Lippi," *Revue archéologique*, bol. 37, 1900, pp. 258, 372; and *The Study and Criticism of Italian Art*, Series II, pp. 90 ff.

[60] It came to that museum too late to be included in Lionello Venturi's *Pitture italiane in America*, published in 1931.

[61] I use the name by which the panel is best known, although ultimately, as we get used to the idea of its presence in this country, it will probably have to be re-christened the Cleveland *tondo*.

[62] *Study and Criticism*, Series II.

[63] He now dates the Badia panel "soon after 1480," influenced, I should imagine, by the documents published by Supino in 1903; see Chapter IV.

than a year or two of difference in style between the Badia and the Santo Spirito pictures. He also pointed out that there would hardly have been time to paint such a series of masterpieces as the 1486 Madonna, the Badia, the Nerli, and the Warren panels between the years 1485, when the Signoria altarpiece was begun, and 1488, when Filippino went to Rome. To this must be added the two pictures for Matthias Corvinus, finished by 1488, and the Strozzi-Bache Madonna. Berenson followed the obvious course and pushed the Nerli and Warren pictures into the nineties, encouraged especially by the architectural backgrounds, which he said show too much archaeological interest to have been designed before the Roman period.

My own view of this problem in chronology has been in part presented. The Badia panel I have placed not later than 1481, which if correct would allow the Nerli picture to take its place in the latter eighties, perhaps 1487 — an interval fully as great as Berenson allowed in dating the Badia 1487 and the Nerli in the early nineties. I have said that I believe Tanai's age in his portrait cannot be much over sixty, which would place the altarpiece in the late eighties; and that the general enthusiasm for decorating family chapels in that decade makes it likely that Tanai did not lag far behind the Bardi and other prominent families in ordering a new altarpiece. Finally there is the evidence of the painting itself, and especially of its ancient frame, which I said seemed to me to show nothing of the antique that cannot be accounted for by what Filippino could have seen in Florence in the eighties.

Does it follow from this that the Warren tondo belongs to the pre-Roman period? [64] Undeniably the Holy Family is close to the Santo Spirito Madonna, especially in the types and gestures of the Virgin, Child, and San Giovannino. But compare the Warren tondo with the "Adoration of the Magi" of March 1496. Except for the suggestion of a simper on her lips, and a slightly different coiffure, the Uffizi Madonna is remarkably like Our Lady of the tondo — at least as much like her as she is like the Virgin of Tanai's altarpiece. The attitude of the Christ Child is the same in both pictures except for the position of the head, whereas the Nerli Bambino repeats the attitude of the Signoria altarpiece and that of the Bache Madonna. The Warren Saint Joseph, especially in the large hands, broad through the palms, and in the heavy loose drapery, is similar to his counterpart in the

[64] The museum now labels the picture 1486. Mr. Francis, the curator of paintings, in his article in the museum Bulletin, November 1932, pp. 146 ff., implied an acceptance of Berenson's dating in the early nineties.

Uffizi Epiphany, except that the latter is beardless. The kneeling king, however, provides a parallel for the familiar bearded type with shaggy grey hair. Flemish influence is possibly to be recognized in the interest in still life shown in the objects scattered on the parapet, in the *tondo*, and as Mr. Francis pointed out in the museum *Bulletin*,[65] the architecture of the town in the distance has a northern look. It is related in type to that in the "Madonna and Child," number 101 in the Kaiser Friedrich, Berlin, which by common consent is associated with Filippino's late period.

As for the antique elements in the architecture, they do less to establish a late date than Berenson would have us believe. The crouching figures on the capital, taking the place of volutes in the Corinthian order and supporting a strikingly non-Vitruvian echinus, are the most classical-looking features except for the pure egg-and-dart moulding just below them; the general effect is thoroughly unconventional from a classical point of view. We know that Filippino let his fertile imagination run riot among the sketches of antique fragments he brought back from Rome; witness the most extravagant examples of it in the Strozzi chapel. But it is worth noting that where armor is introduced in the Warren *tondo*, it takes the form of an excellent "Gothic" breastplate and plumed helmet such as were still being made in the painter's own day!

Berenson failed to mention what seems to me in some respects the closest parallel for the Warren *tondo* — namely, the London Madonna. Again except for her coiffure [66] and costume the latter is almost exactly like the Saint Margaret of the *tondo*, and the Madonna of the Warren panel is similar as well, though the position is reversed. The Child is of the same type in both pictures, and the same model seems to have served for Saint Joseph (Warren) and Saint Jerome (London). Throughout, the correspondence of hands is noticeable. The London altarpiece differs from the *tondo* principally in the treatment of the landscape and in color. Here, I repeat, the influence appears to me to be a combination of elements derived from Leonardo and Piero di Cosimo. We know that Filippino was studying Leonardo's Adoration in 1495; it is the one picture of all others in that master's *œuvre* which could most readily have given him the non-Filippinesque qualities which characterize the London panel.

[65] Page 147.

[66] This coiffure is not of a type limited to the eighties; cf., for instance, that of the Madonna of 1501 in Bologna.

These three, then — the Epiphany of 1496, the London Madonna, and the Warren *tondo* — must have been painted within a very few years, perhaps months, of each other. Since the last-named contains such clear reminiscences of the Santo Spirito altarpiece, I shall place it tentatively as the earliest of the three, say in 1494 [67] or perhaps early in 1495. If this be true, then the pose of the Bambino may be said to have been carried over and used again in the Epiphany; Filippino seems clearly to have been pleased with it, and his ignoring of Leonardo's type of attitude can be the more readily understood if we can provide a prototype for the figure he substituted. Yet he must have been haunted by the beauty of Leonardo's monochrome, and when he came to execute the commission for the Rucellai, in 1496 perhaps, he experimented with new color effects under the older painter's influence. The composition indicates another influence from Leonardo: instead of the flat triangle of the Warren *tondo*, all the figures placed in approximately the same plane, he employs what might be described as a deep triangle, having three rather than two dimensions. This is done in both the "Virgin of the Rocks" and the Epiphany of 1481, and is like nothing else in Filippino's work; even in his own "Adoration of the Magi," in which the triangle is introduced, the Madonna is set not behind the front plane of the picture, but simply higher than her worshippers, as she is in Botticelli's Uffizi Epiphany with portraits of the Medici.

In 1497 Filippino signed and dated a "Meeting of Joachim and Anna," [68] now in the gallery in Copenhagen. From this date until his death we have a series of signed and dated panels; these, with the Strozzi frescoes, set the style of the painter's final period, which, granting certain minor variations, remains distinctly uniform from this time on. But before entering this final phase, he seems to have experimented further with the style of Piero di Cosimo and the Flemish painters.

One instance of this is to be found, I think, in the Saint Jerome now in the Academy, Florence (number 8652; Fig. 13). This for many years passed as an Andrea del Castagno. In *Les Deux Lippi* Supino identified it as the picture mentioned by Vasari, done for the Badia and spoken of in Puccinelli's *Cronica* [69] as "dipinto l'anno 1480 da Filippo Lippi," and

[67] This would fit in nicely with the *tondi* which Raffaellino del Garbo was turning out in the nineties, e.g., the Berlin Madonna with musician angels, no. 90.

[68] The inscription reads: PHILIPPUS DE FLORENTIA MCCCCLXXXXVII. A Danish catalogue of 1827 gives the subject as Laban's farewell to Rachel. [69] Page 11 of the *Cronica*.

having the arms of the Ferranti family on the panel ("nel quadro"). These arms are or were present on the frame, balanced by those of Count Ugo, which would certainly associate the panel with the Badia and prove that this is the picture seen by Puccinelli in the sacristy of that church. As I mentioned above, the two escutcheons are not, however, part of the original panel, which had a rounded top; they were painted on pieces added at the upper corners to fit the picture into a rectangular frame. Filippino's trees to the right had been continued over on to the attached piece to conceal the old edge. When I saw the picture in the winter of 1932–33 it was undergoing restoration; the added corners with the coats of arms had been removed, and the whole panel cleaned and varnished with a thoroughness that gave it almost the effect of a freshly painted modern copy. In spite of this, I was more sure even than when I first saw it, in 1930, that the date 1480 is much too early. This is the opinion of such scholars as Berenson and Venturi, although Supino and others accept the early date.

Critics who accept 1480 as the date of the Saint Jerome find a parallel for the picture in the frescoed Saints Jerome and Augustine in the Ognissanti, painted in the same year by Ghirlandaio and Botticelli respectively. Mengin even allows himself to be persuaded that Filippino and Botticelli used the same model, a suggestion which to me carries no conviction.[70] On the contrary, the type of Filippino's Saint Jerome is related to that of the same saint in his London panel, and to the Saint Joseph in the Warren *tondo*. His attitude is paralleled, though reversed, in the Christ of the Munich "Appearance,"[71] as is the tilt and expression of the head; the large hands, broadly painted, recall those of the London Saint Jerome, the Saint Joseph in the Epiphany of 1496, and certain others in the Minerva frescoes, as well as those of the shepherd in the Copenhagen panel of 1497. Finally, the landscape, though showing primarily Filippino's own lovely quality in the view of river and wooded hillside, suggests Flemish influence in the study of leaves, ferns, shells, and especially the sprays of yellow blossoms overhanging the rocks above the saint. Granted that the Saint Bernard contains a similar study of natural objects, the Saint Jerome's other affinities with work of the nineties seem to me to overbalance this, the only real connection with

[70] Even were there a marked similarity, might one not suppose that Filippino was inspired in his choice of the type by the Saint Augustine, though painted some years earlier?

[71] Meinhof does not mention this Saint Jerome when he compares Filippino's Munich panel to Leonardo's Saint Jerome.

the Saint Bernard. I should date it about 1496, after the Epiphany and not far in time from the London Madonna.

A somewhat similar situation is presented by the two *tondi* of the Museo Civico, San Gimignano, representing respectively the Virgin Annunciate and the Archangel Gabriel (Figs. 56 and 55). According to a record published by Pecori in 1853,[72] the Commune ordered on January 13, 1482 (1483 new style), two *tondi* of the Annunciation, the price to be eighty lire, with forty lire for the frames. The name of the painter is not given. This certainly looks like documentation for Filippino's *tondi*, and is accepted as such by such distinguished scholars as Venturi and Scharf. Berenson's early lists omitted the panels as not being Filippino's; in the less exclusive edition of 1932 he accepts them as largely his, but late. Van Marle considers them fine examples of the late period.

Leaving for the moment the question as to how far these paintings are the work of Filippino himself, let us see to which period of his career they are most closely related. The archangel admittedly recalls that of the principal angel in the Badia panel, particularly in the head, the type of "mottled" or iridescent halo, and to a lesser extent the type of costume. But I think a comparison of the two tends to show that what was fine, sensitive naturalism in the Badia angel has here become a thinned-out formula. The modeling is far more superficial, the hair is arranged in monotonously parallel rows of locks, and the expression is vacant and even stupid, whereas there is the very best of Filippino's psychological subtlety in the Badia head. The cloak of the San Gimignano Gabriel forms blunt, rounded folds where it lies on the ground, whereas such folds in Filippino's work in the eighties take rectangular shapes. The raised right hand, while drawn in Filippino's manner, lacks the substance characteristic of his hands before the nineties. Finally, the color is distinctly different from that of the Badia; it has the chill greyish cast, especially in the flesh tones,[73] which marks the late period, and lacks the warm glowing quality of the Badia or Corsini pictures, which it should certainly resemble if it were painted in 1483.

The Virgin shows even fewer analogies with the style of the eighties. Her robes billow around her with a heaviness never felt in the early period.

[72] Luigi Pecori, *Storia della terra di San Gimignano* (Florence, 1853), p. 572. "Le commeteva il Comune ai 13 di Gennaio 1482, stanziando a premio del pittore, di cui e taciuto il nome, lire 80, e 40 per le cornice" (Lib. di Provv. di Lett. G., no. 134).
[73] This color has much the same feeling as that of the Warren *tondo*.

The impassioned bending of the head is in the intensely emotional spirit of
the nineties and later; the left hand shows the exaggerated pointed projec-
tion at the base of the thumb, a late mannerism already referred to. A com-
parison of this hand with that of the Madonna of 1486 seems to me to
preclude all possibility of the former's having been painted earlier than
the latter. The charming landscape with its town (a fanciful view of San
Gimignano?) is akin to those of the London or San Donato altarpieces rather
than to the Badia.

Another possible argument for a date in the nineties is found in the
Annunciation of the Uffizi (number 1608), there attributed to Botticelli
but more generally taken to be partly or wholly the work of his school
(Fig. 57). This, painted for Santa Maria Maddalena di Cestello while
Filippino was in Rome,[74] may perhaps have been in the latter's mind when,
on his return, he designed the *tondi*. The passionate self-abasement of the
two Virgins is similar; the archangels correspond strikingly, granted, of
course, the traditional element in the pose. The floor inlaid in rectangles
might also point to a connection, though there is nothing unusual in a floor
of this type. However, quite apart from any possible association with Botti-
celli, the style of the San Gimignano *tondi* relates much more closely to
Filippino's manner in the nineties than to that of the earlier decade, espe-
cially the years preceding the Brancacci frescoes.

What then is to be said of Pecori's document? In the first place we have
no proof that the commission of 1483 was given to *Filippino* at that date.
But since the *tondi* correspond so closely to the specifications in the docu-
ment, we may here be faced with another of those delayed orders which so
often afflicted the Quattrocento patron. In the winter of 1482 Filippino
accepted his first public commission for Florence (the frescoes in the Palazzo
Vecchio, first ordered of Perugino). Within the next year or so he was
probably engaged at the Spedaletto, and then with the Brancacci frescoes.
The San Gimignano panels might possibly have been ordered first from
another painter, conceivably Ghirlandaio, whose frescoes in the chapel of
Santa Fina had given him a reputation in that town. The panels might
then have been completed by Filippino, commissioned at some later date

[74] Venturi dates it 1489–1490; Gamba, in Thieme-Becker, a year earlier, 1488–89. A full dis-
cussion of the redecoration of this church (which is now that of Santa Maria Maddalena de' Pazzi)
will be found in Georg Gronau's "Perugino's 'Sankt Bernhard' in der Alten Pinakothek," *Münchner
Jahrbuch*, 1909, IV, 49 ff.

to provide what the constantly overworked Domenico had no time to execute.[75]

As to the amount of work to be attributed to Filippino's own hand, I think the design may safely be taken as his, and the execution of both the figures, as well as the landscape in the *tondo* of the Virgin. In the same picture I believe he painted the chair, desk, books, and perhaps the contents of the cupboard.[76] The interest in light and shade on the furniture and still life points to a continuation of his interest in Flemish painting. The floor and the step to the left were probably filled in by an assistant, who was also responsible for the entire setting of the Gabriel *tondo*. It is almost purely geometric, and the paint is put on with a mechanical flatness and utter lack of sense of space and air except in the view at the left, through the loggia. The assistant may also have had something to do with the head and hands of Gabriel. I take it that Filippino began with the Madonna, and then, being busy with other work, left the companion piece even more completely to the *garzone* to finish.

The *tondi* were probably painted in Florence, where Piero di Cosimo may have seen them in Filippino's *bottega*. This is suggested by the similarity of the former's "Youthful Baptist" (though facing in the opposite direction) in the Dreicer collection of the Metropolitan Museum, New York, to the San Gimignano Gabriel (Fig. 61). The Baptist is in no sense a copy, but is unmistakably painted under the influence of Filippino, the wistfulness of whose boyish type is peculiarly engaging as seen through Piero's eyes.

Another *tondo* which I believe to have been painted before 1497 is that in the collection of Lady Ludlow in London. It is the most thoroughgoing example known to me of Filippino's debt to Piero di Cosimo, showing as it does a definite experimenting with the fuller physical forms and the chiaroscuro of the younger painter. The subject is actually a Rest on the Flight into Egypt, although the Virgin, kneeling and caressing the cheek of her son, who lies on a piece of drapery with his back against a pack-saddle, is really nothing but a variation on Fra Filippo's familiar theme of the Madonna adoring the Child. In the distance Saint Joseph can be seen super-

[75] Ghirlandaio died in 1494, so that if he had had any connection with the original contract another painter would have to have been selected at that date; Filippino's pictures are at least as late as 1494 in style, and, it seems to me, even later. I realize, of course, that the introduction of Ghirlandaio's name in this connection is the purest speculation.

[76] On one shelf lies the same oval box seen on the parapet in the Warren *tondo*.

vising the watering of the ass and an ox (which apparently has followed the Holy Family from Bethlehem); above are sheep and goats, and a shepherd playing a bagpipe. The points that recall Piero are: the rounder face of the Virgin, quite unlike Filippino's own type; the extremely plump and athletic Child, who reflects Piero's earlier borrowings from Signorelli; the interest in animals, already noted in the Academy Saint Jerome and the London Madonna; the strong contrasts of light and shade, on the Virgin's face and neck, for instance; and the dark, rather somber color, with its emphasis on greys and greens — favorites of Piero's. It is to be noted that not one classical detail is introduced; the stone wall and broken parapet to the right are of rough, unornamented masonry, with wisps of straw and a handful of cherries scattered about. The charming landscape, in Filippino's best manner, is much like that in the London altarpiece. The Child is a plumper, more solid brother of the London Bambino, with much more emphasis on the high lights of his pudgy body, a quality which, as I have said, Piero doubtless took from Signorelli, and did not give up until his latest period, after 1500.

The robe of the Virgin is too dark to show the folds clearly; in the cloth on which the Child lies they have the rounded, blunted forms seen in the San Gimignano *tondi*, in contrast to the flatter, more angular ripples which are normal for Filippino. It is as though he had made an effort to inflate all his forms — one of his few definite attempts to come to terms with the ampler physical standards of the nascent Cinquecento, which in general he had the good sense to avoid as out of harmony with his personal style. For the benefit of Morellian critics he has painted the Virgin's left hand in his own peculiar manner, slender and long-fingered, with the characteristic peak at the base of the thumb. The picture, for all its borrowed elements, is one of great charm; the pastoral, idyllic mood is enhanced by the effect almost of moonlight produced by the chiaroscuro.

Although I shall devote a later chapter to a brief discussion of Filippino's relations with his artistic contemporaries, this seems the most suitable place in which to pursue a trifle further the subject of Piero di Cosimo's connection with the master. The scope of this book does not permit a thorough analysis of this interesting problem, but I should like to indicate one or two points which seem to me significant.

In addition to the little Baptist of the Dreicer collection, two or more

ambitious panels of Piero's show a dependence on Filippino. One of these, a *tondo* in Dresden (number 20) shows the Holy Family, with a pair of angels seated above in poses that suggest pediment composition. The shaggy-haired angels, one of them with open mouth and upcast eyes, are clearly derived from Filippino. The Bambino is of the type, based on Signorelli's, which influenced Filippino's Christ Child in the Ludlow *tondo*; compare the snubby little face, bulging abdomen with clearly marked creases in the flesh, and general air of an infant Hercules — quite the reverse of Filippino's wistfully spiritual children.[77] There is a blunt, mundane directness in Piero that constitutes a large part of his peculiar charm, although it would make him, one would fancy, unsympathetic artistic company for a sensitive, rather dreamy soul like Filippino. Nevertheless the two seem to have exerted on each other a mutual fascination. We have the proof of it again in yet another *tondo* (Fig. 59) which was formerly in the Duveen collection, and was acquired in the spring of 1937 by the Toledo Museum of Art.[78] This time the Madonna kneels in a landscape, her hands outstretched toward the Child, who lies asleep. Here the situation in the Ludlow *tondo* is reversed, and Piero has tried to paint a Filippinesque Virgin, basing the type on some such work as the Warren *tondo*. The long, slim fingers, carefully drawn, suggest those of Filippino. The leaning pose of Our Lady's figure, with her draperies spreading about her, forms a natural triangle of the sort which Filippino used as the basis of his composition in the Warren picture. Again, the arrangement of the striped veil over the head is reminiscent of Filippino's work. The fat, shrub-like trees which suggest those of Lorenzo di Credi here offer a hint as to the source of the similar ones in the London Madonna; they may be seen in Piero's work as early as the Stockholm Madonna. Finally, we recognize the same species of bird with a red patch on its head, in the oak tree in the London picture and in the lower right foreground of the Toledo *tondo*.

Neither of these *tondi* of Piero's can be exactly dated, but they certainly belong to the end of the Quattrocento, and since the years 1494–1497 seem the safest time to date works by Filippino showing Piero's influence, it

[77] The veil over the Child's body is made very transparent, in order that the figure may be treated altogether as a nude. Probably under the influence of this tendency of Piero's Filippino used the same gauzy veil in the Ludlow *tondo*.

[78] See Blake-More Godwin, "An Important Italian Painting," *Museum News* (Toledo), March 1937.

follows that pictures in which reciprocal influences can be traced, should probably be dated at the same time. The famous "Bella Simonetta" of Chantilly probably belongs to the same period; the fact that it bears Simonetta Vespucci's name does not affect the date, since that fascinating creature died some time before the earliest moment at which Piero could have painted the picture.

Coming back to the Ludlow *tondo*, which I would date toward the end of 1496, we find it serving as a useful point of departure in another direction quite unconnected with Piero di Cosimo. It is closely related to the "Madonna and Child" in Berlin (Kaiser Friedrich, number 101; Fig. 60). Not all scholars accept this as Filippino's, although no one denies its association with his school. A comparison between it and the Ludlow picture shows that the Bambini are almost exact duplicates, allowing for the different positions of the legs; the Madonnas are similar in type, though their costumes are not the same; and the drapery has the exaggeratedly bunchy quality, with what I have called "blunt" folds. Parallels exist also between Berlin 101 and the London Madonna, especially in the Virgin's hands (which are also like those of the Warren *tondo*) and the way in which the drapery billows around the Child in each case, so that his mother holds a great handful of it against his body.[79] At the same time there is a coarseness and exaggerated heaviness in the expression of Filippino's increasing love of movement, which to me seem to betray the hand of an assistant. What we have in the Berlin panel is, I think, the work of one of the master's *bottega* staff using a design made about 1496, the translation involving an almost total loss of Filippinesque charm, and retaining nothing of Piero di Cosimo except the solid, rounded physical forms. The sketchily painted buildings seen through the window also point to assistant work, as does the plain wall against which the Madonna sits. The affectionate gesture of the Child, who is not usually demonstrative in Filippino's work, is perhaps a reminiscence of Fra Filippo, or, more likely, a reflection of such Quattrocento sculpture as the della Robbia shop produced.

In another room in the Kaiser Friedrich hangs one more panel [80] related, I believe, to number 101 and Lady Ludlow's *tondo*. This (Fig. 61) is

[79] The headdress and striped scarf around the Virgin's shoulders are not unlike those of the Uffizi Madonna of the Epiphany. The wide fold around the upper part of Saint Jerome's drapery (i.e., in London) is duplicated in the Berlin Madonna.

[80] James Simon collection, no. 1.

again a *tondo*, showing the Madonna and Child standing behind a kind of table at either end of which kneels an angel. The label bears the name of Raffaellino del Garbo, an attribution accepted by most authorities, although Berenson's latest list reverses popular judgment and calls it partly Filippino's work. The Virgin and Child are close in type to those of Berlin 101 in spite of a slight difference in the angle of the heads. The feminine-looking angels are closer to Filippino's traditional type, being lineal descendants of those in the Badia altarpiece. The introduction of a parapet with still life suggests, in idea if not in detail, the Warren *tondo*. The polished marble column to the right, again, takes one back to the San Gimignano Gabriel. Both angels and Madonna have the exaggerated angle at the base of the thumb seen in the Ludlow Virgin and elsewhere, but the hands are badly articulated and more awkward than Filippino himself would ever have drawn them. The panel, which has suffered a good deal, shows clumsy repaint (?) in the robe of the Madonna, especially where it shows in the space beneath the table, there being no sense conveyed of the body's weight on the floor.

The Warren, Ludlow, and San Gimignano panels give evidence of Filippino's interest in circular composition in the mid-nineties, and I should say that the Simon Madonna is another example of his research in this field. The attribution to Garbo would seem to be based chiefly on Vasari's description of that elusive painter's style, as being barely distinguishable from that of his master. The Simon picture is about as close to Filippino as anything could come without being unquestionably by him; hence, what more natural than that it should be Raffaellino? To this I would answer by pointing to yet another *tondo* hanging near-by — the standing "Madonna and Sleeping Child between Two Musician Angels," number 90 (Fig. 93). That this last is by Raffaellino, as its label declares, is entirely likely on the basis of its similarities to the Munich Pietà mentioned above — one of the few Raffaellinos for which we have satisfactory evidence of authenticity.[81]

Now Garbo's association with Filippino probably did not last for many years after the completion of the Minerva frescoes; by the turn of the century he had — whether or not one sees fit to identify him with Raffaelle de' Carli — succumbed in large measure to Umbrian influence, which, indeed, seems to have begun to affect him while he was in Rome. The Simon *tondo* is clearly related to the group I have dated about 1496. But the Madonna

[81] I shall go into this matter more fully in the chapter on Raffaellino.

and angels (Berlin 90) can hardly be much later than that year, so that if we accept both *tondi* as Raffaellino's it will be necessary to allow for a distinct change of style on the painter's part, within an awkwardly short space of time, or, indeed, two different kinds of inspiration from Filippino, for his influence may also be traced in Berlin 90. If Raffaellino painted the Simon *tondo* we must assume either that he was still associated with Filippino's *bottega* at the time, or that he had access to a sketch of the master's, neither of which I think likely as late as *c.* 1496. Furthermore, the Simon *tondo* bears no convincing likeness to anything else that can reasonably be ascribed to Raffaellino. Hence I am led to the conclusion that the Simon Madonna is Filippino's design and possibly partly his in execution, but that most of the actual painting was carried out by an assistant who, I suggest, was the same one who painted much of Berlin 101. I believe further that this may have been the same assistant who took a less ambitious part in the San Gimignano *tondi*. In these the less the drapery looks like Filippino's the more it resembles that of both Berlin 101 and Simon; all have similarly timid, unambitious architectural settings, with the polished column occurring in two cases.[82]

At this point, it will be convenient to speak of one or two minor works which probably belong to a date prior to 1497, though I do not make so bold as to associate them with dates more specific. Of these the most delightful is the little panel at Christ Church, Oxford (Fig. 62), showing a centaur wounded by an arrow of Cupid, who lies on the ground in the distance, apparently mildly bored by the ease with which his shaft has found its mark. Near him, in a cave, are a female centaur and her two children. Although Filippino's interest in centaurs might have been stimulated by Botticelli (we have seen him using them on the throne of the Nerli Madonna and at Poggio a Caiano) I think the immediate inspiration here is from Piero di Cosimo. Stylistically the picture seems to belong to the mid-nineties. The landscape, particularly, parallels that of the Cleveland, Ludlow, and London panels; Filippino never painted trees, grass, and summer haze over water with greater sensitiveness. The little panel shows a careful delicacy

[82] To this same group must also belong the "Madonna and Child" with two angels — once more a *tondo* — in the Palazzo Reale in Naples, which I know only from a photograph. The design is probably Filippino's, the execution that of the Simon assistant. The profile head of the angel supporting the Child is the same kind of feeble reflection of the Badia angel that we notice in the San Gimignano Gabriel.

of finish which one does not find in his work at the very end of the century or after 1500.

The design is fascinating and original, arranged on a scheme of diagonals, with neither the symmetry nor the central accent usual in the Quattrocento. The centaur faces the outer edge of the picture, with his back to its center, so that he forms, roughly, a triangle of which the hypotenuse coincides with the diagonal which might be drawn between the upper left- and lower right-hand corners of the panel. The mass of rock and trees balance him at the upper right; and Filippino has introduced a kind of coda for his rhythmic scheme by breaking the limb of a dead sapling in the lower left corner so as to make it echo the triangle formed by the centaur himself.

In color the picture is an attractive harmony of warm browns and greys, set off by the vermilion accent of the centaur's quiver, and the soft green-blue of sky and water.

On the reverse of the panel are sketched three female figures,[83] very Botticellian in style. Although these cannot be associated with any known work of Filippino's, they are doubtless studies for some mythological or allegorical picture, and as such are of no little interest. They vaguely recall the drawing by Filippino, in the Uffizi, of witches (or Medea and an assistant?) with a fantastic cauldron, Berenson number 1300. The presence of the unfinished sketch on the back of a completed panel tends to indicate that the latter was an informal commission, and shows Filippino in an unaccustomed and highly attractive mood. Perhaps it was ordered by one of the young citizens (certainly not a Piagnone!), who admired Filippino's designs for costumes and processions, of which we read in Vasari and in which occupation he was probably most active during the prosperous times of Lorenzo's rule. Its purely lyric quality would make it a perfect illustration for a verse by one of the Cavalier poets, or — to turn one's imagination still further backward — it would not be out of place in a volume of Ovid. One fancies that it would have appealed to the intellectuals at Careggi, disbanded, however, by the time I take the panel to have been painted.

Another interesting little picture, allegorical in subject, is the tiny panel formerly in the Pitti but now transferred to the Uffizi (number 8378; Fig. 63).

[83] These are illustrated in Tancred Borenius' *Pictures by the Old Masters in the Library of Christ Church, Oxford* (Oxford, 1916), Plate XIII.

It shows a boy walking in a landscape, with a serpent knotted around his ankles; a diminutive white animal like a weasel runs along at his feet. In the foreground the same youth lies stretched on the ground making gestures of despair, the serpent now twisted around his waist and running its tongue out at him. Under a tree to the right sits Jove, identified by his armful of thunderbolts. From the mouth of the fallen boy issues the following inscription which runs through the composition: NVLLA DETERIOR PESTIS FAMILIARIS INIMICVS. A view of Florence is to be seen in the background, showing the Duomo, Giotto's Campanile, and the tower of the Badia.

The picture passed for a long time as the work of "Ignoto del XV secolo," and is still so designated in Alinari's photograph. It was recognized by Morelli as Filippino's. The question of date is not easy to settle, but I should place the panel tentatively in the nineties. The head of Jove, and all the hands, suggest that period, and the landscape will bear comparison with the London Madonna, especially in the way the tree is used. Here again we have the painter in an informal mood, dashing off a miniature which in spite of its moral is light in touch and feeling.

The enchanting little "Holy Family with Two Angels" (Fig. 64) bought by the National Gallery of Scotland in 1931, is probably to be dated no later than 1497. In color it has a delightful blue and bronze tone, with touches of gold, and accents of pink, dark olive, and yellow. The dainty and lively execution calls up visions of Amico di Sandro's Chantilly panel, although the blond tonality of the latter is quite different from the darker effect of the "Holy Family." In style it retains in paint more of the spirit of Filippino's best pen sketches than does any other picture of his with which I am acquainted. Was it some such treasure as this that the artist painted for Piero del Pugliese, so exquisitely that he felt incapable of repeating the performance? [84]

The notice in *Pantheon*, May 1931 (p. 221), gives the tantalizing information that it was formerly in a private collection in Austria-Hungary. One thinks at once of Matthias Corvinus, only to realize that the wish has been father to the thought, and that the Edinburgh picture can hardly be as early as the eighties. Nevertheless, I should not be surprised if those lost panels of

[84] "A Piero del Pugliese, amico suo, lavorò una storia di figure piccole, condotte con tanta arte e diligenza, che volendone un altro cittadino una simile, glie la dinegò, dicendo esser impossibile farla" (Milanesi-Vasari, III, 467).

1488 were today hidden in some remote corner of what was once Matthias Corvinus' kingdom. There seems to be no known altarpiece with which the Edinburgh picture can be connected; possibly it was complete in itself, although the rapid, sketchy execution is more to be expected in a predella than in a finished work.

CHAPTER VII

THE LAST PERIOD: FIRST HALF

THE year 1497 is in many respects a satisfactory one from which to date the beginning of Filippino's final period. In the seven years of life which then remained to him, his art followed a course more regular than at any other time of his career. Moreover, we have for these years a full series of dated works and documents, so that the student's task is primarily one of criticism rather than of research. This is the period regarded by many as representing the painter's decline; others rightly see in it, to compensate for the loss of the earlier charm, abundant proof of his progressive tendencies and unabated powers as a painter transitional to the Cinquecento.

The opening of 1497 (January 19) finds Filippino a member of the committee of experts appointed to estimate Baldovinetti's frescoes in Santa Trinità.[1] In the same year, according to Milanesi, he married Maddalena di Pietro Paolo Monti,[2] by whom he had several children. One of these, Francesco, or Giovanni Francesco, was a close friend of Benvenuto Cellini's, as the latter tells us himself in his autobiography; another, Roberto, would seem to have been a friend of the engraver Robetta, who borrowed various motifs and even compositions from Filippino.[3] M. Mengin, always on the lookout for identifiable portraits in Filippino's paintings, points out that the painter's feminine type changes in 1497, and that the new model was prob-

[1] Milanesi-Vasari, III, 491. Horne published documents relating to these frescoes in "A Newly Discovered 'Libro di Ricordi' of Alesso Baldovinetti," *Burlington Magazine*, II (1903), June, July, and August.

[2] Milanesi-Vasari, III, 476, n. 1.

[3] See Chapter X. The reference to Roberto Lippi is to be found in Milanesi-Vasari, VI, 609, in the life of Rustici: "Si ragunava nelle sue stanze della Sapienza una brigata di galantuomini che si chiamavano la Compagnia del Paiuolo, e non potevano essere più che dodici: e questi erano esso Giovanfrancesco (Rustici), Andrea del Sarto, Spillo pittore, Domenico Puligo, il Robetta orafo, Aristotile da Sangallo, Francesco di Pellegrino, Niccolo Buoni, Domenico Baccelli che sonava e cantava ottimamente, il Solosmeo scultore, Lorenzo detto Guazzetto, e Ruberto di Filippo Lippi pittore, il quale era loro proveditore." If this Roberto was Filippino's son, he was probably still in his teens at the time of this Compagnia's activity, since all the members must have been young men, and Roberto would have been more than ten years younger than Andrea del Sarto (born 1486) and over twenty years younger than Puligo (born 1475). Possibly he inherited his father's precocity! The third son, according to Milanesi, was named Luigi, later called Filippo.

ably Maddalena.[4] It is true that some change of the sort occurs, particularly in the profiles, but the heads do not show sufficient character to suggest portraits. I myself would explain the change as a growing indifference to the representation of actuality which accompanies the painter's ever-increasing concern with the expression of emotion and movement.

Still another document exists for the year 1497: Filippino's second will.[5] Gronau gives the date of this correctly as March 6, 1497.[6] Milanesi, whose printed dates it is always safer to check, since there are many inaccuracies, gives 1495,[7] which van Marle apparently copied without investigation.[8] It is in this will that Maddalena Mônti is mentioned, so that, although we have no precise date for the marriage, we at least know that it was not later than the spring of 1497, and it may have taken place during the previous year.

Turning now to the paintings of this period, we may begin with the "Meeting of Joachim and Anna at the Golden Gate," inscribed "Philippus de Florentia MCCCCLXXXXVII," and preserved in the gallery in Copenhagen (Fig. 65). The difference between this and the Epiphany of the previous year is remarkable. A panel of considerable size, it is frankly one of the least pleasing of the painter's works, and illustrates the faults which the enemies of Filippino's late period always adduce in adverse criticism of the Strozzi frescoes: crowded composition, restless movement, inaccurate anatomy, overemphasis on classical accessories. The color is cold and unpleasant, especially the greyish flesh tones; this is the color tendency of the Warren or San Gimignano *tondi* carried still further. Then, too, there is less feeling in the embrace of Joachim and Anna than one would expect of Filippino. The girl attendant to the left is as "camera-conscious" as any of Ghirlandaio's self-possessed damsels in Santa Maria Novella. The stock types are all present, already met with in the Caraffa chapel and soon to recur in the Strozzi: i.e., the turbaned old man, the elaborately dressed girls, the soberer older woman, the peasant with shaggy hair and feet bound with skins and cord. Indeed, the Copenhagen panel might almost, in photographic reproduction, pass for a detail of the Strozzi decorations; and for this reason, as I

[4] *Les Deux Lippi*, p. 202. M. Mengin thinks Maddalena's features are to be recognized in the Saint Catherine of the Tabernacle in Prato, dated 1498.

[5] Referred to by Supino, *Les Deux Lippi*, p. 199. He prints the reference to the will itself, which is preserved in the Archivio di Stato in Florence, Rogiti di Ser Giovanni di Romena.

[6] Thieme-Becker, XXIII, 268.

[7] Milanesi-Vasari, III, 491.

[8] *Italian Schools of Painting*, XII, 294.

shall repeat later, I am persuaded that by 1497 some progress had been made on that shamefully delayed commission — the cartoons, if not some of the actual work in fresco.

To continue the analysis of details in the Copenhagen picture. The right hand of the shepherd has already been compared with that of the London Saint Jerome as a reason for placing the two near together in time. In the background one sees a kind of pseudo-medieval Jerusalem, architecturally akin to the buildings Filippino painted in the Brancacci "Crucifixion of Saint Peter." At the extreme left is the first thoroughgoing piece of archaeology since the Minerva frescoes (and, as I think, the Poggio a Caiano porch) — the Golden Gate itself, looking as though the Roman governors of Jerusalem had themselves supervised the work, albeit with Quattrocento variations. A portion of what Filippino must have intended as a triumphal arch shows channeled columns with pseudo-Corinthian capitals supporting an entablature with bead-and-reel mouldings, a frieze decorated with trophies, shells, and so forth, after the precedent of the Minerva, and a cornice of fairly simple profile, having an egg-and-dart decoration. Above this rise two bands of sculptured panels separated by plain, squat pilasters; another simple cornice separates the two levels. The sculptured panels blend pagan and Christian motives: we see an angel with a palm (or is she intended as Nike?) triumphing over a bound captive, and, further on, three soldiers near a circular temple. Above is a sleeping Venus with cupids, one playing the harp, which brings to mind Filippino's charming drawing in the Berlin Print Room, number 2367 (Berenson, number 1269). To the left of this a figure kneels at the foot of a shrine or votive monument, on which he places a garland. There is little to criticize in this modest and pleasing introduction of the antique. The date is inscribed on the base of the nearest column, with the name of the painter just below, on the podium.

Dr. Bodmer draws attention to the Cinquecento feeling produced by the small number of figures very large in proportion to the size of the panel.[9] Once again Filippino is trying something new. Obviously this particular form of Cinquecento design was not his forte; the agitation of his line detracts from the requisite solemnity of effect, but he deserves credit for his unwillingness to repeat himself. On the whole, the picture is more in-

[9] "Der Spätstil des Filippino Lippi," *Pantheon*, April 1932, pp. 126 ff., and November 1932, pp. 353 ff.

teresting than attractive — a useful landmark among the signed and dated works.

The next dated work is the tabernacle in the Mercatale, Prato, inscribed 1498 (Fig. 66). This fresco, arranged as a triptych on three sides of a rectangular niche, shows the Virgin standing before a richly carved antique altar, a semicircle of cherub heads behind her head suggesting an apse; to the right Saints Stephen and Catherine of Alexandria, to the left Saints Anthony Abbot and Margaret. In spite of its poor condition (the blue of the Virgin's robe has worn away, or was stolen deliberately, and other parts are damaged through exposure to the weather) this beautiful fresco shows that the Copenhagen panel was only a temporary falling below standard (and that owing in part to experiment along creative lines) and that Filippino could still paint masterpieces, although this one is, if anything, reactionary. It will be noticed that nothing remains of Piero di Cosimo's influence. The Madonna and Child are again purely Filippino's own, as are the grizzled Saint Anthony and the slender female saints. The crowd of prayerful *putti* on the clouds are typical as well. The painter asserts his classicism in the elaborately decorated sphinxes at the corners of the altar. A slip of paper in a book on this altar bears Saint Bernard's motto, SVSTINE ET ASTINE [*sic*]. One sees that Filippino is once more drawing the little rectangular folds of cloth where the drapery lies on the ground, especially in the case of the Madonna; otherwise exposure and ill treatment have largely effaced details of drapery. The date is divided into two parts: above Saint Anthony is written ADM/CCCC/LV; above Saint Stephen XXXX/VIII. The color is pleasant in spite of weathering: harmonious effects of brown, orange, brick red, and green, with dull violet-white where the blue has disappeared from the Virgin's robe.

No less than two copies of this Madonna exist to testify to its contemporary popularity. A very poor version, showing only the Madonna and Child, in a circular frame, is preserved in the gallery of the Municipio in Prato. A second copy, also a *tondo*,[10] is still, so far as I know, in the hands of the dealer Matthiesen in Berlin. Although van Marle and Bodmer mentioned it within recent years, neither pointed out (perhaps because it is self-evident) the complete dependence of this panel on the Prato tabernacle. The Vir-

[10] Reproduced in an advertisement of that dealer, *Burlington Magazine*, December 1927, p. xxvii, and by Bodmer in *Pantheon*, November 1932, p. 355, Fig. 8.

gin is almost exactly the same, although the Child's gaze is directed forward, toward the spectator, rather than over his shoulder toward one of the saints. The masculine saints of the tabernacle are omitted, but Saints Margaret and Catherine are repeated almost line for line except that a change in accessories has transformed the former into Saint Mary Magdalen. I agree with Dr. Bodmer [11] that this is a school piece rather than an original; van Marle, with that lack of a discriminating eye which so often vitiates his judgments, calls it "a very important" genuine Filippino.[12] The fact that we have two *tondi* derived from the tabernacle may mean that Filippino himself was responsible for the design adapting the tabernacle composition to a *tondo* shape; but the Matthiesen picture cannot, in my opinion, be the original version.

On May 28, 1498, the Florentine authorities (drawing a long breath of relief, perhaps, at having got rid of Savonarola, executed just five days previously) commissioned Filippino to paint a new altarpiece, for the Sala del Consiglio Maggiore, his old collaborator Chimente del Tasso being chosen to execute the woodwork in connection with the same scheme of redecoration.[13] Vasari says this panel was never finished, but that Filippino made the design for it.[14] The commission was ultimately transferred to Fra Bartolommeo, who, according to Vasari, did not finish it either. There is no record of the subject; however, it is likely that a Madonna was wanted, probably with accompanying saints.

There exist two studies of such a composition, both clearly intended for the same altarpiece and belonging stylistically to the nineties. One is in the Uffizi print room (number 142, Cornice 78; Fig. 67), the other in the collection of Christ Church College, Oxford (Fig. 68). The latter is mounted on a sheet which once belonged to Vasari's scrapbook; in the center of the page appears the engraving used to illustrate the life of Filippino in the *Vite*, and based on the painter's self-portrait in the Brancacci. Each of the two Madonna studies represents her enthroned with four saints, two male on the

[11] *Pantheon*, November 1932, p. 355. Dr. Scharf also cites the panel, calling it a copy.
[12] *Italian Schools of Painting*, p. 342.
[13] For details of this, see Alfredo Lensi, *Palazzo Vecchio* (Milan-Rome, 1929); the commission is cited by Milanesi, Gronau, etc., as well as by Vasari.
[14] "Fece nel palazzo della Signoria la tavola della sala, dove stavano gli Otto di Pratica (i.e., the Madonna of 1486), ed il disegno d'un'altra tavola grande, con l'ornamento, per la sala del Consiglio; il qual disegno, morendosi, non cominciò altramente a mettere in opera" (Milanesi-Vasari, III, 474-475).

left, two female on the right. None of these saints can be identified with certainty except Saint Nicholas, whose three balls, mitre, and crozier are introduced in both sketches. The composition is less completely worked out in the Oxford than in the Uffizi drawing. Here the Virgin sits on a kind of curule chair raised on two broad steps; the two feminine saints kneel to the right in front of a classic portico sketched in perspective. One holds a small cross, the other offers the Child an open book. Saint Nicholas and his companion kneel on the lower step, to the left; the mitre rests on a book at Saint Nicholas' feet. Above this composition are two studies of *putti*, a child's leg, and a very light, quick sketch of two flying angels holding a "cloth of honor" and a ribbon from which a crown is suspended.

The Uffizi sketch is more conventional in that the four saints kneel at the same level; the mitre is twice introduced, to try the effect in different positions. The second masculine saint seems to have a knife in his head, which would make him Peter Martyr, but this may be a scratch of the pen made without symbolic significance. The flying angels have brought the cloth of honor into position behind the Virgin, but the crown is omitted.

The architecture of the Christ Church drawing has been elaborated, in the Uffizi example, to a loggia with round arches at the right. As in one of the Loeser Pietàs, a staircase with figures is introduced; at the left of the composition, a mountainous landscape is indicated. The general type of the design is similar to that of the earlier altarpiece for the Signoria except that the Child is on the Virgin's left knee instead of on her right as in the panel of 1486; but the style and conception of both drawings is too late to be related to the painting. The conservative grouping suggests that the success of the earlier picture may have induced Filippino to try a repetition; indeed (if I am right about the designation of these drawings) the Signoria may have requested this. The Uffizi sheet offers analogies with the Loeser Pietàs both in architectural details, as I have said, and in the introduction of the flying angels.

The fact that Vasari owned one of these drawings is of no help in proving or disproving a connection between them and the commission of 1498. One might, that is, argue that he knew Filippino prepared a drawing because he owned one himself; on the other hand, he so often refers to his collection that one would have expected him to mention specifically the Oxford drawing in connection with his reference to the altarpiece, had he known his own

sheet was a preliminary study for it. Nevertheless, the theory seems to me to be both tempting and plausible.

Filippino may have given some evidence of achievement on the Consiglio altarpiece beyond mere drawings on a small scale, since a report of deliberations of the Operai runs as follows: "June 17, 1500. The painter Filippo di Filippo, for the altarpiece, 205 lire." [15] It is interesting to discover that Tanai de' Nerli was among the authorities who arranged for the redecoration of the Sala on July 15, 1495.[16]

In the month following the giving of the commission for the Sala del Consiglio, a group of Florentine artists met to discuss the repair of the Duomo lantern, which had been struck and damaged by lightning on May 19, 1492 — barely over a month after the death of Lorenzo, in connection with which many citizens had felt it an evil omen. The meeting "pro reparatione Lanternae" took place on June 26; Filippino's name is entered on the record as "Phylippus Fratris Phylippi, pictor." [17]

One more record of the year 1498 has been preserved: Filippino's Portata al Catasto.[18] It is in this document that he speaks of having been "fuori di Firenze" in 1480. He goes on to list the purchase on January 5, 1487 (1488, new style) of a house near San Michele Bisdomini, and also claims ownership of a house in Prato, with a smaller house ("un chasolare") adjacent. This tallies accurately with the details of the will made in 1488 just before the departure for Rome. After this we hear nothing further of him until the Operarii report payment to him on June 17, 1500, as cited above. On November 27 of the same year he received another payment, of 134 lire, 2 soldi, 6 denarii, for the Strozzi chapel; the entry in the family's account book reads, "Filippo di Filippo dipintore dee avere a de 27 di novembre 1500 fiorini 134.2.6 per resto di quella se li deve dare, quando arà finita la capella di S. M. Novella." [19] From the wording of this it is evident that some of the work was at last completed, and had probably been under way for the past year or two if not longer. There are in addition a

[15] Lensi, *Palazzo Vecchio*, p. 115, n. 81. A. S. F., "Delib. e. Stanz. degli Operai d. Pal." X, c. 29ᵗ. "1500, 17 giugno. Filippo di Filippo dipintore sopra la pictura dell'Altare lire 205."

[16] Lensi, p. 115, n. 81.

[17] Cesare Guasti, *La Cupola di Santa Maria del Fiore* (Florence, 1857), p. 120.

[18] Gronau's biography in Thieme-Becker fails to mention it. It was cited by Milanesi (Milanesi-Vasari, III, 492) and part is reproduced in facsimile in *La Scrittura di artisti italiani*, which he published with Carlo Pini in 1876 (p. 78). The document itself is preserved in the Archivio di Stato, Quartiere S. Giovanni, Gonfalone Vaio.

[19] *Vita di Filippo Strozzi*, p. 62, n. 1. This particular entry has frequently been published.

few panel pictures which belong somewhere between 1497 and 1500; these I shall speak of before I take up the subject of the Strozzi frescoes.

First in importance is the superb altarpiece in Berlin (Kaiser Friedrich, number 96) representing Christ on the Cross between the Virgin and Saint Francis, with three small angels catching in chalices the blood from the Saviour's wounds (Fig. 69). The distinctive feature of this panel is its plain gold background, there being no landscape setting except the ground on which the Virgin and Saint Francis kneel — bare brown soil on which bones and skulls are scattered. Dr. Scharf, in an article to which I have already referred,[20] discusses in detail the painting and its history. He cites Vasari's reference [21] to a crucifix and two figures on a gold ground, in "S. Ruffello" (i.e., San Raffaello), and that of Borghini,[22] whose full description of the picture makes it probable that he was relying on his eyes as well as on memory, which was so often Vasari's only source (or rather, the only source he took the trouble to consult). Borghini places the Crucifixion in the Valori chapel of San Procolo; according to him it contained (I translate) "Christ on the cross on a gold ground, with three angels, who receive the blood of the wounds in chalices, and at the foot of the cross is the Madonna, and a Saint Francis showing the most profound feeling; and this panel is set between two pictures, in one of which is Saint John the Baptist, and in the other the Magdalen, figures executed with great care, and above the panel is a Saint Francis receiving the stigmata painted in fresco, and all this work is done in a sweet manner, which he first learned from his father, but improved." The 1807 edition of the *Riposo* adds "but the Saint Francis receiving the Stigmata is lost," and "this panel is now over the high altar with the other two pictures beside it."

Richa's publication of 1754 [23] says that in 1622 Giotto's Madonna was moved from the high altar, to be replaced by "the image of the Crucified on a gold ground with Mary and Saint Francis below, and two other compartments at the sides, in which are represented Saints John the Baptist and Magdalen, and in the other the Virgin Mary, and Saint Francis, which saints are said to be portraits of certain members of the Valori family; the

[20] "Studien zu einigen Spätwerken des Filippino Lippi," in *Jahrbuch der Preussischen Kunstsammlungen*, LII (1931), 20 ff.

[21] "In San Raffaello un Crucifisso e due figure in campo d'oro" (Milanesi-Vasari, III, 464–465). Milanesi here corrects Vasari's spelling of the name of the church, as Vasari himself seems to have done in the second edition of his *Vite*.

[22] *Il Riposo*, II (Milan, 1807), 144. [23] *Chiese fiorentine*, I, 239 and 254.

whole is by the hand of Fra Filippo Lippi, despite the fact that some regard
it as the work of Andrea del Castagno." Further on, he observes that in the
most recent rearrangement this also was removed, "and Fra Filippo's
Crucifix, which for many years had hung in the corridor behind the altar,
in the very year in which I write (1754) the abbot wanted it in the monas-
tery, and the panels of Saint John the Baptist, and of the Magdalen, are in
the Rector's house." [24] Judging from the entry in the 1807 edition of
Borghini, cited above, the three panels must have found their way back to
the high altar in San Procolo. Not long after this the Crucifixion panel was
bought by Solly and exhibited in his collection in the Berlin museum in
1821.

About this time the Academy in Florence acquired two panels of the
Baptist and Magdalen respectively (numbers 8653 and 8654) which, like
the Filippino Saint Jerome, were for a long time labeled Andrea del Cas-
tagno [25] (Figs. 70, 71). A less accurate attribution might indeed have been
made, for the harsh ugliness of the figures, while not, I think, derived from
Castagno, is paralleled in the latter's work. They are now universally ac-
cepted as late works by Filippino, and Dr. Scharf contends [26] that they are
the side pieces belonging to the Berlin "Crucified Christ." In answer to the
obvious objection that the Academy figures are restless and overemotional
in contrast to the repose of the Berlin panel, he points out that the angels in
the latter provide a connecting link, in their tragic feeling and windblown
draperies.

I confess I find it difficult to go as far as this and accept the two saints as
strictly contemporary with the "Christ on the Cross." The angels do not
satisfy me as a connecting link in style; their drapery is certainly restless, but
they have something of the restrained beauty even of the Uffizi panel of
1486, and not a trace of the harsh angularity and strained feeling of the
Academy saints. A parallel might be drawn between the latter and the Saint
Francis of the Berlin picture, who is the weakest part of it; the hands espe-
cially offer analogies, as does the bare foot with its protruding heel, a late
mannerism. The documentary evidence strongly supports Dr. Scharf; but
I cannot help feeling that, if the two saints did once form wings to the Berlin

[24] The original is quoted by Dr. Scharf, *Filippino Lippi*, p. 204, n. 1.
[25] Berenson's list calls the latter "Mary of Egypt," but I see no reason for this, as the figure
holds a conspicuous ointment jar.
[26] *Jahrbuch der Preussischen Kunstsammlungen*, LII (1931), 20 ff.

panel, the latter would have lost heavily by the juxtaposition. The Baptist and Magdalen are like caricatures of Filippino's late style, and even the sincerely felt, if exaggerated, spiritual content does not compensate for the unpleasantness of color and form. The ugliness may have been stressed deliberately for its tragic emotional effect, as is the case with similar subjects by Donatello, whose work in this vein may perhaps have influenced Filippino even at this late date.

Dr. Scharf suggests that the precepts of Savonarola with regard to religious painting may account for the gold background of the Berlin altarpiece, so unexpected in the latter Quattrocento. This I think is undoubtedly correct. As he observes, the theory is given weight by the fact that Francesco Valori, for whose chapel the picture was painted, was head of the Frateschi, ardent supporters of Savonarola.[27] Francesco died on April 8, 1498. Judging both from the style of the panel and from its apparent connection with the teachings of Savonarola, who was executed a few weeks later, this Francesco probably lived to see the finished altarpiece *in situ*. Dr. Scharf points out the obvious likenesses between the Virgin and the Saint Anne of the Copenhagen panel. Everything points to the year 1497 as that of the Crucifixion; at least, it is probably no later than the spring of 1498, and must have been under way earlier than that. As for the Academy panels, taken alone they would suggest a date about two years later, certainly not much before 1500. If they actually were part of the altarpiece of the Valori chapel, might they not have been added later to the central panel? I do not think they are the work of an assistant; had they been entrusted to some *garzone* in 1497, they would not have reflected so clearly the style of the master as it develops about the turn of the century.

There is, as Dr. Scharf remarks, no mention of a predella, which is a rare accessory in Filippino's work, and in general is less common in the late than in the early Quattrocento. I should scarcely go so far as to suggest that to the Berlin panel once belonged the Housman "Dead Christ with Joseph of Arimathea," discussed in the previous chapter, which, despite its stylistic affinities with the Berlin panel, I believe was painted rather earlier, nearer the time of the London Madonna. The angels are much the same; the

[27] Savonarola's disapproval of donors' portraits in pictures makes it unlikely that Richa is right in saying that Valori portraits occur in the altarpiece, under the guise of saints; but quite apart from this, there is no suggestion whatever of portraits in the heads, which are all stock types of Filippino's.

Christ almost identical in type, though the execution is freer and sketchier, as befits a work on a small scale.

A painter of less spiritual sensitiveness might have made the gold background appear as an awkward piece of archaism.[28] Filippino seems to have had sufficient spiritual kinship with the Middle Ages to achieve with his gold an effect truly analogous to that of his Italian, and perhaps even Byzantine, predecessors. This kinship consists partly in an ability to paint a religious picture as such — primarily for the glory of God rather than of the painter or of the patron. The resulting sincerity of feeling is perfectly inescapable and profoundly moving. Even allowing for the weakness of the Saint Francis (whose emaciation and impassioned expression recall the Spanish San Francisco rather than the generally healthier and less neurotic Poverello of Italy) I know of no devotional painting of the period more satisfactory, pervaded as it is with beauty of color and harmony of design, perfectly fused with the genuine religious feeling to which I have already referred. Such a picture deserves to be restored to its proper place over an altar.

The popularity of the San Procolo altarpiece is indicated by several extant copies and adaptations. Filippino himself repeated the theme on a banner preserved in the Horne museum in Florence, with the difference that the Virgin is standing and Saint John the Evangelist replaces Saint Francis. Badly damaged by exposure to weather, this faded ghost of its former self is interesting as the one example we have of the painter's work of this sort, for which Vasari tells us he was so much in demand.[29] The banner can scarcely be dated to any particular year, but it should belong not long after the Berlin panel — very likely some time before 1500.

The Jarves collection in New Haven has a small panel of the crucified Saviour on a dark background, a direct repetition of the Berlin example, though coarser and less careful in execution. This is either by Filippino

[28] Filippino's success in this case is only one of the many instances in the history of art which show that it is not the use of a traditional idea which weakens an archaistic or a derivative work of art, but the point of view behind its use. He was merely doing what so many painters of modern altarpieces fail altogether to achieve when they turn out pseudo-Angelicos of the most painful character. Instead of this spurious and empty medievalism, Filippino adapted a technical device of the Middle Ages and brought it into harmony with forms that were modern, and his own, infusing them with a genuine religious content which is in consequence perfectly communicated to the observer. He did not labor under the apparent delusion sometimes encountered today, that deliberate unsophistication makes for spiritual content in an altarpiece.

[29] I.e., accessories for processions and festivals. Vasari is, however, thinking of secular celebrations rather than those connected with the church. Dr. Scharf considers the banner a workshop piece; see p. 114 of his monograph.

himself or by a well-trained *bottega* assistant — quite possibly the former. Count von Miller Aicholz' collection in Vienna contained a similar picture, which I have not seen; Berenson used to accept it as genuine.[30] There must have been considerable demand for such pictures for purposes of private devotion, especially, no doubt, in the months preceding Savonarola's death, but also later, while the feeling of his supporters still ran high as a result of what they regarded as the martyrdom of a saint. I am able to cite one more example, in the Pinacoteca Communale, Montepulciano — a gallery which, in contrast to the architectural delights of that charming town, offers extraordinarily few attractions in the way of paintings. This is a ruinous little panel, from the hand of a poor copyist, in which the upper half of the Berlin picture, including the angels, is combined with the standing Virgin and Saint John of the Horne banner (Fig. 72). A kneeling Magdalen is added at the foot of the cross, and a landscape has been substituted for the gold background. As it is hardly likely that this copyist used the banner as a model for his figures of Mary and John, it is probable that he knew a variation of the Valori altarpiece by Filippino, now lost, which the master himself repeated on the banner.

Nothing definite is known about Filippino's attitude toward Savonarola. We can only guess as to whether he contributed anything to the bonfires of the Vanities of 1497 and 1498, along with his old teacher Botticelli, although the character of his surviving work suggests that the Dominican reformer would have found little to object to in his output. What can be deduced from his pictures as to his temperament makes it easy to believe that he sympathized with the religious revival. Vasari's character sketch suggests that there were few sins on his conscience (beyond, let us hope, the Strozzi chapel delays) but he seems also to have been popular with the gayer element of the city. For this association there is, of course, no date; very likely all Filippino's connection with pageantry and celebration goes back to his pre-Roman days, when Lorenzo was providing Florence with his Quattrocento bread and circuses. One can scarcely doubt that the nervous, dramatic element in his late work received some stimulus from the methods of the prior of San Marco. And yet — to come back to the Berlin "Crucified Christ" — how extraordinarily restrained it is! No gesture save the outstretched arm of Saint Francis; no agitated draperies except those of the

[30] It is not included in his 1932 list, and I am not certain as to its present whereabouts.

angels, stirred by flight and by the winds of Heaven. As in Spanish sculp-
ture a century and a half later, the emotion is conveyed through the faces,
expressive of an inner burning of the spirit. If Filippino's work is to be com-
pared to "Jesuit" art, the parallel must in this instance be drawn with
Pedro de Mena rather than with Guido Reni.

Another work on a small scale, of about this time, is the double panel in
the Seminario, Venice, one half representing "Christ and the Woman of
Samaria," the other the "Noli Me Tangere" (Fig. 73). They seem to have
been, originally, wings of a small triptych, for private use,[31] of which the
central panel is missing. Stylistically these belong between the Copenhagen
picture and the Strozzi frescoes; the fussy costume of the Samaritan woman
is paralleled in both, as is the well-curb with its mythological reliefs and the
ornate jug. Below each panel (of the Seminario) a pair of winged *putti*
support a cartouche, one reading SI SCIRES DONVM DEI (which occurs in the
Strozzi frescoes) and DA MIHI HANC AQVAM; the other, RABONI — NOLI ME
TANGERE. Each has a charming background with green hills and feathery
trees. In the "Samaritan Woman" there is a view of battlemented gates and
towers. In the "Noli Me Tangere" Filippino reverts to the pleasant old
practice of giving Christ a hoe — as did Fra Angelico in San Marco — that
Mary Magdalen may the more readily suppose him to be the gardener.
Granted the decadence shown by the feeble anatomy (for example, the ex-
cessively small feet and short legs) the panels have a charm which would no
doubt be overbalanced by the faults if the work were on a large scale; as it is,
they have a kind of lyric wistfulness and sentiment well calculated to appeal
to feminine taste.

Yet another minor work of the end of the century is the painting in the
spandrels around a sculptured Saint Sebastian (Fig. 75) in Sant' Ambrogio,
Florence.[32] The statue, of polychromed wood, stands in a niche between the
second and third altars to the left as one enters the church. Above the
Renaissance arch framing the niche are two flying angels in monochrome,
holding a crown between them (Fig. 74); on the frame below the statue is a
small round medallion with an Annunciation painted in colors, but dimmed
by dust and scratches.

[31] The subjects suggest that the triptych (or diptych) was ordered by a woman.
[32] I have discussed this work in an article in *Art in America*, June 1934, pp. 96–98, entitled "A
Pair of Angels by Filippino Lippi," of which the present account is a summary.

Most authorities have ascribed this work to Filippino, although Crowe and Cavalcaselle thought they showed Raffaellino del Garbo's manner.[33] The earliest writers seem, naturally enough, to have been more interested in the Saint Sebastian; Vasari says the sculptor was Leonardo del Tasso, a pupil of Andrea Sansovino's.[34] Richa made the obvious mistake of attributing the statue to the painter Andrea Comodi.[35] Milanesi [36] provides the information that below the statue is an inscription giving Leonardo del Tasso's name and recording his burial there in 1500. What has become of this inscription I do not know; it is no longer to be seen in Sant' Ambrogio, but may possibly exist under a wooden panel let into the wall below the niche, or perhaps this wooden panel replaces the slab with the inscription, which has been taken elsewhere and may even have been destroyed. The evidence contained in the inscription may, I think, be relied on, for Milanesi, for all his occasional slips, would hardly have made up such a statement out of whole cloth; and, moreover, we have Vasari's word for the attribution to Leonardo del Tasso, probably based on the same inscription.

If this Leonardo died in 1500, his death provides a *terminus ad quem* for the paintings, which were in all probability executed at the same time as the statue. Stylistically they belong to the last years of the Quattrocento. The angels have the small feet of the Seminario figures, the exaggerated heels of the Academy "Baptist" and "Magdalen," and much the same sort of drapery bundled clumsily about the figures with narrow strips of cloth. The rather coarse facial types, with thick lips, correspond to those of the Academy saints. The drawing of the hands and the way in which the drapery falls over them recall the Benson-Housman Pietà, as does the shape of the wings. Finally, there is a likeness to the pair of winged genii painted in brownish monochrome just below the window in the Strozzi chapel (Fig. 107). We have seen the motif of flying angels with crowns as far back as the Uffizi Madonna of 1486, and subsequently in the Oxford sketch which I suggested might be a study for the unfinished Consiglio panel, ordered in 1498. Altogether I have no doubt that the angels are from Filippino's hand, and to be dated between 1498 and 1500.

[33] *A History of Painting in Italy*, IV, 304.
[34] Vasari-LeMonnier, VIII, 173.
[35] *Chiese fiorentine*, vol. II, part 2, p. 242.
[36] Milanesi-Vasari, III, 348, n. 1. The inscription is quoted as reading: LEONARDVS TASSIVS CLEMENTIS F. D. HVIVS SEBASTIANI FICTOR, HIC CUM SVIS REQUIESCIT ANNO SAL. 1500.

The Annunciation on the lower part of the frame is also probably his, but so badly damaged that one cannot judge of its original quality. It must always have been a fairly perfunctory bit of ornament, rapidly sketched in.

Since the analogies with the Strozzi chapel are so close, I am inclined to see in the Sant' Ambrogio angels a kind of backhanded indication that the east wall of the Strozzi chapel was finished by 1500. The tomb, of course, would have to have been finished by 1494, the year of Benedetto da Maiano's death; and, in order to complete its setting, Filippino may well have begun with the east wall, that is, after finishing the vault, which would naturally have been undertaken first of all.

Perhaps about 1500 Filippino painted the two small panels in the collection of Sir Henry Bernhard Samuelson in London. Both have been identified as illustrating the life of Moses: one, the miracle of the water drawn from the rock; the other, the worship of the Golden Calf. The former identification is obviously correct; Moses, the usual horns of light issuing oddly from behind his ears, kneels to strike the rock, while the Children of Israel and their flocks gather around to drink. Some use ornate vessels of a type recalling the paraphernalia of Mars' temple in the Strozzi "Miracle of Saint Philip." Two elegant girls in billowy drapery pose self-consciously at the left, apparently in no hurry to join their companions; these clearly hark back to the attendants of Saint Anne in the Copenhagen panel, as Claude Phillips has pointed out.[37] Behind them one sees the medieval tents of the Israelites; across the back of the composition and to the right, a file of camels, and men, women, and children, proceed through a rather charming hilly landscape.

Claude Phillips has tried to show [38] that a man in a turban, seen in profile to the right, is enough like the portraits on medals of Matthias Corvinus to make it possible that this and its companion piece are the pictures sent to Hungary in 1488. He admits that the style does not tally with that date, seeming to belong to a time at least ten years later, yet he cannot resist the fascination of his own hypothesis. But as Poggi pointed out soon afterwards,[39] Mr. Phillips was careless in his reading of Filippino's will, for in that document the subjects of the Matthias Corvinus panels are given quite distinctly

[37] "Two Paintings by Filippino Lippi," *Art Journal*, January 1906, pp. 1 ff.
[38] *Art Journal*, January 1906, pp. 1 ff.
[39] "Due pitture finora ignoti di Filippino Lippi," *Rivista d'arte*, IV (1906), 106.

as Our Lady and Saints, which can by no stretch of the imagination be made to indicate the Samuelson pictures.

The second of these, known as "The Worship of the Golden Calf," would illustrate its title perfectly well were it not for the fact that instead of the immobile metal image made under Aaron's supervision and set up like a piece of sculpture, we here see a full grown and apparently living bull prancing in mid-air above the heads of the people, who sing, dance, and play fantastic musical instruments. Guido Cagnola [40] entered the discussion in order to challenge Mr. Phillips' suggestion that the crescent moon represented on the flank of the bull may be a zodiac sign; he prefers to interpret it as relating to some family's coat of arms. Finally in 1911 Mr. G. F. Hill [41] volunteered the suggestion that Mr. Phillips had been correct in associating the crescent with a sign of the zodiac, and that not only is "this 'Golden Calf' . . . nothing but the sign of Taurus," but it was very possibly based on certain engravings of the planets, which appeared about 1460. This seems to me a convincing proposal. I still believe that what Filippino had in mind as his subject was the worship of the Golden Calf, but one of the zodiac prints may readily have inspired his particular rendering of the theme. The two panels are undoubtedly parts of the same decorative scheme, as the whole style, and the repetition, in both, of such details as the tents, would indicate. Just how they were used is not certain; they are not of a size and shape suitable to a *cassone*, measuring $30\frac{1}{2}''$ x $53''$. Mr. Phillips [42] thought they might have formed part of some decorative ensemble such as Pontormo and others painted, Vasari says, for the wedding of Pier' Francisco Borgherini and Margherita di Roberto Accaiuoli, one of the subjects included having been the life of Joseph.

As to the date, all critics seem to be agreed in putting the panels near the end of the fifteenth century. Stylistically they show both the charm and the weakness of that period. The anatomy, particularly, is faulty, some of the poses being awkward to the point of ugliness; such details as hands, facial types, and drapery are perfectly characteristic. In the "Golden Calf" the lively movement is quite suitable to the subject and makes for pleasant ani-

[40] "Intorno a due dipinti di Filippino Lippi," *Rassegna d'arte*, VI (1906), 41–42.
[41] "On the 'Worship of the Golden Calf' by Filippino Lippi," *Burlington Magazine*, XX (1911), 171–172. In connection with the zodiac prints he cites Hind's *Catalogue of Early Italian Engravings* I (London, 1910), 48, etc., in which the print of Venus is reproduced.
[42] *Art Journal*, January 1906, pp. 1 ff.

mation. In both panels the landscape might be described as fantastic, realistically treated; if such hills existed, they would look like this in mild spring weather. Northern landscape is often so represented. Mr. Phillips thinks this work of Filippino's influenced Piero di Cosimo, but I am inclined to believe that the inspiration went the other way, in large measure at least. The gesturing woman to the left of the stolid cow, in the "Moses Striking the Rock," stirs memories of Piero's figures, such, for instance, as those in the "Hylas and the Nymphs," [43] formerly in the Benson collection and now in Hartford, Connecticut, although the latter is much earlier. The peasant strain and the hint of the grotesque and of caricature so often to be detected in Piero's work may have been responsible for the flavor of the Samuelson panels. Particularly the "Golden Calf" has the rather rowdy enthusiasm of a kermess or country fair, which does not seem to come quite naturally to Filippino, an essentially unfrivolous person.

Finally, one thinks again of the picture containing "piccole figure" done for Piero del Pugliese according to Vasari, and which he felt unable to repeat. This must have been some such decorative panel for a private apartment; and although this kind of remark by Vasari is not to be taken more seriously than his usual idle gossip, one can believe that Filippino was here a trifle out of his element. His best powers, in any case, were being devoted at this time to the frescoes in the Strozzi chapel, to which we must now turn.

[43] Dr. Panofsky regards this picture as representing a scene from the Vulcan myth. He discussed the subject in a lecture at the Fogg Museum, Cambridge, Mass., in February 1937.

CHAPTER VIII

THE LAST PERIOD: SECOND HALF

THE style observed in altarpieces from 1497 on, contains practically all the elements of that exhibited by the Strozzi frescoes. Types, drapery, architecture, even accessories, may be paralleled there, although the last-named, of course, occur in far greater profusion; so that if the actual work on the chapel was, as is usually stated, restricted mainly to the years 1500–1502, the continuity of style between 1497 and 1502 is striking indeed. But an examination of the dated altarpieces after 1500 reveals qualities not observable earlier; hence I believe that the frescoes were completely planned before the turn of the century, and that what had not been finished of the actual painting by 1500 had taken form in the master's mind and in cartoons, so that from 1500 until 1502 he had only to transfer to plaster ideas already visualized or organized. Altarpieces ordered after 1500, being entirely fresh commissions, stimulated his ever-active mind to new solutions of pictorial problems, and hence we find a distinct difference between, for example, the Bologna "Marriage of Saint Catherine" of 1501, and the last of the Strozzi frescoes, the "Raising of Drusiana," dated 1502.

This being my view, I was tempted to take up the Strozzi frescoes in the previous chapter, since their ideas and forms seem to me so closely related to the style of 1497–1500; but inasmuch as the year 1502 marks their completion I have decided to include them here. What I wish to make clear at the outset is that their real creation, in the mind of the artist if not in paint and plaster, seems to me to belong to the last years of the Quattrocento.

For Filippino the new century could have presented few events of significance. Destined to enjoy less than four years of it, he did not live to see the rise of the great Cinquecentisti, Raphael and Michelangelo. For him the Medici were exiled forever. Julius II did not succeed Alexander VI until the year before Filippino's death, the brief reign of Pius III occupying but a portion of the year 1503. But the French invasions continued; and ulti-

mately, as a result of them (for they drove him from Milan in 1500), Leonardo returned to Florence.

He came too late to have any fresh influence on Filippino, for it was 1503 when he reappeared, and then he did little that could have inspired a painter, spending his time largely on his scientific studies and inventions rather than on painting. He did not begin his designs for the "Battle of Anghiari" until the year of Filippino's death; Michelangelo did not receive the commission for the "Battle of Pisa" until 1505. Of the latter's works Filippino was destined to see only the David, which he helped to place on the Piazza della Signoria only a few weeks before his death, and never actually saw *in situ*.

There is a curious irony in the way in which the Fates seem to have timed the death of the painter virtually to the exact moment when the first great achievements of the Cinquecento began to appear. Little is to be gained by speculating as to the possible effect on Filippino of the Michelangelo of the Sistine Chapel, or of what would perhaps have been more to his taste — the Madonnas of Raphael. It is safe to guess that his art would have been none the better for the contact with either, and we may turn to his own last paintings, thankful that he was able to finish them unhampered by forces which would almost inevitably have done them harm.

The payment, in 1500, toward the Strozzi frescoes has already been mentioned, and probably represents, as I have said, compensation for more work than has generally been believed. I suggested in the previous chapter that the east wall must have been finished by that year. Vasari says that the painter began with the vault, implying for it a date in the early nineties, just after Filippino's return from Rome. While this is certainly too early for the existing work, one can readily believe that the vault was the first part of the scheme to be undertaken. This seems to have been the usual practice,[1] as may be seen, for example, in the chapel of San Brizio in Orvieto cathedral, where Signorelli, called in to complete the frescoes begun by Fra Angelico, found the vault the only finished portion.

The subject of the Strozzi ceiling had been specified in the original contract of April 21, 1487, as follows: "In the vault there shall be four figures of Doctors or Evangelists or others, at the pleasure of the said Strozzi,

[1] Common sense would indicate this order of procedure, since by working downwards one may avoid possible damage to the parts already completed.

and they shall be adorned as richly as possible with blue and gold; the rest of the vault all of fine ultramarine blue, at least to the value of four florins of standard weight." [2] Filippo Strozzi clearly had in mind the typical Quattrocento scheme of vault decoration, symmetrical and monotonous, such as was painted by Fra Angelico and Benozzo, and was, a few years after his contract with Filippino, to appear in Ghirlandaio's chapel adjacent to his own; indeed, this part of the decoration (i.e., Ghirlandaio's) may have been finished by 1487.

In Santa Maria Novella Filippino took advantage of the noncommittal word "altri" in the contract, to paint, not the conventional Evangelists or Church Fathers, but the figures of four Patriarchs of the Old Testament. If Filippo Strozzi had anything to do with the choice of this iconography we have no record of it. One possible source for the idea, beyond Filippino's imagination, may perhaps be found in the Baldovinetti chapel in Santa Trinità, the value of which Filippino helped to estimate. The figures in the four vaulting compartments of this chapel are Abraham, Noah, Moses, and David; the committee's report is dated January 19, 1497.[3] The same year saw the completion of the Copenhagen panel, a thoroughgoing example of what might be called Filippino's Strozzi style, offering as it does such close analogies with the frescoes. Might not the painter, anxious to get away from the unavoidable monotony of "Dottori o Vangelisti" have seized upon the ideas embodied in Baldovinetti's vault, as offering much richer opportunities for variety of treatment, especially in costume and accessories? I am strongly tempted to believe that he did just that, setting to work in 1497, perhaps soon after the meeting of the committee in Santa Trinità.

He could, of course, have borrowed nothing from Baldovinetti beyond the iconography, and in that he substitutes Jacob for the older painter's David, Adam for Moses. The Patriarchs of the Gianfigliazzi chapel are about as conventionally monotonous in pose as anything in Fra Angelico's day; each figure sits facing forward, on a kind of flat crescent-shaped mass of cloud, and there is only the barest suggestion of torsion in the poses — at

[2] Strozzi, *Vita*, p. 60: "Nel cielo abbiano a essere quattro figure o Dottori o Vangelists o altri, a elezione del detto Strozzo, e siano ornato d'azzurro oltremarino fine, almeno di pregio di fiorini quattro larghi d'oncia."

[3] Horne, *Burlington Magazine*, II (1903), June, July, and August. Baldovinetti's vault is reproduced opposite p. 170; the document occurs on pp. 353 ff. These frescoes were ordered on July 1, 1471 (*ibid.*, p. 169), so that Baldovinetti is seen to have been guilty of even greater procrastination than was Filippino.

most a slight turn sidewise of head or knee. Filippino, ignoring the contract's specifications of blue and gold (he used them sparingly throughout the chapel), produced a compensating richness of effect through lavish ornament and unprecedented elaborateness of agitated design. Surely Filippo Strozzi never visualized such a "cielo" as this one, in which Annibale Carracci would have recognized a kindred spirit. With this vault he reasserts the Baroque feeling first developed in the Minerva. Anything more spiritually and visually akin to the Bolognese and their artistic descendants it would be difficult to find in the Quattrocento. The problem of foreshortening objects seen from below has not concerned him except superficially, and in that respect he is less a prophet of Baroque ceiling decoration than Mantegna or Melozzo da Forlì. On the other hand, he outdoes both these predecessors in violent movement and intense emotion. His work is of interest and importance as a stage in the development of an essentially Baroque style without benefit of Michelangelo.

The four sections of the quadripartite vault are separated by broad bands simulating ribs, and richly decorated with volutes, palmettes, masks, and the triple crescent of the Strozzi, the whole being edged with painted mouldings in which the bead-and-reel occurs. Each patriarch sits on clouds from which emerge *putti* holding cartouches of various shapes suspended from ribbons, two to a compartment, giving in each case the name of the figure and the word PRIARCHA (Patriarcha). These fill out the lower corners of each triangle. As in the Caraffa chapel, Filippino has managed to vary the poses, all of which show marked *contrapposto*, with great skill and originality.

Adam (Fig. 76) looks like the shepherd of the Copenhagen "Joachim and Anna," both in type and costume. He turns his head, with an almost Jesuitical expression of emotion, to the woman-headed serpent coiled around a fig tree with authentic leaves and fruit. A small boy, doubtless Cain the first-born, huddles against his father, one hand on the latter's hoe. Adam's garment, which blows out in a great curve from his shoulder, is of cowhide; the head hangs over his knee, and the skin of the hind legs, cloven hoofs and all, is knotted on his breast.

The pervading note of remorse and foreboding in the group contrasts strikingly with the triumphant energy of the Minerva sibyls. These figures seem to express the personal feelings of the painter and to epitomize the whole distraught and unhappy state of Florence herself at the end of the

century. Under what different auspices had the Caraffa chapel been painted! There Filippino was a much-praised figure, recommended to a powerful ecclesiastic by the greatest patron of the day, and working in the midst of what must have been the most congenial surroundings; small wonder if the note of rejoicing pervades the frescoes of the Minerva. But he came to the Strozzi filled with remorse, one feels sure, his patron dead perhaps before he set brush to plaster; the Medici exiled, Savonarola conjuring up visions of hell which actual events were bringing to men's immediate experience in the form of warfare, all manner of civil difficulties and disturbances certain to prey upon a sensitive spirit such as Filippino's. What sermons of Savonarola's on sin and the fall of man may not have been in the painter's mind when he drew Adam protecting his frightened child? He lacks the power to give the scene the epic grandeur, the tragic pity and terror with which Masaccio could have infused it (with Michelangelo there would have been no pity, only terror); yet I doubt if either of these greater painters could have conveyed such human tenderness and pathos.

Noah (Fig. 77), next in chronological order, is derived from an antique river god, with a cornucopia in one arm. He is frowning over a book. To the left is the ark with a pair of doves at the door, and on the other side of the patriarch a sizeable and realistic olive branch. "G. Gherardi" has used one of the ribbons of Noah's name plate to record the fact that he restored the work in 1859; he is to be thanked for doing a minimum of damage in the process, and sparing us the distressing effects seen in the Caraffa chapel.

Filippino has violated chronology by putting Jacob next, before Abraham (Fig. 78). He is also reading, with his back to the book so that he has to twist his head and shoulders around to see the pages — a case of *contrapposto* not very logically motivated, but a variation of the attitude borrowed from Pollaiuolo in Rome. One hand holds the vessel with which he poured the oil on the stone pillar after his dream of the ladder; from the other flutters a scroll bearing the inscription HEC EST DOMVS DEI ET PORTA (coeli).[4] As usual, the hair and drapery seem to be caught in a high wind.

Abraham (Fig. 79), of the type of a hoary Deus Pater, looks too over-burdened with draperies to rise. Isaac, curiously enough, is missing; the sacrifice is symbolized by the knife and by an altar decorated with rams' heads and bas-reliefs. The very small head of the ram offered in Isaac's

[4] Genesis 28:17.

place hangs limply over the edge of the altar, which is drawn in perspective as though seen from below. It is significant that Filippino ignores the Biblical altar built of stones, and introduces instead a piece of classical furniture.

Such is the exuberance of antique detail in the decoration of the east wall of the chapel that one would suspect the painter of acquaintance with North Italian Renaissance architecture (Fig. 46). Compared with this the sober, proto-Bramantesque buildings of the "Triumph of Saint Thomas" are the more astounding; the former is much more what we should have expected of Filippino in Rome. I have already suggested that the Strozzi fresco may actually contain borrowings from Milan transmitted through the drawings of Giuliano da Sangallo, who visited that city in 1492–93 and who was engaged upon the Palazzo Strozzi at just the time when Filippino was, I believe, at work in Santa Maria Novella. As co-workers for the Strozzi they must certainly have known each other, the acquaintance quite possibly dating back to the eighties. The candelabra introduced in the embrasure of the tall lancet window particularly suggests Lombard Renaissance taste. As at Poggio a Caiano, the elaborated columns of the Arch of Constantine are introduced. The Roman eagle, sphinxes, and simulated bas-reliefs all contribute to the general ornateness of effect. Superimposed on the classic and pseudo-classic paraphernalia are animated angels with ribbons, shields of the Strozzi, tablets with more or less obscure inscriptions, and a kind of cupboard with skulls, presided over by the two genii whom I have compared to the Sant' Ambrogio angels. One of the music-making *putti* who accompanies "Parthenice" is playing a double flute of a type sometimes met with in antique sculpture. The two allegorical figures to the right of the window, with a harp between them, were borrowed at least twice to be used as a separate composition. Robetta used them in an engraving; and in 1930 I saw a photograph of a design taken from the same group, perhaps intended as a decoration for a mirror.[5]

In color this wall is chiefly a brownish monochrome, relieved very pleasantly by touches of blue and gold. Filippo Strozzi might have preferred more of the latter, but Filippino shows good taste in keeping the tone of the wall subdued in order that the glass may have its full effect by contrast —

[5] This was shown me by Mr. F. F. Mason Perkins, who told me at the time that the little picture was in private hands in Genoa. I judged it to be the work of an assistant or imitator rather than that of Filippino himself.

since color that is partly pure light will always make opaque pigments seem less brilliant. Filippino designed the window, introducing a standing Madonna and Child not unlike those of the Prato Tabernacle, and highly characteristic attendant angels, with Saints Philip and John the Evangelist seated in the compartment below. This really fine window (which would doubtless benefit greatly by cleaning) emphasizes deep green and sapphire blue. Even in its darkened state it is very lovely, the color being permitted to count primarily as such and not, as often happens in Renaissance glass, being made a means of emphasizing the picture represented. One wonders how the window in Tanai de' Nerli's chapel compared with this.

The side walls of the chapel are too well known and too often reproduced to require a detailed description here. Filippino must either have painted the two lunettes first, or the entire right-hand wall, since the date of completion is introduced in the "Raising of Drusiana" to the left. The Miracle and Martyrdom of Saint Philip are singled out by Vasari for special encomiums. His appreciation is only one of our proofs that Filippino was a progressive, painting for the future. The more austere taste of recent generations has seen fit to choose these frescoes for particular derision and censure.

Let us consider first the "Miracle of Saint Philip" (Fig. 80). Upon an almost Baroque altar of bronze and colored marbles,[6] Filippino has set up as rich and bizarre an assortment of antique and pseudo-antique objects as ever cluttered up the rooms of an enthusiastic but ignorant amateur. The fantastic statue of Mars, on his ornate pedestal, loses all prominence in the welter of weapons, ewers, dishes, bits of armor — even a fragment of an iron-studded chariot-wheel. Above, winged Victories subdue bound captives almost exactly like those on the Golden Gate in the Copenhagen panel. Extremely ornate pilasters frame the picture on either side. In costuming the soldiers and citizenry, Filippino has allowed his imagination full play. Most startling is his conception of Roman armor, which has a great deal more to do with sixteenth-century harness than with the greaves and breastplates of the Tenth Legion, and would be hopelessly cumbersome to move about in. If he made studies of such antique representations of armor as he could have seen, for instance, on the Column of Trajan, he interpreted them with great freedom. Witness the unfortunate being to the left in the "Miracle," whose arm emerges from a lion's mouth of bronze, and who can barely

[6] Borromini, one fancies, might have appreciated an altar so designed, but not Palladio!

lift his chin above his massive collar! Mantegna's Roman soldiers are a hundred times more authentic. Nor can Filippino quite get away from the idea of Gothic armor. The statue of Mars wears excellent fifteenth-century leg defenses and sollerets, although so far as I know the Romans never wore any kind of metal protection on their feet. Incidentally, was there no sketch in Filippino's notebook that could have provided an antique model more historically correct? The head of the Mars is one of his stock types, whereas he might have attempted a closer imitation of Roman sculpture. Amico di Sandro came much nearer to the antique in the statue he placed on a high pedestal in the "Death of Virginia."

A toning down of all its paraphernalia might well improve the fresco as a whole. But many critics have been so busy condemning the decorative excesses that they have overlooked certain quite definite virtues. In the first place the general composition is good, the Temple of Mars providing an effective central motif comparable to the throne of Saint Thomas in Rome; the principal characters in the drama are well arranged with reference to their relative importance: Saint Philip in the foreground — a dignified figure not unworthy of his direct ancestor, the Saint Paul of the Brancacci; the discomfited priest of Mars, who, if he does suggest a Joachim driven from the altar, is none the less effective as he turns away from the false god who has failed him; the dragon in the center with the dead youth to the right, in the arms of a turbaned servant, the group of spectators on both sides keeping well out of the way of the chief actors. This seems to me one of Filippino's most successful excursions into the dramatic, albeit it suggests the arrested movement of an overtheatrical *tableau vivant*. Yet how much better focussed this is, from the standpoint of action and subject, than the "Bene Scripsisti" of the Minerva! Surely it is very far from being a failure.

I shall not quarrel with anyone who objects to the color of the architecture here; it is distinctly disagreeable, and tends to overshadow the pleasanter tonality of the figures and drapery. Filippino was here definitely imitating builders' materials, combined with doubtful taste.

The "Martyrdom of Saint Philip" (Fig. 81) in the lunette above is far less successful dramatically; it is primarily a study in mechanics. The comparatively simple treatment of the similar theme in the Brancacci "Crucifixion of Saint Peter" is here carried to an extreme. Every detail of strain and

balance has been considered; one holds one's breath for the shock when the cross shall drop into the hole prepared for it. This is a step on the way toward Tintoretto's great Crucifixion in the Scuola di San Rocco.[7] Antique fragments have been pressed into service; one rope is wound around a broken pier faced with arabesques, and a marble capital provides leverage for the pole that pushes the base of the cross toward the hole. The lines of ropes and ladders, forming a triangle the apex of which is off center, provides an effective basis for the design of the whole composition. If Pollaiuolo would have rendered muscular strain more convincingly, I think we must acknowledge, nevertheless, that Filippino has achieved success in composition as well as in mechanics. He does lay himself open to the charge of wrong emphasis, since it is the slowly, jerkily shifting cross that we are forced to think of, not the tragedy or heroism of martyrdom. In Filippino's defense it may be said that this is, after all, a scene frankly intended as narrative, not devotional. He has chosen to emphasize the point of view of the bystanders or the slaves, the very callousness of whom, evinced by their brisk businesslike manner, may even serve to arouse in the living spectator a kind of righteous resentment.

Mengin suggests [8] that the man and boy to the left of the lunette may be portraits of Filippo Strozzi and his son Giovanni Battista, who was given his father's name after the latter's death in 1491. He cites as proof the busts of Filippo Strozzi in the Louvre and Berlin by Benedetto da Maiano, the former, in marble, having been made for the chapel. I admit the possibility that these are portraits, but I do not think they are much more striking as actual persons than are the similar figures in the Brancacci "Resurrection of the Boy," the "Triumph of Saint Thomas," or even elsewhere in the Strozzi chapel.

On the opposite wall the Roman emperor (who should be Diocletian) is directing the martyrdom of Saint John the Evangelist (Fig. 82). He looks much like the proconsul of the Brancacci, and is attended by a similar bearded man with a turban. Filippino's new classicism introduces a helmeted soldier and a lictor with the emblem of modern Fascism. Slaves,

[7] A step, that is, in the sense that both stress the mechanics of setting up the cross, resolving the design into elements of thrust and counterthrust expressed in diagonals reacting on one another. Filippino, of course, is designing essentially in two dimensions, Tintoretto in three; the former was feeling his way tentatively toward what the latter carried off with magnificent boldness and success.

[8] *Les Deux Lippi*, p. 187.

directed by a centurion in full panoply (including "Gothic" sollerets) feed the fire, giving every indication that the heat is unbearable. The emperor rises from his throne and points angrily, either to the saint, whose calm endurance he finds intolerable, or to the cringing slave who, faggot in hand, crouches behind a shield to avoid the blaze. The scene is rather better realized dramatically and emotionally than the "Martyrdom of Saint Philip." The setting is effective, with a more modified use of antique details. Plenty of classical stage properties are introduced, of course — a trophy of armor hung up between the temple columns, a banner fastened in a curious bracket, a Roman standard. The asymmetry of the architectural setting is particularly satisfactory in effect.

A somewhat similar arrangement, though in reverse, has been adapted for the "Raising of Drusiana" (Fig. 83). To the right is a polygonal temple richly decorated with reliefs and statues, including sphinxes arranged rather like medieval gargoyles; to the left of the center is visible a sculptured altar inscribed ORGIA. A charmingly decorative cinerary urn stands on this; it bears the letters D. M. (i.e., *Dis Manibus*, the conventional beginning of a Roman funerary inscription) and two music-making centaurs flanked by a pair of boar's heads at the angles of the urn. Behind this memorial is another section of arcade, partly in ruins; this was doubtless thought of as a canopy for another cinerary urn, as Filippino seems to have intended the setting to be the cemetery to which Drusiana is being carried. The priest to the extreme left, for instance, carries a round urn carved with birds, *putti*, and again the letters D. M.

In spite of the general and detailed elaboration of the composition the principal figures are given adequate prominence, although the Evangelist is lacking in real majesty. In Drusiana Filippino has a figure more sympathetic to his temperament. He is always a more subtle interpreter of feminine than of masculine emotions. The genuine feeling in Drusiana saves her from theatricality. Indeed, it is she, rather than the saint, who dominates the scene. It is not the power of God working through man that we are made to feel, but the surprise and joy of one suddenly aroused from a sleep of which she herself was unaware.

The genre touch of the children in the group to the right, frightened by a dog and clinging to their mothers, is sometimes criticized as irrelevant and therefore detrimental to the effect as a whole. Vasari may be right when he

says [9] that Filippino intended to contrast the children's emotion over a trivial incident with that of their elders in the presence of a miracle.

I remarked in connection with the Poggio a Caiano fresco that, as is so often the case with Filippino, the sketch for this fresco shows more vivacity than the finished work. But to condemn the painting as over-excited, cluttered with accessories, and whirling with hysterical movement, is, I think, to judge it too completely by its details, which are more conspicuous in a photograph than in the fresco itself.[10] An unprejudiced taste should find much to admire in the cool, sober color with its notes of grey, light green, and mauve, in the breadth of the architectural setting, and in the spacious sky. Because Filippino once submitted to the discipline of Masaccio it will not do to condemn him if his personal style does not continue as an imitation of that master. If the classical accessories are misunderstood and scattered with too lavish a hand, we should nevertheless give Filippino some credit for experimenting with new material. His is a healthy exuberance in which his own enjoyment is everywhere manifest. Never was a classicist less coldly theoretical. He relishes and plays with the antique very much as Horace Walpole enjoyed his eighteenth-century "Gothick," although doubtless the former took his hobby more seriously.

I should be the last to suggest that the Strozzi chapel shows no signs of decadence. They are plainly to be seen in the rendering of anatomy, which since 1497 had been weakening. Hands, particularly, are carelessly drawn; attitudes are sometimes awkward, or bodies poorly articulated — for example, that of the dying boy in the "Miracle of Saint Philip." Types are coarser, drapery tends to be bunchy and stringy, and form as such is incompletely suggested. Even hair, once among the loveliest of Filippino's naturalistic details, has lost its delicate quality. Above all, there is a smallness of scale about the figures, which have a kind of spindly, almost petty character in sharp contrast to the full, dignified types characteristic of the Cinquecento. This is partly due to the fact that Filippino is incapable of that lofty detachment we find in such a man as Raphael — even in lesser spirits of the sixteenth century such as Albertinelli and Fra Bartolommeo. It is not in him to generalize; he is too introspective, too personal, too easily moved. The

[9] Milanesi-Vasari, III, 472.
[10] Photographs of this fresco are distinctly misleading. The small scale of such reproductions serves to exaggerate the crowded effect, and also to indicate contrasts of light and dark which are much less insistent in actuality.

confusion objected to in the frescoes is the confusion felt by the characters themselves, caught in situations of excitement and emotional strain; and much of it is directly communicated to the observer, with a resulting discomfort which is perfectly natural. The consequence, however, is an inevitable loss of grandeur. Nevertheless the work as a whole seems to me to be a fine piece of decoration in the Baroque spirit, which can be admired and enjoyed quite as much after as before looking at Ghirlandaio's thoroughly Quattrocento frescoes in the adjacent chapel.[11]

Is it too much to believe that when Filippino signed his receipt in 1500 he had completed as much as half the chapel? The only thing which would in my opinion prevent such a conclusion is the date 1502, for if there were still two years of work to be done, one would naturally assume that not much progress had been made. But there is ample evidence that he was working on other commissions of importance between 1500 and 1502, so that the painting of even one wall of the chapel might have been stretched over two years.[12] As a matter of fact, we do not know in what month the work was finished; according to the old Florentine system of dating it cannot have been earlier than March 25 of the year we should designate as 1502, but it may have been in the spring or early summer. On the other hand, what better excuse could Filippino have had for failing to carry out the commission of May 1498, for the Signoria, than that he was hard at work in Santa Maria Novella? This I believe was actually the case.

As for the altarpieces which shared with fresco Filippino's attention at the turn of the century, the first is one painted for a member of the Casali, a family important in Bologna and Piacenza. It is still hanging in what was probably its original place, the chapel to the right of the high altar in San Domenico, Bologna. The subject is the marriage of Saint Catherine of Alexandria with Saints John the Baptist, Peter, Paul, and Sebastian (Fig. 84). There was little need for the painter to print, on a fragment of wood (or stone) painted in the corner of the picture: OPVS PHILIPPINO FLOR. PICT. A. S. MCCCCCI, for there can be no question of the picture's authenticity, the style being characteristic of his last period. The date is nevertheless a welcome detail, showing as it does that the panel was finished some months

[11] It is so much finer than one has been brought up to expect that, indeed, one's first view is apt to be a genuinely exciting experience.

[12] Vasari, it will be remembered, remarks that he worked on the chapel "con suo commodo" (Milanesi-Vasari, III, 469).

earlier than the Strozzi chapel. In general the formula of Filippino's previous "holy conversations" has been followed; how like this is, for example, to the arrangement seen in the Uffizi drawing which I have suggested may have been a study for the Signoria commission of 1498![13] But the group shows a new unity of dramatic content as contrasted with the earlier altarpieces, and there is subtle characterization, in the faces of the masculine saints particularly. The ceremony is performed with reverent gravity; no one smiles. As always, Filippino takes his sacred subjects with complete seriousness. Our Lady as Filippino paints her makes no attempt to attract the worshipper, as do the Madonnas of Perugino, for example; her concern is nearly always directly with her Son, or with the saint whom she honors with her presence.

It may be noted that the Virgin here wears, instead of the ornate headdress or coiffure of the 1496 Epiphany, the simpler transparent veil of the London Madonna. Her eyes rest on the Child, whom she supports as he stands on her left knee. This very engaging Bambino leans forward toward Saint Catherine, steadying her hand with his own as he prepares to slip a large pearl ring on her finger. The latter saint is a repetition of herself as she appears in the Prato tabernacle, except for the long slim hand raised to receive the ring. Again one notes the "blunt" drapery folds seen in work of the nineties.

The masculine saints are perfectly characteristic types, all but the Saint Sebastian, whose body is decidedly heavier and more solid than other nudes of Filippino's. An explanation of this is suggested by Vasari's statement that the painter collaborated with Andrea Sansovino on an altarpiece for Lucca.[14] No trace of this is known to exist; the nearest we can come to paralleling such work in the painter's extant *œuvre* is the painted decoration he provided for Leonardo del Tasso's Saint Sebastian, discussed in the previous chapter. There is no reason why Filippino should not have done such work as Vasari describes; at any rate, the Bologna Saint Sebastian indicates the influence of sculpture, specifically of early Cinquecento style, and the preceptor may well have been Sansovino, whose place in rela-

[13] The drawing can, of course, have no connection with the Bologna picture, owing to the difference in central theme and number of saints.

[14] Milanesi-Vasari, III, 466. Milanesi, n. 3, pp. 466–467, says, "Dalla descrizione della chiesa di San Ponziano, anteriore alla soppressione della medesima (che leggesi nella *Guida* di Lucca compilata dal Trenta e dal San Quintino), relevasi che la tavola qui nominata fin d'allora non era più in detto luogo."

tion to early sixteenth-century sculpture is analogous to that of Filippino in painting.[15]

The head of the saint is ill-suited to the heavy body, being a good example of the painter's most characteristic youthful male type — frail and slightly feminine as to feature, with tangled dark curls falling to the shoulders, and parted lips. The other heads are equally typical. Saint Paul's right hand, raised palm upward with the fingers separated and drawn back slightly, is precisely of the sort that is repeated with almost monotonous frequency in the Strozzi frescoes, and begins to be noticeable in the Epiphany. The Baptist's left hand reflects something of Filippino's skill in the eighties; it is a duplication in reverse of the right hand of the Saint Bernard of the Uffizi Madonna. The rest of the Baptist's figure is less successful, with some awkwardness in its articulation which is not wholly concealed by the cloak.

Saint Joseph, crouching in the loggia to the left, suggests that Filippino had continued to be interested in Flemish painting. It is worth noting that the distant town behind him is essentially medieval architecturally, in spite of one building with a dome. A vista seen just between Saint Catherine and the Child reveals an arch and a round fortress-like structure, both crenelated. This persistence in showing medieval towns suggests that for all his classicism Filippino's mental picture of a town was one essentially of the Middle Ages in character even after a century of Renaissance building in Italy.[16]

In the immediate architectural surroundings of the group, classical elements appear, freely interpreted and by no means ornate. These include curious capitals with egg-and-dart mouldings around the echinus; the same motif decorates the modest cornice of a kind of portico with a pediment seen from the side, in perspective. The opposite side is more massive; a frieze of trophies, armor, and allegorical figures is placed below the severely plain cornice, the Casali arms lower still. Six angels, grouped in pairs, balance themselves precariously on the cornices. Some of them show the familiar "lunging" position, and each carries a lighted candlestick. In general they

[15] It is interesting to find Vasari seizing upon the Saint Sebastian as the most striking figure in the altarpiece, as he seems to do when he refers to the picture as "un San Bastiano" (Milanesi-Vasari, III, 467).

[16] Even Rome was full of medieval buildings in his day; neither the splendid Baroque which contributes so much to the effect of modern Rome, nor the systematically restored and excavated antique remains, had yet replaced the crowded structures of earlier centuries. This is illustrated in old prints and drawings, of the Cinquecento and later.

recall in type and drapery those of the Berlin Crucifix. Perhaps, too, they reveal a memory of that motif of figures leaning over parapets, developed in the Minerva frescoes and used again at Poggio a Caiano.

One more element of the antique is introduced, i.e., the Sphinx at the base of the Virgin's altar-like throne, but this is of a type familiar on Quattrocento tombs, and does not indicate any advance in archaeological knowledge.

A note of realism in the accessories suggests, like the Saint Joseph, continued influence from Flanders: the carefully wrought and polished hilt of Saint Paul's sword, Saint Sebastian's arrows and the cord cutting into the flesh of his arms, Saint Peter's abnormally large keys, the fragment of Saint Catherine's wheel, and the pearl ring held by the Child.

In color the panel sets a new note, and one which can be found duplicated in other altarpieces of the 1500's. The tendency to darker tones, modified with grey or black, which seems to have begun in the nineties, here becomes more emphatic. This is due in part, I think, to Piero di Cosimo's way of treating color about 1500 (in the Madonna and Saints of the Innocenti, for instance, or the Assumption of the Uffizi, probably a little later). His palette is more restricted, and shows more striking contrasts than did Filippino's when the two painters first began to influence each other.[17] Broadly speaking, this is a Cinquecento use of color,[18] and its reflection in the last altarpieces of Filippino sets them in clear contrast with what I have called the "Strozzi style" of the latter nineties. In the Bologna panel the presence of black in the tones is distinctly felt, most obviously in the shadows but tinging the brighter hues throughout and giving a tonal unity to the whole such as is rather the exception in the early work. It has a somber richness in strong contrast to the brightness and variety of the eighties. Wine red, brown, the jewel-like deep green-blue of thick bottle glass, with occasional touches of gold, combine to make this one of Filippino's most interesting and satisfactory works from the point of view of color.

Early in the following year, Filippino undertook an important commis-

[17] Piero's "Madonna and Saints" in the Spedale degli Innocenti introduces a Filippinesque head in the background of the group to the left.
[18] Piero's fondness for setting an accent of bright red against dark green, with no other strongly assertive tones, illustrates the sort of thing I mean. Ridolfo Ghirlandaio now and then gives us a somewhat similar effect; I recall particularly the magnificent portrait in the Pitti, in which rich dark red and black are set against cool flesh tones and greyish white. Something of the flavor of this seems to me to be present in the Bologna altarpiece of Filippino.

sion for his birthplace, Prato. On December 16, 1501,[19] the "Octo Defen-
sores et Vexillifer" of that town voted that steps be taken toward the
completion of a panel for their audience chamber—"quod valde indecens est
in dicta audientia nullam habere imaginem Dei vel Sanctorum eius." They
had reason to take steps, for as much as a decade earlier (1491) they had de-
cided on such a picture, "in forme rotunda, in qua quidem tabula pingi
debebat imago gloriosissima Virginis Mariae . . . cum imaginibus Sanctorum
Sptephani [sic] Protomartyris et Leonardi utrimque collocatis . . . ad
excitandas mentes hominum qui eo loci convenient, ut imaginem ipsam
beatae Virginis venerarentur habernetque eam veluti in testem omnium
negociorum, quae ibidem publice agerentur." On November 19, 1493, the
panel was again under discussion, with a unanimous vote that the work be
commenced. On November 26 of the same year the question of a committee
to take charge of the painting and installation of the picture was discussed;
less than two weeks later two members of the council, Antonio di Filippo
Salvi and Ser Galeazzo di Giovanni Pugliese, were elected to direct the
undertaking.

Political and other difficulties prevented any actual work on the altar-
piece (apparently not even the painter was chosen), for the next notice we
have is the one cited above, of December 16, 1501. Nothing definite was
done on that date or on the next recorded, January 19, 1502 (new style). On
January 26 it was agreed that "Inasmuch as Filippo of Florence is a dis-
tinguished painter, and because he was brought up in Prato, and values and
loves this town of ours and all its citizens, and earnestly desires to gratify
them to the best of his ability; therefore it seems good to them that the work
of painting the said panel be given and consigned to him."

About three weeks later (February 13) yet another meeting was held;
this time the picture was described as "in formam hemicycli" in contrast to
the "rotunda" originally decided upon, and in place of Saint Leonard
Saint John the Baptist was specified. Then follow, in the records, the terms
of the contract: Filippino is to decorate the panel and its frame with "auro
fini et buono," at his own expense; ultramarine is to be used "sine parsi-
monia in locis dictae picturae eiusmodi colorem requirentibus, ad usum boni
pictoris." The work is to be done "in civitate . . . Florentiae ubi habitat,

[19] The documents here referred to and partially quoted are published by Gaetano Guasti in
Alcuni Quadri della galleria comunale di Prato discritti e illustrati con documenti inediti (Prato, 1558);
Dr. Scharf also prints them.

et non in terra Prati"; the price, covering expenses incurred by the painter, is fixed at thirty florins "auri in auro." A note is added to the effect that Filippino remitted "florenos duos largos auri in auro, quos exposuerat de suo pro gabella et vehectura dictae tabulae." The transportation here referred to is obviously that of the unpainted panel to the studio in Florence.

On February 15 "Cippi Francisci Marci" is authorized to advance whatever may be necessary for the progress of the work. Such a payment was made on June 10, 1502,[20] when ten florins were issued for the purchase of gold and blue. The payment of the balance was recorded on April 28 of the following year, 1503. An entry of February 23, 1502 (new style), records the payment of sixteen soldi to Silvestro Papino di Cavagliano "for the transportation of the said panel to be painted, from Prato to Florence; the panel was consigned to the said painter Filippino to be painted in Florence" ("pro vehectura dictae tabulae pingendae, delate a terra Prati ad civitatem Florentiae; quae tabula consignata fuit dicto Filippino pictori ad pingendum in civitate Florentiae").

Apparently both perfect documentation and perfect preservation of the picture so recorded is more than we can expect, for this panel, which is still to be seen in the Municipio for which it was painted, is now an unpleasant caricature of its former self, owing to crude and careless repainting. Nothing can be said to exist of Filippino's own work except the design.[21] The panel conforms to the specifications laid down in the contract of 1501, although not quite a "hemicycle," being rather a rectangle with a rounded top, the panel as a whole shaped like a stilted round arch. The height is somewhat greater than the width. Our Lady is seated in a landscape with a low horizon line, Saint Stephen kneeling to her left, the Baptist, in profile, to the right. The composition and its relation to the landscape looks forward to Raphael. The poses of the Virgin and Child are almost precisely those of the Oxford drawing from Vasari's book, which might have served as the basis of the group, although the drawing cannot have been made originally with the Prato commission in view, on account of the number of saints present. The Child's attitude is also similar, though reversed, to the ones

[20] It seems to me that this is in all probability a *terminus ante quem* for the Strozzi chapel. Although the commission for the Prato picture was given in February, Filippino seems to have had no time to begin work on it before June, having no doubt devoted the spring to the last touches in Santa Maria Novella.

[21] The sky and landscape have suffered less than the figures, and show a real sense of space.

seen in the Uffizi Madonna of 1486 and the Nerli altarpiece; it also shows similarity to the Child of the Strozzi chapel window. Saint Stephen recalls his counterpart in the Prato tabernacle in type and vestments, though not, of course, in pose; the Baptist is essentially the Accademia figure fallen on one knee. A painting so carefully contracted for would surely have been executed in the painter's best style. If to the simple and harmonious, if obvious, composition we add, in imagination, the rich and somber color of the Bologna altarpiece, we must conclude that the "Octo Defensores" secured, after their long delay (in this case their own fault, not Filippino's) a picture justifying their highest hopes.

The frame, which according to the contract Filippino was to decorate, must be the work of an untalented assistant, judging from its heavy, uninspired garlands of leaves and fruit and clumsy acanthus leaf at the top. Across the bottom of the panel runs the inscription: AT MEVS HIC NATVS IVSTVS: SERVATE FREQVENTER. SIC VOS IVSTITIAM PAVPERIBVSQVE PII. A. D. MCCCCIII.

It must have been while Filippino was working on the Prato panel — and possibly, of course, in the Strozzi chapel — that he became the subject of another recommendation to a north Italian patron. This time it was no less a person than Isabella d'Este, whose agent was in Florence, on the lookout for suitable painters to carry out decorative schemes for the palace in Mantua. Francesco Malatesta writes, in a letter dated September 23, 1502,[22] that he has been unable to secure the services of Perugino, from whose hand Isabella particularly wanted some work, as that painter is too much encumbered with present commissions; "he almost never finishes a work he has begun, such is his slowness." In these discouraging circumstances Francesco approached Filippino, whose answer is characteristic: that he is at present very busy, but "perhaps after he has finished these [other works] he can serve your Grace." The painter is described as "another famous painter . . . called Filippo di Fra Filippino." "I wished to talk with him," Francesco continues, "but I am told that he cannot begin such a commission for six months, being busy with other works." [23]

These "other works" may, of course, have been the last of the Strozzi

[22] Printed by Horne in *Sandro Botticelli*, Document LVII, pp. 363–364.

[23] This record of a personal interview between Isabella's representative and the painters whom he recommends, strengthens the supposition that the Sforza agent followed the same procedure, and hence had it from Filippino's own lips that he did not work in the Sistine Chapel.

frescoes as well as the Prato panel; they perhaps included, in addition, a large altarpiece dated 1503. In any case this last-named panel may have been commissioned by September 1502 and therefore on Filippino's list of agenda to be completed before he could undertake anything for Isabella. It is the altarpiece of Saint Sebastian (Fig. 85) ordered for the church of San Teodoro in Genoa by Napoleone Lomellini — a member, no doubt, of that distinguished Genoese family who sat to van Dyck in the seventeenth century. The picture has a dramatic history. In the nineteenth century Napoleon Bonaparte paid it the doubtful compliment of carrying it off to Paris; possibly the name of the original owner caught his eye,[24] though I should like to give him credit for having had the good taste to admire the painting itself. Later it was restored to the church in Genoa, whence it was brought to the Palazzo Bianco as part of an exhibition occasioned by the four hundredth anniversary of the discovery of America. There it remained, rapidly deteriorating, while San Teodoro was demolished and replaced by a new building. In 1906 Mario Labò published, under the title "Note Dolenti," an article [25] calling attention to the dangerous condition of the painting, which was only too apparent from the reproduction accompanying the text. The color, especially on the body of Saint Sebastian, had flaked off badly, and bubbles on the surface threatened to break and cause further peeling. Restoration was finally undertaken, with the result that the panel is now safe and presentable, the original work having escaped, I should say, a minimum of harm under the circumstances.

The picture is divided into two parts: the lower, a rectangle slightly higher than it is wide, shows the saint standing on an antique altar and bound to a column. To his right stands the Baptist, to his left Saint Francis. The lunette above contains half-length figures of the Madonna between two adoring angels; the infant Jesus stands on a parapet of cloud, supported by his mother.

This lunette requires little comment. The Virgin, for once aware of the spectator, looks down upon him, mild and serious. The Child is a duplicate, in type, of the Bologna and presumably of the Prato panels; he turns from the split pomegranate with which he is playing, to look at the right-hand

[24] The panel is inscribed IMP. DEO. ET. MAX., and below, NAPOLEONIS LOMELLINI PROPRIETAS. It was probably the painter Gros, rather than Napoleon himself, who ordered the picture removed to Paris; he was Napoleon's agent for the selection of paintings in Italy.

[25] Rassegna d'arte, VI (1906), 61–62.

angel. This is the old familiar composition which had lent itself so agreeably to lunettes since the days of Masolino's fresco at Empoli, and which was a favorite with the della Robbia; the curve of the angel's wings fits that of the frame with a natural grace reminiscent of the carvings of Romanesque tympana. The color strikingly recalls that of the Bologna panel, with its dark tonality and dominant notes of red and slaty green-blue, almost black in the shadows.

Filippino may have derived the pose of the Saint Sebastian from some antique statue reflecting the style of Polyclitus; the raised right arm is comparatively unusual for a bound Saint Sebastian. In physique, of course, there is no suggestion of Greek fifth century work; what does recall the author of the "Canon" is the raised shoulder balanced against the "free leg" and vice versa. The form, slighter than that of the Bologna Sebastian, is more in keeping with Praxitelean than with Polyclitan standards, but we need not look to Greece or Rome to account for a physical type so characteristic of Filippino. The features of the saint show a coarseness, especially in the lips, frequently met with in work of the period; there are plenty of examples of it in the Strozzi chapel.

Saint John repeats in pose and gesture the Baptist of the altarpiece of 1486, except that the position of the feet is different, but the comparison shows how marked has been the decline. Once more we are reminded of the Baptist of the Accademia, gaunt, hollow-eyed, and ugly. Even more clearly does the Saint Francis illustrate Filippino's waning interest in form.[26] The body covered by the brown habit is as flat as paper. The painter has concentrated on the spiritual rather than the physical, and in this haggard, impassioned face I once more see something akin to the Spanish Saint Francis — Ribalta's, for example.

The altar which forms a pedestal for Saint Sebastian is carved with a pair of sphinxes; on the base may be read the inscription asserting Lomellini's ownership, quoted above. The architecture behind the saint shows a partly ruined wall crowned with a frieze carved with a dolphin and anchor motif, based on antique prototypes, and here especially appropriate to a Genoese altarpiece. From the simple cornice springs an arch to frame the Baptist; on the other side a column of mottled orange marble rises precariously from a projecting bit of masonry some distance from the ground. This

[26] The unusual weakness even at this late period may indicate the hand of an assistant.

unconventional treatment of an architectural feature foreshadows the caprices of the seventeenth century.

If Filippino was losing his sense of form, he was still possessed of an eye for realistic detail, as we saw it illustrated in the Bologna altarpiece. Here, for instance, the arrow in Saint Sebastian's right arm has broken near its head, having struck the column to which the martyr is tied. Lizards dart in and out of the cracks in the masonry; an arrow stands against a wall, its cast shadow carefully studied. Bits of landscape in the background show that Filippino is still a master in that field; the almost leafless trees take us back once more to the Portinari altarpiece.

Some time between 1502 and 1504 should be placed the "Blue Madonna" until recently in the collection of Lord Rothermere (Fig. 86). Berenson does not include this picture. It was published by Dr. Bodmer in an article already cited.[27] The coarse features and dark shadows of the style after 1500 are present to a marked degree. It shows less imagination than the Bologna or Genoa altarpieces, being a combination of elements slightly earlier — the ring of *putto* heads has been carried over from the Prato tabernacle, and the Virgin and Child are related to those in Bologna.

Another panel which must have issued from Filippino's *bottega* about this time is the "Madonna Giving her Girdle to Saint Thomas" (Fig. 87) in the anteroom of the Cenacolo di Sant' Apollonia (Castagno Museum) in Florence. This is near enough to the master's style to make one hesitate over its attribution, especially since it reflects the weaker phase of the last period. It is on the whole too feeble in execution and insipid in color to be Filippino's own work, but it comes so close to the style of 1502–1503 that I believe he must have designed it, the outlines to be filled in by an assistant who had learned to speak his master's pictorial language almost without an accent.[28] Only in the papery flatness of the figures (much more pronounced than in the Genoa Saint Francis) and in a weakness in the handling of details does the assistant

[27] "Der Spätstil des Filippino Lippi," *Pantheon*, April 1932, pp. 126 ff. Dr. Bodmer would place it between the years 1495 and 1498; 1495 seems to me too early. Dr. Scharf dates it about 1498 (see p. 57 of his *Filippino Lippi*). He illustrates a shop copy, of *tondo* shape, on Plate 120, Fig. 200.

The Rothermere Madonna was presented by its owner to St. Augustine's church, Kilburn, London, in 1936; see *The Times* for March 17, 1936. I am indebted to my colleague, Miss Eunice Work, for calling this notice to my attention. The picture, which I have since seen, is a fine example of its period in color, drawing, and general quality.

[28] He may possibly have had a hand in the Genoa panel, especially in the Saint Francis, whose habit (the sleeves, particularly) is painted in much the same inept fashion as that of Saint Anthony in the Madonna della Cintola.

betray himself. This weakness is most marked in the Saint Anthony of Padua, who balances the cringing, sentimentalized figure of Saint Thomas. The *putto* heads reappear above; the Madonna's features correspond closely to those of the Rothermere Virgin. The introduction of the incident of the girdle may mean that the panel was commissioned by a Prato patron.

Before turning to the pictures which were left unfinished at Filippino's death, I must mention one more complete work which I would date not later than 1502, although documentary support is lacking: i.e., the "Allegory of Music" in the Kaiser Friedrich museum, Berlin (number 78A; Fig. 88). It has universally been dated at the time of the Strozzi frescoes, and should, I believe, be placed near the end of that work. Bode [29] sponsors the date 1501–02, as does Supino,[30] who compares the figure to those of Charity and Music on the east wall of the Strozzi chapel. One may add that the large and rather rakish wreath worn by the goddess, or muse, is roughly similar to the type adorning the elegant youth with the ewer who hurries away from Drusiana's bier. The romping *putti* are painted with that disregard of form characteristic of the 1500's, when the figures tend to look ironed out. The agitated Baroque sweep of blowing draperies and the fluttering ribbon by which the swan is secured [31] are all trade-marks of the Strozzi work, as is the interest in accessories such as trumpet, pipes, and lyre strung between the antlers of a deer's head. One might for this reason place the panel about 1500, were it not for the color, which has the metallic, slaty quality of the Bologna and Genoa panels. In this case the effect is less somber, as befits an informal theme, but the particular tone of rose set against deep grey-blue, with accents of reddish brown, seems to me unmistakably the palette of 1501–02 or thereabouts. Filippino has here applied the color of the last altarpieces (which he does not develop as early as the nineties) to a drawing of the sort made 1497–1500. As in the still earlier Christ Church Centaur, the composition stresses diagonals, accented by the Muse's arm leading down to the almost heraldic group of the *putti* and swan, the whole counter-balanced by the billowing cloak which suggests the opposite diagonal. Here Filippino expresses the gayest mood in which, throughout his career, he permits himself to be caught. Some such fancies must have been turned

[29] *Gazette des Beaux-Arts*, XXXVII (1888), 488.

[30] *Les Deux Lippi*, p. 192.

[31] Was Filippino perhaps thinking of Leda rather than of a muse? And might he therefore have taken a suggestion from Leonardo?

out, in the form of costumes and floats, for the pageants and processions of which Vasari speaks. A design of this character would have been delightful and appropriate for the Spedaletto or the porch at Poggio a Caiano, although the decoration supplied for the former villa would probably have shown less elaboration and violent movement.

We now begin to encounter pictures which death interrupted. The altarpiece mentioned by Vasari [32] as having been left unfinished by Filippino and carried on by others, of whom he mentions only Alonso Berruguete, Dr. Scharf would identify as the Louvre "Coronation of the Virgin with Four Saints" (number 1416), there ascribed to Piero di Cosimo (Fig. 89). Cean-Bermúdez,[33] probably borrowing from Vasari, repeats the reference to a work of Filippino carried on by Alonso. If Alonso did work on such a panel, it must have been some time after Filippino's death, since the most recent research indicates that Alonso was not in Italy in 1504.[34] As for Dr. Scharf's suggestion, it is more ingenious than convincing. The Louvre Coronation certainly owes something to Filippino, especially the Saint Francis, who repeats the type seen in the Genoa panel, and may have been borrowed from a design of his or of a close imitator working about 1503, such as the assistant who painted the Saint Anthony of the Castagno Museum "Madonna della Cintola." The panel further corresponds to Vasari's account by being conspicuously eclectic: the bishop saints have been quite rightly compared to the work of Ridolfo Ghirlandaio, and, of course, there is the alleged painter of the altarpiece, Piero di Cosimo. The hand of the last-named is, however, most clearly to be discerned in just the portions which could conceivably be Berruguete's, and of the two I think Piero is the more likely choice. These portions include the music-making angels treated in the soft, puffy manner developed by that painter at the end of his career, on the basis of fantastically individualized borrowings from Leonardo and Lorenzo di Credi. If Piero be responsible for these parts then there is nothing in the panel which can

[32] Milanesi-Vasari, III, 474: "Per le monache di San Geronimo, sopra la costa a San Giorgio a Firenze, cominciò la tavola dell' altar maggiore, che dopo la morte sua fu da Alonso Berughetta Spagnola tirata assai bene innanzi; ma poi finita del tutto, essendo egli andato in Espagna, da altri pittori."

[33] *Diccionario historico de los mas ilustres profesores de las bellas artes in España* (Madrid, 1800), I, 131 (under "Alonso Berruguete"): "Regresó Berruguete á Florencia, y muerto Filipo Lippi continuó, aunque no la finalizó del todo, una tabla del altar mayor de las monjas de S. Gerónimo, junto á S. Jorge, que Lippi habia dexado empezada."

[34] Quoted by Dr. Scharf from Ricardo de Orueta, *Berruguete y su obra* (Madrid, 1917), pp. 88 and 269.

reasonably, it seems to me, be ascribed to Berruguete. I therefore accept
Dr. Scharf's suggestion only with reservations. Nevertheless the association
of Berruguete's name with Filippino's is so unexpected that there may be
truth in it; for although the association may be unlooked for it is not
inherently improbable, and Alonso is a curious person for Vasari to have in-
troduced without some sort of grounds in fact.[35] What is more, the Cinque-
cento Spaniard might have been expected to achieve a closer approximation
to Filippino's style than Perugino, or even, perhaps, Albertinelli, far as he
falls below all three as a painter.

In a previous chapter I cited Vasari's story to the effect that when
Leonardo returned to Florence he found Filippino about to begin work on
a Deposition for the Servite church of the Santissima Annunziata, and that
when Leonardo expressed an interest in executing such a work Filippino
gracefully withdrew, yielding the commission to Leonardo. The latter,
having begun the picture, proceeded, after his custom, to leave it unfinished,
and went to France, whereupon Filippino returned to his original task, but
died before it could be completed. There may be a modicum of truth in the
story, which is the sort of thing one can believe of both the painters con-
cerned, but the dates will not bear out the account exactly. We know, for
instance, that Leonardo came back to Florence at the turn of the century,
at the time of the French invasion of Italy, and that he did not go to France
until after the accession of Francis I in 1515, although he did leave Florence
some years before that date. As a matter of fact he was engaged on the
"Battle of Anghiari" in the Palazzo Vecchio during the years 1504–1505.
Filippino, busy with the Strozzi frescoes when Leonardo reappeared in
Florence, is not very likely to have commenced working on a great altarpiece
such as the Deposition at that particular moment, but there is reason for
believing that he did not receive the commission until 1503. Therefore,
unless we assume that Leonardo abandoned the Annunziata altarpiece when
he began to work on the cartoons for the Palazzo Vecchio, Vasari's tale must
be taken as mostly fabrication.

Since in 1503 Filippino was still occupied with the panels for Prato and
Genoa (the former presumably finished in April, the other probably later),

[35] It should also be remembered that Alonso Berruguete was an assistant of Michelangelo's,
as Vasari records, and may therefore have been personally known to the biographer; see his life of
Michelangelo in the *Vite*, Milanesi edition, VII, 489.

the year must have been fairly well advanced by the time work was begun on the Deposition (Fig. 90). At the time of his death (April 18, 1504) the upper half of the panel must have been substantially finished, as is indicated in the document which records its completion by Perugino: [36] according to this, Perugino was to be paid a hundred and fifty florins for having completed the work on the altarpiece, Filippino having had fifty florins for the "many figures" he had been able to paint. From this it is safe to deduce that the upper half, showing Christ and the four men taking down his body, was finished, and the figures below perhaps roughly indicated. Perugino seems to have left the general arrangement of the upper half unaltered, although the figures have been thoroughly retouched according to his own taste, and carried out, perhaps with pupil assistance,[37] with a resulting effect wholly foreign to Filippino's style.

Interesting evidence exists to suggest what Filippino himself intended the composition to be like. For some years the Metropolitan Museum in New York has owned a small panel (Fig. 91) clearly a variation of the Annunziata [38] altarpiece, and correctly attributed to Filippino's workshop. Hard, stringy, and mechanical in style, this panel is nevertheless important for the points in which it differs from the Perugino version. The upper half corresponds almost exactly with the Annunziata panel except in just such details as we may ascribe to Perugino in the case of the latter picture, notably the long hair of the figure on the ladder to the right, thoroughly characteristic of Filippino, for which Perugino has substituted a closely cropped head. Exactly the same difference exists between the corresponding figures on the ground to the right. The group of four women is present in both versions, but the Metropolitan panel shows the Virgin unconscious, with closed eyes, whereas the Umbrian Madonna opens her eyes and seems, as it were, to be holding the pathetic pose, with no real feeling of grief or horror. The two Saint Johns again correspond, although Perugino's is more bland and un-

[36] Walter Bombe, *Geschichte der Peruginer Malerei bis zu Perugino und Pinturicchio* (Berlin, 1912), p. 376: "M° Piero Perugino dipintore de'avere fiorini dugento larghi d'oro sono per aver dipinta et fornita la nostra tavola de l'altare ghrande, della quale lui aveva avere per quello a fatto in detta tavola, fiorini ciento cinquanta d'oro, perche in detta tavola Filippino di . . . dipintore aveva fatto molte fighure, della quale aveva auto fior(ini) 50 d'oro" ("Libro dei Debitori e Creditori" segnato A del 1504 al 1510, c. 122).

[37] Venturi attributes the execution to Andrea d'Assisi, working in Perugino's shop; cf. his *Storia dell'arte italiana*, vol. VII, part 2, p. 689.

[38] I designate the picture by the place for which it was painted, as more specific than the name of its present home, the Uffizi, where it bears the number 8370.

emotional. The most striking difference is in the Magdalen. Whereas in the finished altarpiece she kneels calmly, even primly, at the foot of the cross, her fingertips daintily touching in conventional prayer, the Magdalen of the Metropolitan flings her arms around the base of the cross, her lips parted in a cry of agony. The pose and gesture recall Botticelli's passionate Magdalen embracing the cross, in the Fogg Museum in Cambridge. Here surely is what Filippino intended — intensely dramatic feeling expressed in violent movement. It is the only work of the 1500's apart from the Strozzi frescoes, which shows these qualities to a like degree. Had he lived, Filippino might have given us, in the Deposition, real drama rather than the theatricality of which the Strozzi frescoes may, not unreasonably, be accused.

One further minor difference of detail may be noted: in the foreground of the New York picture the three nails lie on a low rock or stump covered with a cloth; a skull and bones lie near-by, as they do in the Berlin "Christ on the Cross." Perugino has omitted the skull altogether, and makes the cloth and nails less prominent.

The Metropolitan panel cannot possibly be Filippino's own work, but I think it equally certain that it was derived directly from a *bozzetto* of the master's. Dr. Gronau believes he has found this original study in a small painting published by him in 1926,[39] when it was in the hands of a dealer (whom he does not name) in Munich. This study is far less careful and detailed than the New York version; it has indeed the appearance of a *bozzetto* prepared for a larger work. Dr. Gronau argues that if this is not Filippino's original sketch, it must be a copy; but why, he asks, should anyone wish to copy such a work? Apparently, whatever the reason, painters did wish to copy it, for no less than two other versions exist — the Metropolitan picture already discussed, and another in the collection of Lord Rothermere, published by Paul Konody in 1925.[40] This was apparently unknown to Dr. Gronau when he wrote his article, and Mr. Konody of course was not familiar with the Munich version. Dr. Gronau did not even mention the New York panel. Since nobody claims originality for the last-named, we have two candidates for the honor of being Filippino's own sketch. Mr. Konody sees the situation thus: "The painter of this little panel" (i.e., the New York one), says he, "must have followed a model from Filippino's

[39] "Ein Bildentwurf von Filippino Lippi," *Zeitschrift für bildende Kunst*, LX (1926–27), 22 ff.
[40] "Some Italian Masters in Viscount Rothermere's Collection," *Apollo*, October 1925, pp. 190 ff.

own hand, a small preliminary version of the Annunziata altarpiece, and this small original, which bears in every touch the clearest evidence of Filippino's brush, is beyond doubt the panel in Viscount Rothermere's collection." [41] Gronau declares of his Munich find: "Wir besitzen darin, um es vorweg auszusprechen, den Originalentwurf Filippinos für das ganze Altarwerk, wie er es auszuführen gedachte." [42]

For my own part I hesitate to make any final pronouncement on the question. Both studies bear the closest relationship to the New York copy, agreeing among themselves in all points in which they differ from the finished altarpiece, except for minor details. Lord Rothermere's, for example, omits the pliers which in all the other versions are hung conspicuously over the left arm of the cross, beside the knotted ribbon. The skull and bones are lacking only in Perugino's work. Long hair and beards are consistently present in the trio of small panels, where Perugino uses short hair. The Rothermere sketch makes more of the landscape background than do the others, bringing the horizon point up to about the middle of the picture, above the level of the women's heads. This, and the type of landscape, is in keeping with what we should expect of Filippino; Konody compares it to the background of the National Gallery Madonna. The figures themselves recall those of the Samuelson panels, especially that of the bearded man on the ground to the right. As nearly as I can judge from the small reproduction, the Rothermere is more likely than the Munich picture to be the original, the latter having, I think, more the look of a replica such as the New York panel, but unfinished. I cannot believe that it is the master's own work. Nor am I certain about the Rothermere version. Gronau remarks that colored sketches on panel are rare in the Quattrocento, and I should think it possible that all these hack painters, or shop assistants of Filippino's, were inspired by an original pen or chalk cartoon such as normally served as the basis of tempera panels. Small editions of the large altarpiece would be as likely in this case as in that of Filippino's popular "Crucified Christ," (Berlin 96), of which I have listed several small repetitions or adaptations. The fact that the full-sized Deposition was not finished would not necessarily prevent replicas being made from Filippino's studies, and possibly the original study is the one in the possession of Lord Rothermere. The apparent popularity of the composition cannot be denied, and it would seem that

the patriotic Florentines had the good taste to prefer it to Perugino's version. I am able to cite one more replica of it,[43] which I know only from a photograph in Sir Robert Witt's library in London. This forms part of a polyptych in the Bellini collection in Florence; the upper central panel shows the familiar Deposition, varying only in the omission of the ribbon tied to the cross, the heavy veiling of the woman nearest to the cross (who is almost bareheaded in the other examples), and the turning away from Christ of the man who lifts his body down. The rest of the polyptych bears no relation to Filippino.

Whether or not Filippino himself painted the Rothermere picture — and it is possible — we may safely take it and its replicas as evidence of what he intended as the design of the Annunziata altarpiece. The original contract is lost, but it seems to have called for a double panel: the Deposition to face the monks' choir, and back to back with it, facing the main body of the church, an Assumption of the Virgin. The latter was carried out entirely by Perugino (or by him and assistants) in so mediocre a fashion, says Vasari,[44] that the brethren decided to reverse the positions of the two panels, allowing the Deposition to face the congregation, while the Assumption was given the less prominent place, facing the monks' choir. Even as early as Vasari's day the two pictures had given place to a tabernacle for the Sacrament; they were, he says, removed to side chapels. The Assumption is still in place, over the fourth altar in the left aisle; the Deposition, after a long sojourn in the Academy, has been brought to the Uffizi.

Stylistically the Annunziata panel shows the hand of Perugino, and of his assistants, throughout; all that can be attributed to Filippino is the design, which has been modified in the manner pointed out above. Perugino naturally retouched all of his predecessor's work in order to give unity of color and surface quality to the whole; but he was unable to reconcile the style of the earlier work with his own, and the result is far from happy. The Umbrian master's sentimentality is redeemed in his best work by calmness of feeling and simple, well-balanced design, as well as by his beautiful space-composition; the introduction of Filippino's Baroque agitation and intense emotion, even as overlaid by Perugino's retouching, leads inevitably to theatricality comparable to the worst kind of "Jesuit" art. Perugino's inability to fuse these irreconcilables cannot fairly be held against him, but it

[43] Dr. Scharf also lists this example; *Filippino Lippi*, p. 117. [44] Milanesi-Vasari, III, 586.

does speak well for the vitality of Filippino's own design that it was able to make of the Deposition a picture preferred by the Servi to the rather colorless Assumption which was Perugino's own from the outset. I have little doubt that Filippino's, had he lived to complete it, would have been moving and convincing, if perhaps a trifle over-dramatic. It might have compared with Perugino's as a good Guido Reni does with an average Carlo Dolci — the one emotionally sincere, of its type, the other prettified and insipid.

Milanesi tells us [45] that the Deposition was ordered from Filippino in 1503, for two hundred scudi d'oro, by the Servite Fra Zaccheria di Lorenzo. It was not until August 5, 1505, that the Servi turned the commission over to Perugino, who received for his work the sum promised to Filippino,[46] the payment being recorded under the date January 9, 1506.

Our last record of Filippino in public affairs shows him to have served on the committee appointed to decide on the place most suitable for Michelangelo's "David." This statue, undertaken in 1501, was "quasi finita" early in 1504. The committee met on January 25 of that year (new style), and the opinions of the various members have been preserved. Filippino's is characteristic: "Credo che el maestro habia meglio et più lungamente pensato el luogo, et da lui s'intenda, et confirmando el detto tutto di chi à parlato, che saviente si è detto." [47] In the end, of course, the site in front of the Palazzo Vecchio was decided upon. Filippino did not live to see the statue in place, for its transportation to the Palazzo Vecchio was not commenced until May 14, 1504, less than a month after his death, and the work of moving lasted until June 8.

In the Libro Rosso of the Guild of Saint Luke (the same volume which records Filippino's association with Botticelli) one may read the brief entry under Filippino's name: "mori add 18 daprile 1504," followed by mention of "Samichele Bisdomini," the church in which he was buried. Vasari describes his sudden illness and death, and the unusual pomp of his funeral, during which the shops in the Via de'Servi were closed — "come nell'es-

[45] Page 475, n. 2.

[46] Walter Bombe, *Klassiker der Kunst, Perugino*, p. 247. A certain Francesco di Niccolò got 240 gold florins for gilding the frame. Bombe does not say whether the date 1506 is "new style," but we may assume that it is.

[47] Gaye, *Carteggio inedito*, II, 460. This author also prints the documents relating to the commissioning of the David. See also Lensi, *Palazzo Vecchio*, pp. 103 ff. As a sample of the kind of inaccuracies to be found in Milanesi-Vasari (whether due to faulty proofreading or not) we find him giving the date of the committee meeting as 1501 in Filippino's chronology, and January 25, 1502, in that of Giuliano da Sangallo.

sequie de'principi uomini si suol fare alcuna volta." In his first edition
the biographer adds the statement, omitted from the second edition, that
"he was given an honorable burial by his sons," and quotes the flowery and
rather charming epitaph of which no trace remains today.[48] In both
editions the date of the painter's death is given as April 13, 1505. This has
been accepted, together with his age, forty-five, as stated by Vasari, by vari-
ous writers; the entry in the Libro Rosso is, however, certainly correct,
doubtless having been inserted soon after the event. And there is no reason
to suppose that Vasari had anything more than an approximate idea of
Filippino's age.

As for the fitting burial said to have been accorded Filippino by his sons,
that is manifestly impossible if his marriage did not take place until 1497.
The eldest child would have been three or four years younger than was
Filippino when he lost his own father. San Michele has undergone thorough
"restoration" in the Baroque taste, and no trace whatever remains to show
the place of the painter's tomb.

Filippino's epitaph as quoted by Vasari was not wholly inappropriate.
"Design" was by no means dead, nor were invention and art thereafter
wanting to painting; but with Filippino's death the final important link
with the Quattrocento was cut. Botticelli lived on a few years longer,[49]
and lesser men clung for some time to the manner of the earlier century, but
the new style of the Cinquecento was even then flowering. Leonardo was
helping to crystallize it; Raphael was shortly to come to Florence to continue
the development of his personal genius. Piero di Cosimo abandoned his
earlier models and plunged into the new ideas of the dawning century; his
pupils proceeded further along the same lines of development. The full-
blown forms of the Cinquecento, inspired by Raphael and Michelangelo,
the stately pose and solemn gesture, are all established, and show Filippino,
by contrast, as a master whose roots were in the previous century. That he
anticipated so much, not only of the sixteenth but also of the seventeenth

[48] Milanesi-Vasari, III, 476, and footnotes. The epitaph, quoted on p. 476, n. 2, runs as follows:
"Morto e il disegno or che Filippo parte
Da noi; stracciate il crin, Flora; piangi Arno.
Non lavorar, Pittura; tu fai indarno,
Che il stil perdesti e l'invenzione e l'arte."

[49] He died in 1510, but from the point of view of artistic chronology the period which he rep-
resents came to an end no later than 1500; he had, moreover, virtually ceased to produce after the
opening years of the new century.

century, while maintaining his natural spirit as a Quattrocentisto, says much for his fundamental vitality and progressive character. Where Ghirlandaio superbly sums up the qualities of his century but never hints of future developments, Filippino builds upon his artistic inheritance a structure in which most of the principal tendencies of the next two hundred years are prophesied. The archaeology of the Cinquecento, in him, goes hand in hand with the restless movement, the religious intensity, and the elaboration of the seventeenth century. He would have understood and enjoyed Guercino and Guido Reni; the Jesuits could have appreciated his talents as a decorator, albeit his spiritual nature had a melancholy wistfulness too subtle, and too gentle, for their propagandist requirements. His was the kind of temperament about which it is only too easy to sentimentalize; indeed, had he not been overshadowed so immediately by Leonardo and Raphael his work might have had the same perennial and cloying popularity that has clung so misleadingly and undeservedly to that of his more famous contemporaries. Yet he was no spineless effeminate, although such is the impression often conveyed of him. I believe it is to his credit that to the end of his life, with fine independence, he maintained his individuality in the face of influences well-nigh inescapable. The penalty of this artistic integrity was, of course, that he was lost sight of among the rising generation of painters. What mark he did make on them will be considered in the next two chapters.

CHAPTER IX

RAFFAELLINO DEL GARBO

FEW problems in the history of painting are more complicated and baffling — and, alas, tedious — than that of "Raffaellino del Garbo." According to one's interpretation of the documents, or analysis of the paintings, involved, he may be subdivided into as many as four different "artistic personalities," and these four may in turn be combined in more ways than one. Vasari tells us that the painter Raffaellino del Garbo was Filippino's closest follower and hardly to be distinguished from his master; that his later work did not fulfill the promise of his youth; and that he died, in poverty and disrepute, in 1524, at the age of fifty-eight. Among his works are cited the ceiling of the Caraffa chapel, painted, Vasari says, in a "miniaturist manner." [1] He goes on to list various other works, among them a fresco of the "Miracle of the Loaves and Fishes" in the Cestello (later Santa Maria Maddalena de' Pazzi). This fresco is thoroughly documented as ordered by the Cistercian monks in 1503, from the painter "Raffaelle di Bart. Carli," the price to be forty ducats. [2] What is more, the "Mass of Saint Gregory" listed by Vasari as Garbo's [3] bears the signature RFAEL KARLI PXIT A.D. MCCCCCI; and "Our Lady with Saints Jerome and Bartholomew," originally with the "Mass of Saint Gregory" in Santo Spirito, and now in the Corsini palace, Florence, is inscribed RAPHAEL DE KROLIS. PIXIT. A.D. MCCCCC°II. All three of these works are beyond doubt by the same hand, but this style differs markedly from that of the two most usually accepted panels by Raffaellino del Garbo: the Pietà of Munich and the Resurrection of the Uffizi. Critics have accordingly tried to distinguish two separate painters, one Raffaellino del Garbo, the other Raffaelle de' Carli. In addition, an altarpiece in Santa Maria

[1] "Nella Minerva, intorno alla sepoltura del Cardinal Caraffa, v'e quel cielo della volta tanto fine, che par fatta da miniatori" (Milanesi-Vasari, IV, 235).

[2] C. de Fabriczy, in *L'Arte*, 1906, p. 260, "Memorie sulla chiesa di S. Maria Maddalena de' Pazzi a Firenze e sulla Badia di S. Salvatore a Settimo."

[3] This picture, formerly in the Benson collection in London, is now in the Ringling collection, Sarasota, Florida; reproduced in *Les Arts*, October 1907, p. 26.

degli Angeli, Siena, signed and dated RAPHAEL DE FLORENTIA PIXIT A D MCCCCCII, and a Madonna with saints and donors in the Uffizi,[4] inscribed RAPHAEL DE CAPPONIBUS MCCCCC ME PINSIT, are stylistically related to the "Carli" group, but have been taken by some scholars as indicating two more separate entities.

Leaving Raffaelle da Firenze and Raphael de Capponibus out of the discussion for the moment, let us examine the evidence with regard to Raffaellino del Garbo and Raffaelle de' Carli. The Morellian method of connoisseurship which assumed such importance in the nineteenth century, and early twentieth, enabled Berenson to draw a very convincing line between the two styles. One, that of the Munich Pietà and the Uffizi Resurrection, depends primarily on Filippino; indeed, the former picture went for many years under that painter's name. "Carli" is strongly Umbrian, owing much to Perugino and to Pinturicchio. On the face of it there is no difficulty about accepting two "artistic personalities" — to borrow Berenson's phrase.

The search for documentary support of this division of the paintings among two men has revealed the following facts. The Libro Rosso for 1472–1520 registers [5] "Raffaellino de' Bartolommeo del Garbo," 1503–1505. In the tax records of the Santo Spirito quarter of 1498, we find the declaration of "Raffaello di Bartolomeo dipintore," of the parish of Santa Lucia Soprarno, who had two shops, one in the Borgo San Jacopo, the other in the vicinity of Santa Maria del Fiore, i.e., the Duomo. At one time he had a *bottega* in the Via del Garbo (now the Via Condotta); [6] he is mentioned in the records of the Badia, 1513–1517, being registered as "Raffaello di Bartolommeo de' giovanni dipintore." In the Matricole dell' Arte de' Medici e Speziali, November 15, 1499, we find the name "Raphael Bartolomei Nicolai Capponi pictor nel Garbo."

On Carli's side there is evidence as follows: [7] A certain Raffaelle di Bartolommeo di Giovanni di Carlo lost his father, a citizen of Val d'Elsa, in 1479, and then spent two years with a relative, Pasquino di Carlo. He next entered the household of the Capponi. A lawsuit is recorded in 1505 between Raffaelle and Carlo, son of Pasquino; another between the same two men occurred in 1516. No records of later date have come to light.

4 Number 3165. The saints are Francis of Assisi and Zenobius.
5 Milanesi-Vasari (IV, 244) lists the various Raffaelli.
6 Berenson (*Drawings of the Florentine Painters*, I, 94) quotes Horne on this point.
7 These details are listed by Gronau in Thieme-Becker, V, 604.

We have then the following names and dates:

Raffaellino di Bartolommeo del Garbo — 1503-1505
Raffaello di Bartolomeo dipintore — 1498
Raffaello di Bartolommeo di Giovanni dipintore — 1513-1517
Raphael Bartolomei Nicolai Capponi — 1499
Raffaelle di Bartolommeo di Giovanni di Carlo, who later belonged
 to the Capponi household
Raffaelle di Bart° Carli — 1503
Rfael Karli — 1501
Raphael de Krolis — 1502
Raphael de Capponibus — 1500.

We know further that the Capponi commissioned Raffaellino del Garbo to paint the Resurrection for their chapel at Monteoliveto, and Vasari says that the portrait of Niccola Capponi occurs in it.

Now it is just possible to thread one's way among these names, keeping Carli and Garbo separate — and, if you will, Raffaelle de' Capponi. But in order to do so we must accept it as a fact that both Raffaelli had the same father's name (Bartolommeo) and also apparently the same grandfather's (Giovanni). Berenson [8] thought he had found a different name for Carli's grandfather — Niccolò — but this I take to belong to the name Capponi, Carli's patron. We should also observe that the Capponi adopted, or took into their household, Raffaelle de' Carli, an adequate painter certainly before 1500, but gave commissions to Raffaellino del Garbo. And if Raphael de Capponibus is a third person, their patronage must have extended even further. Finally, it is to be noted that, as Ulmann has pointed out,[9] no two of these Raffaelli are found in the same list. If there were two, why were they not, as contemporaries, both registered in the Libro Rosso or the cadastral records?

All this seems to me to allow a dangerously large rôle to coincidence. Indeed, were it not for the stylistic discrepancies in the pictures, I think critics would have no hesitation in believing that all these documents refer to the same painter. He does not sign pictures before 1500; in that year he calls himself by his adoptive name, Capponi; later he uses his own family name of Carli. The "Garbo," like the diminutive form "Raffaellino"

[8] *Drawings of the Florentine Painters*, I, 94.
[9] "Raffaellino del Garbo," *Repertorium für Kunstwissenschaft*, XVII (1894), 90 ff.

which usually goes with it, is distinctly a nickname, which he would quite naturally avoid as an official signature on pictures.

On the other hand, can the paintings be made to bear out this conclusion? We have seen that Vasari treats Garbo's and Carli's documented or signed works as those of a single painter, but he says his early promise was not fulfilled by his later work, and that in the end it became so poor that his pictures did not even seem to have come from his own hand ("le cose non parevano più di sua mano"). Of course, this conclusion would naturally follow if Vasari, confusing the work of two painters, had compared the Munich Pietà with the Corsini Madonna of 1502; on the other hand, there is at least an equal chance that his conclusion was based on fact. How far are we to trust his testimony, and to what extent may it be used in support of the documentary evidence?

The famous biographer has been caught in so many errors that whenever there is a question of his reliability on a certain point no one likes to give him the benefit of the doubt. Those who, like Milanesi and Berenson, wish to bisect the Garbo personality, are safe enough in saying that Vasari had little interest in the minor painter Garbo and even less in Carli; that he rarely troubled to verify his memory or notes, and in this case simply lumped the Garbo-Carli *œuvre* under Garbo's name. He was indeed quite capable of such slipshod doings. But it must also be remembered that the painter he discusses died, so he says, only twenty-five years or so before the first edition of the *Vite* was published; that he (Vasari) knew Bronzino, who, he tells us, studied with Garbo before he worked under Pontormo; and that with his knowledge of obscure masters whose work can no longer be attached to their names, it would be strange if he did not know Raffaelle de' Carli, protégé of the powerful Capponi, who signed several works.

Admitting that Vasari has at least an even chance of being right, let us consider the pictures themselves. The problem they represent is of the greatest complexity and difficulty, as is shown by the number of solutions offered. "Raphael de Florentia" can be ruled out at once, the Siena altarpiece so signed, and dated 1501, being in precisely the same style as the Carli group of the early Cinquecento (i.e., the "Mass of Saint Gregory," the Corsini Madonna, and the Cestello "Loaves and Fishes"). "Carli" would naturally enough sign himself as a Florentine when painting for another city, especially perhaps when that city chanced to be an

ancient rival and enemy of Florence. Of Raphael de Capponibus more presently.

As a basis for "Garbo's" style we have the Pietà and the Resurrection (Figs. 51 and 92). The work in the Caraffa chapel is valueless as evidence owing to its thorough repainting, though there is no real objection to believing Vasari's story that Garbo was Filippino's assistant there. If he was born in 1466 [10] he would have been twenty-two when the frescoes were begun — a perfectly suitable age for an assistant, and about what Piero di Cosimo was when he went to work in the Sistine Chapel under Cosimo Rosselli.

The authentication of the Munich Pietà and of the Uffizi Resurrection, while not perfect in either case, has found general acceptance, and rests on the following evidence. The Anonimo Gaddiano [11] writes, under the name "Raffaelle del Garbo Pittore," "Fece in Santo Spirito una tavola d'altare dove dipinse una pietà, opera molta bella.

"Dipinse un crucefisso in tavola nell'oratorio de fratj di Monteuliveto fuorj di Firenze."

Vasari also refers to the Resurrection,[12] which he says was painted at the order of the Capponi for their chapel, "Il Paradiso," under the church of San Bartolommeo at Monteoliveto, and that it contained a portrait of Niccola Capponi as one of the sleeping soldiers. He also mentions a Pietà in Santo Spirito: "In the church of Santo Spirito in Florence, in a panel above that of the Nerli by his master Filippo, he painted a Pietà: a work considered very fine and praiseworthy; but in another of Saint Bernard, the perfection of the other is lacking." [13]

For both of these early sources there is further corroboration. The Resurrection of the Uffizi is known to have come from San Bartolommeo at Monteoliveto; Poggi,[14] in 1903, spoke of the frame as still in the church, but pointed out that Vasari's statement as to the portrait of Niccola Capponi is incorrect, since the Niccola associated with the chapel (as mentioned in the archives of the convent) was born in 1451 and would therefore have been a

[10] Acceptance of Vasari's statement of his age at death, and its date, would give 1466 for his birth year.

[11] C. de Fabriczy, *Il Codice dell' Anonimo Gaddiano* (Florence, 1893), p. 86.

[12] Milanesi-Vasari, IV, 235–236.

[13] Milanesi-Vasari, IV, 236–237: "Nella chiesa di Santo Spirito in Fiorenza, in una tavola sopra quella de' Nerli di Filippo suo maestro, dipinse una Pietà; cosa tenuta molto buona e lodevole; ma in un' altra di San Bernardo, manco perfetta di quella."

[14] "La Chiesa di S. Bartolommeo a Monte Oliveto presso Firenze," *Miscellanea d'arte*, I (1903), 62–63.

much older man than the youth in the picture. As for the Pietà, it also was for some time in the hands of the Capponi, but this is a coincidence, for it seems to have been painted for the Nasi, whose chapel in Santo Spirito is next to that of the Nerli as described by Vasari, although he does not mention the name of the family. The history of the panel has been clarified through documents [15] relating to Perugino's "Vision of Saint Bernard," now in the Alte Pinakothek, Munich. This was painted for the church of Santa Maria Maddalena di Cestello (now de' Pazzi) at the time of the restoration of that church about 1480–1500, when leading Florentine families sponsored and decorated chapels. Two of these chapels were owned by the Nasi: one contained the Perugino Saint Bernard, which hung there until 1628. At that date the nuns, who had replaced the Cistercian monks shortly before, wished to substitute a painting of their patroness, Santa Maria Maddalena de' Pazzi. Francesco Nasi, then head of the family, obtained the custody of the Saint Bernard and apparently kept it in his palace in the Borgo San Jacopo. In his will, drawn in 1637, he stipulated that it should be hung in the Santo Spirito chapel, in which he wished to be buried. After his death two years later his sister Hortensia, wife of Tommaso Capponi, carried out these instructions, removing the Pietà which had hung for generations in the Nasi chapel and had given it its name of "Cappella della Pietà." This altarpiece was subsequently stored in the Palazzo Capponi. In 1651 Hortensia's son, the Marchese Capponi, had the Saint Bernard also brought to the palace, paying for a copy to be hung in his uncle's chapel.[16] From the Capponi palace the Pietà and the Saint Bernard both passed into the collection of King Ludwig of Bavaria, and thence to the Alte Pinakothek.

The Pietà must then be the one described by Vasari as hanging in the Nasi chapel in the mid-sixteenth century, attributed by him to Garbo. The tradition of Garbo in this chapel was evidently so strong that Richa, who saw the copy of the Perugino in place of the Pietà, called it Garbo, although he knew it was a copy substituted for an earlier original.[17] Milanesi, unfamiliar with the history of Perugino's picture (which he had not seen when he published his edition of Vasari, but knew from a reproduction), nevertheless

[15] "Peruginos 'Sankt Bernard' in der Alten Pinakothek," Gronau, *Münchner Jahrbuch*, IV (1909), 49 ff.

[16] This is still in place.

[17] *Chiese fiorentine*, IX, 23: "La cappella de' Nasi, dove Raffaellino del Garbo dipinse Maria, che detta a San Bernardo sedente in atto di scrivere."

recognized the style of the copy as Peruginesque, and concluded that Vasari had mistakenly identified the original painting as by Garbo.[18] For once documentary evidence has proved Vasari's accuracy, for, of course, the original Perugino was still in the Cestello when he wrote. Milanesi was further confused by Vasari's statement: "Ma in un' altra (tavola) di San Bernardo, manco perfetta di quella." This cannot have been the Perugino Saint Bernard, since we have it on record that that picture was still in the Nasi chapel of the Cestello in 1626, when Urban VIII ousted the resident monks and refused them permission to take Perugino's altarpiece along with certain other church possessions which they were allowed to remove.[19] Vasari referred, I believe, to the "Madonna and Saints" in the left transept (this chapel bears what I take to be the Benci arms, as does the frame of the altarpiece) dated 1505 and stylistically surely a "Carli." The Saint Bernard in this, as I shall repeat later, is derived from Filippino's Badia panel and hence might well have been, in the eyes of Vasari, the most striking thing about the picture.

A comparison of the Munich Pietà and the Uffizi Resurrection shows that they must be by the same hand, and probably painted within a very few years, if not months, of each other. Thus they provide a safe basis for further reconstruction of Garbo's achievement. Stylistically closest to them is the lovely *tondo* in Berlin (number 90), which though lyric in mood where the larger panels aim at the tragic or dramatic, nevertheless reveals details too close to the Pietà to be identified otherwise than as Raffaellino's work. No one, so far as I know, has questioned this attribution. I should say that the *tondo*, being closest in style to Filippino, is probably earliest, and the Uffizi Resurrection, least like Filippino and most Umbrian, is latest of the three. The Pietà I have already indicated, in a previous chapter, as belonging to the mid-nineties, about 1496, and as constituting the last direct contact with Filippino, although his influence persists even into the 1500's when Raffaellino is almost wholly committed to the manner of Perugino and Pinturicchio.

The Kaiser Friedrich claims more "Garbos" than any other single museum. I have already said something of the Simon *tondo*, which I do not accept as his; the *tondo* just cited (number 90) hangs near-by. This lovely panel (Fig. 93) of the Madonna and sleeping Child in a landscape with

[18] Milanesi-Vasari, IV, 237, n. 1.　　　[19] Gronau, *Münchner Jahrbuch*, IV (1909), 49 ff.

musician angels still shows the influence of Filippino, but to it has already been added that of Umbria.[20] Filippino contributed suggestions for the drapery and the ornate lyre of one of the angels, also for the type of the Virgin's right hand; her head, though not very close to Filippino's, does derive from the post-Roman brunette type rather than the blonde one more characteristic of the eighties. The landscape likewise recalls Filippino, but it also feels Umbrian in its soft airy spaciousness. Above all the mood is Umbrian [21] rather than Florentine — a gentle dreaminess, especially to be felt in the angel to the left. This is not quite like Filippino's melancholy, which is usually, particularly after 1493, coupled with a marked emotional intensity. Perhaps Filippino approaches the Berlin *tondo* most nearly in his own *tondo* in the Cleveland Museum, which should belong to the same date.

The chief evidence for authorship of the Berlin *tondo* is the likeness of the left-hand angel to the one, also at the left, in the Munich Pietà. The latter is perhaps as eclectic a work as Garbo ever painted. The Saint John the Evangelist is still Filippinesque and the pose of the Magdalen is probably, as I have said, influenced by the Munich "Appearance of Christ to the Virgin," but the composition seems to be based on Perugino's Pietà of the Uffizi (painted *c*. 1493) while the coarsened types, almost brutalized in the case of John the Baptist, suggest that Raffaellino like Filippino was studying Piero di Cosimo and Flemish painting. Piero di Cosimo himself used the same Peruginesque composition for a Pietà now in Perugia (Fig. 94); the arrangement of three angels above, with instruments of the Passion, would indicate that he drew on Garbo, perhaps taking the composition entirely from him without recourse to Perugino, since Garbo's panel was conveniently at hand in Santo Spirito, Perugino's in a monastery outside Florence.[22] The heavy hands, particularly Saint John the Evangelist's right, with the exaggerated junction of thumb and palm, clearly recall Piero's.

By the time the Resurrection was painted, Garbo was profoundly under Umbrian influence. Not that he had lost all memory of Filippino's precepts

[20] Raffaellino could have studied both Perugino and Pinturicchio in Rome, and the former later in Florence. A copy of this *tondo* is preserved in the Samuelson collection in London.

[21] A comparison might also be drawn with Venetian work of the late Quattrocento; the iconographical theme of the sleeping Infant Jesus is particularly popular in Venice, as, for example, in the work of Alvise Vivarini.

[22] It was painted for the Gesuati of San Giusto alle Mura (Bombe, *Perugino*, p. xvi). The chronology is not certain here, but I believe Piero's Pietà is nearer the turn of the century than Garbo's, on the basis of comparison with his other pictures.

— witness the fancifully dressed and turbaned soldier hurrying away at the right, the decoration of sphinxes and *putti* on the sarcophagus, and to some extent the landscape. But the whole conception of the Christ floating in mid-air above the tomb, and the hazy horizon behind him, recall Perugino. Most of the soldiers show the coarse features and stringy though heavy drapery of the Munich Pietà. The sleeping boy to the right, with his head on his hand, who Vasari says represents Niccola Capponi, is too young to be that worthy, but there is no special reason why he might not be some other member of the family except that he has scarcely enough individuality to suggest a portrait. He is akin to Garbo's Filippinesque type.

Vasari certainly overpraises the picture, which is theatrical in its straining for effect, especially in the saccharine Christ, too solid and realistic to float convincingly. The effect has something of the embarrassing inappropriateness of the Ascension scene as it is staged at Oberammergau — a mystical conception which, except for the very naïve, is best left to the imagination, or at most, treated with the non-realism possible in primitive art. It is just this representation of mystical subjects in aggressively literal forms that makes late Renaissance and Baroque altarpieces so often trying, and when, as here, sentimentality is added the result is apt to be painful.

Garbo's difficulty is largely that he is too much of a Florentine to express himself sincerely in the Umbrian idiom. Vasari, carried away by the novelties and touches of realism, found the picture more satisfactory than most of us are likely to today. It is competent work, well enough composed, and as an altarpiece probably quite admirable in the eyes of the average Florentine; but it has none of the charm of the Berlin *tondo* (the subject may partly be blamed for that) nor the rather grim vigor of the Munich Pietà.

As regards details, the hands are closer to those of the Berlin *tondo* than to those of the Pietà, and the "Capponi" head is not unlike that of the left-hand Berlin angel. The landscape offers analogies with the Pietà, especially in the group of buildings with domes and machicolated ramparts. In color it is less distinguished than either, combining rather strong, harsh tones with little regard for their interrelations. The Pietà, on the contrary, makes good use of a strong violet-blue running through the composition and giving it a distinct unity.

I would point out in passing the little coiling fold in Christ's robe, a purely calligraphic touch such as Botticelli sometimes introduces. It is to be

seen in the loincloth of the Munich Christ, and is met with elsewhere in Garbo's work.

The picture should probably be dated somewhere in the latter nineties, but there is nothing to indicate the precise year. The increasing Umbrian quality would tend to put it after rather than before the Munich Pietà, which, as I have said, seems to be related to Filippino's Munich altarpiece of c. 1495. To the same period belongs the "Portrait of a Man" which came to the National Gallery as part of Sir Henry Layard's bequest, there called Botticelli. It has also been attributed to Botticelli's school and to Garbo, and some have thought it a portrait of Lorenzo il Magnifico. This is improbable, although the type vaguely recalls Lorenzo. For one thing he is too young — unless we may take it as an evocation from the past, like the alleged posthumous portraits of Simonetta Vespucci. Something in the curiously distorted shape of the head, the coarse but vigorous handling, and the views seen through the two windows does suggest Raffaellino. The color is effective — a striking harmony of brown, greenish-brown, and orange. If this be Garbo's — there is some doubt of it — it suggests that he was hesitating between the Florentine and Umbrian points of view, and had perhaps strengthened the Florentine tendency temporarily by observations of Botticelli's work.[23]

It is possible that Garbo may be responsible for the *tondo* of the Madonna, Child, and little Saint John between two angels, in the Corporation Gallery, Glasgow (number 368), where it is exhibited as a Botticelli (Fig. 95). Berenson and Ulmann give it to Garbo, van Marle to Filippino. The design may be based on Filippino's work — the general arrangement recalls the Warren *tondo* — but in execution it is, I think, even farther from his style than from Botticelli's. The general stringiness of the drapery, the hands, and the types of the angels agree fairly well with those of the Berlin *tondo* and parts of the Munich Pietà, but the Madonna's face is different in shape, although the flesh tones have the same pallid quality as the Berlin picture. This again may be a deliberate imitation of Botticelli on the part of Raffaellino, always too restless and impatient, it would appear, to settle down to the serious de-

[23] Acceptance of this as Garbo's imposes a similar attribution for the Berlin "Bust of a Young Man," number 78, which Berenson and Morelli have given to Garbo, Bode to Botticelli, under whose name it is catalogued in the museum. The harmony of browns and golden flesh tones is similar to that in the Layard picture. It seems to have undergone some restoration, which may account for what in itself seems too smooth a finish for Garbo, e.g., over-cleaning.

velopment of a single style. I think there is enough indication of this eclec-
ticism in his three most authentic works to allow us to believe in an ultimate,
and rather spineless, surrender to Umbria.

Although the bringing of Botticelli into the scene here offers some
dangers, because it gives guess-work a large share in the discussion, I must
mention the various "Simonettas," "Ignotas," or female saints ascribed
sometimes to Sandro, sometimes to Raffaellino. The half-length "Magda-
len" in Christ Church library is to be suspected of coming from Garbo's
hand; so is a bejeweled and be-braided "Simonetta" in the Kaiser Friedrich
(number 106A). I do not feel at all certain about any of these. If Raffael-
lino did pass through so marked a Botticellian phase, it must have come to
an end well before the end of the Quattrocento.

Before proceeding to an examination of the "Carlis" it is necessary to
consider what evidence there is as to the work which led up to the more or
less homogeneous group of which the Resurrection and the Pietà form the
core. I have said that nothing is left in the Minerva chapel to support or
disprove Vasari's statement that Raffaellino assisted Filippino there, al-
though there is no real reason why he should not have done so. If he did, he
had probably been studying in the master's *bottega* during the eighties, per-
haps entering upon his apprenticeship about the time Filippino was at work
in the Brancacci. Consequently we should expect his painting of this time
to be strongly Filippinesque, for I do not suppose Filippino's temporary ab-
sorption in Masaccio's style affected his *bottega*; on the contrary, the Ma-
donna of 1486 points clearly to an unbroken tradition of his individual style
as asserted in 1480–81 in his Saint Bernard. It is this latter manner which
should be looked for in the earliest Raffaellinos. A picture of this character
is the "Madonna with Saints Sebastian, Andrew, Giovannino, and Two
Angels" in the Kaiser Friedrich (number 98; Fig. 22). This has been
attributed almost unanimously to Garbo, Berenson's being the chief dissent-
ing voice.[24] The panel is very closely related to Filippino's manner of the
eighties; the saints particularly recall those of the Lucca panel (i.e., the
"Four Saints" in San Michele), and the Madonna may have been painted
with the Uffizi Virgin of 1486 in mind. A drawing of Saint Andrew [25]
is so closely related to the same saint in the Berlin picture that Ulmann was

[24] He calls it school of Filippino, in the 1932 list.
[25] Berenson, *Drawings of the Florentine Painters*, II, 69, number 1278.

persuaded it was Garbo's; [26] I myself agree with Berenson that Filippino made the drawing; and that it served as the basis of the painting there can be no doubt. This in turn would tend to prove that the Berlin Madonna actually came from Filippino's workshop, painted under his supervision. The Saint Sebastian is unmistakably Filippinesque; so are the angels, and the Child, although here the type is not quite successfully imitated. There is great selfconsciousness in the drawing of the hands (as in Filippino's own early work), this detail evidently having caused the young painter special trouble. Throughout the panel one feels the awkwardness of a youthful artist not yet in possession of his full powers.

This artist drew not only on Filippino but also on Ghirlandaio. Although Filippino's Corsini *tondo* suggests a hint of Ghirlandaio's influence, it is not enough to account for the Ghirlandaiesque features in the Berlin picture. The elaborate arched throne, the parapet with vases of flowers, and the oriental rug all indicate a direct study of that artist's altarpieces — for example, the one in the Uffizi, of the early eighties, in which the enthroned Madonna is accompanied by Saints Michael and Raphael, two holy bishops, and four small angels (number 881). Filippino's pupil seems to have borrowed extensively from this very picture,[27] to such an extent, indeed, that were his types and drapery not so clearly based on Filippino's the Berlin Madonna might be classified as school of Ghirlandaio. Hence Filippino can scarcely have supplied the design for the whole of the pupil's altarpiece, but simply studies of individual figures. It may well have been a commission he was too busy, in the Carmine, to carry out, and turned over to an assistant whom he left largely to his own devices. If not, the picture at least serves to show that Filippino was famous enough in the eighties to be imitated, for no admirer of his would have been likely to copy the earlier style after Filippino returned from Rome.

As for the panel's being Garbo's, the attribution rests on the argument that (1) Garbo was Filippino's closest follower; (2) if he worked in the Caraffa chapel he must have been serving his apprenticeship, or working as a *garzone*, in the master's shop before 1488; (3) the Berlin Madonna is closer to Filippino than to any other painter. Putting together these points, we arrive

[26] "Raffaellino del Garbo," *Repertorium für Kunstwissenschaft*, XVII (1894), 111.

[27] The pose of the Berlin Saint Sebastian is an awkward translation of the jaunty attitude assumed by Ghirlandaio's Saint Michael, and one of the angels in the Ghirlandaio peeps around a column of the throne in a way which perhaps suggested to Garbo (?) his placing of San Giovannino.

at the conclusion that the picture is Raffaellino's. None the less, I think Berenson is right in arguing that it shows no clear stylistic resemblance to Garbo's known work (still less to "Carli's") and hence there is no really conclusive evidence for the attribution. Out of respect to tradition I am willing to let this attribution stand, but only with the addition of a question mark after Garbo's name.

Another panel in the same museum (number 87; Fig. 21) shows the Madonna enthroned between two angels, who hold a curtain behind her, and Saints Nicholas, Dominic, Vincent, and Peter Martyr. This also is ascribed to Garbo. It is unmistakably Filippinesque, of the eighties in types, drapery, and especially the bright color, with its emphasis on blue and orange-yellow. The hands again cause difficulty but are less awkward than in Berlin 98. The reminiscences of Ghirlandaio are less pronounced, but a comparison with that painter's Madonna with four saints and two angels in the Uffizi (number 8388) suggests that the Berlin painter drew on it for general arrangement and in details such as the Bambino. I am not sure that these two so-called Garbos are by the same hand; they seem more alike in photographs than in actuality. I prefer simply to call them school or workshop of Filippino. In the case of Berlin 87 it is quite likely that Filippino supplied sketches; the Saint Vincent is related to the Badia Saint Bernard, and the angels suggest his manner. The chief interest in the two altarpieces lies in the evidence they offer of Filippino's popularity in the eighties, and, probably, of his need for *bottega* assistants, owing to the press of work.

With our present knowledge I think we must be content to leave this early period of Garbo's career as a matter for conjecture, and to accept the Berlin *tondo* with the musician angels (number 90) as his earliest certain work. Then follows the group associated with the Munich Pietà, which must bring us near the turn of the century. It should be at this point that Carli steps in to supplant Garbo, with his signed and dated works of the early 1500's. The meeting of the two styles occurs in the "Madonna with Saints and Donors" in the Uffizi dated 1500 and signed RAPHAEL DE CAPPONIBUS (Fig. 96). Filippino's influence is still to a certain extent recognizable. The small altarpiece with the Crucified Christ between the Virgin and Saint John, placed in the foreground of the picture, is so Filippinesque that one is tempted to see in it a copy of a lost original, or at least a variation on the master's popular Crucifix type which originated two or three years earlier.

Moreover, this "Raphael," if he had not been studying the Nerli altarpiece (the kneeling donors suggest this), had certainly looked at the Madonna of 1486, then in the Sala del Consiglio. The pose of the Child — and what an insipid, doll-like Bambino, contrasted with Filippino's grave, vigorous one! — is almost a copy, except for the difference in the hands, "Raphael's" Child blessing instead of fumbling with a book. The Virgin's hand is extended toward her son in much the same fashion in both altarpieces. The pattern of grotesque heads, with what looks like an Indian feather headdress, alternating with a plant form, on the step of the throne, is quite similar to the moulded cornice of the niche in Filippino's Madonna. Instead of the richly carved throne, however, "Raphael" substitutes a curtain and baldacchino of purely Umbrian type, such as Pinturicchio often introduces. The Virgin is young, pretty, and characterless, an imitation of Pinturicchio's Madonnas without their rather taking piquancy. Saint Francis, on the other hand, is more Peruginesque, with the small mouth and languishing upward gaze so hard for most of us to regard as sincere in feeling. Saint Zenobius, wearing, as he does in Filippino's altarpiece, a morse enameled with the lily of Florence, is absolutely wooden and perfunctory. The donors have, naturally enough, perhaps, more life and character than the saints, whom "Raphael" supposed he was idealizing; but they too seem indifferent, like people decorously attending mass through custom but not particularly moved thereby. There is an immense difference between such portraits and the deeply felt and finely characterized Nerli couple.

The background again points to Umbria, the sky unclouded but brightening toward the horizon. The incident of Saint Francis receiving the Stigmata is introduced in miniature to the left. The town behind him is very like the one in the Munich Pietà in its predilection for picturesque domes and spires. Elsewhere the artist wastes his energies on petty decorative detail. The picture as a whole is a kind of triumph of the obvious; everywhere the path of least resistance is followed, the superficially attractive seized upon. Have we to do with a man turning to a sort of *détente* as a relief and a reaction from the troubled time under Savonarola, whose diatribes may have made more than one painter feel that creative effort was futile if not actually dangerous to the soul? Or are we in the presence of a new painter, fundamentally mediocre, who never had done better and could not be expected ever to rise above this dead level of competent mediocrity?

Berenson answered the question by calling the painter Raffaelle de' Carli, who was, he thinks, in Garbo's shop at the time the Madonna was painted.[28] Garbo was, he says, employed by the Capponi at the time; hence Carli signed with the *bottega* name the altarpiece theoretically produced by Garbo, who may even have taken some part in the execution, if only in supplying the design. This is a possible way out of the difficulty. But it must be remembered that Carli seems also to have been a protégé of the Capponi, and a perfectly competent, if uninspired, painter by 1500. If his father died in 1479, when he was no longer a baby, he must at least have been something over twenty by the turn of the century, and he might have been still older, since we have no clue to his age at the time of his father's death. Why should the Capponi, then, have continued to employ Garbo if they had brought up Carli in their own household? And as a rich and powerful family, why did they not put their protégé Carli into a more distinguished *bottega*? Garbo's Portata al Catasto of two years earlier had complained of poverty, in his case apparently more genuine than the condition one automatically develops in the presence of a tax-return sheet.

Is it not equally probable that Raffaelle Carli, protégé of the Capponi, was sent to study painting with Filippino [29] some time in the eighties; that after his return from Rome in the early nineties the Capponi patronized him as an independent master, ordering at least one important picture, the Uffizi Resurrection? This, by the way, is thereby quite possibly shown to belong to a date prior to 1498, since the painter can hardly have been in the dire financial straits of which his tax declaration complains if he had just finished the altarpiece for the chapel at Monteoliveto; it must have commanded a goodly fee. By this time he would have been living independently and maintaining his various shops. In the nineties he may, along with so many of his fellow-citizens, have fallen on evil times; the Capponi may have ceased to patronize the arts, and perhaps (if we may believe Vasari's account of Raffaellino's disagreeable temper and untidy habits) they did not care to have anything

[28] *Drawings of the Florentine Painters*, I, 86 ff. The Madonna under consideration was painted for the church of Santa Maria Nuova.

[29] Filippino would have been a likely enough choice; the Capponi themselves had several chapels in Santo Spirito, where they could have admired Tanai de' Nerli's altarpiece about the time Raffaelle would have been finishing his training, although this is too late to coincide with the beginning of the boy's apprenticeship. Possibly he may have been sent to Filippino on account of, and about the time of, that master's prominence as painter in the Brancacci, which chapel is, of course, in the neighborhood of Santo Spirito.

further to do with him. The "de Capponibus" on the altarpiece of 1500 may have been either a plea for fresh recognition from his early patrons, or perhaps a gesture of defiance. After this he turns back to his old family name, Carli.

All of which gets us nowhere with regard to the paintings, if too many points have to be stretched to include the panel of 1500 in the same *œuvre* as the Uffizi Resurrection and the Munich Pietà. Berenson has gathered together [30] a number of pictures which he believes represent Carli's youthful work; these are characterized by a strong influence of Ghirlandaio, with whom it could be argued Carli first studied. They center around the "Madonna and Saints" at Volterra, and two similar compositions still *in situ* in Santo Spirito. The association with Carli's work is possible, and were it not for the documents one would perhaps be disposed to accept them without argument. However, quite apart from written records (which it is possible to deify quite as unreasonably as the evidence of ear-lobes and finger-joints), I do not feel that Berenson's proposition is absolutely conclusive. The Volterra panel particularly (Fig. 97) does not seem to me to lead up to any of the others in the group, in spite of certain general similarities, chief of which is a common denominator of Ghirlandaio. It differs from the Santo Spirito pair in having a strange, cold tonality, as of old silvery-green metal, especially in the flesh tones; and a rather lively mannerism in showing the heavy forms, particularly in the ornate throne of the Madonna and the affected upward gaze of the double-chinned Child and angels. The effect of the whole is that of an energetic but provincial painter whose chief allegiance is to Ghirlandaio but who has also looked with interest at products of Pollaiuolo's atelier.[31]

Much more colorless and uninteresting are the two Madonnas in Santo Spirito. These hang in the same transept as the "Madonna and Saints" dated 1505 (Fig. 98) which is unmistakably by the same hand as the Sarasota and Corsini Carlis. In both the Child suggests the influence of Verrocchio's *bottega*, while the angels in one of them betray a knowledge of Botticelli. The setting in both is the familiar arched niche flanked by walls with trees behind. In each case the saints are carefully labeled — the one inscription with which the modern student could comfortably dispense, since

[30] *Drawings of the Florentine Painters*, I, 86 ff.

[31] I also feel a kind of spiritual kinship with such a Padua-trained northerner as Bartolommeo Vivarini.

there is no mistaking the identity of any of the holy personages. The name of the painter and the date are withheld.

All these three pictures [32] belong, no doubt, to the eighties, stylistically, and this was the period that saw so much activity in chapel decoration in Santo Spirito; witness the Bardi and, as I think, the Nerli altarpieces. One might go so far as to say that Garbo-Carli (or Carli, rather) was painting in this Ghirlandaiesque manner when he first joined forces with Filippino, and that after the Roman interlude he reverted to some of his earlier tendencies. But I think it more likely that the Santo Spirito panels were turned out, not by Raffaelle, but by some even more obscure painter or painters in the shop of Ghirlandaio, that much-sought-after master having been thoroughly overloaded with commissions in the eighties; or, if not actually painted in his *bottega*, they must have been done by a man less busy and less expensive than the greatest masters. As to this man's being Carli and not Garbo, I cannot feel that the style of these panels develops inevitably into that of the signed Carlis — at least, no more inevitably than do the Garbo Pietà and Resurrection. Is there any particular reason, for instance, why the highly individual and slightly brutal Saint Bartholomew (the knife makes the murderous appearance the more insistent) of the Santo Spirito pictures should in the Corsini Carli allow his hair to grow down over his shoulders, when Saint Jerome's remains short, revealing his ear?

One more possibility. There is indeed some similarity between the two Saint Bartholomews of the Ghirlandaiesque panels and the same saint in the Corsini Carli, which was painted for Santo Spirito. Is it not conceivable that the eclectic Carli-Garbo, required to paint a Saint Bartholomew, might have taken the type from those, which must certainly have been in the church for many years by 1501, and with which, as the protégé of a family owning chapels in Santo Spirito, he must have been thoroughly familiar? The Corsini saint, of course, is long-haired, as Filippino would have painted him, but the curving knife is precisely the same. At the same time, a comparison based principally on an accessory such as this is not very forceful.

Of the further development of Carli little need be said except for a few suggestions as to the chronology of undated pictures. As a framework there are the Uffizi Madonna of 1500, the "Mass of Saint Gregory" and the

[32] I am not satisfied that the Volterra panel is by the same hand as the two in Santo Spirito; but, like them, I think it should be classified as school of Ghirlandaio, rather than as Carli or Garbo.

Corsini panel of 1501 (Fig. 99); the Siena altarpiece ("Raphael de Floren-
tia") of 1502; the Cestello "Loaves and Fishes" of 1503; the Santo Spirito
Madonna of 1505, and a documented panel of "San Giovanni Gualberto
Enthroned with Saints," dated 1508. Of the works cited by Vasari we have
the "Madonna and Four Saints" painted for San Salvi, which seems to
have been the picture now in the Louvre (number 1303; Fig. 100), although
the Madonna is being crowned, a detail of iconography omitted by Vasari,
who also described side pieces and a predella, which have disappeared.
Otherwise his description fits satisfactorily. This picture, as has been recog-
nized, combines elements of "Carli" and "Garbo," which those who believe
in two painters explain as a case of collaboration similar to that of the
Madonna of 1500. For my own part I regard it as a useful piece of evidence
for linking the two "personalities" together as one, particularly as the Garbo
style occurs in the minor portions of the panel, i.e., the musician angels and
the cherubim surrounding the Coronation. The composition is in general
based on Botticelli's altarpiece of the Uffizi. The painter has resurrected the
attitude of kneeling on one knee which he used in the Munich Pietà, having,
I think, derived it from Filippino. In type all the angels show a reversion to
the Filippinesque manner. They have much of the charm and something of
the liveliness of drawing which characterizes those of Berlin 90. The Virgin
is attractively girlish, similar to the Madonna of 1500 but with neither veil
nor mantle over her long fair hair. Christ is the rather heavy-lidded, some-
what sentimental type of the Resurrection. As for the four saints, they are
Peruginesque and uninteresting, though if the painter had not been trying so
hard to be Umbrian the head of Saint Bernard might have been a fine study;
as it is, the fundamentally vigorous type is smoothed over and robbed of most
of its character.

The resulting panel is in a sense comparable in effect to the Filippino-
Perugino Deposition. I believe it might indicate a deliberate but still only
partial return on Garbo's part to the style of his earlier master, as a bid for
popularity. Vasari tells us he took special pains with this altarpiece in
gratitude to the abbot of San Salvi for relieving his poverty by the commis-
sion.[33] He may have felt that the style which had brought him fame in the
nineties would do so again, yet he could not quite give up the Umbrian

[33] Milanesi-Vasari, IV, 238: "Nel che si portò molto bene, perchè fu sovvenuto in quella sua
miseria da quello abate."

manner which he found so much to his taste. Possibly the death of Filippino
early in 1504, and the stir it made in Florence, directly influenced Garbo in
the revival of his master's manner. Stylistically I think it falls between the
dated works up to 1503 and the Santo Spirito panel of 1505. The saints of
the Louvre Coronation tally closely with those of the Siena altarpiece of
1502; that of 1505 is, like the Coronation, full of borrowings from Filippino.
The most noticeable of these is the Saint Bernard, a rather bloodless and
pietistic imitation of Filippino's in the Badia; he holds the devil by a chain, as
though it were a pet monkey. One panel of the predella (Fig. 101) contains
an approximate copy of the whole Badia group of Saint Bernard's vision,
with the difference that the scene takes place in a room and there are two
angels instead of four; but it is significant that Raffaellino chose Filippino as
his model here instead of Perugino, whose treatment of the same subject he
could have studied in the Nasi chapel of the Cestello. On the other hand we
might have expected the Martyrdom of Saint John the Evangelist (Fig. 102)
in the predella to have been based more definitely than it is on Filippino's
version in the Strozzi chapel. None the less there is a Filippinesque quality
throughout the predella. Again, as in the Louvre Coronation, we find the
painter relegating the style of his earlier master to minor parts of the picture;
did he feel vaguely ashamed of this temporary disloyalty to Umbria?

The attractive *putti* who hold up curtains on either side of Our Lady's
throne wear thin drapery drawn in what I have called a "stringy" fashion,
more like Raffaellino's Filippinesque style than the blunt smooth folds of his
Peruginesque manner. Their heads, with fairly thick curls, double chins,
and piquant little noses, are much more closely related to the cherubs of
the Louvre Coronation than to the blandly sentimental Christ Child of, say,
the Corsini "Carli," although they have approximate counterparts in the
putti of the latter picture, who emerge from the spandrels of the throne and
hold up a string of jewels.

To the same period — c. 1504–1505 — must belong the lovely *tondo* in
Naples,[34] where it has incredibly been called a Lo Spagna (Fig. 104). This is
really almost too good to be the Garbo of the 1500's; yet a comparison with
his Louvre and Santo Spirito panels establishes his authorship. The Virgin's
oval, rather sweetly expressionless face, with neatly drawn, arched eyebrows,
is characteristic; so is her right hand, holding a pomegranate, while the Child

[34] Number 43, Museo Nazionale. This is now labeled Raffaellino del Garbo.

is seated in much the same pose as in the Santo Spirito example. His head is almost an exact replica of the right-hand cherub head in the Louvre Coronation. San Giovannino might be his twin brother. His bunchy drapery has the stringy quality and somewhat the same arrangement as the Santo Spirito *putti*, and among the folds occurs the little coiled fold noted in the Pietà and the Resurrection. The landscape is perhaps more Florentine than Umbrian; something in the fat, bushlike trees in the distance suggests Piero di Cosimo [35] with perhaps an admixture of Lorenzo di Credi. The Virgin sits on the ground, her pose well adapted to the curve of the frame. The book, open at the "Magnificat," and propped on a stump, is not perhaps an altogether successful accent, but the composition as a whole is stabilized by the luminous opening in the heavens, and the pigeon (not, I presume, intended as the dove of the Holy Spirit) on the ground, directly on axis. Berenson accepts this as Garbo's, and I confess it shows considerably more power than the signed Carlis; at the same time the parallels with these make me conclude that the *tondo* is Carli (i.e., Garbo) in an unusually inspired and painstaking mood. Indeed, it is possible that the picture was not painted until after Raphael Sanzio came to Florence in 1506.[36]

In the church of San Lucchese near Poggibonsi is a "Noli Me Tangere," given by common consent to Carli. Here the Umbrian quality is based distinctly on Pinturicchio rather than on Perugino, particularly in the centrally placed date palm and the decoratively symmetrical arrangement of the other trees. The figures of Christ and the Magdalen are so close to those of the Cestello fresco of 1503 — especially the profile head of the latter — that I am led to wonder whether it was painted just before the Cestello picture and after the altarpiece of 1502 in Siena. Raffaellino need not, of course, have painted either panel on the spot, but if he did go to

[35] I believe this picture has actually been attributed to Piero; but he would never have been satisfied with such an obviously pretty type as this Virgin.

[36] A slightly weaker but not unattractive *tondo* of about the same time as the Naples picture is the one in Prato (number 36 in the Municipio) showing the Madonna and Child seated on a parapet with San Giovannino kneeling in adoration alongside. The background is very Umbrian, and the whole picture suggests the influence of Raphael. The Saint John recalls his counterpart in Filippino's Nerli and Cleveland panels, or the Woodward fragment. The composition was popular enough to be copied by weaker hands; a repetition of it exists in the gallery in Montepulciano.

A Madonna and Child with the little Saint John (Fig. 103) was published in 1932 by Dr. Bodmer, who spoke of it as having been owned by Goldschmidt and Wallerstein in Berlin; see *Pantheon*, November 1932, p. 354. He calls it a late Filippino, but it seems to me, judging from the photograph, a good example of Raffaellino's work, done at about the same time as the Naples *tondo* discussed above.

Siena he would have been within easy reach of Poggibonsi. Moreover, the Pinturicchio-like elements could be conveniently explained by a visit to Siena, although that would probably mean putting the date later than the Cestello fresco; the Piccolomini library was not begun until 1503, the year of Pius III's brief term as pope. In any case, the Poggibonsi panel cannot be far removed in time from the Cestello work.

One more instance of the fusion of the "Garbo" and "Carli" style occurs in the not very exciting Annunciation over the high altar in the monastery chapel of San Francesco, Fiesole (Fig. 105). In this the insipid Madonna is in the weakest "Carli" manner; the slightly unkempt Gabriel is more like "Garbo." Two grisaille prophets in medallions, and a Deus Pater above, are revivals of Filippino, among the most vivid instances of this influence in Garbo. The God the Father reminds one of Vasari's statement that Filippino "in San Francesco, outside the San Miniato gate, facing the sacristy, ... did a God the Father with several children." [37] While this can scarcely be the Fiesole picture, I should think it quite possible that Raffaellino based his figure on Filippino's in the other church of San Francesco, omitting the *fanciulli*, who probably took the form of a circle of *putti* such as are introduced in the Prato tabernacle and Lord Rothermere's Madonna.

Since Raffaellino is not my primary interest in this book, I shall make no attempt to list his complete *œuvre*, which unhappily includes some dull and valueless work, unworthy of survival beyond the Cinquecento. But it has seemed essential, as I said at the outset, in speaking of this chief follower of Filippino's to record in general my opinion regarding his work and identity, although there is little enough pleasure to be derived from their investigation.

Raffaellino de' Carli del Garbo might stand as a kind of symbol of the whole study of the arts. He illustrates with embarrassing and relentless clarity the divergent aims and results of "connoisseurship" versus document-worship. On the student's attitude toward these two methods of approach depend very largely the conclusions ultimately to be reached by him as to the painter or painters involved. And I believe that in order to come to conclusions satisfactory at least to one's self, it is necessary to be committed with some arbitrariness, if not fanaticism, to one of these two points of view.

[37] Milanesi-Vasari, III, 465. "In San Francesco, fuor della porta a San Miniato, dinanzi alla sagrestia, fece un Dio Padre con molti fanciulli."

The more one recognizes the limitations of both, the less likely one is even to satisfy one's self. That one can in addition satisfy scholars in general I do not believe. Even a direct statement in a newly discovered document to the effect that Raffaelle de' Carli, protégé of Niccolò Capponi, had a studio in the Via del Garbo and about 1502 was commissioned to paint an altar-piece for the church of Santa Maria degli Angeli, Siena, would (assuming its authenticity were beyond question) leave *in statu quo* the matter of a dual "artistic personality." At present, on the other hand, I do not see how the documents which do exist can be divided convincingly among the component parts of this personality except by the tortuous reasoning of a trained lawyer committed to the defense of a difficult case. What we do derive from the study of this rather tedious and seldom inspired painter is a distrust — I daresay a healthy one — for our own methods of scholarship. Raffaellino is certainly a figure the pleasure in whose study must be chiefly that of the chase; and that, much as I respect those who enjoy it, is after all a kind of by-product of art as a contribution to, and reflection of, life. Too often we forget that a name makes no difference to the quality of a picture. Useful as it is to unearth historical and other facts about a painter, such facts have little to do with his permanent value *as* a painter. The names of Garbo, Carli, or even Raffaelle, can do nothing to improve work which is in nearly every case fundamentally mediocre.

CHAPTER X

OTHER PUPILS AND FOLLOWERS

IT WAS doubtless the rise, just at the time of Filippino's death, of the great masters of the early Cinquecento which prevented him from forming anything which can be called a school. Raphael, Leonardo, and above all Michelangelo, were the great exemplars of the new century, and to them the majority of young painters turned for inspiration and guidance; Filippino's influence seems to have been limited in the main to the lesser spirits who felt his charm or saw in his work easier solutions to pictorial problems than were offered in the paintings of the great triumvirate. Hence it is that, although there exists a considerable number of pictures called "School of Filippino," practically none of them can be associated with known names, and most of them are of indifferent quality. Neither can so much as a single homogeneous group be isolated from among them, such as might tentatively be connected with one of the pupils whom Vasari names.[1] These pupils, indeed, are no more than names, with the exception of Raffaellino del Garbo, who carried his master's art into a blind alley, combining it with secondhand Umbrian elements and contributing nothing fresh or creative to the development of painting. Probably most of the copies or imitations of Filippino were painted by hack workers for patrons in modest circumstances who were neither interested in nor able to afford the productions of the more progressive masters or their pupils. In most cases all that remains of Filippino is the empty shell of a design, his types and mannerisms being coarsened, weakened, or even travestied. Such are the feeble imitations, cited in previous chapters, of the Bologna "Marriage of Saint Catherine" or the Prato tabernacle. In quality they correspond closely to the cheap 'hand painted" copies of popular "old masters" for sale in Europe today, and as such they have little interest or significance except as proving a mild

[1] Pupils cited by Vasari include only Raffaellino del Garbo and Niccolo Zoccolo, called Niccolo Cartoni.

popularity of Filippino's work in the Cinquecento — for none seem to belong to a later century.

There are certain exceptions to the general rule of mediocrity, most of these having, in fact, been attributed at one time or another to Filippino himself. It is with these that I propose to deal, leaving the poorer things to those who care to seek them out in van Marle's lists. A few in the latter category have already received mention in earlier chapters, in connection with the originals from which they derive.

In my opinion the most interesting painter to come under the influence of Filippino was Piero di Cosimo, whose relation with that master I have already discussed. It is not insignificant that Piero, very catholic in his tastes as a collector of artistic ideas, should have included those of Filippino as a matter of course along with borrowings from Signorelli, Leonardo, and Lorenzo di Credi, for Piero, once free of his early master Cosimo Rosselli, had an unerring eye for masters worth studying. There could scarcely have been a greater fundamental difference than existed between the two painters: Filippino gentlemanly, cultivated, sensitive, evidently a social favorite; Piero — if we are to believe Vasari — dirty, unkempt, erratic, boorish perhaps, fond of solitude. In neither do the elements borrowed from the other combine perfectly with those to which they are united; Piero's oddly Nordic bluntness and solidity of form is slightly obtrusive in Filippino, and the latter's types look effeminate and sentimental, introduced among the rugged peasants of Piero's characteristic work.[2] In landscape the two come nearest to speaking the same language. In problems of space, light, and the forms of clouds and distant hillsides they meet on common ground, with, I think, an admiration of Flemish work as a common denominator, together with a poet's love of nature for its own sake. But the poet's point of view colors everything Filippino does, whereas Piero — a kind of cisalpine Adrian Brouwer — finds landscape the only subject which he can express in a wholly lyric idiom.

Of a wholly different character, though perhaps even more intimately associated with Filippino, is the engraver Cristofano Robetta. Mr. John Walker [3] has pointed out briefly the relationship which seems to have

[2] An instance of this kind of juxtaposition in Piero's work is to be seen in his "Madonna with Saints" in the Innocenti gallery.

[3] *Bulletin of the Fogg Art Museum*, March 1933, pp. 33–36.

existed between the two. I agree with him that there seems to have been a personal connection, Robetta actually having had access, it would seem, to drawings of the painters. He took his inspiration from paintings of Filippino's post-Roman period, almost without exception, and it must have been in the nineties that the association was strongest. The best known of Robetta's engravings after Filippino is no doubt his version of the 1496 Epiphany.[4] There is also an engraving of a single figure with two baby fauns, a free translation of the group of mother and children to the right in the Strozzi "Raising of Drusiana." [5] Another engraving inspired by the Strozzi frescoes shows two fantastically dressed women with a harp between them,[6] taken from the group to the right of the window in the chapel (cf. Fig. 107). It will be remembered that the same composition was used for a small painting probably of Filippino's workshop; [7] Robetta may have used some such model in making his engraving.

Yet another print of Robetta's shows the Madonna, Child, San Giovannino and three angels.[8] Stylistically this suggests the influence of Filippino, possibly combined with that of Raffaellino del Garbo, but I know of no precise prototype for it, and Robetta is famous for the freedom with which he modified borrowed details. These borrowings of his are usually altered in the direction of simplification, as though he found the delicate intricacies of Filippino too much for his own powers. Compared with the originals which inspired him, his prints tend to look rigid and labored, as though the medium gave trouble and prevented the flexibility of pen and brush — as indeed it does except in the hands of the most expert technicians. This does not mean, however, that Robetta's translations of Filippino are without charm.

I do not think that Robetta's engraving after the Badia "Vision of Saint Bernard" [9] indicates a connection between the two as early as the eighties;

[4] Berlin Kupferstichkabinett, B6–877.17, etc. Signed ROBETTA. The figure of the man standing at the extreme right of the Adoration in the foreground was repeated even more accurately by Robetta in another print which Mr. Walker did not mention. It is interesting to recall that Robetta also made several engravings after Piero di Cosimo.

[5] Mr. Walker makes this comparison, which occurred to me independently of his article. He reproduces the print, from the impression in the Bibliothèque Nationale, Paris, in reverse, the better to show its similarity to Filippino's figures; see Bulletin of the Fogg Art Museum, March 1933, p. 34.

[6] Berlin Kupferstichkabinett, B.23, etc. Signed RBTA.

[7] Cf. Chapter V above.

[8] Berlin Kupferstichkabinett, B.13.867.17, etc.

[9] Reproduced in Le Gallerie Nazionale Italiane, II (Rome, 1896), Plate XV and p. 140.

it is more probable that the engraver chose it as a subject likely to be popular. It is more interesting than attractive, showing clearly Robetta's tendency to omit subtleties of detail and vary the original arrangement of his model. He greatly simplified his task by omitting much of the landscape background, substituting a wide expanse of sky above a low horizon line — a feature which, if it does not indicate laziness on the part of the artist, does point to the end of the Quattrocento as its earliest possible date.

The drawing of the potbellied nude male regarded by Berenson as Filippino's, and accepted as such by Mr. Walker,[10] I am not convinced is his. Mr. Walker believes it proves that Robetta had access to sketches of Filippino's as well as to paintings publicly exhibited, since he introduces it into a large composition of the Baptism.[11] But even if the sketch here used is not Filippino's, I am inclined to believe that Robetta did have the use of drawings by that painter. The composition of the Baptism as a whole is not Filippino's, although that in itself would not prevent the drawing from being his.

Another name which can be associated with Filippino's is that of Mariotto Albertinelli. It will be recalled that after the former's death the monks of the Certosa di Pavia turned to Albertinelli for the altarpiece which Filippino never carried beyond sketches. We have no assurance that the second attempt of the monks succeeded any better than the first. Whether the later altarpiece would have shown borrowings from Filippino, as the latter's Epiphany indicates the influence of Leonardo, it is impossible to say, although Filippino's work had not gone far enough to provide much for a later painter to build on. However, such borrowings do occur in the somewhat eclectic "Madonna and Saints" in the Louvre (number 1114, Fig. 106) signed and dated 1506.[12] Berenson says this was "begun by Filippino, who laid in the Saint Jerome." [13] "Albertinelli," he continues, "must have been assisted by Bugiardini in the execution of the rest, especially in the Child and landscape." If Filippino did do any "laying in," I should go farther than Berenson and suggest that he is responsible for much of the Madonna and Child; the latter's body corresponds fairly closely to the curiously

[10] Fogg *Bulletin*, March 1933, pp. 35–36; Fig. 3, p. 36.

[11] Fogg *Bulletin*, March 1933, p. 37, Fig. 4. The engraved version does not appear as the reverse of the drawing.

[12] MARIOCTI DE BERTINELLIS OPUS — Ā.D̄.M̊. DVI.

[13] *Italian Painters of the Renaissance*, p. 4.

flattened plumpness of babies in his altarpieces of the 1500's and the pose of Our Lady's hands recalls Filippino's formula, although in execution they show the soft, puffy fullness of many Cinquecento hands, as though, as is true of types of that century contrasted with those of the Quattrocento, the entire figure had, so to speak, put on weight. The Child's head is only remotely Filippinesque (neither does it seem to me strikingly to suggest Bugiardini) and his mother's even less so except for a suggestion, in the small prim mouth, of the type we see in Filippino's Epiphany. As for the drapery, it is as far as possible removed from Filippino. This is true of Saint Jerome's robes as well, and his head, except perhaps for its high oblong shape, has no connection with the older master, whose manner is, however, clearly recognizable in the arm and hands. The Saint Zenobius on the right may be ascribed wholly to Albertinelli.

This picture serves to show how little Filippino had to do either with the physical forms or the design of the Cinquecento — design, that is, in the realm of the altarpiece. Another painting of Albertinelli's, the Visitation of the Uffizi, is a stock example of the difference between the Quattrocento and Cinquecento points of view, and although the Louvre Albertinelli does not reveal such breadth and simplicity, it does on the whole show a similar character: large, solemn figures, simply placed within the frame, and generalized as to draperies and expression. Filippino is always more absorbed in the specific, whether of external detail or of individual feelings. In an altarpiece of this kind he could occasionally design simply; the best example is his London Madonna; but he never approximated the broad, massive, stately forms which Woelfflin has so well analyzed as being essentially of the Cinquecento. In this respect Piero di Cosimo is more akin to the new century than is Filippino; witness, for example, his "Assumption of the Virgin" in the Uffizi, painted very near the beginning of the century.

If we allow for the difference in execution, the Louvre Albertinelli might indeed be a panel left unfinished at Filippino's death. The architectural fragment with a ram's head and the fantastic coiled trumpet, one on either side of the relief of Adam and Eve above which the Madonna stands, might have been painted by him. This relief of the Fall of Man is remote in type from Filippino, and the carefully painted background lacks the atmospheric quality he would have given it. The little town to the right, with its patriotic display of lion, weather-vane of the Palazzo Vecchio, and banner sur-

mounted by the lily of Florence, is highly engaging. Saint Zenobius can be seen kneeling in the street, performing one of his miracles of raising a dead person being carried to the grave.

The argument for Filippino as the originator of the panel is supported by the fact that this is, so far as I know, an isolated instance of his influence on Albertinelli, on whom that influence would thus have been arbitrarily imposed. In general the younger painter was chiefly affected by the Raphaelesque phase of sixteenth-century style.

I am unable to associate any other names with paintings based directly on Filippino's,[14] and therefore cannot propose definite painters to take the responsibility for the next group I wish to discuss: certain panels in the United States, most of them exhibited over the name of the master himself.

The most attractive of these, in my opinion, is the "Madonna Adoring the Child Supported by an Angel," in the Toledo museum (Fig. 108). Lionello Venturi attributes it to Filippino.[15] Acquired by Toledo from the Dreyfuss collection in Paris, it was originally purchased in Florence in 1851. It is a work of undeniable charm. Certainly the style derives in part from that of Filippino in the early eighties; the theme of the Virgin worshipping the Child, who lies on the ground before her, is the popular one descending ultimately from Fra Filippo, and the angel leans forward with a deprecating gesture and beseeching upward gaze associated with Filippino's debt to Botticelli. But none of the details will bear comparison with those of authentic early Filippinos. The firm, rounded contours of the Virgin's face are more akin to Ghirlandaio than to Filippino's delicately frail type; her hair, thick, smooth, golden blonde, and almost straight under the white veil, has a dead, flaxen quality impossible to duplicate in Filippino's work, and suggests the even more dully painted hair of the Madonna whom Graffione substituted for the Tabernacle of the Sacrament in Baldovinetti's fresco in Saint Ambrogio, Florence. (In these two, incidentally, the hands are almost exactly alike.) The fat, snub-nosed Bambino has no connection with Filippino's type, belonging rather to Verrocchio's tradition. In the angel one recognizes Filippino's way of crushing sleeves into parallel wrinkles, a right hand

[14] The debt to him of such men as Francesco Botticini and Graffione, sometimes cited, seems to me to have been extremely slight.

[15] In *Art News*, April 16, 1931, p. 13, this opinion is quoted. The picture was evidently acquired too late to be included in that author's *Pitture italiane in America* (1931); it reached the Toledo collection in 1930, but was not put on exhibition until January 1931. See also Blake-More Godwin, *Museum News* (Toledo), December 1933.

familiar in his work, and the aforementioned sentimental expression; but all these mannerisms are executed with a laborious care that bespeaks an imitator rather than the master himself, expressing himself in his own natural idiom.[16] But what particularly sets the angel apart from those of Filippino is his hair. Filippino, to claim the picture at all, would have to have painted it before 1488; but comparing this hair with that of, say, the Badia angels or the angels of the Madonna of 1486, we find it entirely different. It looks as though a coarse comb had been drawn straight through it, leaving neat parallel locks ending in tidy little snail-shell curls, a little like the hair of a king or jack in a deck of cards; whereas Filippino's hair is crisp, tangled, wind-blown, and has a characteristic soft elasticity peculiarly his. The Toledo angel's hair recalls Francesco Botticini's.

Another non-Filippinesque element appears in the halos, which, though streaked with gold, lack the iridescent effect so regularly met with in the altarpieces of the eighties; note also the enthusiastic use of gilding, with which Filippino dispenses almost entirely. The Toledo painter has sprinkled the angel's light raspberry-colored tunic with little clusters of gilt dots, dressed the Virgin in red dotted with gold, and caused fine gilded lines to radiate from the Christ Child's body. In color the picture is attractive, the most striking note being green (never a favorite with Filippino) — a pale pea-green for the angel's sleeves, a deep olive tone in the grass and foliage. The Madonna's conventional dark blue robe is brought into harmony with the rest by being given a greenish cast, and the architecture in the background is of a cool flat grey.

I should classify this panel as by a partial imitator of Filippino, but one who is also drawing on other painters, such as Botticini and perhaps some follower of Verrocchio. It is not close enough to Filippino even to be regarded as of his "school," much less of his *bottega*.

In this connection I might mention a few more variations on the same iconographical theme, of the Adoring Virgin. The Graffione in Saint Ambrogio is one, although it has little in common with Filippino beyond the general arrangement of the figures. In the Bambino the way in which the

[16] Notice, for instance, the awkwardness with which the folds of the Madonna's robe fall in a corrugated, curving mass just beyond the Child's right foot. The painter seems to have been at a loss as to how to make the transition from vertical to horizontal (a detail which seldom troubles Filippino, with his characteristic arrangements of rectangular folds lying on the ground). The resulting fold or mass of cloth looks like a wrinkled boot half pulled off.

finger is put in the mouth is taken from Fra Filippo rather than from his son (cf. the example painted by the Frate for the Medici chapel, now in Berlin). Iconographically closer to the Toledo picture is a ."Madonna Adoring" with two angels kneeling before her, one supporting the Child, in the Ca'd'Oro, Venice (Fig. 109).[17] Stylistically this panel is more homogeneous than the Toledo example, and shows a better understanding of Filippino. His iridescent halos have been imitated, and the color includes the master's favorite orange-yellow. While not perhaps close enough to be a *bottega* piece, this certainly deserves to be classified as Filippino's school.

An apparently popular variation on the Adoration theme is one perhaps better designated as Holy Family, the sleeping Saint Joseph being introduced and the little Saint John substituted for the angels. Such a group occurs in a *tondo* in the Venice Academy (number 49), of indifferent quality (Fig. 110). The architecture includes the free-standing column noticed in Filippino's altarpieces of the nineties. A very close relative of this, except that San Giovannino is omitted, was published by van Marle [18] as a "fine creation" of Filippino's. This picture, in a private collection in Amsterdam, I know only from a photograph, but on the basis of that I should call it a poor copy or imitation, certainly not an original. The figures of Mary, Joseph, and the Child are so precisely like those in the Venice *tondo* (the Amsterdam example is of the same shape) that a single model must have served for both, either a lost original of Filippino's own or a variation by a follower or pupil. Van Marle also publishes a half-length Madonna with hands clasped in prayer [19] which he calls a Virgin Annunciate. This panel, in a private collection in Florence, looks to me like another example of the famous Adoring Virgin; the prayerful attitude is unusual for an Annunziata, and this is a clear repetition of the Venice Academy type except that the

[17] This type of Adoration, an elaboration of the version seen in the early Uffizi "Madonna Adoring" (number 3249), may derive from an original planned and perhaps painted by Filippino in the mid-nineties. Evidence for this is afforded by a drawing in the Uffizi (Fig. 111), number 205, cornice 75 (Berenson, *Drawings*, no. 1304), showing two angels and Saint Joseph in addition to the Virgin and Child. The three-dimensional treatment of the architecture of the background, the fine curling shape of the angels' wings, and the general handling relate this to work of the nineties; it is close, for instance, to the Loeser drawings, although the silverpoint has rather less of the masterly lightness and crispness which characterize the pen sketches. I know of no school piece which closely reproduces the drawing, which may have been modified when the picture came to be painted. The number of related copies makes it seem likely that Filippino actually completed a similar composition which was drawn on more or less freely by imitators.

[18] *Italian Schools of Painting*, XII, 321.

[19] *Ibid.*, p. 337.

face is turned slightly more toward the spectator. It is certainly not by Filippino.

Other examples of the same sort might be cited — for example, a *tondo* in Lille (Musée Wicar, 932) with shepherds and San Giovannino may, as Berenson thinks, be a copy of a lost Filippino. But nothing is to be gained by listing these,[20] which often reflect one or more styles in addition to Filippino's — Botticelli's, Lorenzo di Credi's, or Jacopo del Sellaio's — and in quality most of them are worse than mediocre.

The Detroit Institute of Arts owns a predella panel of the adoration of the Magi (Fig. 112) which the director, Dr. Valentiner, now attributes to Bartolommeo di Giovanni (Berenson's Alunno di Domenico). Since, however, at the time of its acquisition he ascribed it to Filippino under the influence of Leonardo,[21] it seems worth while to say a word as to the latter attribution. As Dr. Valentiner pointed out, certain details such as the barking dogs, and the horses with their ample curves and elegant gait, closely parallel sketches of Leonardo's; this, however, does not strengthen the attribution to Filippino. An earlier attribution gave the panel to Lorenzo di Credi,[22] which seems to me to be nearer the mark; the rounded forms and the tilted head of the young king in the foreground clearly bespeak a connection with that painter.[23] An artist's characteristics are often modified when he turns from large panels to the small scale of a predella, especially in details, which tend to be slurred over — a kind of shorthand in brushwork or drawing. But even granting this, and further that predelle by Filippino are so rare that we cannot make general statements about them, I should still be unable to accept the Detroit Epiphany as his. One of his types is recalled in the head of the dark man with the short beard, his hands clasped in prayer, to the right of the youngest king; and possibly, though more remotely, by Saint Joseph, whose right hand shows a favorite Filippinesque pose. The

[20] An interesting exception to the above statement is to be found in a panel showing St. Francis with four saints, one of them St. Louis of Toulouse, in the Samuel H. Kress collection in New York. Ascribed to Filippino, this seems to me to be a copy of a lost original for which a sketch is recognizable in a drawing now in the Corsini gallery in Rome, number 130452. The drawing, well known as an authentic Filippino, shows St. Francis standing between two kneeling saints. The one to the left, who wears a crown, may well represent St. Louis of Toulouse; the other is an elderly woman. Dr. Scharf illustrates the sketch on Plate 108 of his monograph, Fig. 166.

[21] *Bulletin of the Detroit Institute of Arts*, April 1930, pp. xviii ff., "A Predella Painting by Filippino Lippi."

[22] Suida, *Leonardo und sein Kreis* (Munich, 1929), Pl. 17.

[23] Berenson solves the problem by calling the picture "Alunno di Domenico"; see *Italian Pictures of the Renaissance*, p. 6.

Madonna and Child seem to me to show nothing of the master's manner, particularly the former, whose veil, arranged so as to suggest the wide frilled cap of certain peasant costumes, is related neither to the transparent bunchy veil derived by Filippino from Botticelli and Fra Filippo, nor to the older medieval fashion of the cloak drawn over the head, which Filippino used in the Ludlow *tondo* and the Prato tabernacle. The general shape of heads and faces is wide and low, whereas Filippino's tend toward a high oblong, and the drapery is also uncharacteristic. Finally, the color, with its ruddy flesh tones, is not related to anything I know of Filippino's. One naturally has a better right to reject a name in connection with a picture if one can offer a substitute, but in this case I can go no farther than to attribute the panel to an unknown Florentine of the fifteenth century, whose connections with Leonardo and Lorenzo di Credi are more apparent than those with Filippino. As Dr. Valentiner observed, the Leonardesque elements are those of his work prior to the Milanese period, so that the Detroit picture should date sometime between 1478 and 1482 (Dr. Valentiner limits it to 1378–1480). But even granted that Filippino was influenced slightly by Leonardo at this date, I still should be unable to see that the Epiphany had anything to do with the former's early style. It is even harder to relate it to his work of the post-Roman period.

Berenson accepts as a late Filippino the "Madonna and Child" with Saint John the Baptist and an angel (Fig. 113) in the Altman collection of the Metropolitan Museum, New York. It is so identified in the gallery.[24] While there is scarcely a detail of this panel which does not in some fashion suggest Filippino, the effect of the whole is such that I am forced to call this too a school piece, or quite possibly a *bottega* product. The Child's head is the least characteristic feature. The proportions of the figures are not quite typical either, and a detail like the small waist of the Virgin looks unfamiliar. Finally, the color has a curious muddy tone, different alike from the clear strong contrasts of the eighties and the richer, more somber palette of the latest period. The Altman picture is from the hand of a workshop assistant using a design of Filippino's, so it seems to me, and working about the turn of the century.

Even from the study of the foregoing examples it is clear that Filippino

[24] Metropolitan Museum of Art, *Handbook of the Benjamin Altman Collection*, 2nd ed. (New York, 1928), p. 41.

created no school worthy of the name, exerting only a brief and superficial influence on his own and one or two succeeding generations. Van Marle, to whom Filippino is distinctly unsympathetic, explains this as follows: "The absence of a school of Filippino, who, apart from Raffaellino del Garbo, had really but few followers, leads us to believe that many contemporary artists of his advanced years realized what Filippino lacked in spite of his unquestionable technical gifts." [25]

I have already indicated my opinion that with the younger men it was not so much that Filippino failed them as a preceptor as that they were unable to withstand the tremendous new forces of which the fountainhead was Rome. Or one might put it another way and say that Michelangelo and Raphael began where Filippino left off, having formulated ideas these younger masters were to carry further, but not having lived long enough to develop forms adequate for the expression of those ideas. Filippino's forms — his figure types, drapery, etc. — were still rather more Quattrocento than Cinquecento at the time of his death, and it is scarcely surprising that they should not have been transmitted to the next generation save in the form of perfunctory imitative altarpieces for modest patronage. As for van Marle's talk of "lack" in Filippino's work, I admit that there is lack of a sort; but on the other hand it can scarcely be argued that the influence of Michelangelo and Raphael was wholly beneficial. Ardent followers of Filippino might legitimately have expected to develop into as good painters as Giulio Romano or Vasari. If Raphael and Michelangelo opened an artistic epoch, they also terminated it; anything more painful than the general run of their archaeologist followers it is difficult to find in the history of art. When painting (the center shifted from Florence to Rome) again experienced a renascence, with the Baroque, the characteristic and genuinely vital qualities therein were precisely those which Filippino had prophesied in his late work. Meanwhile he had done his share in stimulating the growing interest in archaeology as such, largely through the medium of his sketchbook. Since he was not committed to any definite theory of painting and design, and not aggressive enough to challenge a professional rival, it is little wonder that his artistic following was small. None the less, for the lack of such a following his personal popularity and the high esteem with which he was remembered even in Vasari's day is surely compensation worth having.

[25] *Italian Schools of Painting*, XII, 371–373.

BIBLIOGRAPHY

BIBLIOGRAPHY

Albertini, Francesco, *Memoriale di molte statue e pitture della città di Firenze, fatto da Francesco Albertini prete, e Baccio da Montelupo scultore, e stampato da Antonio Tubini, nel 1510,* republished by Luigi Massimi and Luisa Piaggio (Florence, 1863).

Allende-Salazar, Juan, "Alonso de Berruguete en Florencia," *Archivo español de arte y arqueologia,* no. 30, September–December 1934, pp. 85 ff.

Antal, Friedrich, "Breu und Filippino Lippi," *Zeitschrift für bildende Kunst,* LXII, (1928–29), 29 ff.

Archivio di Stato in Firenze, Accademia del Disegno, no. 2: Debitori e Creditori, Libro Rosso, 1472–1520, Segnato A, c. 57.

Archivio della Badia, no. 333, Camporearum, vol. III.

Baldanzi, Ferdinando, *Delle pitture di Fra Filippo Lippi nel coro della cattedrale di Prato* (Prato, 1835).

Bardi, Alessandro, *Filippo Strozzi* (Florence, 1894).

Beckerath, Adolf von, "Notes on Some Florentine Drawings in the Print Room, Berlin," *Burlington Magazine,* VI (1904), 234 ff.

"Die Winter–Ausstellung der Royal Academy 1910," *Repertorium für Kunstwissenschaft,* XXXIII (1910), 282.

Bell, C. F., *Drawings by the Old Masters in the Library of Christ Church, Oxford* (Oxford, 1914).

Berenson, Bernhard, *The Drawings of the Florentine Painters, Classified, Criticized and Studied as Documents in the History and Appreciation of Tuscan Art,* 2 vols. (New York, 1903).

The Florentine Painters of the Renaissance (New York, 1896).

Italian Pictures of the Renaissance (Oxford, 1932).

Old Master Drawings, vol. VIII, no. 31, December 1933, pp. 32 ff., and illustration pl. 35.

"Amico di Sandro," *Study and Criticism of Italian Art,* series I (London, 1901).

"An Unpublished Masterpiece by Filippino Lippi," *Study and Criticism of Italian Art,* series II (London, 1902).

"Un Possibile Antonello da Messina ed uno impossibile," *Dedalo,* June 1923, pp. 42 ff.

"Un Botticelli dimenticato," *Dedalo,* June 1924, pp. 17 ff.

"Un Chef-d'œuvre inédit de Filippino Lippi," *Revue archéologique,* vol. XXXVII, 3rd series (1900), pp. 239–243.

Bernadini, Giorgio, "Alcuni Disegni inediti o poco noti negli Uffizi," *Bolletino d'arte,* IV (1910), p. 152 ff.

"Di alcuni dipinti di secondaria importanza a Lucca, Firenze, Venezia, e Rovigo," *Bolletino d'arte,* VI (1912), 300 ff., and illustration, p. 298, fig. 6.

Bernascone, Cesare, *Studi* (Verona, 1859).

Bicchierai, Zanobi, *Alcuni Documenti artistici non mai stampati* (Florence, 1855), pp. 15–16.

Bocchi, Francesco, and Cinelli, Giovanni, *Le Bellezze della città di Firenze* (Florence, 1677).

Bode, Wilhelm, *Die Kunst der Frührenaissance in Italien* (Berlin, 1926).

"La Renaissance au Musée de Berlin," *Gazette des Beaux-Arts,* vol. XXXVII, 2nd period (1888), p. 488.

Bodmer, Heinrich, "Der Spätstil des Filippino Lippi," *Pantheon*, April 1932, pp. 126 ff., and November 1932, pp. 353 ff.

Bombe, Walter, "Eine Pietà von Piero di Cosimo in der Pinakothek zu Perugia," *Der Cicerone*, vol. XVI, December 1924, pp. 1171 ff.

Geschichte der Peruginer Malerei bis zu Perugino und Pinturicchio, auf Grund des Nachlasses Adamo Rossis und eigener archivalischer Forschungen (Berlin, 1912), p. 376.

"Una Pietà di Piero di Cosimo," *Augusta Perusia*, II (1907), 88–89.

"Urkundliches aus dem Archiv Mercanzia in Florenz," *Monatshefte für Kunstwissenschaft* (1912) pp. 349–350.

Borenius, Tancred, "Early Italian Pictures in the Collection of Lord Carmichael," *Apollo*, I (1925), 67–68.

"Some Pictures in the Collection of Viscount Lee of Fareham," *Apollo*, I (1925), 127.

Pictures by the Old Masters in the Library of Christ Church, Oxford (Oxford, 1916).

Borghini, Raffaello, *Il Riposo*, II (Milan, 1807), 143 ff., 175 ff.; also edition of 1584 (Florence), p. 358.

Breck, Joseph, "Dipinti italiani nella raccolta del Signor Teodoro Davis (Newport)," *Rassegna d'arte*, vol. XI, July 1911, pp. 114–115.

Brockhaus, Heinrich, "Die Brancacci-Kapelle in Florenz," *Mitteilungen des Kunsthistorischen Instituts in Florenz*, vol. III, no. 4, pp. 179 ff.

Burkhardt, Jacob, *Der Cicerone* (Basel, 1855; Leipzig, 1910, and New York, 1908).

Burlington Magazine, XXX (1917), 244 (unsigned).

Vol. LXV (1934), advertisement supplement, pl. I, "Notable Works of Art Now on the Market."

Cagnola, Guido, "Intorno a due dipinti di Filippino Lippi," *Rassegna d'arte*, VI (1906), 41–42.

Carmichael, Montgomery, "Fra Filippo's portrait," *Burlington Magazine*, XXI (1912), 194 ff.

Carocci, Guido, *Arte e storia*, November 1899, pp. 135–136.

L'Illustratore fiorentino, IV (Florence, 1907), 5–6.

Cartwright, Julia, *The Painters of Florence* (London, 1901).

Catalogue of the Art Treasures of the United Kingdom Collected at Manchester in 1857, p. 17; also supplementary catalogue (same volume), "Drawings and Sketches of Old Masters," p. 5.

Catalogue of Italian Pictures at 16, South Street, Park Lane, London, and Buckhurst in Sussex, collected by Robert and Evelyn Benson (privately printed, 1914).

Catalogue of Paintings in the Collection of Jules S. Bache (New York, 1929).

Catalogue of the Pictures, National Gallery, Trafalgar Square (London, 1921).

Cean-Bermúdez, Juan Augustin, *Diccionario historico de los mas ilustres profesores de las bellas artes en España*, I (Madrid, 1800), 131.

Cellini, Benvenuto, *Memoirs of Benvenuto Cellini*, various editions, Book I, chap. III.

Chiapelli, Alessandro, *Arte del Rinascimento* (Rome, 1925), pp. 378 ff.

Cinelli, Giovanni, and Bocchi, Francesco, *Le Bellezze della città di Firenze* (Florence, 1677).

Cocchi, Arnaldo, *Le Chiese di Firenze, dal secolo IV al secolo XX* (Florence, 1903).

Colasanti, Arduino, "Nuovi Dipinti di Filippo e di Filippino Lippi," *L'Arte*, Anno VI (8–10) August–October 1903, pp. 302 ff.

"Opere d'arte ignote o poco note," *Bolletino d'arte*, Anno IV, 1910, pp. 189 ff.

"Two Unpublished Pictures by Fra Filippo and Filippino Lippi," *Connoisseur*, vol. VIII, September–December 1903, pp. 232 ff. (reprint of article in *L'Arte*, 1903; see above).

Collection of J. Pierpont Morgan, Drawings by the Old Masters Formed by C. Fairfax Murray, vols. II, IV (privately printed, 1910 and 1922).

Colnaghi, Sir Dominic Ellis, *A Dictionary of Florentine Painters, from the XIII to the XVII Centuries*, edited by Konody and Brinton (London, 1928), pp. 153 ff.

Connoisseur, "The Holden Collection Acquires a Filippino Lippi," vol. XCI, no. 379, March 1933, p. 207.

Constable, W. G., *Paintings by Italian Masters in the Possession of William Harrison Woodward*: a Catalogue (Oxford, 1928).

Crowe, J. A., and Cavalcaselle, G. B., *A History of Painting in Italy; Umbria, Florence, and Siena, from the 2nd to the 16th Centuries*, edited by Langton Douglas and G. de Nicola, vol. IV (London, 1911).

Cust, Lionel, "La Collection de M. R. H. Benson," *Les Arts*, October 1907, no. 70, pp. 6, 18.

Ede, H. S., *Florentine Drawings of the Quattrocento* (New York, 1926), p. 11, and pls. 38–43.

Egger, Hermann, *Romische Veduten; Handzeichnungen aus dem XV–XVIII Jahrhundert*, vol. I (Leipzig, 1911), pl. 83 (for comparison with Filippino's view of S. Giovanni in Laterano in Sta. Maria sopra Minerva).

Escher, Konrad, *Die Malerei des 14. bis 16. Jahrhunderts in Mittel- und Unteritalien* I (Berlin-Neubabelsburg, 1922), 166 ff.

Fabriczy, C. de, *Il Codice dell'Anonimo Gaddiano nella Biblioteca Nazionale di Firenze*, estratto dell'*Archivio Storico Italiano*, Series V, vol. XII (Florence, 1893).

"Memorie sulla Chiesa di Santa Maria Maddalena de' Pazzi a Firenze e sulla Badia di San Salvatore a Settimo," *L'Arte*, 1906, p. 260.

"Giovanni Dalmata," *Jahrbuch der Königlich Preussischen Kunstsammlungen*, XXII (1901), 235, n. 4.

Fantozzi, Federigo, *Nuova Guida, ovvero descrizione storico-artistico-critica della città e contorni di Firenze* (Florence, 1857), pp. 684 ff.

Farinola-Vaj, *Alcuni Documenti artistici* (Florence, 1855), pp. 15–16, 18.

Fausti, Luigi, "Le Pitture di Fra Filippo nel Duomo di Spoleto," *Archivio per la storia ecclesiastica dell'Umbria*, II (1915), 1 ff.

Félibien des Avaux, *Entretiens sur les vies et sur les ouvrages des plus excellens peintres anciens et modernes*, I (Paris, 1666), 197–198.

Ffoulkes, Constance Jocelyn, "Le Esposizioni d'arte italiana a Londra," *Archivio storico dell'arte*, series I, no. vii (1888), pp. 162–166, and *ibid.*, no. xiii, p. 304.

Förster, Ernst, *Geschichte der italienischen Kunst*, III (Leipzig, 1872), 328 ff.

Francis, Henry Sayles, "A Tondo by Filippino Lippi," *Cleveland Museum Bulletin*, November, 1932, pp. 146–148.

Frey, Carl, *Il Codice Magliabecchiano, cl. XVII, 17, contenente notizie sopra l'arte degli antichi e quella de Fiorentini da Cimabue a Michelangelo Buonarroti, scritte da Anonimo Fiorentino* (Berlin, 1892).

Il Libro di Antonio Billi, esistente in due copie nella Biblioteca Nazionale di Firenze (Berlin, 1892).

Sammlung ausgewählter Briefe an Michelagniolo Buonarroti (Berlin, 1899), p. 7.

"Studien zu Michelagniolo Buonarroti und zur Kunst seiner Zeit," *Jahrbuch der Königlich Preussischen Kunstsammlungen*, XXX (1909), 121 ff.

Frizzoni, Gustavo, *Arte italiana del Rinascimento* (Milan, 1891), pp. 236 ff., 242 ff.

"Disegni di antichi maestri," *L'Arte*, VIII (1905), 243 ff.

"I Nostri Grandi Maestri in relazione al quinto fascicolo dei disegni di Oxford," *L'Arte*, X (1907), 89 ff.

Frizzoni, Gustavo, "La Pinacoteca Strossmayer," *L'Arte*, VII (1904), 427 ff.

"La Galerie Layard," *Gazette des Beaux-Arts*, XVI (1896), 475 ff.

"La Galleria Comunale di Prato," *Rassegna d'arte*, XII (1912), 114 ff.

"La Mostra d'arte retrospettiva del 1904 a Düsseldorf," in *Rassegna d'arte*, V (1905), 6.

"Die Sammlung Habich," *Zeitschrift für bildende Kunst* (1892), p. 137.

Fumi, L., "Pietro Perugino e il quadro nella cappella di San Michele della Certosa di Pavia," *Bolletino della regia deputazione di storia patria per l'Umbria*, XIV (1908), 97 ff.

Gallerie Nazionale Italiane, Le, II (Rome, 1896), 140, pl. XV.

Gamba, Carlo, "Dipinti ignoti di Raffaelle Carli," *Rassegna d'arte*, VII (1907), 104 ff.

Gaye, Giovanni, *Carteggio inedito d'artisti dei secoli XIV, XV, XVI, publicato ed illustrato con documenti pure inediti*, vols. I and II (Florence, 1840).

Gerspach, "La Galerie Corsini," *Les Arts*, no. 52, 1906, pp. 12 ff.

Geymüller, Heinrich von, and Stegmann, Carl von, *Die Architektur der Renaissance in Toscana, dargestellt in den hervorragendsten Kirchen, Palästen, Villen, und Monumenten*, vol. V (Munich, 1885–1908).

Giglioli, Odoardo, "Disegni sconosciuti di Filippino Lippi, e del Pontormo," *Dedalo*, VII (1926–27), 777.

Giornale storico degli archivi toscani, che si publica dalla Soprintendenza Generale agli Archivi del Granducato, II (Florence, 1857), 248.

Gnoli, Umberto, "Contratto per gli affreschi nella pareti laterali della cappella Sistina," *Archivio storico dell'arte*, VI (1893), 128–129.

Pittori e miniatori nell'Umbria (Spoleto, 1923), pp. 109–110, 243 ff.

Godwin, Blake-More, "An Important Italian Painting," *Museum News* (Toledo), March, 1937.

"Our Painting by Filippino Lippi," *ibid.*, December 1933.

Gronau, Georg, in Thieme-Becker, *Allgemeines Lexikon der bildenden Künstler*: V, 552 ff., 604 ff.; IX, 202–203; XIII, 170 ff.; XXIII, 268 ff.

"Peruginos 'Sankt Bernhard' in der Alten Pinakothek," *Münchner Jahrbuch der bildende Kunst*, vol. IV (part 1, 1909), p. 46 ff.

"Über zwei Florentiner Madonnen des Quattrocento," *Pantheon*, November 1930.

"Ein Bildentwurf von Filippino Lippi," *Zeitschrift für bildende Kunst*, 60 Jahrgang (1926–27), pp. 22 ff.

Guasti, Cesare, *La Cupola di Santa Maria del Fiore* (Florence, 1857).

Guasti, Gaetano, *Alcuni Quadri della galleria comunale di Prato descritti e illustrati con documenti inediti* (Prato, 1858).

I Quadri della galleria e altri oggetti d'arte del comune di Prato (Prato, 1888).

Guthmann, Johannes, *Die Landschaftsmalerei der toskanischen und umbrischen Kunst von Giotto bis Rafael* (Leipzig, 1902).

Halm, Peter, "Das unvollendete Fresko des Filippino Lippi in Poggio a Caiano," *Mitteilungen des Kunsthistorischen Instituts in Florenz*, Heft VIII, Band III, July 1931.

Handzeichnungen alter Meister im Städelschen Kunstinstitut, fünfte Lieferung (Frankfurt a/M, 1910).

Harck, Fritz, "Notizien über italiensche Bilder in Petersburger Sammlungen," *Repertorium für Kunstwissenschaft*, XIX (1896), 428, 431.

Heil, Walter, "The Jules Bache Collection," *Art News*, April 27, 1929, pp. 3 ff.

Hellmann, George S., "Drawings by Italian Artists in the Metropolitan Museum," *Print Collectors' Quarterly*, vol. VI, no. 2 (1916), pp. 157 ff.

Hill, G. F., "On 'The Worship of the Golden Calf' by Filippino Lippi," *Burlington Magazine*, XX (1911), 171–172.

Hind, A. M., *Catalogue of Early Italian Engravings Preserved in the Department of Prints and Drawings in the British Museum*, vol. I (London, 1910).

Holmes, Sir Charles, *Old Masters and Modern Art, the National Gallery, Italian Schools*, I (London, 1923), 67 ff.

Horne, Herbert P., *Alessandro Filipepi, Commonly Called Botticelli, Painter of Florence* (London, 1908).

Justi, Ludwig, *Die italienische Malerei des XV Jahrhunderts* (Berlin, 1910), pp. 61 ff.

Katalog der Königlich Alteren Pinakothek (Munich, 1911), p. 81 (also edition of 1930, which repeats the earlier edition in condensed form).

Knackfuss, H., and Zimmermann, M. G., *Allgemeine Kunstgeschichte*, vol. II (Leipzig, 1900).

Knapp, Fritz, *Piero di Cosimo: ein Übergangmeister vom florentiner Quattrocento zum Cinquecento* (Halle, 1899).

— *Die künstlerische Kultur des Abendlandes: eine Geschichte der Kunst und des künstlerischen Weltanschauungen seit dem untergang der alten Welt*, vol. II, "Der Sieg der malerischen Anschauung; Hochrenaissance, Barock, und Rokoko" (Bonn-Leipzig, 1923), pp. 30 ff.

— "Hugo van der Goes Portinari-Altar und sein Einfluss auf Leonardo da Vinci, Botticelli, Filippino Lippi, Piero di Cosimo, u. a.," *Mitteilungen des Kunsthistorischen Instituts in Florenz*, Band 2, Heft V (1917), pp. 194 ff.

Konody, P. G., *Filippino Lippi* (London, 1905).

— "Some Italian Masters in Viscount Rothermere's Collection," *Apollo*, October 1925, pp. 190 ff.

Kugler, Franz Theodor, *Handbook of Painting of the Italian Schools*, edited by Sir Charles Eastlake, I (London, 1855), 202 ff.

Labò, Mario, "Note dolenti," *Rassegna d'arte*, VI (1906), 61–62.

Lafenestre, Georges, *La Peinture italienne* (Paris, 1885), pp. 220 ff.

Lanzi, Luigi, *The History of Painting in Italy from the Period of the Revival of the Fine Arts to the End of the 18th Century*, translated by Thomas Roscoe, I (London, 1828), 92 ff.

Lasareff, Vittore, "Una Pittura di Filippino Lippi a Leningrado," *L'Arte*, January–February 1928, pp. 36–37.

Lasinio, *Peintures de Masaccio, Masolino, Giotto, Lippi, e Ghirlandaio, dessinées par Lasinio Fils et gravées par Charles Lasinio, conservateur du Campo Santo de Pise* (Florence, 1812).

Lastri, Marco, *L'Etruria pittrice, ovvero storia della pittura toscana dedotta dai suoi monumenti, che si esibiscono in stampa, dal secola X fino al presente*, vol. I (Florence, 1791), pl. XXVII.

Layard, Sir Henry Austen, *The Brancacci Chapel and Masolino, Masaccio, and Filippino Lippi* (London, 1868), pp. 33 ff.

Lensi, Alfredo, *Palazzo Vecchio* (Milan-Rome, 1929), pp. 72–74, 115 (n. 81), 240.

Leporini, Heinrich, *Die Stilentwicklung der Handzeichnung XIV bis XVIII Jahrhundert* (Vienna-Leipzig, 1925), p. 48.

Lermolieff, Ivan, *pseud.; see* Morelli, Giovanni.

Liphart, Ernest de, *Les Anciennes Écoles de peinture dans les palais et collections privées russes; la peinture italienne* (Brussels, 1910), pp. 23 ff.

Litta, Conte Pompeo, *Famiglie celebri italiani* (Milan, 1874), vol. X (Capponi).

Loeser, Charles, "Über einige italienische Handzeichnungen des Berliner Kupferstichkabinetts," *Repertorium für Kunstwissenschaft*, XXV (1902), 351.

Mackowsky, Hans, "Filippino Lippi," *Das Museum*, VIII (1904), 40.

Mantz, Paul, *Histoire des peintres de toutes les écoles: école italienne*, edited by Blanc (Paris, 1866).

Marle, Raimond van, *The Development of the Italian Schools of Painting* (The Hague), vols. XI (1929), XII (1931), and XIII (1931).

Masters in Art, "Filippino Lippi," part 87, vol. VIII, March (Boston, 1907).

Mather, Frank Jewett, *A History of Italian Painting* (New York, 1923).

Mattei, P. S., *Guida del Carmine* (Florence, 1819), pp. 13, 40 ff.

Meder, Joseph, *Handzeichnungen alter Meister aus der Albertina, und aus Privatbesitz*, neue Folge, vol. II (Vienna, 1922–25).

Medici, Ulderigo, *La Cappella dei Principi Corsini in Santo Spirito e un quadro di Raffaelle de' Carli* (Florence, 1875). (Cf. Ulmann, in *Repertorium für Kunstwissenschaft*, 1894, p. 92, n. 7.)

Meinhof, Wernher, "Leonardo's Hieronymus," *Repertorium für Kunstwissenschaft*, vol. LIII, no. 3 (1931), pp. 118 ff.

Mendelsohn, Henriette, *Fra Filippo Lippi* (Berlin, 1909).

Mengin, Urbain, *Les Deux Lippi* (*Les Maitres d'Art* series, Paris, 1932).

"Fra Filippo Lippi a Spolète," *Revue de l'art ancien et moderne*, vol. LVI, no. 307, June 1929, pp. 11 ff.

Mesnil, Jacques, "Botticelli à Rome," *Rivista d'arte*, III (1905), 112 ff.

"Notes sur Filippino," *Rivista d'arte*, May–June 1906, pp. 100–102.

Metropolitan Museum of Art: Catalogue of Paintings (New York, 1924), pp. 195 ff.

Metropolitan Museum of Art: Handbook of the Benjamin Altman Collection, 2nd edition (New York, 1928), p. 41.

Meyer, Julius, "Zur Geschichte der florentinischen Malerei des XV Jahrhundert," *Jahrbuch der Königlich Preussischen Kunstsammlungen*, XI (1890), 3 ff.

Migliore, del, *Firenze illustrata* (Florence, 1684), p. 115.

Milanesi, Gaetano, *Le Vite de' più eccellenti pittori, scultori, ed architettori*, by Giorgio Vasari (Florence, 1878), vols. III and IV.

Nuovi Documenti per la storia dell'arte toscana del XII al XV secolo (Rome, 1893), p. 148.

Sulla storia dell'arte toscana (Siena, 1873), pp. 147 ff.

and Pini, Carlo, *La Scrittura di artisti italiani* (Florence, 1876).

Mongan, Agnes, "The Loeser Collection of Drawings," *Bulletin of the Fogg Art Museum*, vol. II, no. 2, March 1933, pp. 22 ff.

Morandi, (Morando) M., *Santa Maria del Fiore* (Rome, 1887), p. 56.

Morelli, Giovanni, *Della pittura italiana* (Milan, 1897).

Die Galerie zu Berlin (Leipzig, 1893).

Die Galerien zu München und Dresden (Leipzig, 1891), pp. 126 ff.

Italian Painters: Critical Studies of Their Works; the Borghese and Doria-Pamfili Galleries in Rome, translated by C. J. Ffoulkes (London, 1892), pp. 115 ff.; also edition of 1893, vol. II, pp. 96 ff.

"Handzeichnungen italienischer Meister," *Kunstchronik*, neue Folge III (Leipzig, 1892), pp. 28–29.

Müller-Walde, Paul, "Beiträge zur Kenntnis des Leonardo da Vinci," *Jahrbuch der Königlich Preussischen Kunstsammlungen*, XVIII (1897), 113–114, 165.

Müntz, Eugene, *L'Età aurea dell'arte italiana* (Milan, 1895), p. 83.

Histoire de la peinture, II (Paris, 1891), 652 ff.

"Nuovi documenti," *Archivio storico dell'arte*, II (1889), 483–484.

"Studi Leonardeschi," *Archivio storico dell'arte*, III (1897), 4 ff.

Nasse, Hermann, "Gemälde aus der Sammlung des Univ. Professors Dr. Freih. F. von Bissing zu München," *Münchner Jahrbuch der bildenden Kunst*, VI (1911), 227 ff.

Neilson, Katharine B., "A Pair of Angels by Filippino Lippi," *Art in America and Elsewhere*, June 1934, pp. 96 ff.

Néoustroïeff, A., "I Quadri italiani nella collezione Leuchtenberg," *L'Arte*, VI (1903), 330.

Offner, Richard, *Italian Primitives at Yale University; Comments and Revisions* (New Haven, 1927), p. 7.

Paccioli, Luca, *Summa de arithmetica* (Toscolanum, 1523), p. 3 verso.

Panofsky, Irwin, "Imago Pietatis," *Festschrift für Max J. Friedlander zum 60. Geburtstage* (Leipzig, 1927), pp. 283 ff.

Parker, K. T., "Eine neugefundene Apollozeichnung Albrecht Dürers," *Jahrbuch der Preussischen Kunstsammlungen*, XLVI (1925), 252, n. 2, and p. 253, illustration.

Parnassus, March 1931, p. 52, and April 1931, p. 24.

Passerini, *Geneologia e storia della famiglia Rucellai* (Florence, 1861).

Patch, Thomas, *Selections from the Works of Masaccio, Fra Bartolommeo, and Giotto* (Florence, 1770–72), pl. XXVI (cf. Mattei, *Guida del Carmine*, p. 55, n. 2).

Patzak, Bernhard, *Die Renaissance- und Barockvilla in Italien*, II (Leipzig, 1913), 118 (*Palast und Villa in Toscana*).

Pecori, Luigi, *Storia della terra di San Gimignano* (Florence, 1853), p. 572.

Pératé, André, "La Peinture italienne au XV^e siècle," in Michel's *Histoire de l'art*, vol. III, part 2 (Paris, 1908), pp. 693 ff.

Petrovics, Alexis, "Budapest: Museum der Bildenden Künste, Neuerwerbungen," *Belvedere*, Forum VII (1925), pp. 119 ff.

Philippi, Adolf, *Die Kunst der Renaissance in Italien*, I (Leipzig, 1897), 247 ff., 256–257.

Phillips, Claude, "Two Paintings by Filippino Lippi," *Art Journal*, January 1906, pp. 1 ff.

Pini, Carlo, and Milanesi, Gaetano, *La Scrittura di artisti italiani* (Florence, 1876).

Poggi, Giovanni, "La Chiesa di S. Bartolommeo a Monte Oliveto presso Firenze," *Miscellanea d'arte*, I (1903), 62–63.

"Due Pitture finora ignoti di Filippino Lippi," *Rivista d'arte*, IV (1906), 106.

"Note su Filippino Lippi," *Rivista d'arte*, VI (1909), 305 ff., and VII (1910), 93 ff.

Puccinelli, Placido, *Istoria dell' eroiche attione di Ugo il Grande, Duca della Toscana, di Spoleto, e di Camerino, Vicario d'Italia per Ottone III Imperatore; e Prefetto di Roma, di nuovo ristampata con curiose aggiunte, e coretta. Con La Cronica dell' Abbadia di Fiorenza, suoi Privilegi Pontificii, e Cesarei* (Milan, 1664), pp. 8 and 11 of the *Cronica*.

Raccolta d'elogi d'uomini illustri toscani, compilati da vari litterati fiorentini, 2nd edition (Lucca, 1770), pp. clxi ff., cccxvi.

Rankin, William, "Early Italian Pictures in the Jarves Collection of the Yale School of Fine Arts at New Haven," *American Journal of Archaeology*, April–June 1895, vol. X, no. 11, p. 149.

"Two Panels by Piero di Cosimo," *Burlington Magazine*, X (1906–07), 332 ff.

Richa, Giuseppe, *Notizie istoriche delle chiese fiorentine* (Florence, 1758).

Richter, J. P., *Catalogue of Pictures at Locko Park* (n. p., n. d.), p. 99.

Rio, A. F., *De l'art chrétien*, I (Paris, 1861), 392 ff.

Rivista d'arte, III (1905), 133, "Notizie" (no signature).

Röttinger, Heinrich, "Breu-Studien," *Jahrbuch der kunsthistorischen Sammlungen des Allerhöchsten Kaiserhauses*, vol. XXVIII, pt. I, 1909, pp. 38–39.

Rosini, Giovanni, *Storia della pittura italiana, esposta coi monumenti*, III (Pisa, 1850), 102 ff.

Rosselli, Tommaso, and del Turco, Sassatelli, "La Chiesetta di San Martino dei Buonuomini a Firenze," *Dedalo*, March 1928, pp. 610 ff.

Rumohr, C. F. von, *Italienische Forschungen*, II (Berlin-Stettin, 1827), 246–250, 273–276, 277, 309.

Sacher, Helen, *Die Ausdruckskraft der Farbe bei Filippino Lippi* (Strassburg, 1929).

Scharf, Alfred, "Filippino Lippi and Piero di Cosimo," *Art in America and Elsewhere*, vol. XIX, February 1931, pp. 59 ff.

Filippino Lippi (Vienna, 1935).

"Eine Pinzelzeichnung Filippino Lippis in Berliner Kupferstichkabinett," *Berliner Museum*, Jahrgang LI, Heft 6 (1930), pp. 145–147.

"Die frühen Gemälde des Raffaellino del Garbo," *Jahrbuch der Preussischen Kunstsammlungen*, vol. LIV, no. 3 (1933), pp. 151 ff.

"Studien zu einigen Spätwerken des Filippino Lippi," *Jahrbuch des Preussischen Kunstsammlungen*, LII (1931), 201 ff.

"Zum Laocoön des Filippino Lippi," *Mitteilungen des Kunsthistorischen Instituts in Florenz*, vol. III, no. 8, January 1932, pp. 530 ff.

Schmarzow, August, "Catarina Sforza," *Gazette des Beaux-Arts*, September 1897, p. 192.

Francisci Albertini opusculum de mirabilibus novae urbis Romae (Heilbronn, 1886).

"Meister des XIV und XV Jahrhunderts im Lindenau-Museum zu Altenburg," *Festschrift zu Ehren des Kunsthistorischen Instituts zu Florenz* (Leipzig, n.d.), p. 182.

Schmid, Max, "Der kunsthistorische Kongress in Budapest, 1896," *Zeitschrift für bildende Kunst*, December 1897, p. 65.

Schmidt, J. von, "Gemälde alter Meister in Petersburger Privatbesitz," *Monatsheft für Kunstwissenschaft*, Jahrgang II (1909), pp. 163 ff.

Schubring, Paul, *Cassoni: Truhen und Truhenbilder der italienischen Renaissance* (Leipzig, 1923), text, pp. 120, 122, and 292 ff.

"New Cassone Panels," *Apollo*, V (1927), 105, and illustration, p. 106.

"Die Madonna Strozzi von Filippino Lippi," *Zeitschrift für Christliche Kunst*, XVIII (1905), 98 ff.

Serie degli uomini i più illustri nella pittura, scultura, e architettura, con i loro elogi, e ritratti incisi in Roma, dalla prima restaurazione delle nominate belle arti fino ai tempi presenti (Florence, 1771), pp. 123 ff.

Sirén, Osvald, *A Descriptive Catalogue of the Pictures in the Jarves Collection Belonging to Yale University* (New Haven, 1916), pp. 149 ff.

"Italian Pictures in Sweden," *Burlington Magazine*, V (1904), 439 ff.

Staryje-Gody, April 1912, p. 41, and plate opposite p. 36.

Stegmann, Carl von, and Geymüller, Heinrich von, *Die Architektur der Renaissance in Toscana, dargestellt in den hervorragendsten Kirchen, Palästen, Villen und Monumenten*, vol. V (Munich, 1885–1908).

Steinmann, Ernst, *Die sixtinische Kappelle*, I (Munich, 1910), 35 ff., 190 ff., 463, 497 (n. 1), 506 ff.

Strong, Sir Arthur, *Reproductions of the Drawings by Old Masters in the Collection of the Duke of Devonshire* (London, 1902), pls. XI, XIV, XXXIV.

Strozzi, Lorenzo, *Vita di Filippo Strozzi il vecchio, scritta da Lorenzo suo figlio*, edited by Giuseppe Bini and Pietro Bigazzi (Florence, 1851).

Strutt, Edward, *Fra Filippo Lippi* (London, 1901), pp. xxiii, 183 (document XII).

Suida, Wilhelm, *Leonardo und sein Kreis* (Munich, 1929), p. 244 and pl. 17.

Supino, Igino Benvenuto, *Les Deux Lippi*, translated by J. de Crozals (Florence, 1904).

"La Cappella del Pugliese alla Campora e il quadro di Filippino," *Miscellanea d'arte* (later *Rivista d'arte*), I (1903), 1 ff.

"Il Quadro di Filippino Lippi nella Badia fiorentina," *Vita d'arte*, vol. I, no. 3, March 1908, pp. 143 ff.

Symonds, John Addington, *The Renaissance in Italy: the Fine Arts* (New York, 1888), pp. 247 ff.

Terey, Gabriel de, "Italian Pictures in the Keglevich Collection" (Budapest), *Burlington Magazine*, L (1927), 189; pl. II B at p. 185.

Thieme-Becker, *Allgemeines Lexikon der bildenden Künstler von der Antike bis zur Gegenwart* (Leipzig, 1907–).

Thode, Henry, "Pitture di maestri italiani nelle gallerie minore di Germania," *Archivio storico dell'arte*, vol. III, series I (1890), pp. 255–256.

Turco del, Sassatelli, and Rosselli, Tommaso, "La Chiesetta di San Martino dei Buonuomini a Firenze," *Dedalo*, March 1928, pp. 610 ff.

Ulmann, Hermann, *Sandro Botticelli* (Munich, 1893), pp. 97 ff.

"Piero di Cosimo," *Jahrbuch der Königlich Preussischen Kunstsammlungen*, XVII (1896), 47 ff.

"Raffaellino del Garbo," *Repertorium für Kunstwissenschaft*, XVII (1894), 90 ff.

"Zu Raffaellino del Garbo," *Repertorium für Kunstwissenschaft*, XIX (1896), 186–187.

Valentiner, W. R., "Leonardo as Verrocchio's Co-worker," *Art Bulletin*, XII (1930), 43 ff.

"A Predella Painting by Filippino Lippi," *Bulletin of the Detroit Institute of Arts*, vol. XI, no. 7, April 1930, pp. xciii ff.

Vasari, Giorgio, *Vite*; editions of Milanesi, Le Monnier, Blashfield-Hopkins (*see* Milanesi).

Vavasour-Elder, Irene, "Two Florentine Panel-Paintings," *Art in America and Elsewhere*, vol. XVIII, no. 6 (1930), p. 294.

Venturi, Adolfo, *Storia dell'arte italiana*, vol. VII, pt. 1 (Milan, 1911).

Studi del vero attraverso le raccolte artistiche d'Europa (Milan, 1927), pp. 70 ff.

"Nelle pinacoteche minori d'Italia," *Archivio storico dell'arte*, VI (1893), 410.

"Il Maestro di Correggio," *L'Arte*, vol. I, June–September 1898, p. 302.

Venturi, Lionello, *Pitture italiane in America* (Milan, 1931), pls. ccii and cciii.

"A Filippino Lippi," under "Contributi," in *L'Arte*, new series, vol. III, September 1932, pp. 418 ff., and illustration, p. 415.

"Saggio sulle opere d'arte italiana a Pietroburgo," *L'Arte*, XV (1912), 125 ff.

Vischer, Robert, "Sienesische Studien," *Zeitschrift für bildende Kunst*, X (1875), 306.

Vittadini, G. B., "Novità artistiche del Museo Poldi-Pezzoli in Milano," *Archivio storico dell'arte*, vol. I, series 2 (1895), pp. 201–202.

Voss, Hermann, "Handzeichnungen alter Meister im Leipziger Museum," *Zeitschrift für bildende Kunst*, neue Folge XXIV (1913), pp. 227 and 229.

Walker, John, "A Note on Cristofano Robetta and Filippino Lippi," *Bulletin of the Fogg Art Museum*, March 1933, pp. 33–36.

Woermann, Karl, in Robert Dohme's *Kunst und Künstler: des Mittelalters und der Neuzeit*, vol. I, pt. 2 (Leipzig, 1878), pp. 54 ff.

and Woltmann, Alfred, *Geschichte der Malerei: die Malerei der Renaissance*, II (Leipzig, 1882) pp. 171 ff.

Woltmann, Alfred, and Woermann, Karl, *Geschichte der Malerei: die Malerei der Renaissance*, II (Leipzig, 1882), 171 ff.

Yashiro, Yukio, *Sandro Botticelli and the Florentine Renaissance* (London, 1929).

Zeichnungen alter Meister im Kupferstichkabinett der Königlich Museen zu Berlin, vol. I (Berlin, 1910), pls. 15–21.

Zimmermann, M. G., *Allgemeine Kunstgeschichte*, vol. II (Leipzig, 1900).

Zucker, Paul, *Raumdarstellung und Bildarchitekturen im florentiner Quattrocento* (Leipzig, 1913), p. 114.

INDEX

INDEX

ILLUSTRATIONS

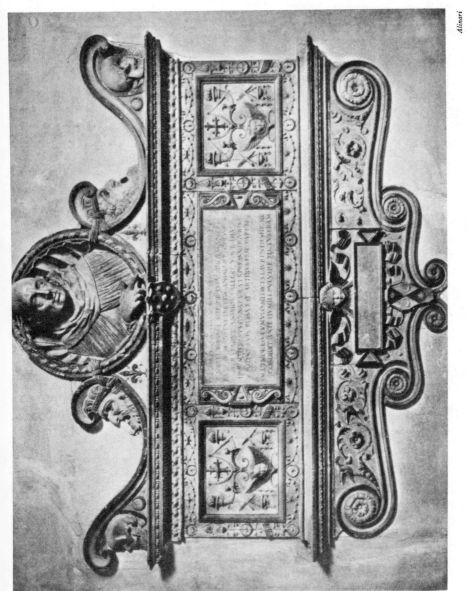

FIG. 1. MONUMENT OF FRA FILIPPO LIPPI

CATHEDRAL, SPOLETO

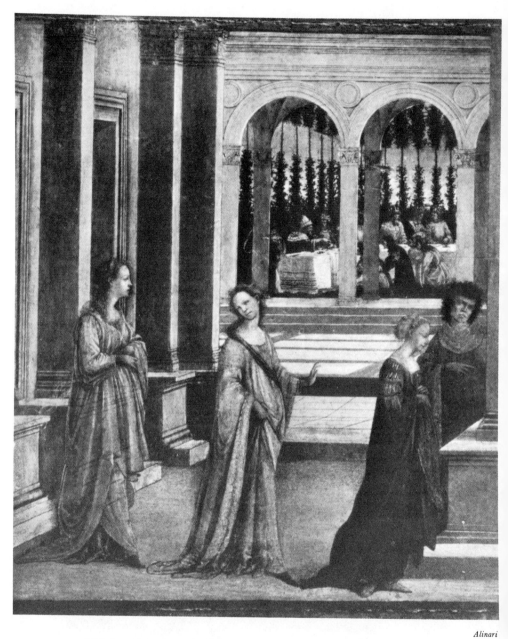

Alinari

FIG. 2. AMICO DI SANDRO. STORY OF ESTHER, DETAIL
MUSÉE CONDÉ, CHANTILLY

FIG. 3. AMICO DI SANDRO. ADORATION OF THE MAGI

National Gallery, London

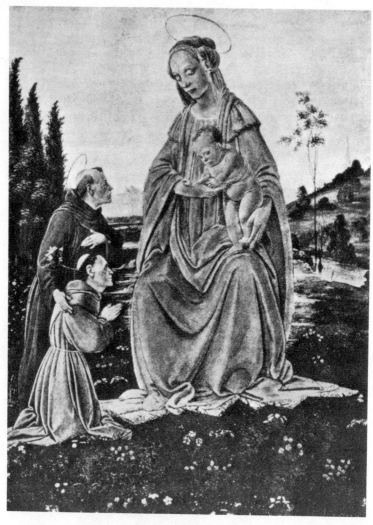

FIG. 4. FILIPPINO. MADONNA AND CHILD WITH
ST. ANTHONY OF PADUA AND A MONK
MUSEUM OF FINE ARTS, BUDAPEST

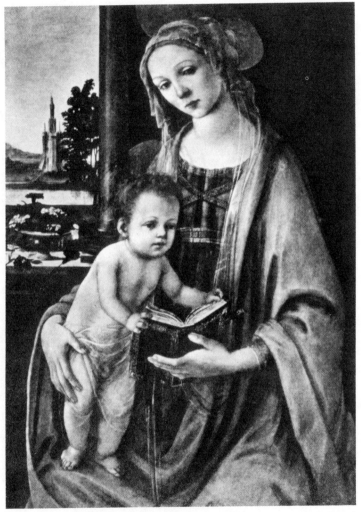

FIG. 5. FILIPPINO. MADONNA AND CHILD
KAISER FRIEDRICH MUSEUM, BERLIN

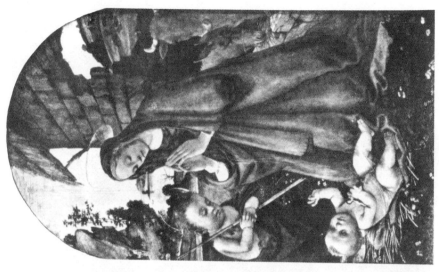

Brogi

FIG. 7. SCHOOL OF FILIPPINO. MADONNA
ADORING THE CHILD

FERRONI MUSEUM, FLORENCE

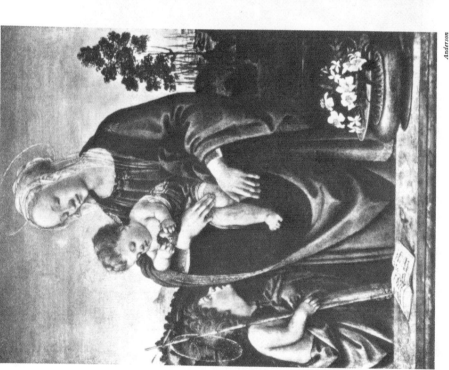

Anderson

FIG. 6. FILIPPINO. MADONNA AND CHILD WITH ST. JOHN

NATIONAL GALLERY, LONDON

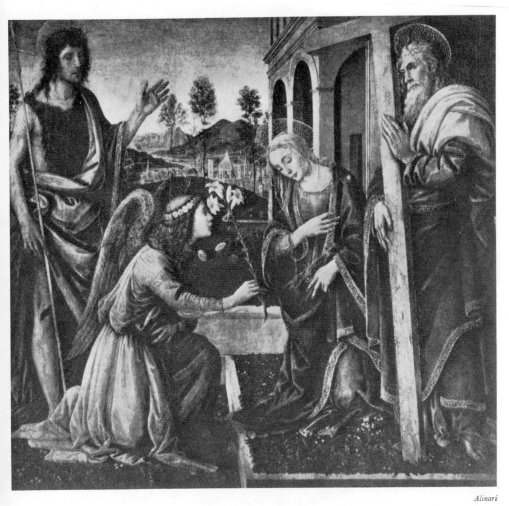

FIG. 8. FILIPPINO. ANNUNCIATION, WITH SS. JOHN THE BAPTIST AND ANDREW
NATIONAL MUSEUM, NAPLES

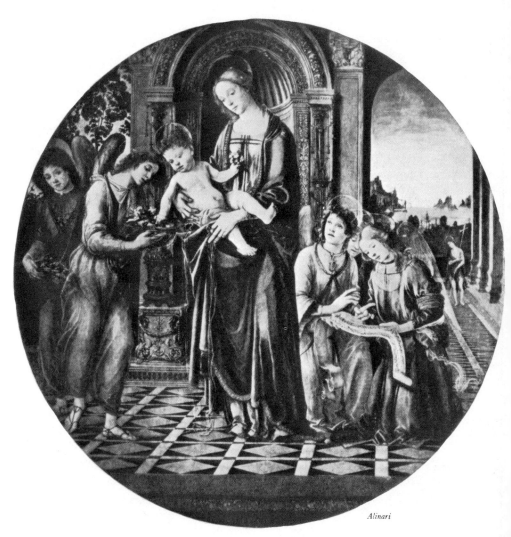

Alinari

FIG. 9. FILIPPINO. MADONNA AND CHILD WITH ANGELS
CORSINI GALLERY, FLORENCE

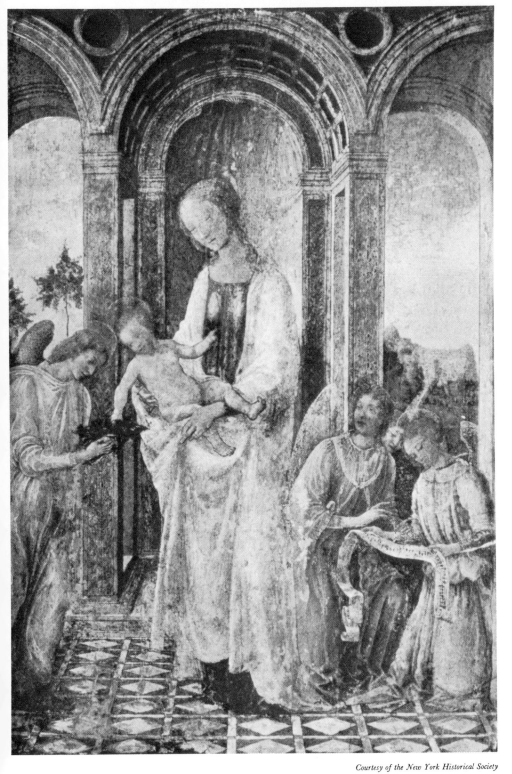

FIG. 10. FILIPPINO. MADONNA AND CHILD WITH ANGELS
NEW YORK HISTORICAL SOCIETY, NEW YORK, N. Y.

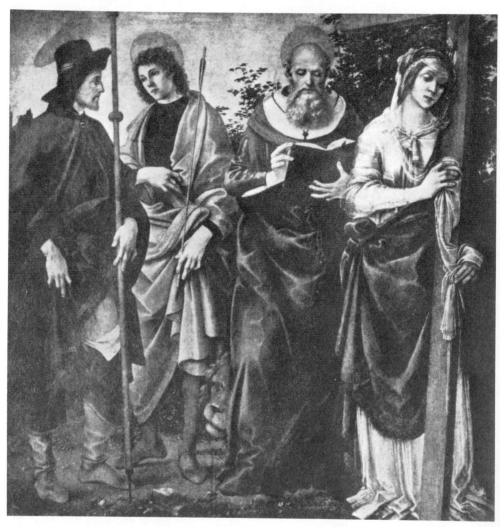

FIG. 11. FILIPPINO. FOUR SAINTS
SAN MICHELE, LUCCA

FIG. 12. SCHOOL OF FILIPPINO. MADONNA ENTHRONED WITH FOUR SAINTS (1487)

PINACOTECA, LUCCA

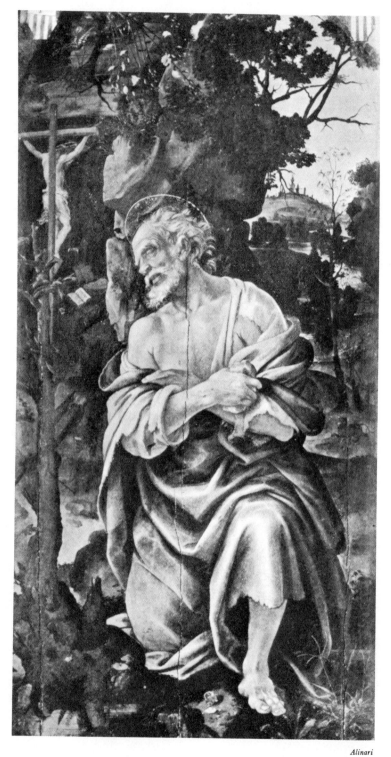

FIG. 13. FILIPPINO. ST. JEROME
ACADEMY, FLORENCE

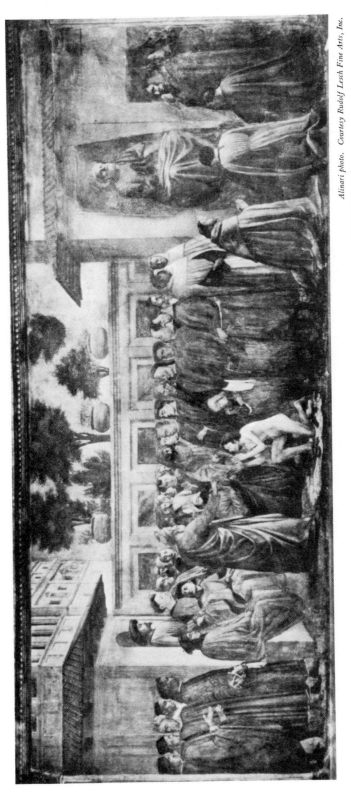

FIG. 14. FILIPPINO AND MASACCIO. RESURRECTION OF THE KING'S SON

BRANCACCI CHAPEL, STA. MARIA DEL CARMINE, FLORENCE

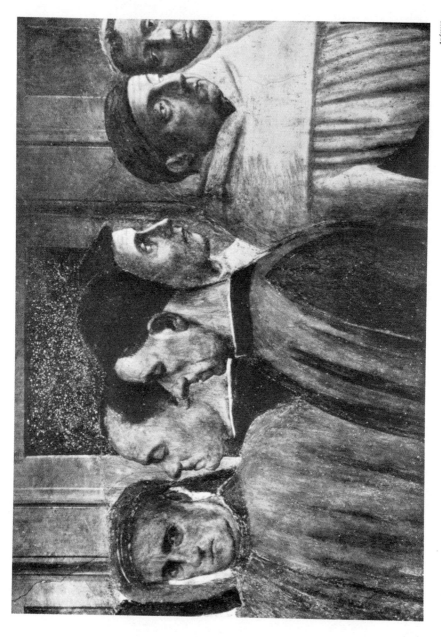

FIG. 15. FILIPPINO AND MASACCIO. RESURRECTION OF THE KING'S SON, DETAIL, GROUP OF HEADS

Brancacci Chapel, Sta. Maria del Carmine, Florence

FIG. 16. FILIPPINO AND MASACCIO. CRUCIFIXION OF ST. PETER AND
SS. PETER AND PAUL BEFORE THE PROCONSUL, DETAIL
BRANCACCI CHAPEL, STA. MARIA DEL CARMINE, FLORENCE

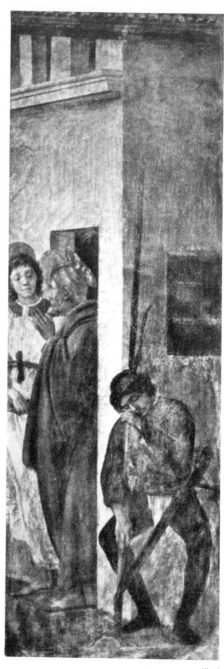

FIG. 17. FILIPPINO. ST. PAUL VISITING
ST. PETER IN PRISON

Brancacci Chapel, Sta. Maria del Carmine,
Florence

FIG. 18. FILIPPINO. ST. PETER DELIVERED
FROM PRISON

Brancacci Chapel, Sta. Maria del Carmine,
Florence

Alinari

FIG. 20. FILIPPINO. SELF PORTRAIT, DETAIL IN THE
SCENE OF SS. PETER AND PAUL
BEFORE THE PROCONSUL

Brancacci Chapel, Sta. Maria del Carmine, Florence

Alinari

FIG. 19. FILIPPINO. SO-CALLED SELF PORTRAIT

Uffizi, Florence

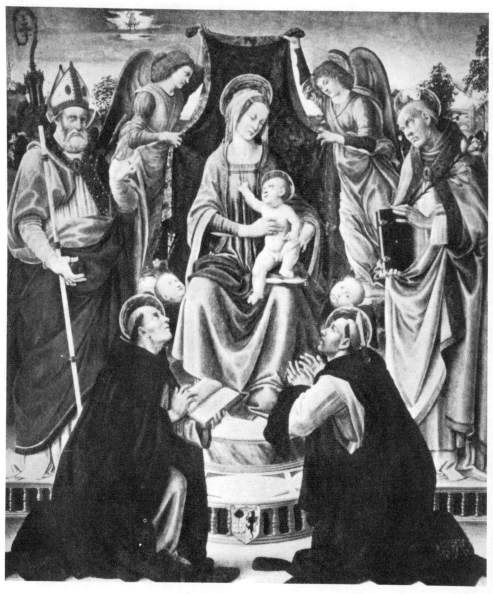

FIG. 21. SCHOOL OF FILIPPINO. MADONNA AND SAINTS

Kaiser Friedrich Museum, Berlin

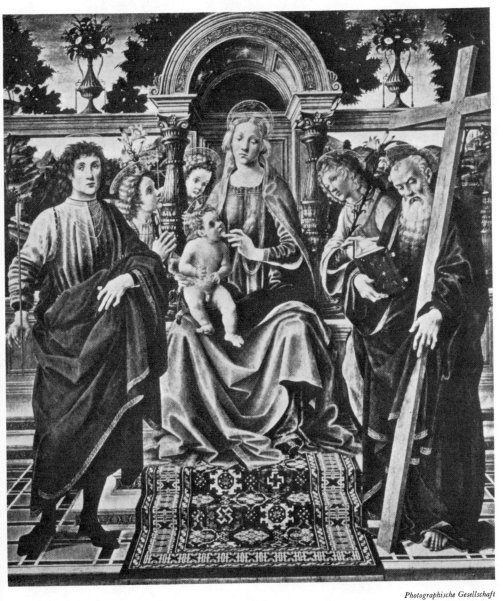

FIG. 22. SCHOOL OF FILIPPINO. MADONNA WITH SS. SEBASTIAN AND ANDREW
KAISER FRIEDRICH MUSEUM, BERLIN

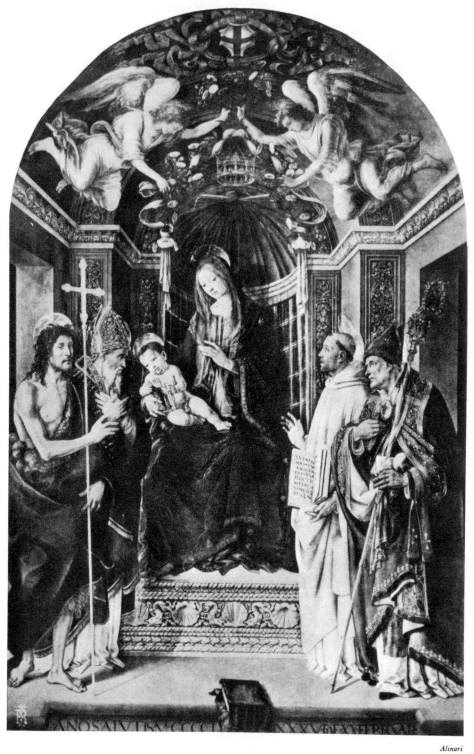

FIG. 23. FILIPPINO. MADONNA ENTHRONED WITH SAINTS (1486)
UFFIZI, FLORENCE

FIG. 25. FILIPPINO. HEAD OF AN ANGEL

FIG. 24. FILIPPINO. ANGEL

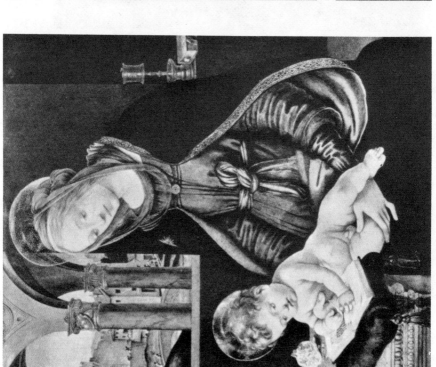

FIG. 27. PIERO DI COSIMO. MADONNA AND CHILD

Royal Palace, Stockholm

FIG. 26. FILIPPINO. MADONNA AND CHILD

Bache Collection, New York, N. Y.

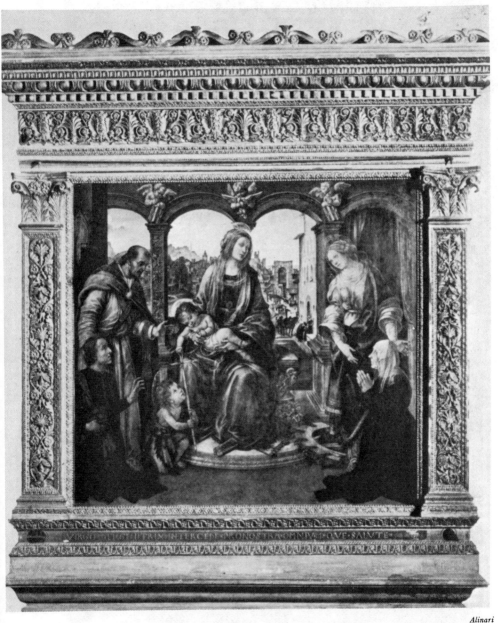

FIG. 28. FILIPPINO. MADONNA AND CHILD WITH SAINTS AND DONORS
NERLI CHAPEL, STO. SPIRITO, FLORENCE

Brogi

FIG. 29. FILIPPINO. MADONNA AND CHILD WITH SAINTS
AND DONORS, DETAIL, HEAD OF ST. CATHERINE

Nerli Chapel, Sto. Spirito, Florence

Alinari

FIG. 30. FILIPPINO. MADONNA APPEARING TO ST. BERNARD,
DETAIL, ANGEL AT LEFT

Badia, Florence

FIG. 31. FILIPPINO. TIBURTINE SIBYL

VAULT, CARAFFA CHAPEL, STA. MARIA SOPRA MINERVA, ROME

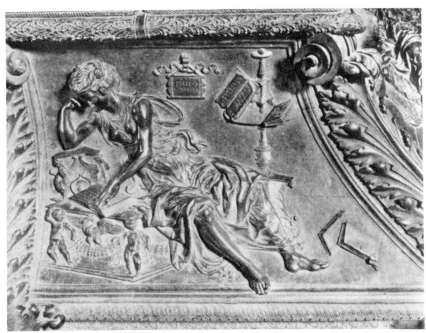

FIG. 32. ANTONIO POLLAIUOLO. PHILOSOPHY, FIGURE FROM TOMB
OF SIXTUS IV

CHAPEL OF THE SACRAMENT, ST. PETER'S, ROME

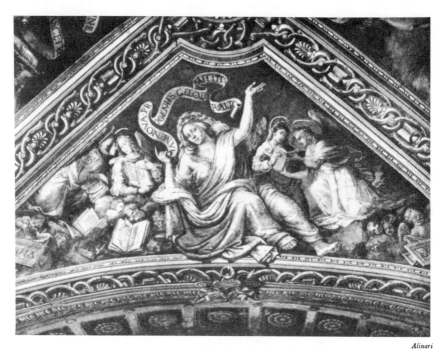

FIG. 33. FILIPPINO. CUMAEAN SIBYL

VAULT, CARAFFA CHAPEL, STA. MARIA SOPRA MINERVA, ROME

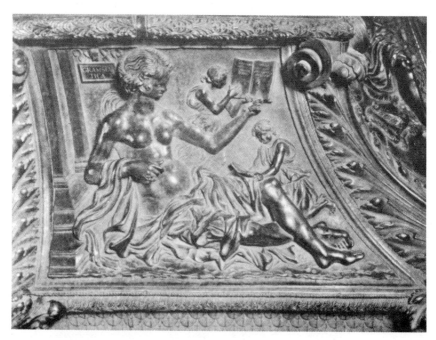

FIG. 34. ANTONIO POLLAIUOLO. GRAMMAR, FIGURE FROM TOMB
OF SIXTUS IV

CHAPEL OF THE SACRAMENT, ST. PETER'S, ROME

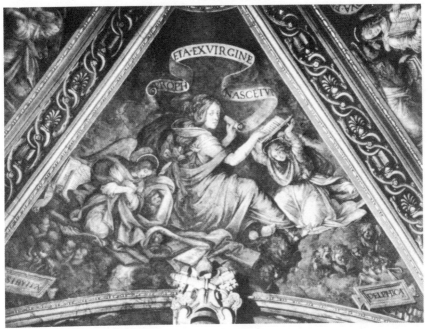

FIG. 35.　FILIPPINO.　DELPHIC SIBYL
Vault, Caraffa Chapel, Sta. Maria sopra Minerva, Rome

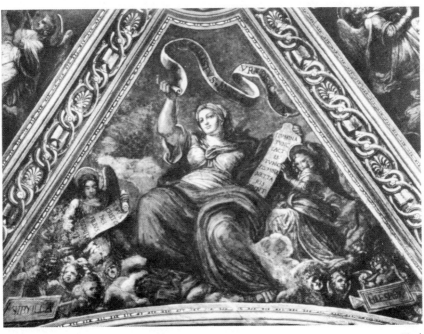

FIG. 36.　FILIPPINO.　HELLESPONTINE SIBYL
Vault, Caraffa Chapel, Sta. Maria sopra Minerva, Rome

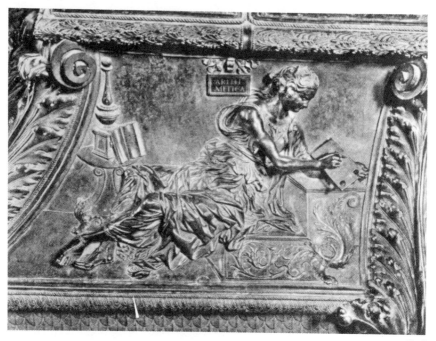

FIG. 37. ANTONIO POLLAIUOLO. ARITHMETIC, FIGURE FROM TOMB
OF SIXTUS IV

CHAPEL OF THE SACRAMENT, ST. PETER'S, ROME

FIG. 38. ANTONIO POLLAIUOLO. MUSIC, FIGURE FROM TOMB OF SIXTUS IV

CHAPEL OF THE SACRAMENT, ST. PETER'S, ROME

FIG. 39. FILIPPINO. ASSUMPTION OF THE VIRGIN
CARAFFA CHAPEL, STA. MARIA SOPRA MINERVA, ROME

FIG. 40. FILIPPINO. TRIUMPH OF ST. THOMAS AQUINAS

CARAFFA CHAPEL, STA. MARIA SOPRA MINERVA, ROME

Anderson

FIG. 41. FILIPPINO. STUDY FOR THE TRIUMPH OF ST. THOMAS
BRITISH MUSEUM, LONDON

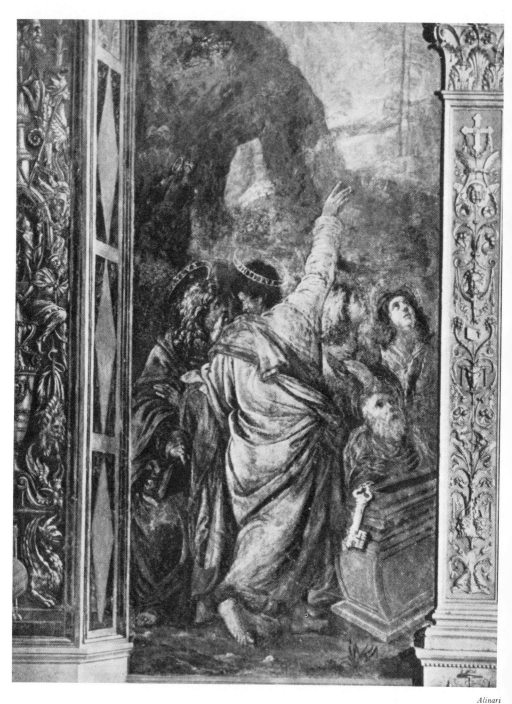

FIG. 42. FILIPPINO. APOSTLES

DETAIL OF FRESCO ON EAST WALL, CARAFFA CHAPEL, STA. MARIA SOPRA MINERVA, ROME

FIG. 43. FILIPPINO. SACRIFICE OF LAOCOÖN
Unfinished Fresco, Villa Reale, Poggio a Caiano

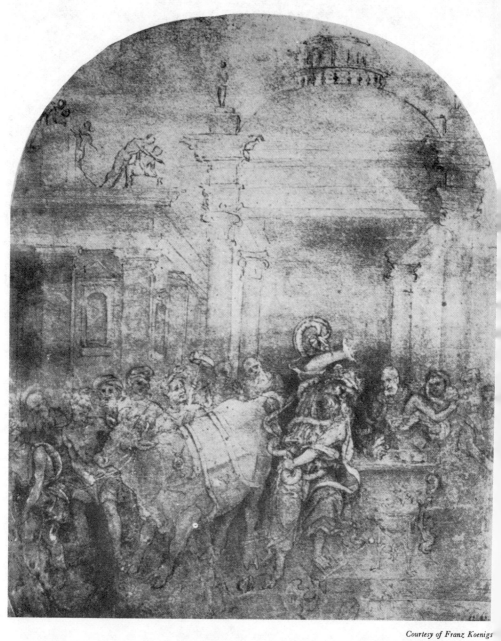

FIG. 44. FILIPPINO. DRAWING FOR THE POGGIO A CAIANO FRESCO
KOENIGS COLLECTION, HAARLEM

FIG. 45. FILIPPINO. EAST WALL, STROZZI CHAPEL, STA. MARIA NOVELLA, FLORENCE

FIG. 47. FILIPPINO. PIETÀ
DRAWING, FOGG MUSEUM, CAMBRIDGE, MASS.

FIG. 46. FILIPPINO. PIETÀ
DRAWING, FOGG MUSEUM, CAMBRIDGE, MASS.

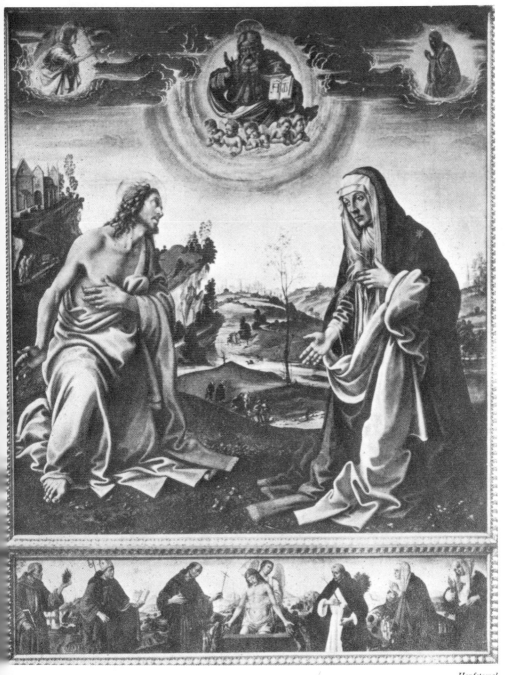

FIG. 48. FILIPPINO AND ASSISTANTS. CHRIST APPEARING TO THE VIRGIN
ALTE PINAKOTHEK, MUNICH

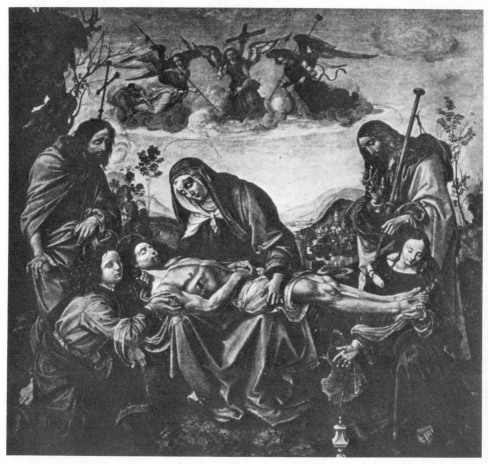

FIG. 49. RAFFAELLINO DEL GARBO. PIETÀ
ALTE PINAKOTHEK, MUNICH

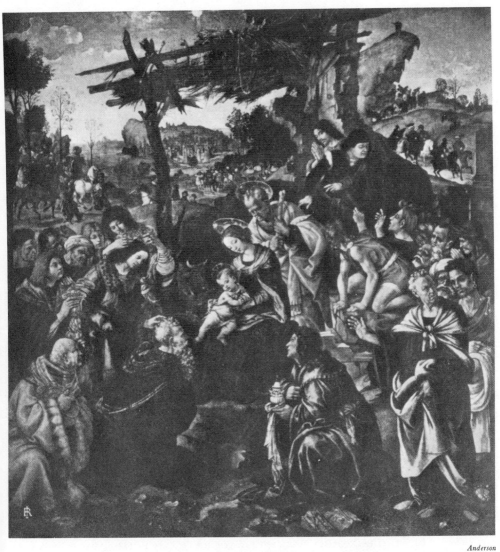

Anderson

FIG. 50. FILIPPINO. ADORATION OF THE MAGI (1496)

UFFIZI, FLORENCE

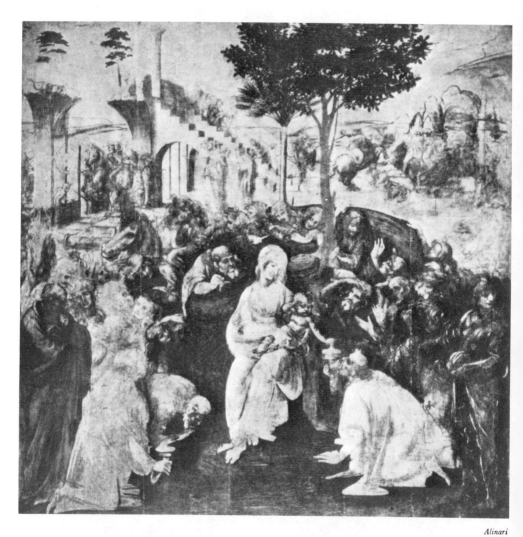

FIG. 51. LEONARDO DA VINCI. ADORATION OF THE MAGI
Uffizi, Florence

FIG. 52. HUGO VAN DER GOES. RIGHT WING, PORTINARI ALTARPIECE

UFFIZI, FLORENCE

FIG. 53. FILIPPINO. MADONNA AND CHILD WITH SS. JEROME AND DOMINIC
NATIONAL GALLERY, LONDON

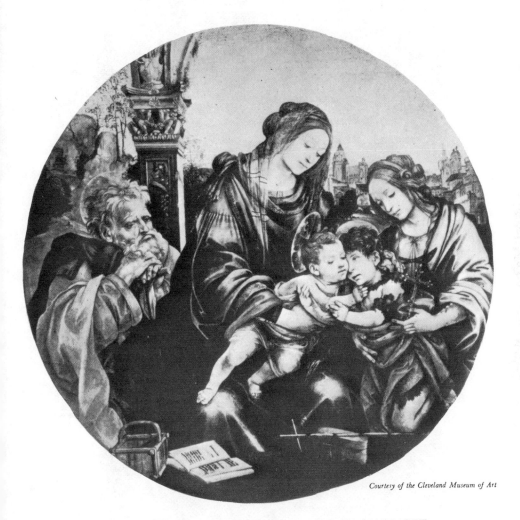

FIG. 54. FILIPPINO. HOLY FAMILY WITH ST. MARGARET
MUSEUM OF ART, CLEVELAND, OHIO

Alinari

FIG. 56. FILIPPINO. VIRGIN ANNUNCIATE
MUSEO CIVICO, SAN GIMIGNANO

Alinari

FIG. 55. FILIPPINO. ANGEL OF THE ANNUNCIATION
MUSEO CIVICO, SAN GIMIGNANO

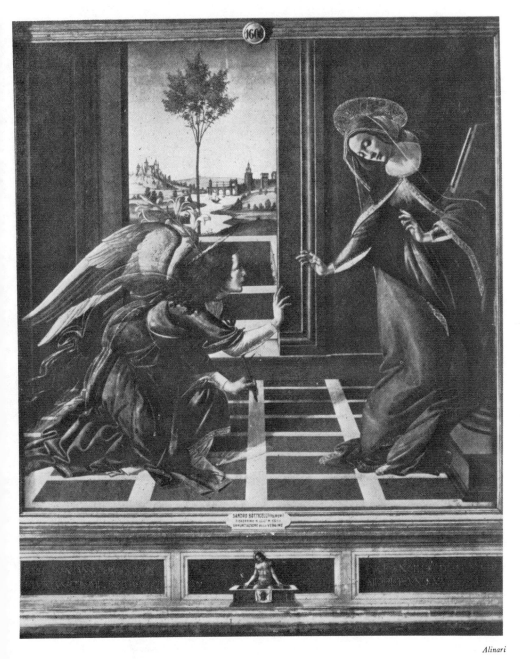

FIG. 57. SCHOOL OF BOTTICELLI. ANNUNCIATION

UFFIZI, FLORENCE

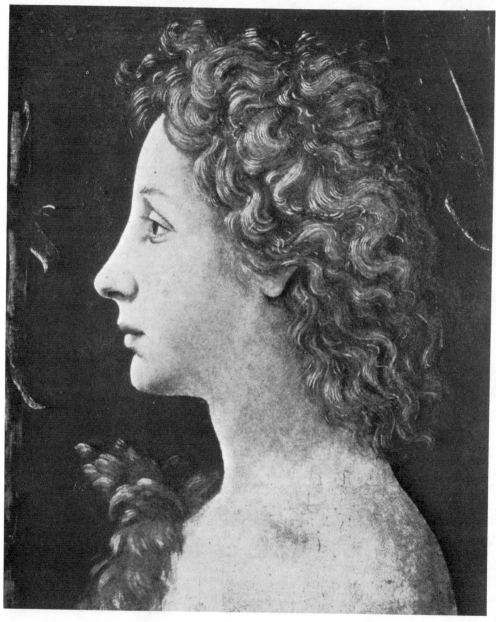

FIG. 58. PIERO DI COSIMO. HEAD OF THE YOUNG BAPTIST
DREICER COLLECTION, METROPOLITAN MUSEUM OF ART, NEW YORK

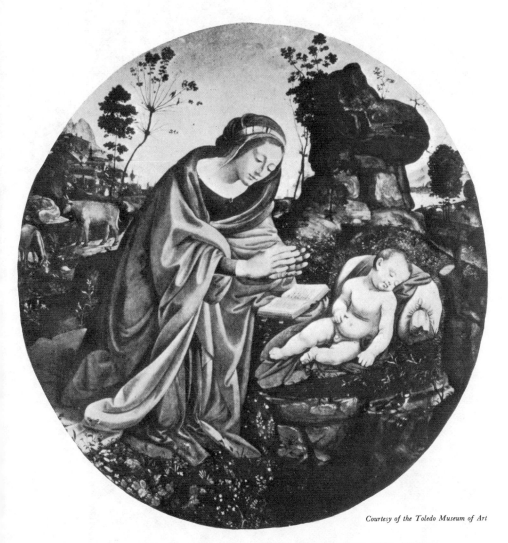

FIG. 59. PIERO DI COSIMO. MADONNA ADORING THE CHILD
MUSEUM, TOLEDO, OHIO

FIG. 61. FILIPPINO AND ASSISTANT. MADONNA AND CHILD
WITH TWO ANGELS

SIMON COLLECTION, KAISER FRIEDRICH MUSEUM, BERLIN

FIG. 60. FILIPPINO AND ASSISTANT
MADONNA AND CHILD

KAISER FRIEDRICH MUSEUM, BERLIN

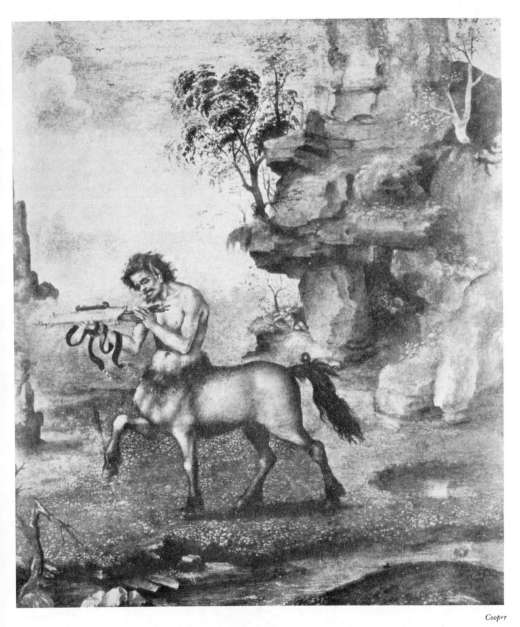

Cooper

FIG. 62. FILIPPINO. WOUNDED CENTAUR

Christ Church Library, Oxford

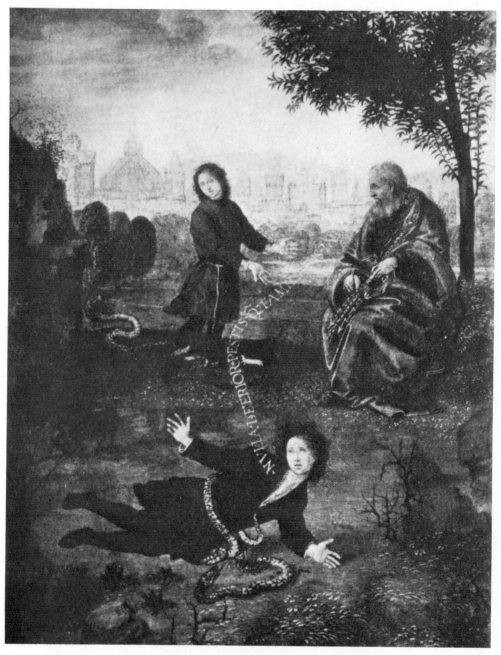

FIG. 63. FILIPPINO. ALLEGORY
UFFIZI, FLORENCE

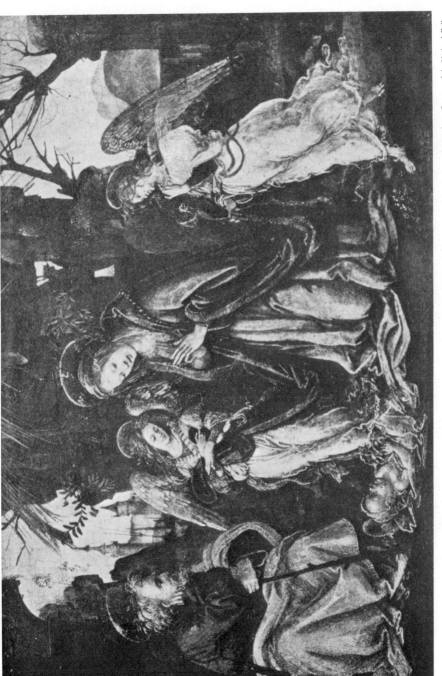

FIG. 64. FILIPPINO. HOLY FAMILY WITH TWO ANGELS

NATIONAL GALLERY, EDINBURGH

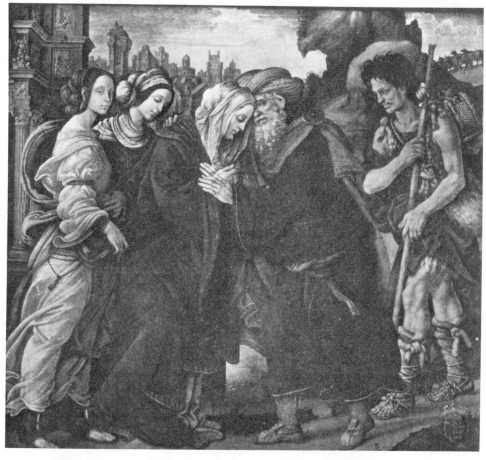

FIG. 65. FILIPPINO. MEETING OF JOACHIM AND ANNA (1497)
Museum, Copenhagen

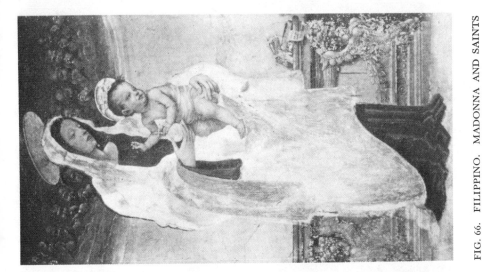

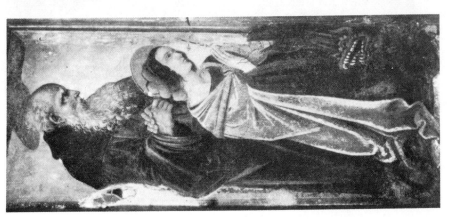

FIG. 66. FILIPPINO. MADONNA AND SAINTS
STREET TABERNACLE (1498), PRATO

FIG. 67. FILIPPINO. MADONNA AND SAINTS
DRAWING, UFFIZI, FLORENCE

FIG. 68. FILIPPINO. SHEET OF DRAWINGS
CHRIST CHURCH LIBRARY, OXFORD

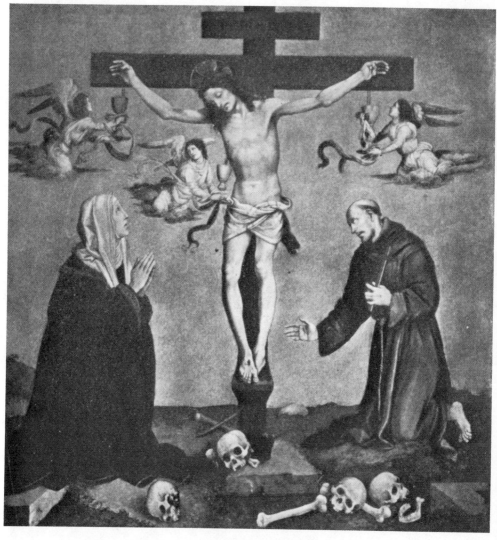

FIG. 69. FILIPPINO. CHRIST ON THE CROSS, WITH THE VIRGIN AND ST. FRANCIS
KAISER FRIEDRICH MUSEUM, BERLIN

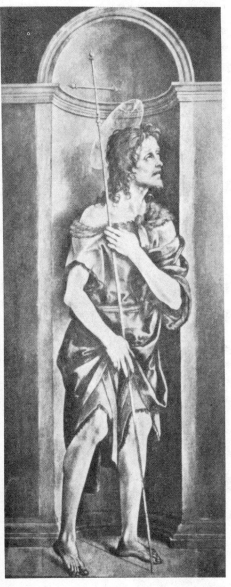

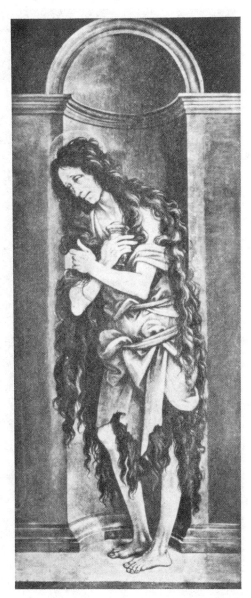

Alinari

Alinari

FIG. 70. FILIPPINO. ST. JOHN
THE BAPTIST
ACADEMY, FLORENCE

FIG. 71. FILIPPINO. ST. MARY
MAGDALEN
ACADEMY, FLORENCE

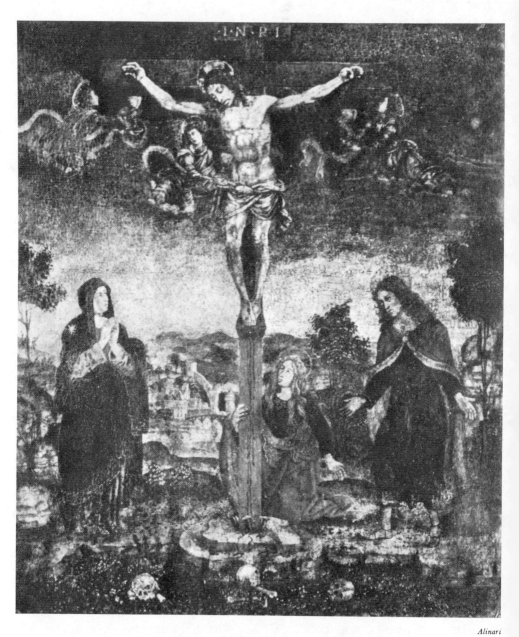

FIG. 72. SCHOOL OF FILIPPINO. CRUCIFIXION
PINACOTECA COMUNALE, MONTEPULCIANO

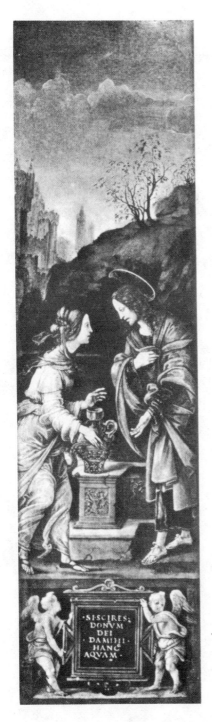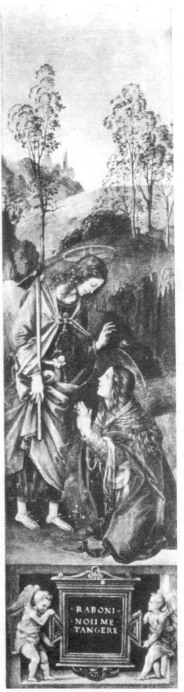

FIG. 73. FILIPPINO. CHRIST AND THE SAMARITAN
WOMAN; "NOLI ME TANGERE"
SEMINARIO, VENICE

FIG. 74. FILIPPINO. TWO ANGELS

SANT'AMBROGIO, FLORENCE

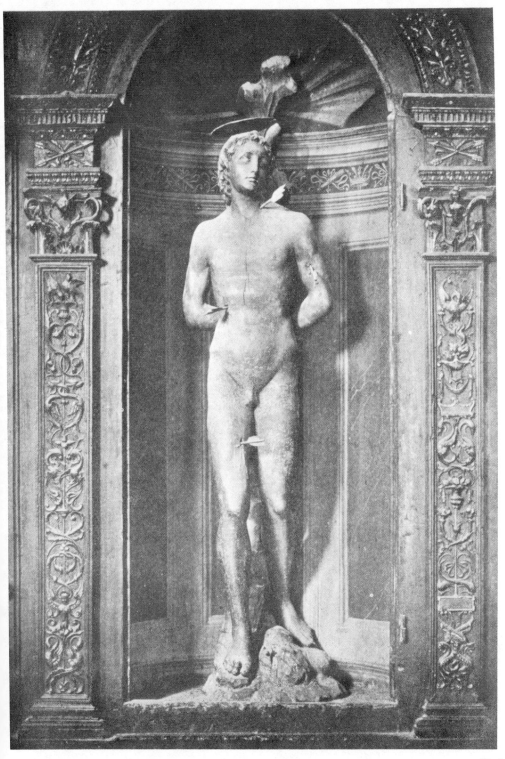

FIG. 75. LEONARDO DEL TASSO. ST. SEBASTIAN, WOODEN FIGURE
IN NICHE BELOW FILIPPINO'S ANGELS
SANT'AMBROGIO, FLORENCE

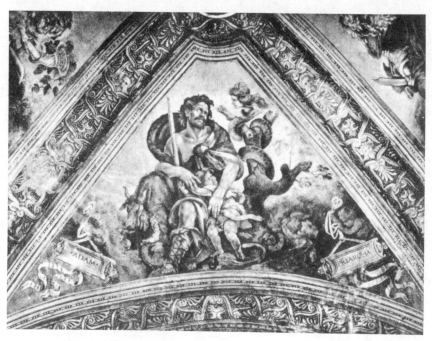

Alinari

FIG. 76. FILIPPINO. ADAM

Vault, Strozzi Chapel, Sta. Maria Novella, Florence

Alinari

FIG. 77. FILIPPINO. NOAH

Vault, Strozzi Chapel, Sta. Maria Novella, Florence

FIG. 78. FILIPPINO. JACOB

Vault, Strozzi Chapel, Sta. Maria Novella, Florence

FIG. 79. FILIPPINO. ABRAHAM

Vault, Strozzi Chapel, Sta. Maria Novella, Florence

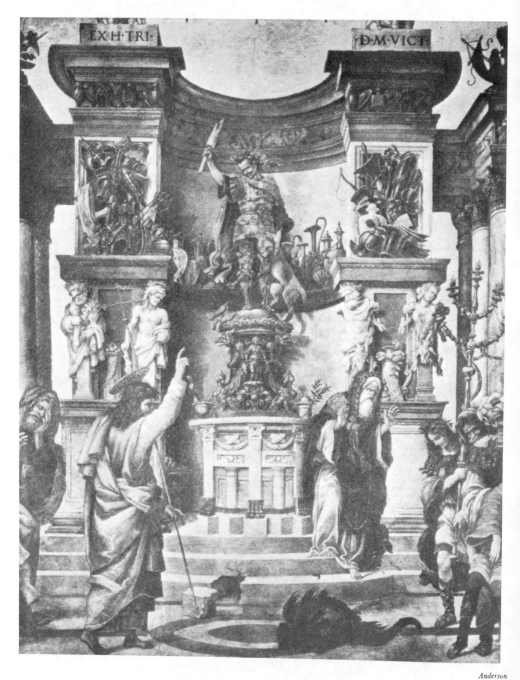

FIG. 80. FILIPPINO. ST. PHILIP EXORCISING THE DEMON, DETAIL

SOUTH WALL, STROZZI CHAPEL, STA. MARIA NOVELLA, FLORENCE

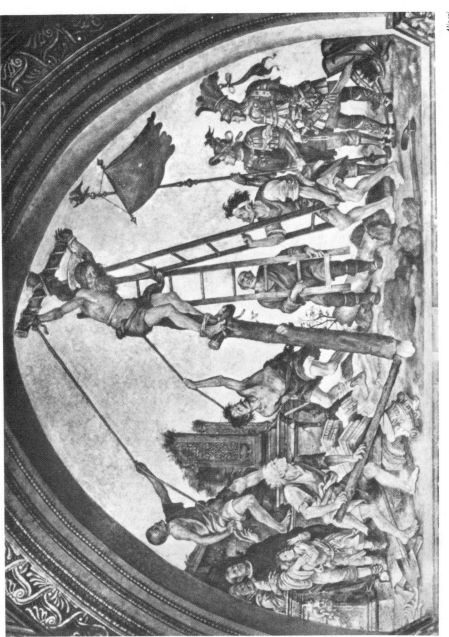

FIG. 81. FILIPPINO. MARTYRDOM OF ST. PHILIP

South Wall, Strozzi Chapel, Sta. Maria Novella, Florence

FIG. 82. FILIPPINO. MARTYRDOM OF ST. JOHN THE EVANGELIST

North Wall, Strozzi Chapel, Sta. Maria Novella, Florence

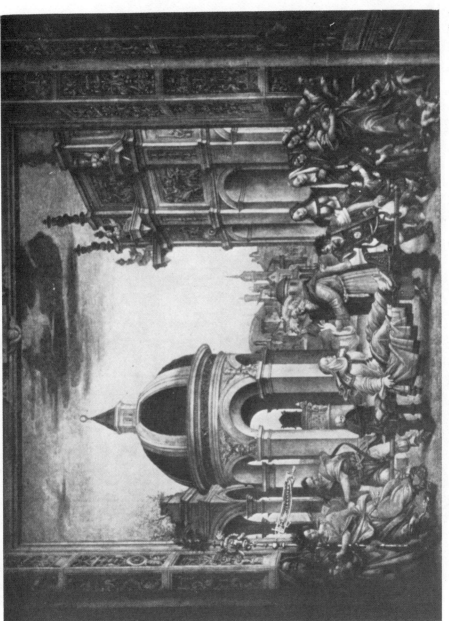

FIG. 83. FILIPPINO. RAISING OF DRUSIANA (1502)
NORTH WALL, STROZZI CHAPEL, STA. MARIA NOVELLA, FLORENCE

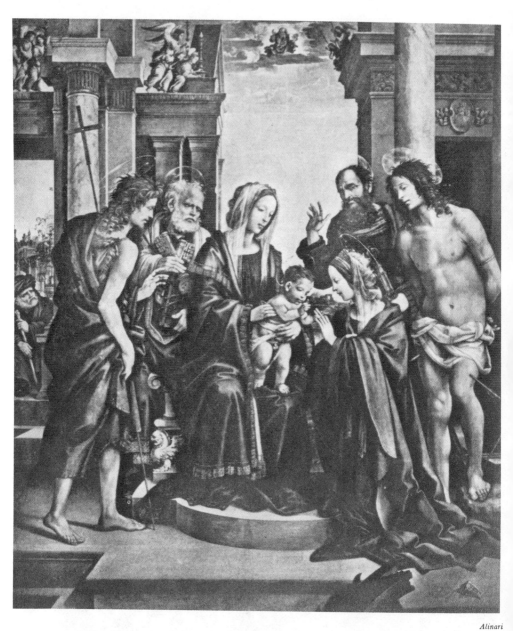

FIG. 84. FILIPPINO. MARRIAGE OF ST. CATHERINE (1501)

SAN DOMENICO, BOLOGNA

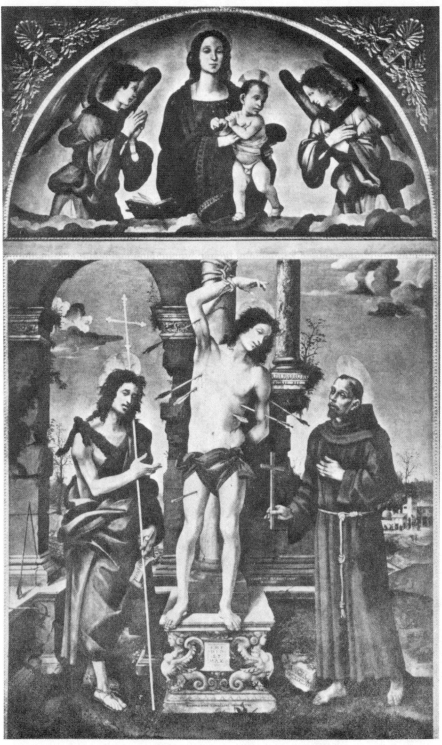

FIG. 85. FILIPPINO. ST. SEBASTIAN BETWEEN SS. JOHN
THE BAPTIST AND FRANCIS (1503)
PALAZZO BIANCO, GENOA

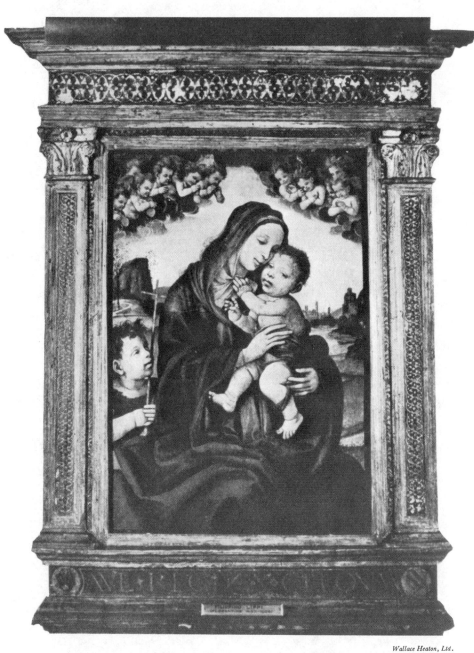

FIG. 86. FILIPPINO. MADONNA AND CHILD WITH ST. JOHN

St. Augustine's Church, Kilburn, London (formerly in Lord Rothermere's Collection)

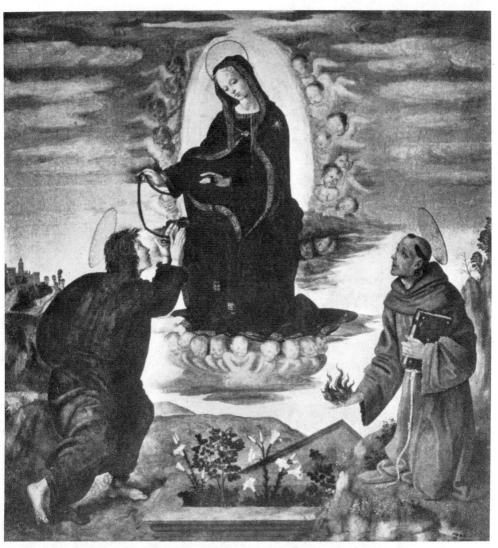

FIG. 87. SCHOOL OF FILIPPINO. MADONNA GIVING HER
GIRDLE TO ST. THOMAS, WITH ST. FRANCIS
CASTAGNO MUSEUM, SANT'APOLLONIA, FLORENCE

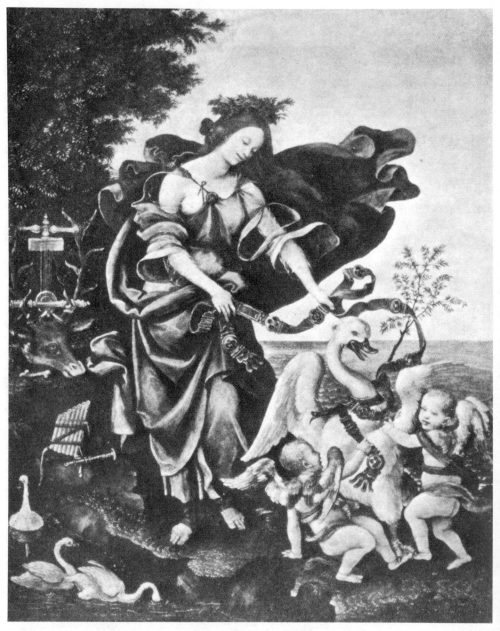

FIG. 88. FILIPPINO. ALLEGORY OF MUSIC

KAISER FRIEDRICH MUSEUM, BERLIN

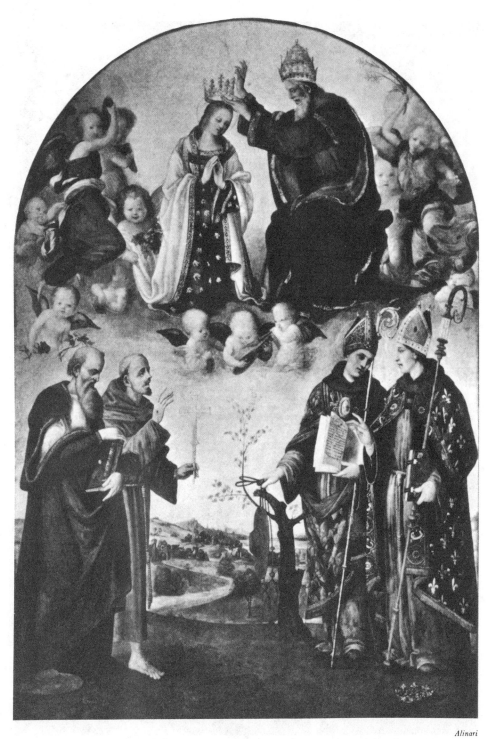

Alinari

FIG. 89. PIERO DI COSIMO AND OTHERS. CORONATION OF THE VIRGIN
LOUVRE, PARIS

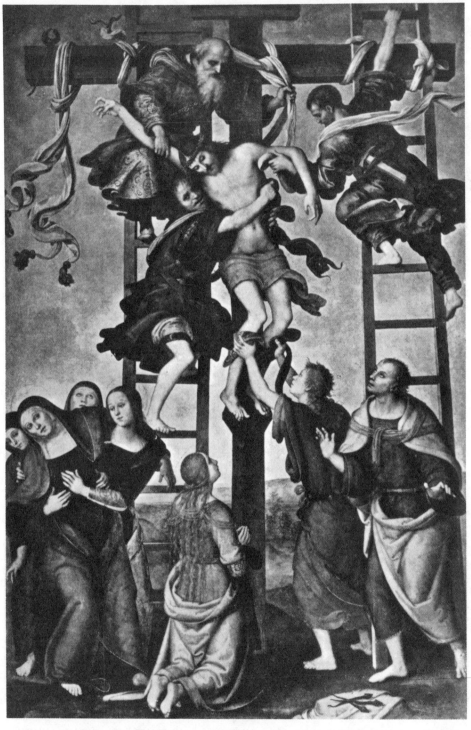

FIG. 90. FILIPPINO AND PERUGINO. DEPOSITION

Uffizi, Florence

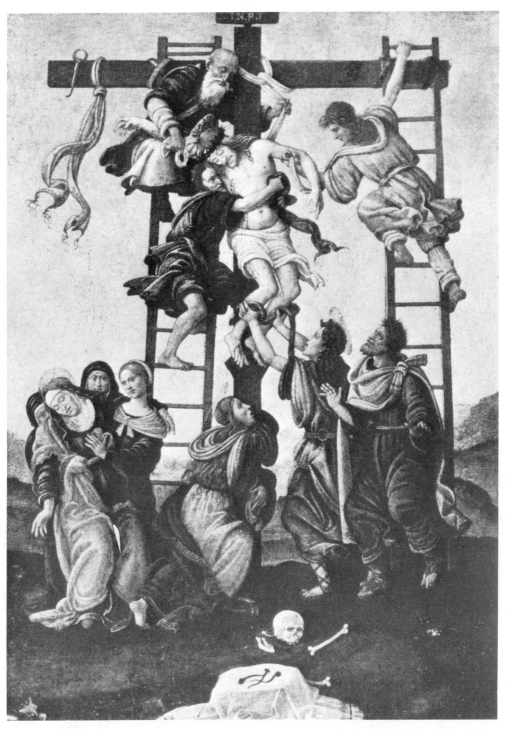

FIG. 91. COPY AFTER FILIPPINO. DEPOSITION
METROPOLITAN MUSEUM OF ART, NEW YORK, N. Y.

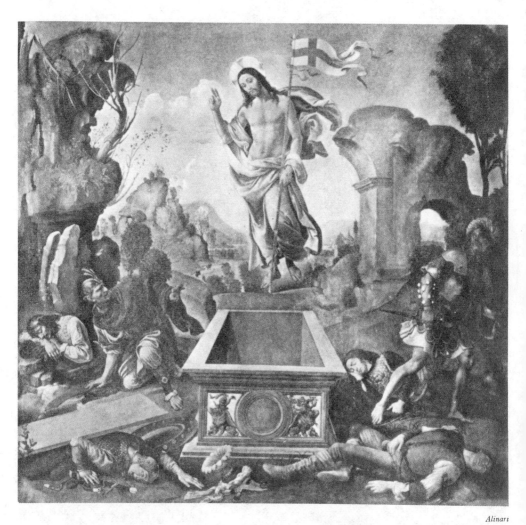

FIG. 92. RAFFAELLINO DEL GARBO. RESURRECTION
Uffizi, Florence

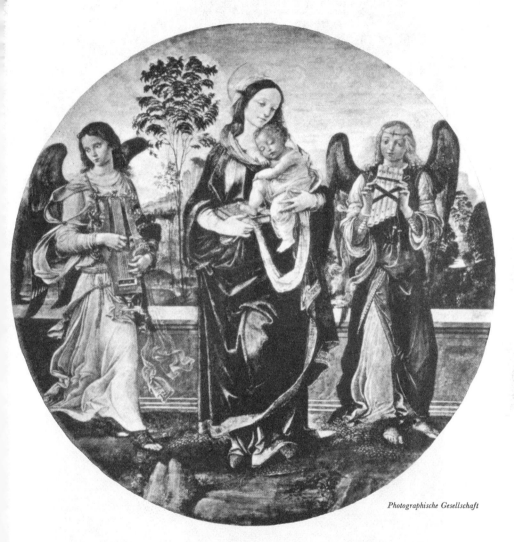

FIG. 93. RAFFAELLINO DEL GARBO. MADONNA AND SLEEPING CHILD WITH
TWO ANGELS

KAISER FRIEDRICH MUSEUM, BERLIN

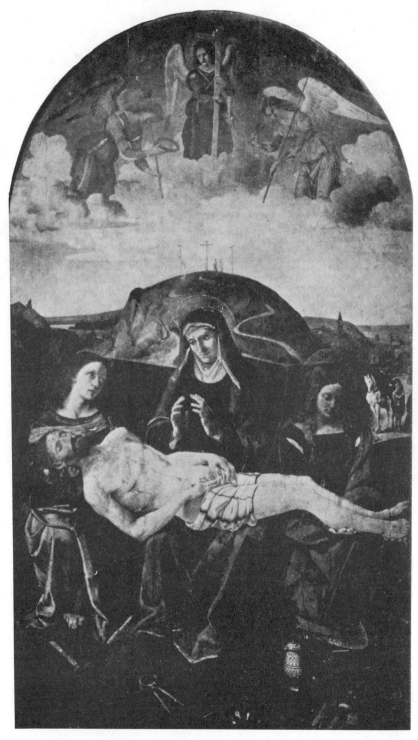

FIG. 94. PIERO DI COSIMO. PIETÀ

PINACOTECA VANNUCCI, PERUGIA

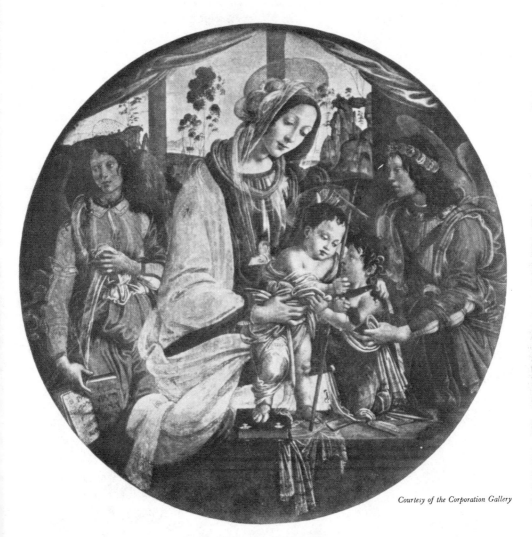

FIG. 95. RAFFAELLINO DEL GARBO (?). MADONNA WITH
ST. JOHN THE BAPTIST AND ANGELS
CORPORATION GALLERY, GLASGOW

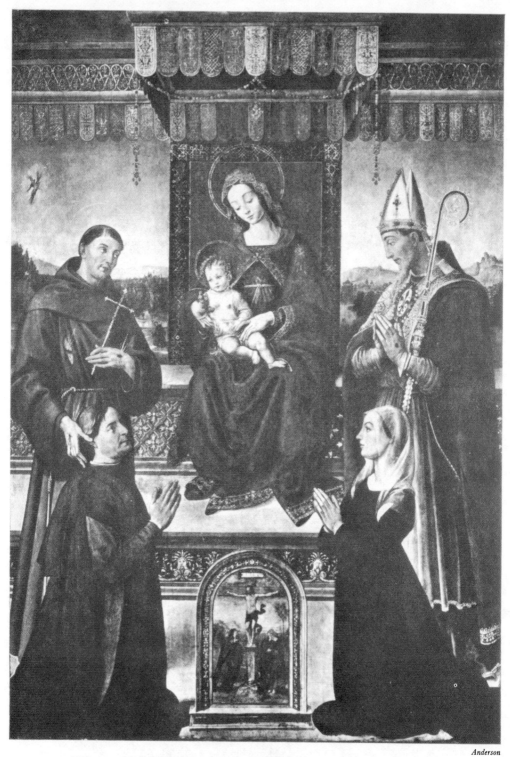

FIG. 96. RAFFAELLINO DEL GARBO. MADONNA ENTHRONED
WITH SAINTS AND DONORS (1500)
UFFIZI, FLORENCE

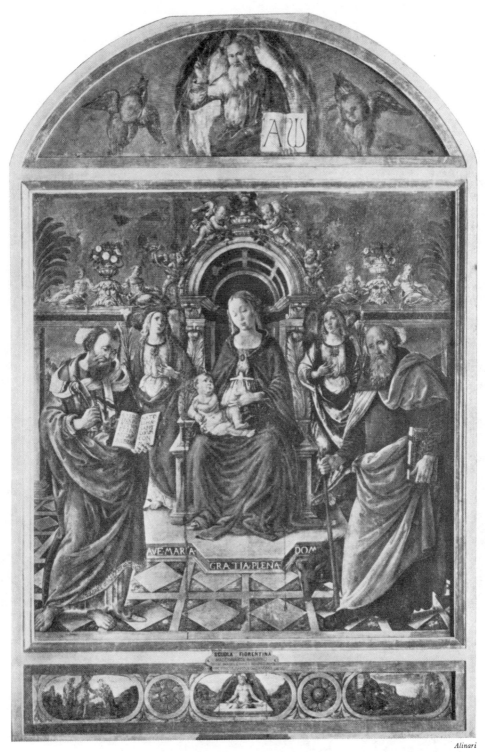

FIG. 97. FLORENTINE FIFTEENTH CENTURY. MADONNA ENTHRONED WITH SAINTS

Palazzo dei Priori, Volterra

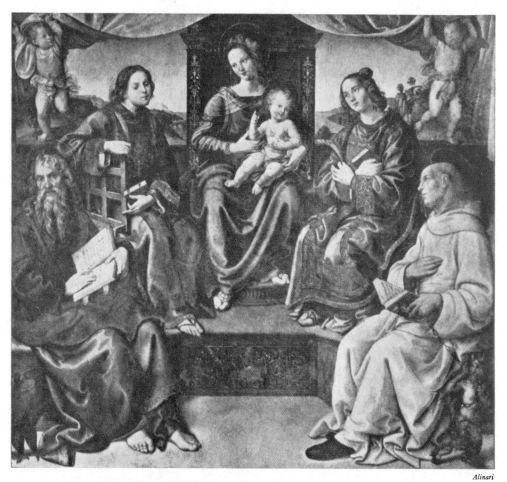

Alinari

FIG. 98. RAFFAELLINO DEL GARBO. MADONNA AND SAINTS (1505)
SOUTH TRANSEPT, STO. SPIRITO, FLORENCE

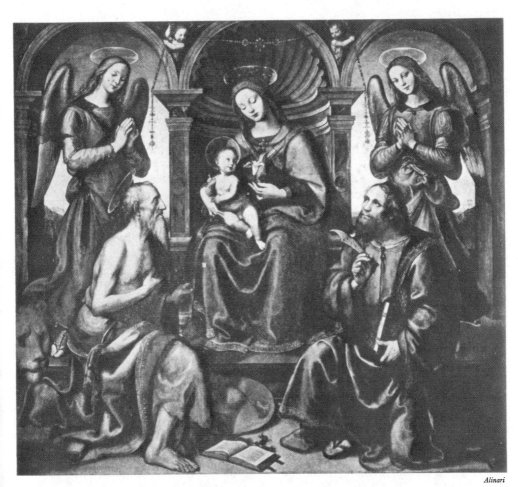

Alinari

FIG. 99. RAFFAELLINO DEL GARBO. MADONNA AND SAINTS (1501)
CORSINI GALLERY, FLORENCE

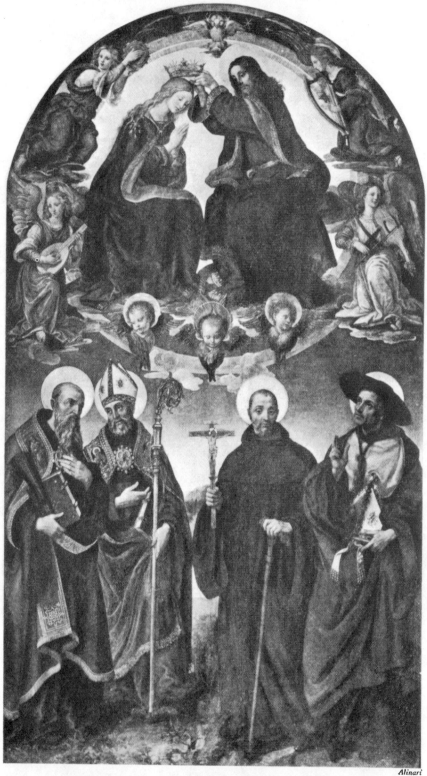

FIG. 100. RAFFAELLINO DEL GARBO. CORONATION OF THE VIRGIN
LOUVRE, PARIS

FIG. 101. RAFFAELLINO DEL GARBO. VIRGIN APPEARING TO ST. BERNARD
PREDELLA, ALTARPIECE IN STO. SPIRITO, FLORENCE

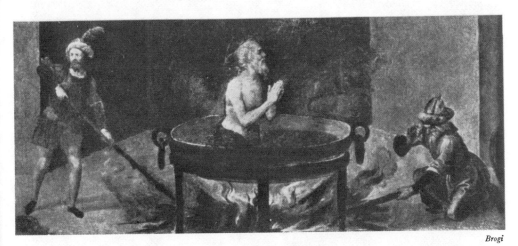

FIG. 102. RAFFAELLINO DEL GARBO. MARTYRDOM OF ST. JOHN THE EVANGELIST
PREDELLA, ALTARPIECE IN STO. SPIRITO, FLORENCE

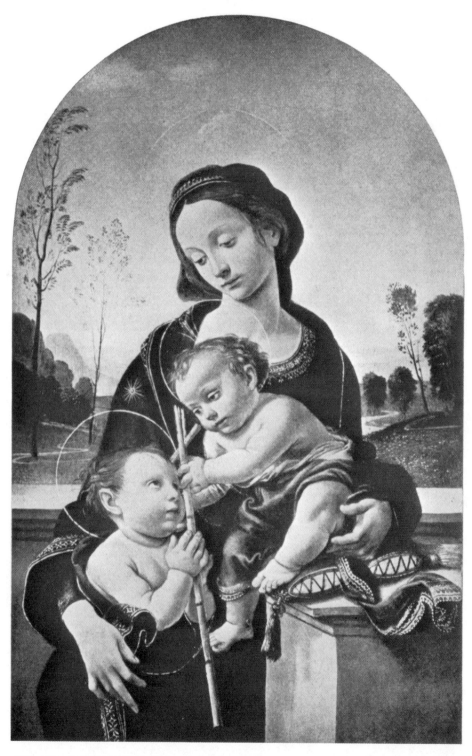

FIG. 103. RAFFAELLINO DEL GARBO. MADONNA AND CHILD WITH ST. JOHN
GOLDSCHMIDT AND WALLERSTEIN, BERLIN

Brogi

FIG. 104. RAFFAELLINO DEL GARBO. SEATED MADONNA
AND CHILD WITH ST. JOHN
NATIONAL MUSEUM, NAPLES

FIG. 105. RAFFAELLINO DEL GARBO. ANNUNCIATION
San Francesco, Fiesole

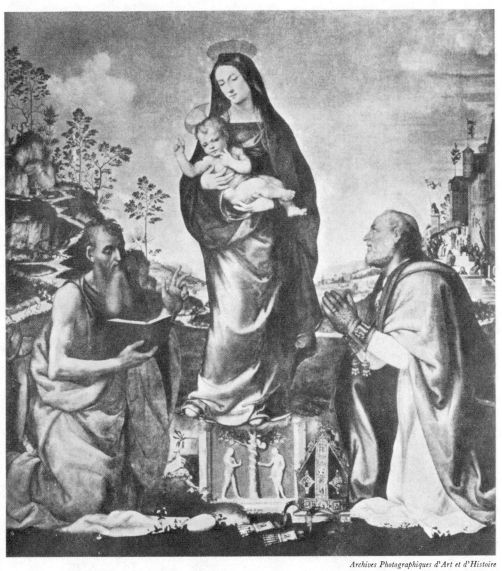

FIG. 106. ALBERTINELLI. MADONNA WITH SS. JEROME AND ZENOBIUS

LOUVRE, PARIS

FIG. 107. FILIPPINO. EAST WALL, DETAIL

Strozzi Chapel, Sta. Maria Novella, Florence

FIG. 109. SCHOOL OF FILIPPINO. MADONNA
ADORING THE CHILD, WITH TWO ANGELS

Ca'd'Oro, Venice

FIG. 108. SCHOOL OF FILIPPINO. MADONNA ADORING
THE CHILD

Museum, Toledo, Ohio

Braun

FIG. 111. FILIPPINO. HOLY FAMILY AND ANGELS
DRAWING, UFFIZI, FLORENCE

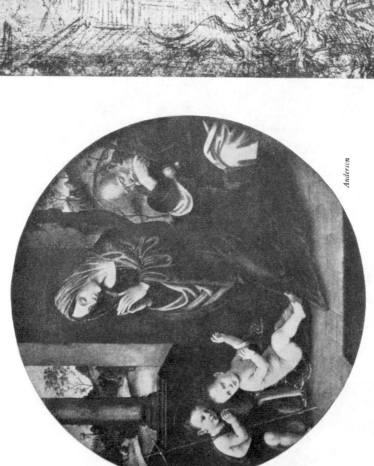

Anderson

FIG. 110. SCHOOL OF FILIPPINO. HOLY FAMILY
ACADEMY, VENICE

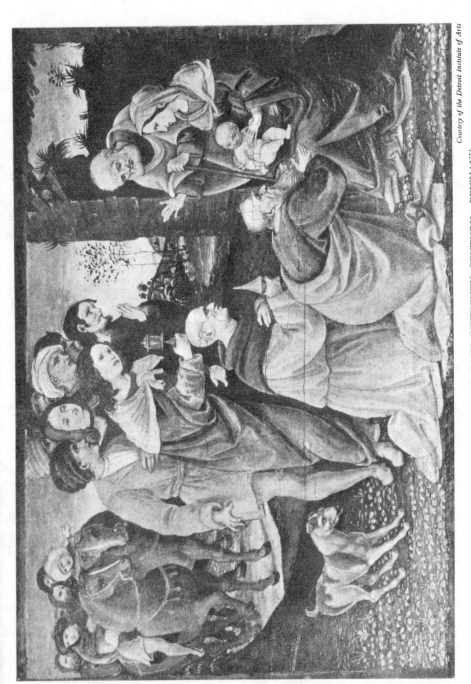

FIG. 112. FLORENTINE SCHOOL, LATE FIFTEENTH CENTURY. EPIPHANY

INSTITUTE OF ARTS, DETROIT

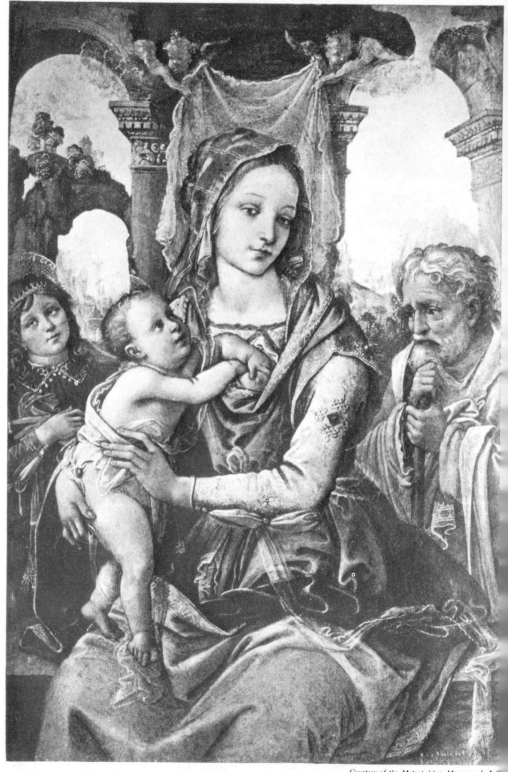

FIG. 113. SCHOOL OF FILIPPINO. HOLY FAMILY WITH AN ANGEL
ALTMAN COLLECTION, METROPOLITAN MUSEUM OF ART, NEW YORK, N. Y.